EXPANDING

HORIZONS

PAINTING AND
PHOTOGRAPHY OF
AMERICAN
AND CANADIAN
LANDSCAPE
1860-1918

EDITED BY
HILLIARD T.
GOLDFARB

M

THE MONTREAL
MUSEUM
OF FINE ARTS

SOMOGY
ART
PUBLISHERS

© Mixed Sources
Product group from well-managed
forests, controlled sources and
recycled wood or fiber
www.fsc.org Cert no. SW-COC-000952
© 1996 Forest Stewardship Council
FSC

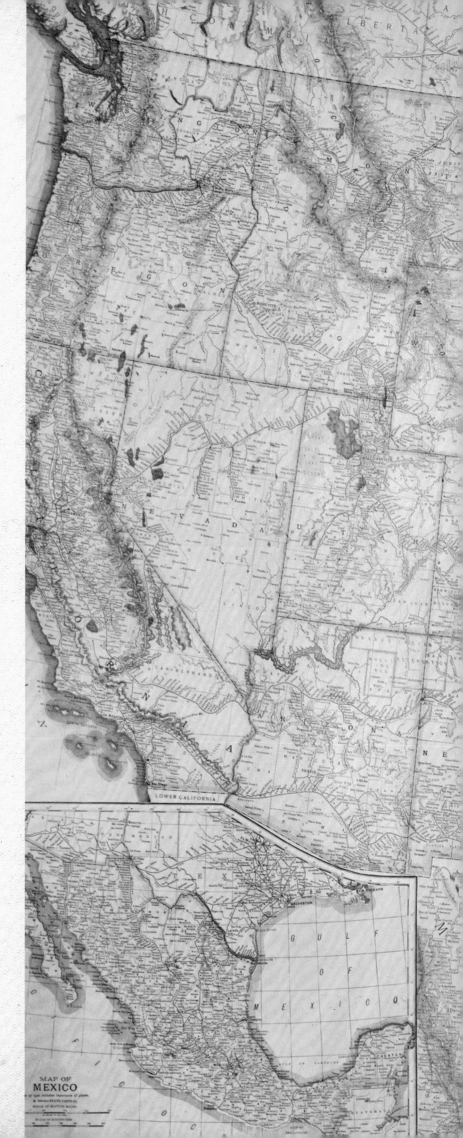

<u>Expanding Horizons: Painting and Photography of
American and Canadian Landscape 1860-1918</u> enhances
our understanding of an essential period in both
American and Canadian history that encompassed each
country's westward expansion and affirmation of
nationhood. This exhibition, an ambitious examination
of historical American and Canadian art, identifies
developments in the conceptualization and depiction
of landscapes and places, the two traditions side
by side, in an enlarged, international context.

Throughout its 30-year history, the Terra
Foundation for American Art has supported exhibitions,
scholarship and educational programs in the field
of historical American art. We are committed to
supporting projects such as this, which are designed
to engage audiences in an international dialogue.
Additionally, the foundation has a particular interest
in fostering multi-national perspectives; <u>Expanding
Horizons</u> is truly a cross-cultural effort through
the involvement of a dedicated team of both Canadian
and American scholars.

The Terra Foundation for American Art is very
proud to support this exhibition and to lend artworks
from our collection of historical American art.

Elizabeth Glassman
President and Chief Executive Officer

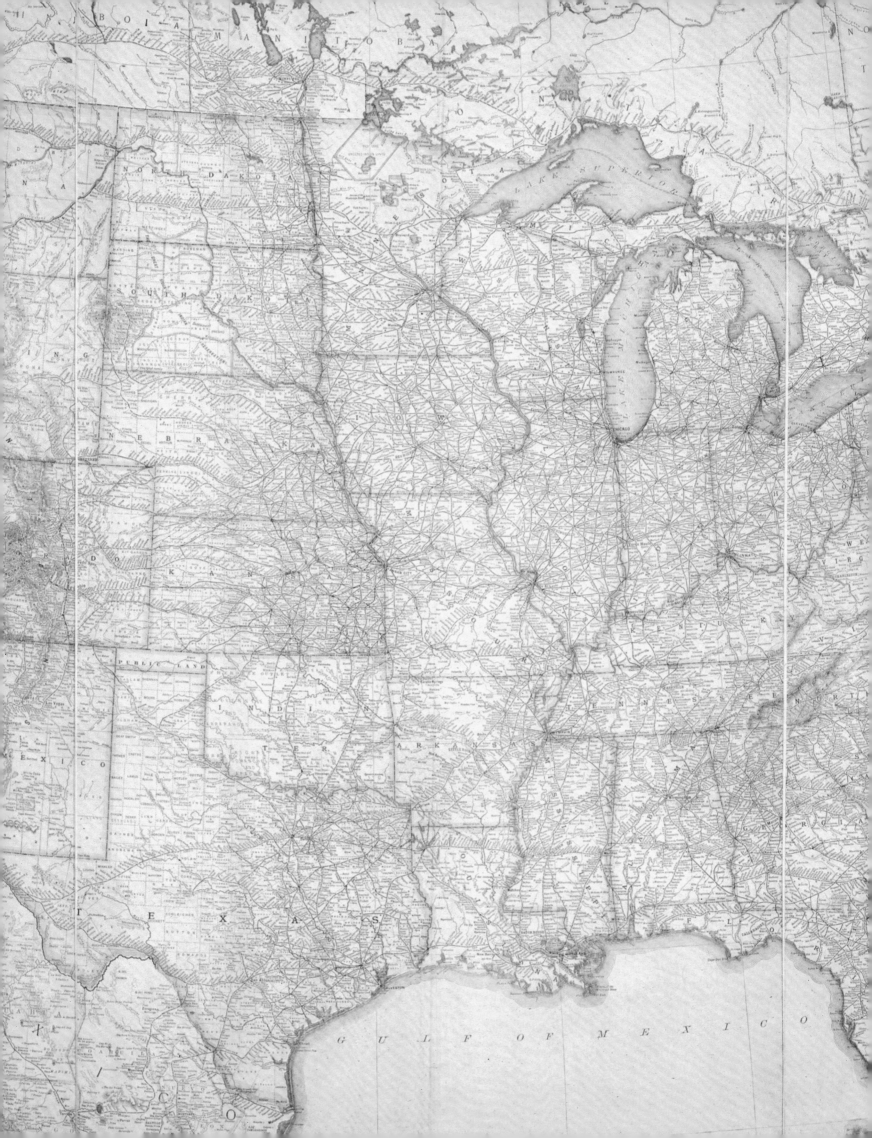

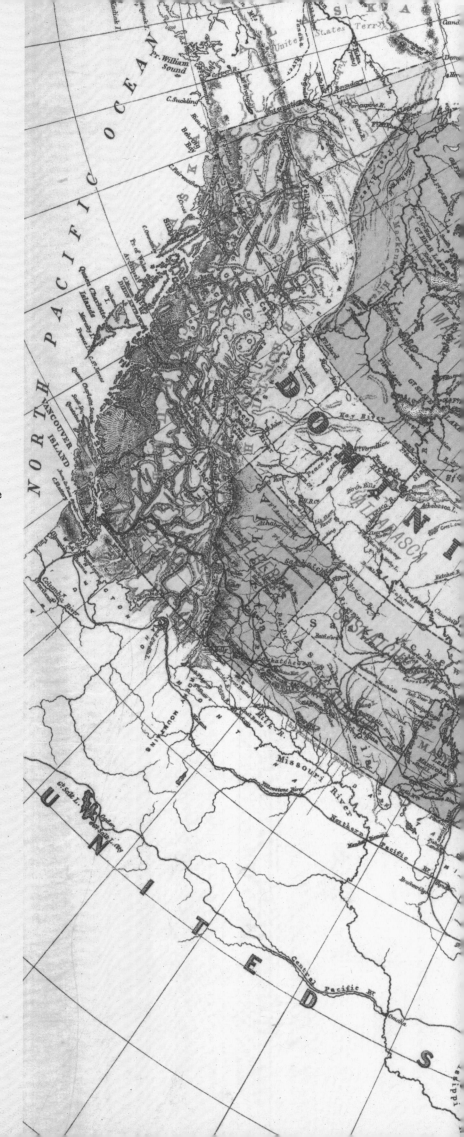

Sun Life Financial is pleased to play a role in presenting <u>Expanding Horizons: Painting and Photography of American and Canadian Landscape 1860-1918</u> and to be able to help bring Canadian and American art to as large an audience as possible.

Comprising nearly two hundred paintings and photographs of landscapes, this exhibition provides an opportunity to explore and enjoy magnificent works executed during an era of significant artistic and historical transformation by talented artists who drew inspiration from the open spaces of these two countries, where nature is an ever-present force. Truly a delight to the eye and food for the soul, the photographs and paintings included in this exhibition speak to us not only of the indisputable tourism value of these unique locations, but also of the vulnerability of these irreplaceable treasures, which we are called upon to protect.

Sun Life Financial recognizes and commends the important contribution of this exhibition to the understanding of the landscape art produced at this time in history and to the broadening of our knowledge of this topic with its focus on national and regional identities. It is proud to play a part and to help make the arts more accessible through this exhibition and its catalogue.

Cultural life is brighter under the sun.

Sun Life Financial

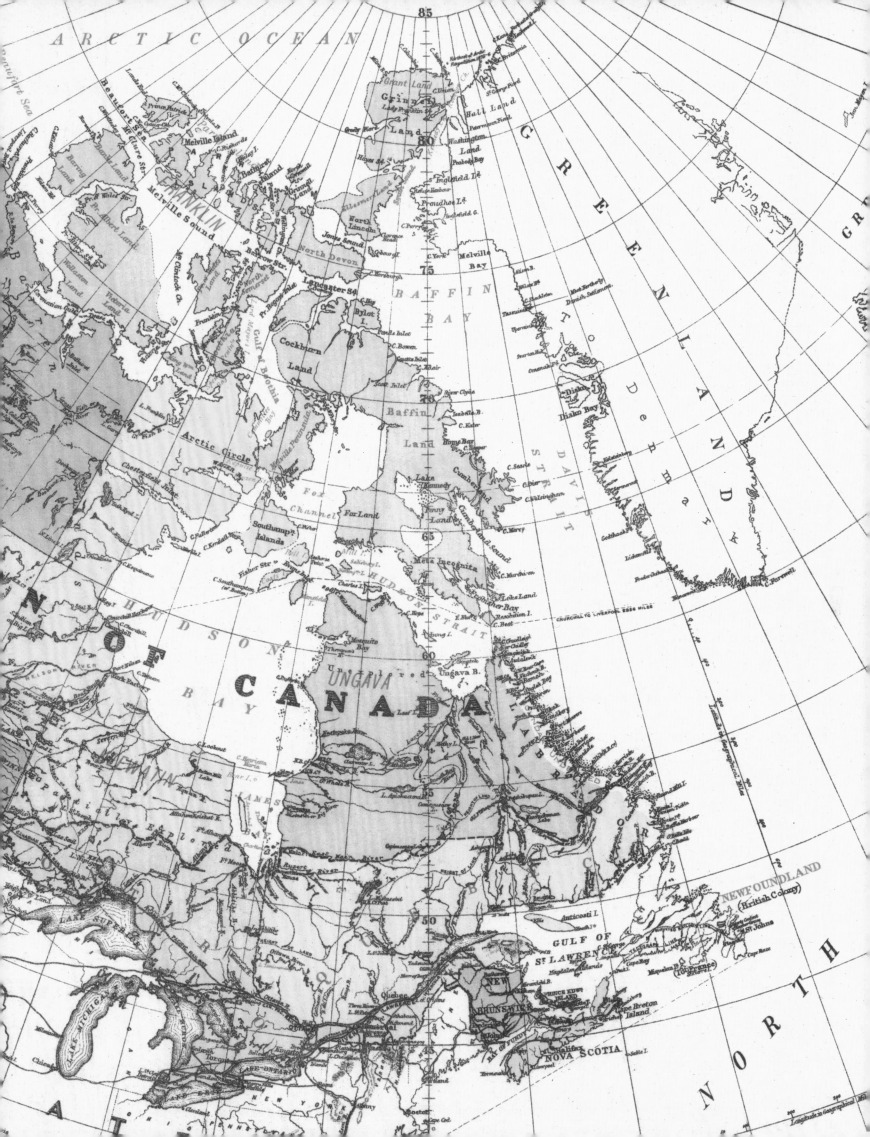

Authors

Philip Brookman
Director of Curatorial Affairs
Corcoran Gallery of Art, Washington

Brian Foss
Associate Dean, Academic and Students Affairs
Faculty of Fine Arts
Concordia University, Montreal

François-Marc Gagnon
Director
The Jarislowsky Institute for Studies in Canadian Art
Concordia University, Montreal

Hilliard T. Goldfarb
Associate Chief Curator
The Montreal Museum of Fine Arts

Richard Hill
Assistant Professor
Art History and Visual Arts Department
York University, Toronto

Lynda Jessup
Associate Professor
Department of Art
Queen's University, Kingston

T. J. Jackson Lears
Professor
Rutgers History Department
Rutgers University, New Brunswick, New Jersey

Rosalind Pepall
Senior Curator of Decorative Arts (Early and Modern)
The Montreal Museum of Fine Arts

Ian Thom
Senior Curator of Canadian Art
Vancouver Art Gallery

Nature
Transcen-
dent

The Stage
of History
and the
Theatre
of Myth

Man
Versus
Nature

Nature
Domesticated

The Urban
Landscape

The Return
to Nature

Commentaries accompanying the illustrated works are by Hilliard T. Goldfarb.

Endangered Horizons

The nineteenth century—the age of conquering ever-distant horizons—was but yesterday. The North Americans of Canada and the United States considered the rapacious conquest of new wilderness simply a way of exploiting seemingly inexhaustible natural resources. The saga of those pioneers was accompanied by the discovery of a natural heritage transcended by a spirituality, a religious fervour that recognized in the pristine landscape the work of the Creator. In contrast to the corruption of the Old World, America represented a new Promised Land. Drawing from the European romanticism of Burke, Goethe and Chateaubriand and influenced by the explorer-scientist Humboldt's "views of nature," the American landscape artists Church, Cole and Moran, as well as the photographers, in their works conveyed their wonder at the marvels of the natural world. At the same time as the first national parks were created (in 1872 in the United States and in 1885 in Canada) and a policy to protect forests and parks was instituted by a visionary president, Theodore Roosevelt, engineers launched their iron and concrete assault on the mountains and rivers of an immense territory.

In 2000, Jean Clair and Pierre Théberge's starry-eyed exhibition Cosmos: From Romanticism to the Avant-garde brilliantly celebrated the arrival of the new millennium, opening the twenty-first century to a world without limits. Today, however, following one hundred years of exploration and exploitation, a dramatically different vision prevails—that of a world whose horizons are constantly becoming closer, more tangible and more vulnerable. The explorer's sense of nature as gigantic, monumental and beyond measure has now given way to alarm about an endangered planet, as the final, cosmic frontier is still unfit for living beings. A drastic reversal of view has taken place, as if we were looking through the opposite end of the telescope. Our global perception of the natural world is of a planet with cruelly diminished horizons. In the few short years since 2000, protecting the environment has become a major concern, despite persistent sceptics. Following a period of cosmogonic lyricism, the pragmatic necessity to act on convictions arising from our sense of urgency has all the seriousness of a deep-sea diver's warning bell.

With this exhibition, the Montreal Museum of Fine Arts intends to change its practices in terms of exhibition design and publications. It is not opportunism that motivates us, but rather the exhibition affords us a forthright look at current attitudes about the natural world, and I would like to reflect its value through the environmentally conscious prism of contemporary creation. Nature inspired artists in the past, and it continues to engender the same intrinsic respect today. The architecture firm Atelier Big City has designed an imaginative layout that makes full use of recyclable or reusable materials and emphasizes mechanical construction methods. The exhibition's fixtures and fittings have been developed by molo, a well-known Vancouver eco-design firm whose work is represented in MoMA. Thanks to the graphic design studio orangetango, as well as printer Transcontinental Litho Acme, the exhibition's catalogue is a true innovation in art book publishing through its environmentally friendly design, choice of materials and print production process. I would like to thank our partners, who have taken environmental considerations into account, as part of their corporate culture, and the team at the Montreal Museum of Fine Arts, as well as that under Kathleen S. Bartels at the Vancouver Art Gallery, for their important addition to the scholarly content developed by Hilliard T. Goldfarb.

Nathalie Bondil
Director and Chief Curator
The Montreal Museum of Fine Arts

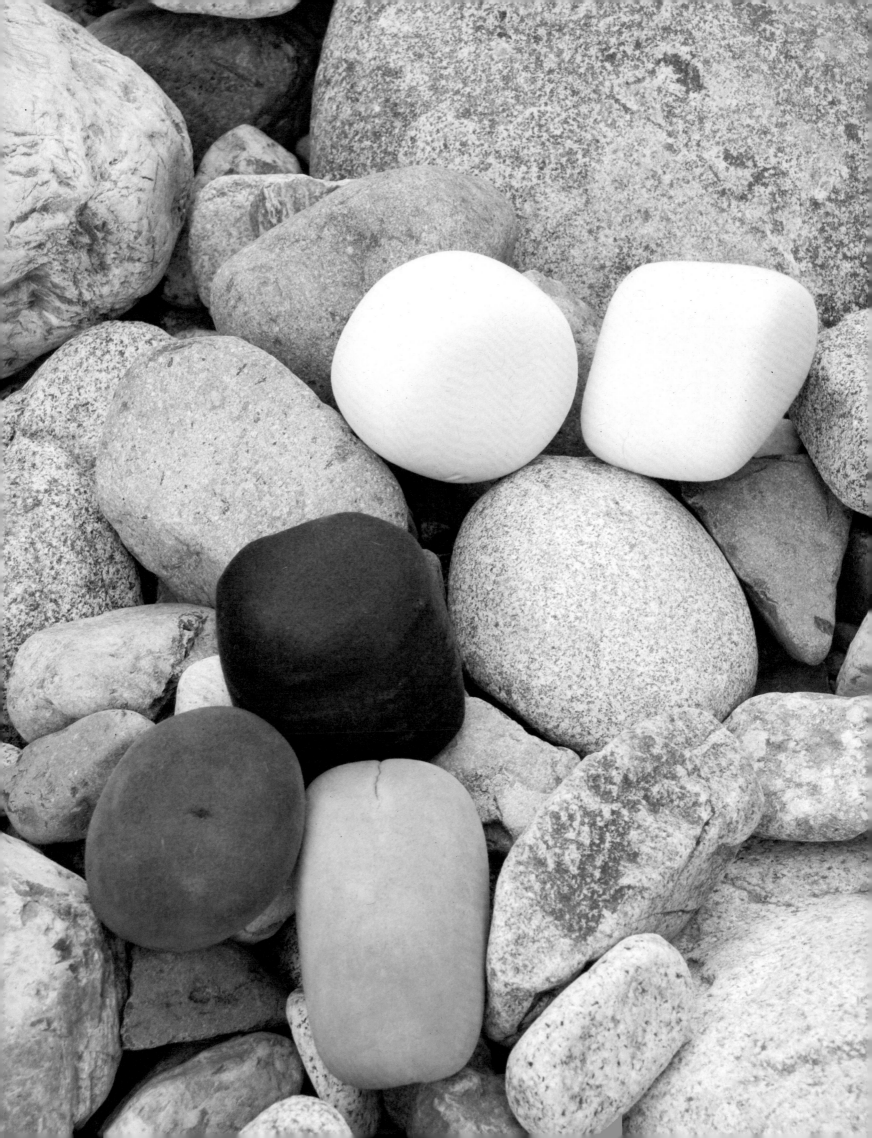

This catalogue is published in conjunction with the exhibition
Expanding Horizons: Painting and Photography of American and
Canadian Landscape 1860-1918, an exhibition organized by the
Montreal Museum of Fine Arts. The exhibition receives financial
support from the Terra Foundation for American Art and
Sun Life Financial.

Curator

Hilliard T. Goldfarb
Associate Chief Curator
The Montreal Museum of Fine Arts

Exhibition venues

The Montreal Museum of Fine Arts
Michal and Renata Hornstein Pavilion
From June 18 to September 27, 2009
Design
Atelier Big City
molo

Vancouver Art Gallery
From October 17, 2009 to January 17, 2010

The Montreal Museum of Fine Arts

Brian M. Levitt
President

Nathalie Bondil
Director and *Chief Curator*

Paul Lavallée
Director of Administration

Danielle Champagne
Director of Communications and
*Director of the Montreal Museum
of Fine Arts Foundation*

The exhibition receives financial support
from the Exhibition Fund of the Montreal
Museum of Fine Arts Foundation and the
Paul G. Desmarais Fund.

The Museum would like to thank the Volunteer
Association of the Montreal Museum of
Fine Arts as well as its Friends and the many
corporations, foundations and individuals
for their contributions.

The Montreal Museum of Fine Arts also
wishes to thank the Canada Council for the
Arts and the Conseil des arts de Montréal.
The Museum also acknowledges the Quebec's
Ministère de la Culture, des Communications
et de la Condition féminine du Québec for
its ongoing support.

Catalogue

The Montreal Museum of Fine Arts

Head of Publishing
Francine Lavoie

Associate Publisher
Sébastien Hart

Revision
Louise Gauthier

Translation
Donald Pistolesi
Kathleen Putnam

Proofreading
Jane Jackel

Copyright
Linda-Anne D'Anjou

Research and documentation
Thierry-Maxime Loriot
Manon Pagé

Technical support
Sylvie Ouellet

Graphic design
orangetango

Pre-press and printing
Transcontinental Litho Acme

Distribution

*Expanding Horizons: Painting and Photography
of American and Canadian Landscape 1860–1918*
© The Montreal Museum of Fine Arts /
Somogy Art Publishers, 2009
ISBN MMFA : 978-2-89192-334-7
ISBN Somogy : 978-2-7572-0307-1

Aussi publié en français sous le titre
*Grandeur nature. Peinture et photographie des
paysages américains et canadiens de 1860 à 1918*
© Musée des beaux-arts de Montréal /
Somogy éditions d'art, Paris, 2009
ISBN MBAM : 978-2-89192-333-0
ISBN Somogy : 978-2-7572-0303-3

Legal deposit : 2nd quarter 2009
Bibliothèque et Archives nationales du Québec
Library and Archives Canada
Legal deposit : August 2009
Bibliothèque nationale de France

Printed in Canada

The Montreal Museum of Fine Arts
P.O. Box 3000
Station H
Montreal, Quebec
Canada
H3G 2T9
www.mmfa.qc.ca

Cover : Albert Bierstadt, *Yosemite Valley*, 1968 (cat. 47, detail)

P. 2–3 : Matthews, Northrup & Co., *Official Railroad Map of
the United States, Dominion of Canada and Mexico*, 1890,
photo © Corbis

P. 4–5 : John Johnston, *Map shewing the provinces and districts
of Canada, Department of Interior*, Ottawa, 1890, 36 x 58 cm,
Bibliothèque et Archives nationales du Québec, photo BAnQ

P. 9 : molo, *felt rocks*, 2005, high-density 100% wool felt,
molo design, ltd.

Canada

CALGARY
Glenbow Museum
—
University of
Calgary

FREDERICTON
The Beaverbrook
Art Gallery

HAMILTON
Art Gallery of
Hamilton

KLEINBURG
McMichael
Canadian Art
Collection

MONTREAL
Canadian Centre
for Architecture
—
McCord Museum
—
McGill University
Library,
Rare Books and
Special Collections
Division
—
The Montreal
Museum of
Fine Arts
—
Power Corporation
of Canada
—
Private Collection
—
V.I. Antiques and
Fine Arts
—
Victor Isganaitis

OTTAWA
Library and
Archives Canada
—
National Gallery
of Canada

QUEBEC CITY
Musée national
des beaux-arts
du Québec

THORNHILL
Private collection

TORONTO
Art Gallery
of Ontario
—
The Government
of Ontario
Art Collection
—
The Justina M.
Barnicke Gallery

VANCOUVER
Vancouver Art
Gallery

WINDSOR
Art Gallery
of Windsor

WINNIPEG
The Winnipeg
Art Gallery

England

LONDON
Private collection

Scotland

EDINBURGH
The National
Gallery of Scotland

United States

ANDOVER
Addison Gallery of
American Art

BERKELEY
The Bancroft
Library,
University of
California

BOSTON
Isabella Stewart
Gardner Museum
—
Museum of
Fine Arts

CANYON
Panhandle Plains
Historical Museum

CHICAGO
Terra Foundation
for American Art

COUNCIL BLUFFS
Union Pacific
Railroad

DENVER
Denver Public
Library

FORT WORTH
Amon Carter
Museum

HANOVER
Hood Museum
of Art

HARTFORD
Wadsworth
Atheneum
Museum of Art

**HASTINGS-ON-
HUDSON**
The Newington-
Cropsey
Foundation

HOUSTON
Meredith and
Cornelia Long

LOS ANGELES
Autry National
Center of the
American West
—
The J. Paul Getty
Museum
—
Los Angeles
County Museum
of Art

MANCHESTER
Currier Museum
of Art

MINNEAPOLIS
Walker Art Center

NEW BRITAIN
New Britain
Museum of
American Art

NEW HAVEN
Yale University
Art Gallery

NEW YORK
The Metropolitan
Museum of Art
—
Museum of the
City of New York
—
The New York
Historical Society

NORFOLK
Chrysler Museum
of Art

OAKLAND
Oakland Museum
of California

ORANGE
Stark Museum
of Art

PHILADELPHIA
Pennsylvania
Academy of
the Fine Arts
—
Philadelphia
Museum of Art

ROCHESTER
George Eastman
House
—
Memorial Art
Gallery of the
University of
Rochester

SAN ANTONIO
San Antonio
Museum of Art

SAN DIEGO
Timken
Museum of Art

SAN FRANCISCO
Fine Arts Museums
of San Francisco
—
San Francisco
Museum of
Modern Art

SANTA FE
The Georgia
O'Keeffe
Foundation

SEATTLE
University of
Washington
Libraries,
Special
Collections
Division

**SOUTHWEST
HARBOR**
Southwest Harbor
Public Library

SAINT LOUIS
Saint Louis
Art Museum

WASHINGTON
Corcoran
Gallery of Art
—
Hirshhorn
Museum and
Sculpture Garden,
Smithsonian
Institution
—
Library of
Congress
—
National Gallery
of Art

WILLIAMSTOWN
The Sterling and
Francine Clark Art
Institute
—
Williams College
Museum of Art

For my nephew Seth Kursman

Crossed Destinies: Manifesting the Paths of Nationhood in the United States and Canada through Landscapes, 1860-1918

Hilliard T.
Goldfarb

The years seared at their margins by the experiences of the American Civil War and the First World War witnessed the fulfillment of a transcontinental territorial ambition in the United States that had originated in the early nineteenth century. The fulfillment of this ambition and the changing economic, political and social realities of this epoch fundamentally moulded a sensibility of "American-ness" related to yet quite distinctive from that of the antebellum years, from which a modern national identity emerged. Farther north, events leading to the 1867 Act of Confederation, the integration of territories and provinces into a federal system and a westward expansion (facilitated, as in the United States, by the rail-road) also led to changing economic, political and social realities within Canada. The evolution of a more broadly envisioned national identity yet continuing regional tensions, notably among Anglophone, Francophone and Metis constituencies, culminated in the contrasting images of the conflicting and violent domestic reactions to conscription during the First World War between Quebec and the other provinces, and the victory of the Canadian troops at Vimy Ridge. In both countries, regionalism, the powerful assertion of distinct cultural identities and heritages within expanding national frontiers, the mythologizing of history, and the perception and treatment of Native populations were the crucibles through which these national self-consciousnesses were forged.

In the United States, this expansion outward into the North American continent was given conscious expression in the concept of Manifest Destiny, which originally promoted annexation of Texas, the Oregon Territory and territorial appropriations from Mexico, but also encompassed at various historical moments Canada, Mexico itself, Cuba and Central America. The term was coined by the journalist John L. O'Sullivan in 1845, in an article arguing for the annexation of the Republic of Texas. The article, appropriately entitled "Annexation," appeared in the July–August issue of the *United States Magazine and Democratic Review*, of which he was editor. Later that year, in a column that appeared in the December 27 issue of the *New York Morning News*, of which he was also editor, he extended his argument to the Oregon Territory, whose borders were in dispute with the British.

O'Sullivan went as far as to state that the entire territory should be American and was justifiably so "by the right of our manifest destiny to overspread and to possess the whole of the continent which Providence has given us for the development of the great experiment of liberty and federated self-government entrusted to us." These arguments had been presaged in an earlier article by him, "The Great Nation of Futurity," published in the November 1839 issue of the *Democratic Review*, in which he affirmed that, in the diversity of their citizenship and in the great democratic freedoms and moral virtues embodied in their governmental system, the American people were destined, with Divine blessing, to establish across the western hemisphere a "Union of many Republics." While the origins of the concept of American exceptionalism can be traced back to New England writers and preachers of the seventeenth century, its full territorial implications were a phenomenon of the nineteenth century, and O'Sullivan was articulating ambitions already expressed in 1811 by John Quincy Adams. In correspondence with his father, Adams spoke to the destiny of that same Providence to realize a single North American nation with a single language, shared customs and culture, and a political system under one Union. In 1819, Adams, who was then Secretary of State, through force of arms and hard negotiation, had expanded the American territory to encompass Florida and land to the Pacific. His vision was hardly unique. As early as 1805, Thomas Jefferson had spoken of the eventual likelihood of Canada's annexation. Of course, much of the American attitude toward Canada, apart from any lucrative financial prospects, was based on an intense distrust of (and two wars with) Great Britain.

American expansion westward—the occupation and cultivation of slave and free territories and new states, and, in the aftermath of the Civil War, the movement of large numbers of settlers, both citizens and waves of immigrants, to recently surveyed lands to establish new beginnings on defined properties and exploit discovered mineral riches from Virginia City, Nevada, to the Klondike—was encouraged not only by the press, but also by government and railroad company advertisements and by private promotional brochures featuring inspiring images of fertile wheat fields and opportunities for settlement. Likewise, photographs of nature's wonders in newly surveyed western territories led to the creation of Yellowstone National Park in 1872, the first of its kind in the United States, and a conservancy movement that culminated at the outset of the new century under Theodore Roosevelt. Canada followed suit with the creation of Banff National Park in 1885. By the latter part of the century, railroad companies on both sides of the border encouraged travel and tourist ventures through advertising campaigns, exhibited paintings and readily affordable photographs featuring grand panoramas of landscapes and mountain ranges.

Canada knew no such phenomenon as Manifest Destiny. Yet the history of Confederation, its expansion westward and the crucial unifying of the provinces through the Canadian Pacific Railway cannot be understood without reference to the country to its south. Canada's symbiotic relationship with the United States informed its development and evolving national identity, despite festering and, at times, explosive internal divisions among the English, French and Metis communities. Apart from speeches in the US Congress and articles in the press urging,

at different times throughout the century, the integration of the Canadian North into the Union, specific events south of the border motivated Canadian unification. A tense Civil War neutrality, seen by the United States as biased toward the secessionist South (as was Britain's), frequently threatened trade relations, and cross-border incidents (and later Fenian raids) agitated unification negotiations, first at Quebec City in 1864 and subsequently at meetings leading to the 1867 Confederation accord. The American obsession with closing off British territorial access to North American ports (shared by Russia to facilitate the 1867 purchase of Alaska), sweetened with Ottawa's offer to build a transcontinental railroad (albeit ultimately partly underwritten and directed by Americans), played a role in encouraging an increasingly isolated British Columbia to enter Confederation in 1871. The United States' aggressive bid to the Hudson's Bay Company, on the heels of the Alaska purchase, to acquire Rupert's Land, a territory encompassing a quarter of the North American continent, was reluctantly refused by the Company only under pressure from Britain and Canada. The latter acquired the immense territory in 1869 for a bargain price of a million and a half dollars. Made without consulting the Metis and Aboriginal populations, the purchase ultimately led to the Red River Rebellion. A Canadian immigration promotional program was mounted in the 1880s for the Prairie and Western Provinces, competitive with that of the United States. Focusing its brochures and posters primarily on Britain, the program extended its campaign to Continental Europe at the end of the century under Wilfrid Laurier, who saw in the mingling of nationalities a means of defusing cultural tensions between Quebec and the other provinces.

This exhibition seeks to explore and compare the evolving paths of nationhood in Canada and the United States as reflected through painted and photographed landscapes. By exploring and comparing close to two hundred works—the underlying intentions that led to their creation, their themes and their complementary yet distinctive compositional structures and styles—much can be revealed about both countries. Beginning in the 1840s, the Hudson River School's vision of the North American landscape as an expression of a Divine covenant resonated with the call for westward and outward expansion. Over the succeeding decades, this vision of the landscape found different stylistic expressions, some filled with missionary zeal. The American landscape was proclaimed as offering both self-revelation and the fulfillment of a national destiny, in which mythologized Indigenous populations played no role, a subsidiary role, or were seen as obstacles.

During these years, many Canadian artists were very aware of and profoundly influenced by stylistic movements and major cultural events in the United States. The impact of works by the Hudson River School, the influential visits of American artists, such as Robert S. Duncanson, the Armory Show in New York and the *Exhibition of Contemporary Scandinavian Art* in Buffalo, both in 1913, as well as the art commerce in Boston and New York affected the history of Canadian painting. In photography, the changing aesthetics and the subjects selected by American ùartists, beginning with the documentary images from surveys of the West conducted after the Civil War, were later paralleled by Canadian photographers working on commission for the Canadian Pacific Railway, while the technical advances realized by George Eastman offered new opportunities to photographers in both

countries. At the same time, a vibrant, independent photographic enterprise existed in Canada, most notably in the studio of William Notman and his successors. Canadian painters distinguished themselves in their more domestic and less monumental approach to landscape, both aesthetically and literally—their canvases were generally considerably smaller and they did not tend to share the American taste for cycloramas and enormous scale. They also carried within them different attitudes toward their relationship with nature. Furthermore, Montreal being the centre of Canadian artistic activity during the second half of the nineteenth century, there was a marked openness to Continental European trends.

I chose the period of 1860 through 1918 precisely because it encompasses the anguishing and transforming experience of the Civil War (the carnage of which exceeded six hundred thousand casualties) and its politically and socially altering aftermath in the United States; the Act of Confederation and the emergence of a broader, sophisticated community of painters and photographers in Canada; and both countries' re-energized focus westward to the Pacific Coast and realization of transcontinental ambitions. The codification of national myths of identity and the nations' diverse and unfortunate portrayals of Indigenous populations and heritages as being outside of these practical ambitions and idealized myths are also considered. The presentation concludes with a consideration of later stylistic developments in communicating these ambitions and myths through landscapes, culminating in the dramatic innovations of the first two decades of the twentieth century.

I selected the title *Expanding Horizons* to convey the territorial, social, political and psychological dimensions of landscape imagery in these countries. Remarkably, this is the first focused exploration and analysis of this crucial and visually splendid subject as concurrently articulated in the United States and Canada during the second half of the nineteenth century and the first decades of the twentieth century.

To better explore and analyze these distinctions, the exhibition has been divided into six thematic sections which, while inevitably maintaining a certain chronological flow, serve to guide the viewer through the two countries' distinctive attitudes toward the terms of encounter with nature. "Nature Transcendent" explores the spiritually infused idealization of landscape conjoined with the meticulous detailing embraced by the Hudson River School and its followers. That style and vision, which influenced painters in Canada, continued to inform landscape imagery in the United States to the end of the century, metamorphosing into Luminism, which favoured a less grandiloquent, more internalized evocation of spiritual experience before Nature. "The Stage of History and the Theatre of Myth" examines the historical and mythic contexts against which landscape imagery was projected in the two countries and the concomitant depictions of Native peoples. Representations of the landscape thus served as manipulated backdrops for consciously modelled histories, even in the choices and framing of photographic imagery. "Man versus Nature" investigates the manners in which the transformation, exploitation and destruction of Nature were presented in the name of progress. While Canadian imagery generally focused on the dynamic challenges and interplay between Man

and Nature, with the notable exception of photographs documenting the laying of the transcontinental railroad, American imagery tended to emphasize Man's domination of Nature's powers and obstacles. "Nature Domesticated" turns to a different vision of Nature that evolved in North America as a result of continent-wide settlement and the rise of the city. For an increasingly urbanized population seeking relief from daily stress and the personal reassurance of individualism, Nature became a source of leisure and refuge for idyllic escapism. The dramatic population shift to urban centres in the latter part of the nineteenth century and the rise of major metropolises across the continent provided a novel motif for both photographers and painters in the two countries. "The Urban Landscape" examines how images of the city embodied the notions of optimism and Providential destiny previously articulated by the evocation of Virgin Nature. This new urban frontier, however, was also capable of entrapping its residents in a debasing and dehumanizing existence. The exhibition comes full circle with "Return to Nature," a thematic section which addresses artists' "rediscovery" of the transcendence of Nature. Minimizing the depiction of everyday life, artists worked within the stylistic terms of the twentieth century, adopting vivid abstract colours and simplified forms to evoke Nature's spiritual dimension.

Essays by leading scholars on both sides of the border address issues proposed by these themes. I also have included my own observations in commentaries accompanying the works in the catalogue, not only to present the historical context and relevant biographical details, but also to encourage the reader to consider the implications of these contexts on the American and Canadian attitudes toward their territorial heritages.

The idea for this project occurred to me over four years ago, in the process of becoming a Canadian, and thus a dual citizen of the two countries whose artistic productions are featured here. I was surprised to discover that, as noted above, no major exhibition had ever been held on late nineteenth-century and early twentieth-century American and Canadian landscape art. While the choice of works and themes is mine, I wish to acknowledge with gratitude Andrew Walker and Sarah Cash for their helpful suggestion of the final section's theme.

To be both an American and a Canadian is a wonderful privilege, and the efforts reflected in this exhibition and catalogue are dedicated to my beloved native and adopted countries.

paribus se legibus ambae invictae gentes aeterna in foedera mittant

* * * * * * *

My own scholarly specializations are linked to pre-nineteenth-century European art. I am therefore indebted to many for their encouragement and support in the realization of this project. The Terra Foundation for American Art provided crucial early encouragement and essential financial support. While the list of individuals to whom I am indebted is long, indeed, I wish to highlight the following: Bryan Adams, Andi Alameda, Brian Allen, Lynne Armstrong, Richard Armstrong, Daina Augaitis, Iglika Avramova, Karen Zelanda Baker, Kathleen Bartels, David Bomford, Elaine Bradson, David Brigham, Nicolette Bromberg, Philip Brookman, John Buchanan, Jim Burant, Timothy Burgard, Dennis Burks, Pamela Caserta, Alan Chong, Michael Clarke, Michael Conforti, Helen Cooper, Sean Corcoran, Cynthia Culbert, Elliot Davis, Victoria Dickenson, Louise Dompierre, Barbara Fischer, Kevin Fitzgerald, Valeria Fletchder, Kathleen Foster, Robert Futernick, Cassandra Getty, Michael R. Grauer, Barbara Greendale, Alicia Grimaldi, Kathy Halbreich, Robert Harman, Eleanor Harvey, Charles Hill, Erica Hirshler, Donald Hogan, Meredith Hutchins, Douglas Hyland, Victor Isganaitis, Carol Marie Johnson, the Hon. Serge Joyal, Brian Kennedy, Elizabeth Kennedy, Peter Kenny, Marilyn Kim, James Kopp, Elizabeth Kornhauser, Jim Kroll, Rebecca Lawton, Juan A. Llano, Meredith and Cornelia Long, Karen Love, Karol Lurie, Barbara Lynes, Barbara MacAdam, Brenda Mainwaring, Paul Maréchal, Michael Martin, Nancy Mowll Mathews, Gerald McMaster, Weston Naef, Maria Naula, Wataru Okada, Erin O'Toole, Marion Ottinger, Jr., Nils Pedersen, Catherine Perron, John Porter, Lisa Quirion, Richard Rand, Gillian Reddyhoff, Dennis Reid, Jock Reynolds, Kathy Ricciardelli, Carla Rickerson, Bernard Riordon, Malcolm Rogers, Linda Roth, Fred and Beverly Schaeffer, Amy Scott, Marjorie Searl, Kate Skelly, Helen Smailes, Thomas Smart, Anthony Speiser, Appolonia Steele, Jill Sterret, Joe Struble, Kurt Sunerstrom, Joy Tahan, Ian Thom, Nancy Thomas, Melissa Thompson, Christian Vachon, Christopher Varley, Mary Vesty, Richard Virr, Rachel Waldron, Katherine Ware, Jacqueline Warren, Catherine Wass, Barbara Weinberg, Bruce Wiedrick, Scott Wixom, David Wooters and Ellen Zazzarino. Of course, this exhibition would have been impossible without the generosity of the many lenders, public and private, listed elsewhere. Lastly, I wish to thank the management and staff of the Montreal Museum of Fine Arts for their collegial friendship, conscientiousness, inventiveness and enthusiastic support. Within the curatorial department, I am particularly grateful to my inexhaustible assistant Sylvie Ouellet and to the supportive research activities of Thierry Loriot.

Flexible Frontiers: Expansion, Contraction, Regeneration

T. J. Jackson
Lears

Expanding Horizons—the title captures the intertwining mythologies of the North American continent. It seems to describe a meteorological event, impelled by a force of nature. Expansion is what metal does when heated or what gases under pressure do when released from a confined space. Yet historians have appropriated the word to characterize the European settlement of North America—and especially its Anglo-Saxon version. For the English pioneers who laid claim to much of North America, horizons were always expanding in one direction only—toward the west, toward the setting sun. In textbooks and scholarly monographs, "westward expansion" evokes a process that sounds as neutral, inevitable and benign as "spring thaw." But it was none of these things.

Westward migration across North America was an assertion of culture over nature, of human fantasy and ingenuity over the intractable physical environment. It was also a fundamental departure from the existing patterns of human settlement there. When Indigenous North Americans "arranged themselves—when they thought in terms of natural connections to a world beyond their own—they did so along geographical continuities running north and south through the continent," writes the historian Elliott West.[1] Ways of life had nothing to do with later political divisions. "Indian peoples of Saskatchewan had more in common with those in the Dakotas, and people in British Columbia with those in Washington and Oregon, than either had with peoples in Ohio or Quebec."[2] The High Plains, Great Basin, Rocky Mountains and Pacific Northwest—not lines on a map or political ideals—defined the varying lives of the Aboriginal inhabitants, who were baffled by the strange white men pressing forward to possess the land. From the Indigenous view, westward expansion ran counter to the natural order of things.

Europeans had been drawn to a dreamlike West for centuries. Bards of exploration created a fantastic place of ease and plenty, worth braving storm and starvation to find. From St. Brendan in the sixth century to Columbus and his successors in

the fifteenth and sixteenth, voyagers to the west envisioned some version of the mythic Isles of the Blest—beyond the Pillars of Hercules (at the Strait of Gibraltar), shimmering from afar, somewhere in the Western Sea. When they landed in the New World, many thought they had discovered the Earthly Paradise. Soon enough it would become apparent that the North American continent was not as Edenic as the first voyagers had imagined. It was filled with rocky, unyielding soil, malarial swamps and inhabitants who were increasingly provoked by the settlers' intrusions onto their hunting grounds and sacred spaces. But the utopian vision survived. The language of inexorable westward expansion acquired imperialist and nationalist idioms, animating ideologies of inevitable progress and Manifest Destiny. Canadian and American pioneers were hard-headed pragmatists in many ways, but they were also restless dreamers, for whom nature was not only a force to be mastered and made fruitful, but also an ever receding backdrop, a gorgeous sunset.

By the late nineteenth century, the settlers' horizons had expanded to fill nearly the entire continent. The victory of European culture over North American nature was all but complete—or so thought the Anglo-Saxons who dominated that culture in Canada and the United States. Chicago, Toronto and other cities were becoming the hubs of an immense agricultural hinterland, the nodes in a vast, emerging network of market exchange. Transcontinental railroads bestrode the land on both sides of the forty-ninth parallel—itself a triumph of culture over nature, a boundary that had nothing to do with geography and everything to do with the power of modern nation-states. Economic development, technological advance and national ambitions all cut across the grain of the North American landscape. Indeed some projects, such as the drive to farm the arid high plains beyond the hundredth meridian, epitomized a promethean disregard for the implacable power of nature. In the United States especially, the moving middle border of the frontier fostered a sense of boundless possibility for the individual, a constant chance of starting over, perhaps even of reinventing the self.

The mythology of westward expansion, in various forms, animated Canadian as well as American culture. Yet the question remains: for whom was the horizon expanding? Not for Aboriginal peoples, but for white settlers—and hardly for all of them. Women played a counterpoint to the threnody of frontier individualism, upholding familial and communal values against the individualist claims of the masculine self. And despite the menfolk's celebration of their inexorable advance, many were unsuccessful. Other questions persist as well. What happened when the horizon stopped expanding as the land was fully settled? Anglo-Saxon elites, especially in the United States, needed to find some way to keep it going, in fantasy and in fact, by redefining the frontier as the city or the empire and by locating new arenas for masculine self-testing—the more desolate the better (the frozen North was a favourite). Yet ultimately the expansionist vision confronted the restrictions imposed by nature. What happened when the physical environment reasserted itself against the claims of man? This essay addresses those questions, focusing primarily on the United States, where most of the frontier mythology was generated, but concluding with reflections on the cultural overlap across the forty-ninth parallel. On both sides of that border, the most important expanding horizons were in people's minds.

Visions of westward expansion linked the musings of London philosophers with the farthest reaches of North America. Consider the origins of the University of California. In 1860, the trustees of the College of California, in Oakland, purchased thirty acres of land for the "benefits of a country location."[3] On April 16, they gathered at what is now known as Founders' Rock to dedicate their new campus. Local lore suggests that the Rev. Frederick Billings, one of the trustees, was standing on the rock facing west when the name of the campus came to him: Berkeley.[4] The choice was hardly random. Bishop George Berkeley was an eighteenth-century Anglican divine and moral philosopher who advocated colonizing North America. His "Verses on the Prospect of Planting Arts and Learning in America" (1752) presented the New World as a place of fresh starts and fair hopes.

In happy climes, the seat of innocence,
Where nature guides and virtue rules,
Where men shall not impose for truth and sense
The pedantry of courts and schools:

There shall be sung another golden age,
The rise of empire and of arts,
The good and great inspiring epic rage,
The wisest heads and noblest hearts.

Not such as Europe breeds in her decay;
Such as she bred when fresh and young,
When heavenly flame did animate her clay,
By future poets shall be sung.

Westward the course of empire takes its way:
The four first Acts already past,
A fifth shall close the Drama with the day;
Time's noblest offspring is the last.[5]

Berkeley's verse embodied tensions that would characterize expansionist discourse for centuries. His vision of "empire" was not one of a complex society but rather one of a pastoral "seat of innocence" promising "another golden age" of vigorous and wide-ranging accomplishment—the sort of accomplishments that Europe "in her decay" no longer "breeds." The New World would reanimate European culture, recalling the days when it was "fresh and young." Yet even as the revitalized empire made its way westward, the poet was burdened with the melancholy sense of an ending. The New World civilization would be "Time's noblest offspring," but also "the last." Frontier expansion in a New World environment would regenerate decadent European cultures but it would also eventually reach the end of its tether. The spectre of such decay haunted the framers of the United States Constitution, inspiring them to block the centralization of power by separating it into three balanced branches of government. The fear that power would become concentrated and inevitably transform the virtuous republic into a corrupt empire survived into the early decades of the nineteenth century. The classic representation of that cyclical understanding of history was Thomas Cole's series of paintings *The Course of Empire* (fig. 1, 2).

However, at about the same time, a new optimism emerged in England and North America based on a faith that there was nothing inevitable about cyclical decline, that one could periodically refresh oneself in springs of primitive simplicity, and that the source of that revitalization lay, almost always, to the west. Among the seekers was philosopher Henry David Thoreau, who headed westward because "the future lies that way to me, and the earth seems more unexhausted and richer on that side ... Eastward I go only by force; but westward I go free."[6] That movement made him one with his nation and indeed with all humanity, which "progress from east to west."[7] Thoreau's faith preserved the progressive side of Berkeley's vision through the nineteenth century, inspiring paeans to Manifest Destiny as well as paintings of the empire's westward course (fig. 3, 4).

Yet Thoreau's primitivism undercut his progressive stance: "The West of which I speak is but another name for the Wild ... In Wildness is the preservation of the World."[8] This extraordinary pronouncement has come to seem ordinary in recent decades—a familiar slogan for Sierra Club posters on college campuses. But in the nineteenth century, it challenged the Puritan and Enlightenment orthodoxies that defined moral progress as the increase of self-control. In looking to wildness as a fount of renewal, Thoreau implicitly posed a disturbing possibility: once the continent was settled, the source of revitalization would be lost forever. The rise and fall of Rome embodied a recurring pattern. "The story of Romulus and Remus being suckled by a wolf is not a meaningless fable," Thoreau wrote. "The founders of every state which has risen to eminence have drawn their nourishment and vigor from a similar wild source. It was because the children of the Empire were

not suckled by a wolf that they were conquered and displaced by the children of the northern forests who were."[9] Civilization spread the seeds of its own decline.

Historian and philosopher Frederick Jackson Turner embraced this outlook when he stepped to the podium at the 1893 World's Columbian Exposition in Chicago with the report of the Superintendent of the 1890 Census that announced the closing of the United States' frontier. This modest document, Turner believed, marked a pivotal historical moment: "Up to our own day American history has been in a large degree the history of the colonization of the Great West. The existence of an area of free land, its continuous recession, and the advance of American settlement westward, explain American development."[10] Turner's frontier, like Thoreau's, was not a place but a process—a repeated ritual of renewal.

Each generation of Turnerian pioneers experienced a "perennial rebirth" through immersion in wildness. "The wilderness masters the colonist … It finds him a European in dress, industries, tools, modes of travel, and thought. It takes him from the railroad car and puts him in the birch canoe. It strips off the garments of civilization and arrays him in the hunting shirt and the moccasin."[11] Like Thoreau, Turner reversed the conventional tendency to elevate civilized restraint over primitive energy. For him, regression to a savage state was not a descent into Hell (as the Puritan captivity narratives had imagined it), but a necessary prelude to a regenerated self, the core of a dynamic national character that would guarantee social progress.

By 1893, however, such progress had become problematic. As Turner said, "Now, four centuries from the discovery of America, at the end of a hundred years of life under the Constitution, the frontier has gone, and with its going has closed the first period of American history."[12] For centuries the "expanding horizons" of the frontier had been contracting for the red man. Now they were contracting for the white man as well. What that meant, in Turner's view, was that the process of renewal had come to an end. American men would have to find a new arena to develop their mettle. This was not a trivial matter: the national character itself was at stake. Or so Turner and many of his contemporaries thought.

Turner's frontier thesis epitomized British-Americans' fear that they had settled into staleness and flab, as well as their yearning for revitalization that would lead to Roosevelt's cult of "the strenuous life" and pave the way for the empire. Turner's thesis reduced Aboriginal people to little more than the vehicle for white renewal. It also neglected the crucial role of women as civilizers, not to mention the importance of family and community as supplements to rugged individualism.

Writer Hamlin Garland's autobiography, *A Son of the Middle Border* (1914), provides a powerful counter-narrative to Turner's frontier thesis. Garland's father, Richard, was a pioneer par excellence. He was also a deluded dreamer, ceaselessly packing up his household and heading over the next hill, toward the setting sun. Garland's mother, Belle, was less than enthusiastic about the moves, which estranged her from community and kin and often proved economically disastrous. Though his father never stopped dreaming of expanding horizons, for his mother the promise of frontier life became little more than a cruel mirage.

Almost as soon as Richard Garland returned from the Civil War, he began thinking of "the glorious prairies he had crossed on his exploring trip into Minnesota before the war."[13] Those endless flat spaces were a farmer's dream come true, a far cry from the family home in the hill country of Wisconsin. Like Thoreau, the elder Garland "no more thought of going east than a liberated eagle dreams of returning to its narrow cage," Hamlin recalled. As he sang "'O'er the Hills in Legions, Boys!'" by the fireside, "my father's face shone with the light of the explorer, the pioneer … but on my mother's sweet face a wistful expression deepened and in her fine eyes a reflective shadow lay. To her this song meant not so much the acquisition of a new home as the loss of all her friends and relatives."[14] Expanding horizons for men were often contracting ones for women.

fig. 1 Thomas Cole, *The Course of Empire: The Consummation of Empire*, 1836 fig. 2 Thomas Cole, *The Course of Empire: Destruction*, 1836

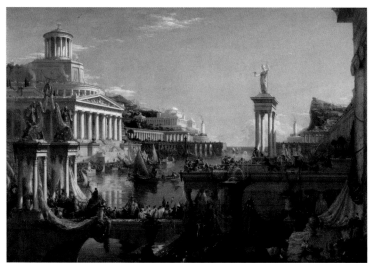

fig. 1

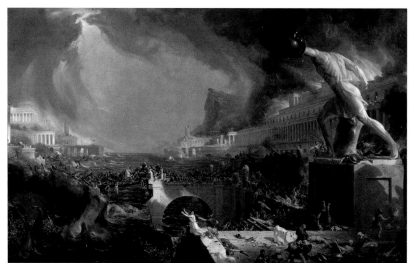

fig. 2

But a woman's pain could not deter a man from moving. Richard Garland bought land in Iowa where the woods and the prairie met, but that did not satisfy him; within a few years the family headed west again, toward the open grassland of Mitchell County, Iowa. "My heart filled with awe as well as wonder," Garland recalled, when he first found himself surrounded by prairie, "the majesty of this primeval world exalted me." The sceptical son "felt for the first time the poetry of the unplowed spaces." His father on the other hand had no time for exalted reflections: "Forward march!" the Union army veteran shouted. "Hour after hour he pushed into the west, the heads of his tired horses hanging ever lower, and on my mother's face the shadow deepened, but her chieftain's voice cheerily urging his team lost nothing of its clarion resolution. He was in his element."[15] And so, for a while, was his son who could not have asked for a more expansive horizon. Still he recounted how "the bleaching white antlers of by-gone herbivora lay scattered, testifying to the 'herds of deer and buffalo' which once fed there … Something sweet and splendid was dying out of the prairie."[16] This theme of loss would become more insistent as Garland's narrative progressed, but at first he told of inhabiting "a wide world with a big, big sky which gave alluring hint of the still more glorious unknown wilderness beyond."[17] Except for young girls like Laura Ingalls Wilder, who took similar delight in the landscape and later recorded it in *Little House on the Prairie* (1935) and other books, this feeling of liberation was mainly a masculine fantasy. In Garland's recollection, grown women were too bowed down with domestic duties, "too tired and too worried to re-act to the beauties of the landscape."[18]

Garland's autobiography is a study in masculine longings for regeneration through the frontier experience. In 1880, when his father persuaded the family to join the exodus of settlers heading for Dakota territory, the westering thrust had acquired a new urgency: "Free land was receding at railroad speed, the borderline could be overtaken only by steam, and every man was in haste to arrive."[19] When Garland saw sunrise on the Dakota prairie, he too was caught up in the promise of regeneration: "Again, as eleven years before, I felt myself a part of the new world, a world fresh from the hand of God."[20] This was the "perennial rebirth" that Turner had located on the frontier.

But Garland could not sustain that feeling for long. The Dakota weather would not allow it. Shivering in a ramshackle cabin in the early morning dark with the temperature at -40 degrees, Garland experienced what he called the "turning point." He struck out eastward from his Dakota claim, with the northwest wind at his back. Astonished, his father insisted that it was "against the drift of things" and that "the place for a young man [was] in the west."[21] In spite of his father's plea, Garland headed for Boston where, befriended by William Dean Howells, he began to establish himself as a writer.

Soon, he would convince his reluctant father to abandon the creed of his youth and help him return to Wisconsin. After stepping westward for decades, the Garlands were participating in the closing of the frontier. They were "about to double on their trail, and their decision was deeply significant … In the years between 1865 and 1892 the nation had swiftly passed through the buoyant era of free land settlement, and now the day of reckoning had come."[22] His father's dreams of boundless opportunity "had ended in a sense of failure on a barren soil."[23] It would be hard to find a stronger challenge to the promise of ever expanding horizons.

In the United States, longings for regeneration through frontier experience were intensified by the Civil War. The conflict fostered a surge of romantic nationalism that reinforced prewar ideas of Manifest Destiny, endowing westward expansion with a providential aura. During the decades after the Civil War, memories and fantasies of heroism bred a martial ethic that enveloped North and South alike, sanctifying the army's mop-up operation against the Plains Indians and inspiring white men to look for new worlds to conquer.

The young Theodore Roosevelt became the poster boy for white male revitalization. Coming of age in the 1880s, he was primed to be receptive to the revival of

martial virtue. A nearsighted, asthmatic boy, he turned his own struggle to overcome weakness into a lesson for an entire "leadership class." His quest for physical regeneration inspired his foray into the Black Hills at about the same time the Garlands were struggling to stake their claim on the Dakota prairie. For privileged men like Roosevelt (and Turner) the frontier was a focus for personal revitalization; for farm families like the Garlands it was a hardscrabble setting for mere survival.

Roosevelt recorded his frontier self-test in his autobiography (1913). When a foulmouthed bully in a Dakota saloon taunted him repeatedly as "four-eyes," the well-bred Easterner could take it no longer—he knocked the ruffian senseless. In what would become a central pattern of revitalization for upper-class men, frontier experience provided fresh opportunities for virile self-assertion.[24]

The problem was that those opportunities were becoming harder to find. Most men, even among the more affluent, did not have the resources or leisure to embark on extended junkets to the Wild West. And the West—as Turner made clear—was not as wild as it used to be. So the trick was to keep moving, seeking new worlds and new challenges. Young Roosevelt's developing outlook melded the mop-up operation on the frontier with the dawning possibilities of an overseas empire. Eventually Roosevelt would locate the lineage of such an empire in the advance of "English-speaking" settlers across the "waste spaces" of North America, a migration he celebrated in *The Winning of the West* (1889–1896).[25] Returning the "waste space" of the Philippines to the Filipinos, he said, would be like giving back Arizona to the Apaches. In either case, reversing the march of progress was unthinkable.[26]

As Turner fretted about the closing of the frontier and Roosevelt imagined the empire as its antidote, entertainers mass-marketed frontier fantasies. One of these fantasies was created by William Cody, a Union Army veteran who had set up shop as a railroad grading contractor after the war and quickly won local fame as a crack buffalo hunter. Soon, the soldiers stationed nearby took to calling him "Buffalo Bill" and Cody realized the theatrical possibilities of his reputation. In 1882 he organized the *Old Glory Blowout* in Omaha, Nebraska, an event that combined stunt riding with a staged buffalo hunt. The show's success convinced him to expand, and by 1886 *Buffalo Bill's Wild West: America's National Entertainment* was filling such venues as Madison Square Garden. Staged—like Berkeley's course of empire—in five acts it unfolded, from primeval forest and prairie to cattle ranch and mining camp, and then culminated in a sensationalist re-enactment of Custer's Last Stand.[27] After the Battle of the Little Bighorn in 1876, General George Armstrong Custer was extolled as a veritable Chevalier Bayard, redeeming morally sluggish Americans from bourgeois torpor, and by the 1890s he had achieved iconic status—*Custer's Last Fight*, a lithograph of a drawing by Otto Becker (1854–1945) based on a painting by Cassilly Adams (1843–1921), hung in thousands of saloons, courtesy of Anheuser-Busch Brewing Company (fig. 5). The apotheosis of Custer revealed that even (perhaps especially) after the frontier was closed, fantasies of its regenerative impact would flourish in Americans' imaginations. Or at least in the imaginations of those Americans who resided in the United States.

So where does Canada fit into the picture? The Canadian economist Harold Innis provided a distinct alternative to Turner's frontier thesis by developing a metropolitan thesis, emphasizing the central role of eastern cities in creating the Canadian west as a hinterland of food and raw materials for an urban-based economy. In contrast to the American "Wild West," Innis emphasized a Canadian "Mild West," claiming that the country had been kinder to its Aboriginal inhabitants. After all, Sitting Bull fled to Canada after Little Bighorn, accepting government protection in exchange for keeping the Queen's Peace. Against the desperadoes of the Wild West, he held up the icon of the Mountie (later caricatured as the stolid Dudley Do-Right). The North West Mounted Police were a force for order on the Canadian frontier. Created by Sir John A. Macdonald's Conservative government in 1873, the Mounties kept ruffians from running amok amid such frontier temptations as the

Yukon Gold Rush of 1897. When Canadians looked for mythic inspiration, they looked to the Arctic rather than to the West. And what they found there, according to this interpretation, was very different from the primitivist renewal imagined by Turner and Roosevelt.

Yet the differences between Canada and the United States can easily be over-emphasized. With respect to "Indian policies," the Canadians were not much milder than the Americans. If there were differences in procedural details, there were also underlying similarities in outcome—extermination or something close to it. United States Chief Justice John Marshall's phrase "domestic dependent nations" described Aboriginals' situation in both countries, which worked within the same basic legal framework as they drove "Indian tribes" to the margins of the continent.[28] On both sides of the forty-ninth parallel, advocates of irresist-ible progress preached a common mission: redemption of the continent from its savage inhabitants. Everyone agreed that the "Indians" were vanishing into the "western sea," as the American poet William Cullen Bryant had foreseen as early as 1824.[29] By the late nineteenth century, the image of Aboriginal people huddled on the shores of the Pacific, with the setting sun in the background, had become a familiar artistic motif. Canadian and American cartoonists alike presented the driving of the "Indians" into the sea as the inevitable triumph of civilization over barbarism—"What It Must Come To," as a *Toronto News* cartoonist put it in 1885. So the white man's horizons expanded to fill the continent and the red man's contracted to near non-existence.

Despite variations in emphasis, the two countries' cultures converged in the common mythology of westward expansion, and the differences between the metropolitan thesis and the frontier thesis were more apparent than actual. Innis embraced the idea that the "wildness" of the Far North had imparted a distinctive vitality to Canadian life. Thoreau and Turner would have been pleased. Geography was destiny, at least insofar as it sustained national character by providing opportunities for personal renewal.[30]

The triumph of the Union Army in the Civil War intensified Americans' sense of their God-given role in the sacred drama of world history. But even romantic nationalism crossed national boundaries. Ideologues on both sides of the border honoured Anglo-Saxon supremacy and imperial destiny. The blending of national character with physical strength proved tempting to Canadians as well as Americans. The journalist Walter Nursey summarized decades of conventional wisdom in 1909, when he wrote of life in Canada a century earlier: "The very atmosphere of her northern latitude, the breath of life that rose from lake and forest, prairie and mountain, was fast developing a race of men with minds as enduring as iron and minds as highly tempered as steel."[31] The North could be a version of the revitalizing western frontier. The beginnings of this idea can be traced to 1869, when Robert Grant Haliburton, Fellow of the Royal Society of Northern Antiquaries of Copenhagen, asked the Montreal Literary Club if "the generous flame of national spirit [could] be kindled and blaze in the icy bosom of the frozen North," he had no doubt that it could. "*We are the Northmen of the New World*," he announced.[32] Physical strength was a corollary of national greatness. In 1884, the physician William Hales Hingston declared that future Canadians would be "taller, straighter, leaner people" who would aid in "erecting, in what was so lately a wilderness, a monument of liberty and civilization, broader, deeper, firmer, than has ever yet been raised by the hand of man."[33] Central to this supremacy was the "northern blood" that produced "strenuousness" and carried the "germ" of liberty: "Southern races" were not suited to the demanding climate of the North. At about the same time, Anglo-Saxons in the United States were beginning to argue that Italians and other "Southern races" were inassimilable to American society. Racial anxieties crossed borders.

So did gender anxieties. A nervous masculine ethos animated the overlapping fanta-sies of "the North" and "the West"; indeed the two regions had coexisted in fantasy for centuries. The North and the West were both a place and a process, as much culture as nature. The myths surrounding them blurred and overlapped. Consider Robert Service's poem "The Shooting of Dan McGrew" (1906), which represents the Yukon Gold Rush in enduring frontier conventions: a deadly confrontation in the

fig. 3 Currier and Ives, drawing by F. F. Palmer, *Across the Continent, "Westward the Course of Empire Takes Its Way,"* 1868 **fig. 4** Emmanuel Leutze, *Westward the Course of Empire Takes Its Way,* 1862

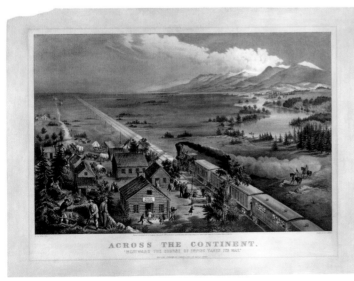

fig. 3

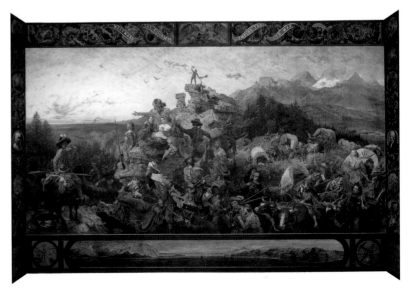

fig. 4

Malamute saloon between the gambler Dangerous Dan McGrew and "a miner fresh from the creeks, dog-dirty, and loaded for bear." The miner looks like "a man who had lived in hell" and when he sits down at the piano, he plays a strange Northern melody, redolent of silence and cold and clarity. Service's poem slides toward a climax of vengeance: "crazed with 'hooch,'" the miner lurches from the piano stool and the story ends in gunplay, with both Dan and the miner lying dead, rivals for the love of "the lady that's known as Lou."[34]

These frontier stereotypes became staples on both sides of the border. As the historian Daniel Francis observes, "no less a critic than Ronald Reagan proclaimed Service his favourite poet."[35] Distinctions between North and West, real enough with respect to climate and cartography, dissolved in the mythic drama of frontier regeneration. The most important frontiers were those of the imagination, where many could test their masculinity against the relentless forces of nature. Indeed the emphasis on the conquest of nature underscores the key commonality between the two frontier myths—their joint faith in economic development through technological control of the environment. Both Canadians and Americans embraced the notion that their expanding horizons required the systematic development of apparently limitless natural resources. During the mid-nineteenth century, the loosening of ties between Canada and the mother country led to a realization that colonial dependency was no longer possible. "Canada is now thrown upon her own resources," the *Canadian Economist* announced in 1846, "and if she wishes to prosper, those resources must be developed."[36] Political independence demanded economic independence and vice versa.

As the historian Donald Worster writes, the two countries followed "different versions of the same myth"[37]—both used state power to promote economic development in different ways at various moments in their history; both depended on a dynamic relation between the frontier and the metropolis; and both neglected to consider the ways that nature fought back against thoughtless attempts to master it.[38]

About the same time the United States' frontier closed, settlers on both sides of the forty-ninth parallel began to confront the difficulties of farming on arid high plains. For Canadians, high latitudes and short growing seasons were the primary problems; for Americans, drought and heat were the main threats. West of the hundredth meridian, many farmers paid heavily for their failure to grasp the implacable power of nature. In Dakota, Richard Garland and fellow settlers leaped from their wagons and planted their stakes "with whoops of joy."[39] But by harvest time, "an ominous change had crept over the plain. The winds were hot and dry and the grass, baked on the stem, became as inflammable as hay … Smiling faces were less frequent. Timid souls began to inquire, 'Are all Dakota summers like this?' and those with greatest penetration reasoned, from the quality of the grass which was curly and fine as hair, that they had unwittingly settled on an arid soil."[40] It was a defining moment in the history of the frontier—the dawning revelation that the homestead ideal could not make the transition to the arid west. But that did not prevent the United States from embarking on a massive irrigation project in 1902, the first of many meant to continue the mastery of nature.

That dream dies hard. Yet even in the early 1900s, at the same time that the United States began its promethean irrigation project, some Canadians and Americans were beginning to see nature as a partner rather than a blank slate and accept government as a necessary custodian of scarce and valuable resources. In recent decades, the environmental movement has encouraged the recognition that the systematic mastery of nature is a destructive illusion. We need to build on that recognition, to expand our vision of expanding horizons beyond its human-centred base. Otherwise that dream will disappear in a handful of dust.

fig. 5 Milwaukee Lithographic and Engraving Company, drawing by Otto Becker, *Custer's Last Fight,* 1896

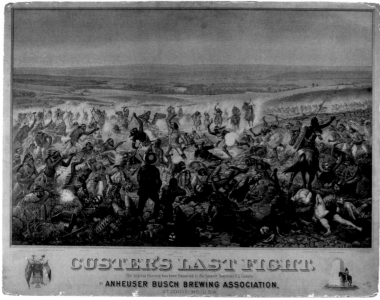

fig. 5

** * * *

1 Elliott West, "Against the Grain: State-Making, Cultures, and Geography in the American West," in *One West, Two Myths: a Comparative Reader,* Carol Higham and Robert Thacker, eds., 2 vols. (Calgary: University of Calgary Press, 2004), 1:5.

2 Ibid.

3 Quoted in Susan Cerny, "Founders' Rock," *Berkeley Landmarks,* March 3, 2001, http://www.berkeleyheritage.com/berkeley_landmarks/founders_rock.html.

4 Ibid.

5 George Berkeley, "Verses on the Prospect of Planting Arts and Learning in America," in *The Works of George Berkeley, D. D. Bishop of Cloyne,* George Sampson, ed., 2 vols. (London: George Bell and Sons, 1898), 2:125–126.

6 Henry David Thoreau, "Walking" (1851), in *Walden and Other Writings,* Brooks Atkinson, ed. (New York: Modern Library, 1950), 607.

7 Ibid., 608.

8 Ibid., 613.

9 Ibid.

10 Frederick Jackson Turner, "The Significance of the Frontier in American History" (1893), reprinted in his *The Frontier in American History* (New York: Henry Holt, 1920), 1.

11 Ibid., 2, 4.

12 Ibid., 38.

13 Hamlin Garland, *A Son of the Middle Border* (New York: MacMillan, 1917), 42.

14 Ibid., 42, 63.

15 Ibid., 82.

16 Ibid., 85.

17 Ibid., 133.

18 Ibid., 139.

19 Ibid., 244.

20 Ibid., 245.

21 Ibid., 316.

22 Ibid., 439.

23 Ibid., 463.

24 Theodore Roosevelt, *An Autobiography* (1913; repr., New York: Library of America, 2004), 378.

25 Theodore Roosevelt, *The Winning of the West* (1889–1896; repr., New York: Current Literature Publishing Company, 1905), 1:1.

26 Theodore Roosevelt, "Letter to Edward Oliver Wolcott, September 15, 1900," cited in John Judis, *The Folly of Empire* (New York: Scribner, 2004), 62.

27 Robert W. Rydell and Rob Kroes, *Buffalo Bill in Bologna: the Americanization of the World, 1869–1922* (Chicago: University of Chicago Press, 2005), 29–34.

28 John Marshall quoted in West, 10.

29 William Cullen Bryant quoted in Brian W. Dippie, "One West, One Myth: Transborder Continuity in Western Art," in *One West, Two Myths,* 2:47.

30 Dippie, 46–48.

31 Walter Nursey, *The Story of Isaac Brock* (Toronto: W. Briggs, 1909), 173, quoted in Carl Berger, "The True North Strong and Free," in *Nationalism in Canada,* Peter Russell, ed. (Toronto and New York: McGraw Hill, 1966), 4–5.

32 Robert Grant Haliburton, *The Men of the North and Their Place in History* (Montreal, 1869), 2, quoted in Berger, 5–6, emphasis in original.

33 William Hales Hingston, *The Climate of Canada and Its Relation to Life and Health* (Montreal: Dawson, 1884), 265–266, quoted in Berger, 11.

34 Robert W. Service, "The Shooting of Dan McGrew," in *Songs of a Sourdough* (Toronto: William Briggs, 1907), 30–34.

35 Daniel Francis, *National Dreams: Myth, Memory, and Canadian History* (Vancouver: Arsenal Pulp Press, 1997), 158.

36 Quoted in Heinz W. Arndt, "Economic Development: a Semantic History," *Economic Development and Cultural Change* 29, no. 3 (April 1981), 461.

37 Donald Worster, "Two Faces West: The Development Myth in Canada and the United States," in *One West, Two Myths,* 1:26.

38 Worster, 23–45. Indeed, a metropolitan thesis could explain American as well as Canadian history as hub cities colonized hinterlands in both countries. See William Cronon, *Nature's Metropolis: Chicago and the Great West* (New York: W. W. Norton and Co., 1992).

39 Garland, 303.

40 Ibid., 308.

Nature

Transcendent

" The true province of Landscape Art is the representation of the work of God in the visible creation, independent of man, or not dependent on human action."

Asher Durand,
American Hudson River School Painter

The Most Northerly Horizon

Rosalind
Pepall

Westward Ho! Valley is a strange appellation for a depression between two mountain ranges on Ellesmere Island, the most northerly land mass of the Canadian Arctic Archipelago. Thomas Mitchell, a young seaman travelling in 1875–1876 with the George Nares polar expedition, sketched himself on Ellesmere looking toward Westward Ho! Valley—not a western American pioneer scene as might be expected, but an endless expanse of whiteness stretching out to the horizon (fig. 1). Mitchell, an assistant paymaster whose talents included charting the northern topography, was able to capture in his small sketchbook the scale of the Arctic landscape and the insignificance of man within the infinite expanse of one of earth's most northerly frontiers.[1]

European artists from as early as the seventeenth century had imagined visions of the Arctic landscape, even though North America's farthest reaches were marked *terra incognita* on maps. The North was a real and an imagined place—real for the Inuit and their ancestors, the Thule people and before them the Dorset settlers, who lived on the land; real for the whalers who hunted the great mammals of the North; and real for transient explorers who, like Mitchell, ventured through this uncharted territory. At the same time, it was an imagined place in the minds of artists, poets, writers and armchair travellers lured by the romance and adventure of polar exploration. During the second half of the nineteenth century however, as the Arctic became more familiar territory, the response of artists changed. Once regarded as terrifying and desolate, the North became a source of personal regeneration for the creative spirit.

A landscape of the imagination it surely was for German artist Caspar David Friedrich, who created one of the masterworks of the Northern Romantic tradition, *The Polar Sea* (fig. 2). Inspired by English captain William Parry's 1819–1820 expedition in search of the Northwest Passage to the Pacific Ocean through the Canadian Arctic islands and straits, Friedrich depicts massive shards of jagged ice, heaved upward by the frozen sea.[2] Almost incidental in the painting's composition, a tiny ship stands as a metaphor for the physical power of nature's forces over man.

Parry's expedition was just one of England's many exploratory missions in search of the Northwest Passage.[3] During the first half of the century, explorers, including Parry, described the Arctic as a place of deathlike stillness and desolation. Having faced its perils, they were lauded for their bravery and patriotism in the domestic and foreign press. The English obsession with the North reached a peak in 1845 with the disappearance of the Franklin ships. The loss of Sir John Franklin and his men dampened the enthusiasm of the British navy for finding the Northwest Passage and further fuelled the Romantic image of lost adventurers pitted against the overwhelming forces of nature, especially as Franklin's widow made repeated and very public attempts to find her husband, even soliciting the help of the President of the United States, Zachary Taylor.[4]

In the United States, the urgent call to search for Franklin was taken up by New York shipping merchant and philanthropist Henry Grinnell, who sponsored the first American expedition to the Arctic in 1850 and a second in 1853. Elisha Kent Kane, a young doctor, accompanied the first Grinnell expedition and led the second, which proved to be a harrowing two-year trip. Immensely popular and charismatic, Kane became a national celebrity through his lectures and writings about his experiences.[5] Although he never found traces of Franklin, he captivated the American public with his two-volume book, *Arctic Explorations: The Second Grinnell Expedition in Search of Sir John Franklin, 1853, '54, '55*, illustrated with almost three hundred engravings after his own sketches.[6]

The publicity surrounding the second Grinnell expedition would not have gone unnoticed by American painter and adventurer Frederic Church, who excelled in capturing the mystery of unexplored regions of the earth. Unlike Kane, Church never travelled above the Arctic Circle. He began his career painting picturesque views of areas such as the Catskills, the White Mountains and Niagara Falls, which he visited five times between 1848 and 1858 (see Brookman, fig. 3). "He is intoxicated with Niagara," reported the family with whom he stayed on his visits.[7] Church then expanded his vision further afield in his search for sublime displays of natural wonders. Spurred on by his admiration for the German geologist, world traveller and writer Alexander von Humboldt, Church ventured into the sparsely inhabited regions of South America. His *View of Cotopaxi*, 1857 (not reproduced), and *Heart of the Andes*, 1859 (not reproduced), mounted in heavy, draped frames to reflect the weight and majesty of the subjects, show vast expanses of jungle beneath smouldering volcanic mountains. In his evocations of the supernatural in these grandiose landscapes,

Church inherited Friedrich's Romantic sensibility and meditative approach.[8] Like Friedrich, he eventually turned his eye toward the North.

In 1859, Church's sense of adventure and instinct for understanding the interests of his public drew his attention to the Arctic regions. Church would have heard of Elisha Kent Kane's 1853–1855 expedition first-hand, as he was a good friend of Dr. Isaac Hayes, who had accompanied Kane on his trip and named a northern Arctic peak near Kennedy Channel after Church.[9] In June, Church set sail from Boston for Newfoundland and the coast of Labrador, sketching icebergs flowing down from the Arctic waters. During this trip, he commented to his travelling companion, Louis Legrand Noble, that the wild and rocky landscape of this Canadian frontier reminded him of the South American mountain ranges, or Cordilleras.[10] This brings to mind Kane's cosmological view that the Arctic regions shared the same geological structure as the densest forests and barest deserts of the earth. Comparing the mountains of Greenland with the Ghats of India, Kane wrote: "How strangely this crust we wander over asserts its identity through all the disguises of climate!"[11] Using his drawings and watercolour sketches from the Labrador trip, Church applied the same Romantic vision with which he painted the South American landscape and Niagara Falls to produce one of the most famous American paintings of the North, *The Icebergs* (fig. 3).

Completed in 1861, the large painting depicting monumental white icebergs looming in an uninhabited frozen land affirmed the unearthly character of the Arctic landscape and its ability to arouse fear and awe. In a discussion of the North in the literary imagination, Francis Spufford has commented on the association of whiteness with feelings of dread, which contributed to shaping the view of the Arctic as a terrifying place. Spufford draws attention to the symbolism of whiteness in Herman Melville's epic story of the albino whale Moby-Dick which instilled great terror in the whaling community.[12] Despite the traditional association of white with purity and innocence, Melville writes, "Yet for all these accumulated associations with whatever is sweet, and honourable, and sublime, there yet lurks an elusive something in the innermost idea of this hue, which strikes more of panic to the soul than that redness which affrights in blood."[13]

But in Church's *Icebergs*, not all is white. Although the artist had never progressed farther north than Labrador, he carefully studied the effects of light reflected in the whiteness of the icebergs off the Labrador coast. The painting reveals the unexpected range of colour in the barren landscape, from the blue graffiti-like markings on the glacier in the foreground to a spectrum of pinks, blues and golden tones reflected in the imposing monoliths of ice in the background. At the right of the painting, an earthy lump of rock thrown up from below intrudes on this pristine beauty, as does the fallen mast, which alludes to the Franklin shipwreck.[14] Church masterfully conveyed a silent communion with nature through the frozen stillness of his imagined Arctic landscape.

Church evoked the same feeling of divine revelation when he returned to his favourite subject in the painting *Niagara Falls, from the American Side* (cat. 1), but this time through the depiction of the thunderous torrent of water and spray. Even though Niagara Falls attracted many visitors, as the well-worn rocky path in the foreground suggests, the only sign of human activity in the painting is a tiny figure on a precariously perched platform overlooking the falls in the left foreground. Just below, withered bracken clinging to the edge of the cliff alludes to the deadening passage of the water's force. The cascading falls symbolized the energy of nature as a life-giving and life-taking force. A rainbow of hope in the lower right corner completes the spiritual metaphor of this most famous natural wonder.[15]

Like Church, the American artist William Bradford was also inspired by Elisha Kent Kane's account of his 1853–1855 Arctic expedition. After several visits to the Labrador coast, Bradford pushed farther north toward Greenland on an expedition he led in summer 1869. As many Arctic explorers had done before him, Bradford published an account of his trip.[16] Before even opening this large portfolio, the reader is lured into the tale by the cover embossed with the most popular symbols associated with the North—an iceberg and a seal enclosed in a medallion edged with dripping icicles, and a polar bear in its own shaped cartouche (fig. 4). Each letter of the main title, *The Arctic Regions*, is encased in ice. The Gothic-style presentation inspires a sense of adventure and mystery. However, Bradford

fig. 1 Thomas Mitchell, *Westward Ho! Valley, Ellesmere Island*, 1876 **fig. 2** Caspar David Friedrich, *The Polar Sea*, 1823–1824

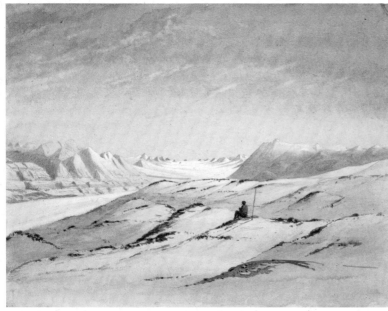

fig. 1

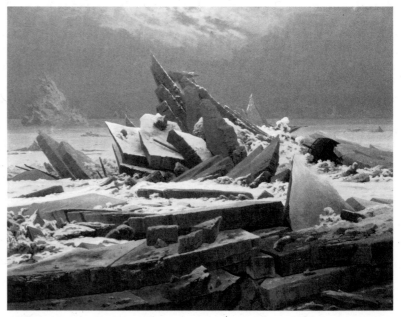

fig. 2

did not depict the North simply as a place of terror and bleak whiteness. Less concerned than Church with revealing the divine presence in nature, he painted picturesque compositions of ships stalled among fantastic icebergs and small figures clambering over hummocks of ice in the glowing Arctic light (cat. 79). Bradford was especially impressed by the myriad shapes of the icebergs. In his writings, he expressed his awe at the beauty and grandeur of the Arctic landscape and the "perfect feeling of solitude" he felt there, affirming he could have spent all year contemplating it. With a painter's eye, Bradford described the colours he saw: "From dead white to glossy, glistening satin; from the deepest green to all the lightest shades; and from faint blue to deepest 'lapis luzuli;' and again, as some lofty berg passed between us and the sun, its crest would be bordered with an orange-coloured halo, in which sometimes prismatic shades appeared."[17]

Although the sense of desolation and danger made an impression upon him, Bradford was overwhelmed by the magnificence of the northern landscape, claiming that the Arctic scenery was unsurpassed "by any landscape in the world, not excepting the far-famed Yo-Semite valley itself."[18] The perception of the Arctic as menacing was giving way to one of respect and admiration for this new horizon in which to discover light, colour and form.

Convinced that the "sun-given powers of the camera" could best capture the ever-changing effects of light on the landscape, Bradford hired professional photographers John L. Dunmore and George Critcherson of Boston to document the account of his trip with their high-quality, tipped-in albumen prints (cat. 80).[19] He would later use these prints together with his own sketches to recreate the romance, colour and narrative of his Arctic experience in the paintings produced in his studio. Bradford captured the public's imagination with his book and paintings, which found a ready audience willing to pay high prices. His *Sealers Crushed by an Iceberg*, 1866 (not reproduced), which was exhibited at the William and Everett Gallery in Boston, attracted over five hundred visitors a day.[20]

Published in 1873, Bradford's travel account was the first to include photographs of the Arctic.[21] Others soon followed, and by the time of the George Nares expedition in 1875–1876, ships usually had their own photographic equipment.[22] The camera marked the end of reliance on sketches and paintings to illustrate publications of Arctic expeditions, and soon the focus of illustration shifted from the landscape to the people of the North, whose activities and personalities presented a more dynamic subject in black and white. Gone too were the haunting depictions of polar expeditions caught in ice under a sublimely moonlit sky. By the end of the nineteenth century, the mystery of the Arctic had diminished with the charting of many of its previously unexplored areas. Already in 1861 *Harper's Weekly* declared, "Romance and the heroism are always the same, and every voyage does us the great service of destroying the terror which invests the silent world of ice."[23] As Chauncey Loomis has so aptly stated, the sublime could no longer be mapped.[24]

By 1921, the North had become the "friendly Arctic" in the memoirs of Canadian-born explorer Vilhjalmur Stefansson.[25] In the same decade, Canadian artists turned to the northern wilderness areas of their country in order to expand their own horizons in a quest for national identity. In their efforts to create a distinctive Canadian art in the 1920s, the Group of Seven artists embraced the Canadian landscape and ventured into the vast, uninhabited areas of Ontario, the Western Rocky Mountains and finally the Arctic.[26]

Alexander Young Jackson, a central figure in the Group, was the first to set his sights on Canada's North. His curiosity was piqued by a radio message broadcast to an RCMP sergeant stationed "on top of the world" at Ellesmere Island.[27] In 1927, Jackson boarded a Canadian government supply boat, the *Beothic*, which took him to this top-of-the-world place. Jackson appears to have been somewhat frustrated with the limited range of subject in the North and the difficulty of capturing ice floes from a boat.[28] Even though Jackson was probably more at home with the autumn colours of the Laurentian Shield than with the vast Arctic expanse, in 1930 he jumped at the chance to take a second trip on the *Beothic* with fellow Group of Seven artist Lawren Harris.

The mystery and silence of the Arctic took hold of Harris. He was enraptured by the pristine beauty of the North and his trip became a spiritual awakening. Here was a landscape he had been searching for. Here were the barrenness, infinite space, luminous celestial light and majestic forms he could translate

fig. 3 Frederic Edwin Church, *The Icebergs*, 1861 **fig. 4** William Bradford, *The Arctic Regions Illustrated with Photographs Taken On an Art Expedition to Greenland*, 1873

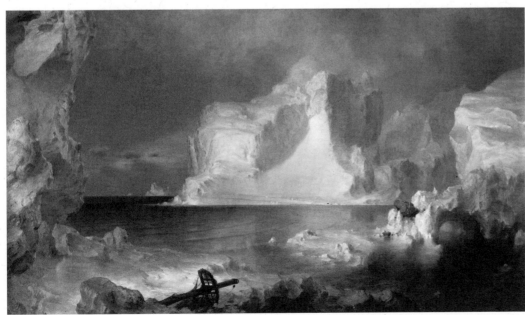

fig. 3

fig. 4

into pure geometry, stark lines and solid masses. His earlier canvases of Lake Superior and the Rocky Mountains foreshadowed his Arctic paintings through which he sought to reveal the spiritual dimension of nature. The stillness in Harris's northern paintings is not otherworldly in the nineteenth-century sublime sense of a foreboding and terrifying silence; they are otherworldly in the positive sense of a communion with a divine order. Inspired by the religious roots of his youth, the transcendentalism of Walt Whitman and his belief in theosophical ideas, Harris expressed in his Arctic landscapes the presence of the universal in nature.[29]

In 1928, two years before travelling to the Arctic, Harris wrote that Canadians were imbued with the spirit of the North, equating it with a sense of spontaneity and freedom. In the article he referred to "the replenishing North" as a source of regeneration for Canadian artists who sought to go beyond the conventions of European academic art: "To-day the artist moves toward purer creative expression, wherein he changes the outward aspect of Nature, alters colours, and, by changing and re-shaping forms, intensifies the austerity and beauty of formal relationships, and so creates a somewhat new world from the aspect of the world we commonly see; and thus he comes appreciably nearer a pure work of art and the expression of new spiritual values."[30] As a result of his Arctic visit, Harris's paintings after 1930 became more spare, the forms reaching into the sky became more geometric, the light appeared less natural, and cool blues and greens were the dominant hues in a limited range of colour.

Harris continued to question and explore systems of thought. As he travelled further within himself and developed his personal communion with the landscape, he reached beyond the actual representation of nature to convey, in an abstract way, its spiritual dimension. The actual site of the landscape became irrelevant in a landscape of the mind. In the same vein, the great twentieth-century explorer and discoverer of the North Pole, Frederick Cook, wrote in his posthumously published *Return from the Pole*: "The greatest mystery, the greatest unknown, is not that beyond the frontiers of knowledge but that unknown capacity in the spirit within the inner man of self ... Therein is the greatest field for exploration."[31]

* * *

1 For more on Mitchell's work in the Arctic, see Michael Bell, "Thomas Mitchell: Photographer and Artist in the High Arctic, 1875–76," *Image* 15, no. 3 (September 1972), 12–21; Rosalind Pepall, "Icebergs, Polar Bears and the Aurora Borealis," in *Cosmos: From Romanticism to the Avant-garde*, exhib. cat., Jean Clair, ed. (Montreal: Montreal Museum of Fine Arts, 1999), 117, 128, 130.

2 Werner Hofmann, *Caspar David Friedrich 1774–1840*, exhib. cat. (Munich: Prestel; Hamburg: Hamburger Kunsthalle, 1974), 258–259. Parry's *Journal of a Voyage for the Discovery of a North–West Passage from the Atlantic to the Pacific* was published in London in 1821.

3 John Barrow, Second Secretary of the British Admiralty from 1804 to 1845, was a great enthusiast of geographical exploration and saw in the search for the Northwest Passage a way to re-employ naval officers at the end of the Napoleonic wars.

4 The attraction continues today with new discoveries surrounding the event, as the Canadian government puts its mark on Arctic history to affirm the country's sovereignty in the North. See, for example, John Geiger, "Ottawa to Mount Search for Lost Franklin Ships," *The Globe and Mail*, August 14, 2008.

5 Michael F. Robinson, "A Man of Science and Humanity: Elisha Kent Kane," *The Coldest Crucible: Arctic Exploration and American Culture* (Chicago: University of Chicago Press, 2006), 31–54.

6 Elisha Kent Kane, *Arctic Explorations: The Second Grinnell Expedition in Search of Sir John Franklin, 1853, '54, '55* (Philadelphia: Childs and Peterson, 1856).

7 Quoted in John K. Howat, *Frederic Church* (New Haven: Yale University Press, 2005), 69.

8 Robert Rosenblum, *Modern Painting and the Northern Romantic Tradition: Friedrich to Rothko* (New York: Harper and Row, 1975), 68. However, Rosenblum points out that Church does not have the same depth of meaning in his paintings of the sublime as Friedrich.

9 Howat, 91. Hayes headed his own expedition to the Arctic in 1860 and wrote *The Open Polar Sea: A Narrative of a Voyage of Discovery towards the North Pole, in the Schooner "United States"* (New York: Hurd and Houghton, 1867).

10 Cited by Howat, 93, from Louis L. Noble, *After Icebergs with a Painter: A Summer Voyage to Labrador and around Newfoundland* (New York: Appleton, 1861), 65. At the time, Church and Noble were sailing along the coast of Newfoundland, near Petty Harbour.

11 Kane cited in Francis Spufford, *I May Be Some Time: Ice and the English Imagination* (London: Faber and Faber, 1996), 92. Spufford observed that these comparisons provided reassurance to the explorer and noted: "Lift off the robe of snow, where the powers of frost and air reign, and you find the same rocky bone-structure that hides elsewhere under a robe of jungle, a robe of forest, a robe of sand." See p. 93.

12 Spufford, 88.

13 Herman Melville, *Moby-Dick, or The Whale* (New York: Harper and Brothers, 1851; Berkeley: University of California Press, 1979), 191. Citation is to the University of California Press edition.

14 When the painting did not sell, Church added the mast in reference to the Franklin shipwreck, changed the original title from *The North* to *The Icebergs* and exhibited the work in London in 1863. The original title may have been misconstrued as going against English foreign policy which favoured the South during the American Civil War. The first owner of *The Icebergs* was English railway magnate Sir Edward Watkin, who had seen icebergs on one of his trips to Canada in 1861 when he was a director of the Grand Trunk Railway of Canada. Eleanor Jones Harvey, *The Voyage of the Icebergs: Frederic Church's Arctic Masterpiece*, with contributions by Gerald L. Carr (New Haven: Yale University Press, 2002), 66, 68–69; Eleanor Jones Harvey, "The Artistic Conquest of the Far North," in *Cosmos*, 109.

15 For an in-depth study of the context and significance of Church's painting, see Jeremy E. Adamson, "Frederic Edwin Church's 'Niagara': The Sublime as Transcendence" (PhD diss., University of Michigan, 1981).

16 William Bradford, *The Arctic Regions Illustrated with Photographs Taken On an Art Expedition to Greenland* (London: Sampson Low, Marston, Low and Searle, 1873).

17 Ibid., 11–12.

18 Ibid., 49.

19 The photographers worked for the Boston firm of James Wallace Black. See Richard Kugler, *William Bradford: Sailing Ships and Arctic Seas* (New Bedford, Massachusetts: New Bedford Whaling Museum; Seattle: University of Washington Press, 2003), 74–77.

20 Ibid., 23; Russel A. Potter, "Distant Visions, the Poles in Western Visual Culture," in Samuel Scott, *To the Ends of the Earth, Painting the Polar Landscape* (Salem: Peabody Essex Museum, 2008), 18–19.

21 Photographic equipment was included on the ill-fated 1845 Franklin expedition and on the 1853–1855 Kane expedition, but with few results. Douglas Wamsley and William Barr, "Early Photographers of the Arctic," *Polar Record* 32, no. 183 (October 1996), 295–296, 307.

22 Thomas Mitchell supplied Nares with a collection of photographs from the voyage. See Bell.

23 Howat, 121.

24 Chauncey C. Loomis, "The Arctic Sublime," in *Nature and the Victorian Imagination*, U. C. Knoepflmacher and G. B. Tennyson, eds. (Berkeley: University of California Press, 1977), 112.

25 Vilhjalmur Stefansson, *The Friendly Arctic: The Story of Five Years in Polar Regions* (Toronto: Macmillan Company of Canada, 1921).

26 Charles C. Hill, *The Group of Seven: Art for a Nation* (Ottawa: National Gallery of Canada, 1995). For another interpretation of the Group of Seven artists' response to the landscape see *Beyond Wilderness: The Group of Seven, Canadian Identity and Contemporary Art*, John O'Brian and Peter White, eds. (Montreal and Kingston: McGill-Queen's University Press, 2007).

27 A. Y. Jackson, *A Painter's Country: The Autobiography of A. Y. Jackson* (Toronto: Clarke, Irwin and Co., 1958), 93.

28 A. Y. Jackson, *The Arctic 1927* (Manotick, Ontario: Penumbra Press, 1982), unpaginated.

29 Many have discussed Harris's paintings in relation to these influences. See, for example, Sherrill E. Grace, *Canada and the Idea of North* (Montreal and Kingston: McGill-Queen's University Press, 2002), 9–11; Ann Davis, *The Logic of Ecstasy: Canadian Mystical Painting 1920–1940* (Toronto: University of Toronto Press, 1992); Christopher Jackson, *North by West: The Arctic and Rocky Mountain Paintings of Lawren Harris 1924–1931* (Calgary: Glenbow Museum, 1991).

30 Lawren Harris, "Creative Art and Canada," in *Yearbook of the Arts in Canada 1928–1929*, Bertram Brooker, ed. (Toronto: Macmillan Company of Canada, 1929), 185.

31 Cited in Robert McGhee, *The Last Imaginary Place: A Human History of the Arctic World* (Toronto: Key Porter Books, 2004), 239. (Cook claimed that he was the first to reach the North Pole in 1908, although Admiral Robert Edwin Peary successfully challenged this claim.)

François-Marc
Gagnon

The Forest, Niagara and the Sublime

The aim of this short essay is to demonstrate that representations of the landscape that thrived in the United States and Canada during the period covered by this exhibition sought to disguise its true nature by invoking the theme of the sublime as defined by the philosophers of the eighteenth century and construed in the nineteenth. Nothing is less innocent than the idea of the landscape. It arose with individualism and thus with the right to own property. The gaze cast upon nature, then transferred to canvas, is a gaze of possession and exclusion, of exploitation and privilege—as photographers, more honest than painters, have always shown us. On the other hand, when the sublime enters the picture, the notion of possession is forgotten, and the experience is transformed into something mystical, transcendent and flattering for the viewer.

Photographers made no effort to hide the railroads, the rampant felling of tall trees, the soldiers' dead bodies heaped on Civil War battlefields and, later, the cities' polluted air. In the present exhibition, this may be observed in the photographs of Timothy O'Sullivan (*A Harvest of Death, Gettysburg, Pennsylvania*) (cat. 51), George Barnard (*Trestle Bridge at Whiteside*) (cat. 84), William Henry Jackson (*Canyon of the Rio Las Animas, W. H. J. and Co., Denver*) (cat. 90), Darius Kinsey (*Four Logs from One Fir Tree Scaled 27,000 Feet. Cherry Valley Timber Co., Stillwater, Washington*) (cat. 91), Carleton E. Watkins (*Cofferdam at End of Main Diversion [Golden Feather Mining Claim]*) (cat. 96) and Alfred Stieglitz (*The Hand of Man* [cat. 158] and *The City of Ambition* [cat. 166]). Painters, on the other hand, depicted the Rockies, the primeval forest and stormy skies. And

of course the public preferred the image served up by painters to that of the photographers because it helped them forget not only the destruction of nature but also technology and war, and made them believe in progress and economic "growth," by definition limitless.

We know something about this here in Canada, where since 1910 people have droned on about the country's "wilderness," even as it was being assailed from all directions by mining companies, railroads and lumberjacks. Sublime indeed are the views offered by Lawren Harris, A. Y. Jackson and Tom Thomson of the land emptied of the First Nations, of forests on the shores of the Great Lakes reduced to a single tree, of the Precambrian Shield laid bare by prospecting hither and yon.

If the sublime did not have as strong a hold on Quebec, it is because a different route was taken in escaping from reality—toward the past rather than the future, toward the bucolic, simple-minded "good old days" of our "ancestors" rather than toward the development and exploitation of natural resources. Our need was to "survive," as they said. Our need was to preserve the French language—"guardian of the faith" (the Catholic faith, of course)—and our old ways and customs as purebred Canadians. It was just as much of an escape, but toward "our master the past," toward a sort of naive and senseless Messianism that made us agents of the Truth amid the heretics and according to which we might lay claim to a purity fraught with peril. While English Canadian painters strove to eliminate all human presence from their paintings, French Canadian painters were depicting village streets of yesteryear and tilled fields.

The Forest

It intrigues me that this period is when an attempt was made, in both Canada and the United States, to append the forest to the realm of the sublime. It was not a matter of course. The forest is noticeably absent from definitions of the sublime formulated in the early aesthetic reflections of the eighteenth-century philosophers. Neither Edmund Burke nor Immanuel Kant mentions the forest in particular as a place for experiencing the sublime. For Burke, the quintessential experience of the sublime is the night, and he explains what lies behind it in a striking statement: "Indeed terror is in all cases whatsoever, either more openly or latently the ruling principle of the sublime."[1]

One might assume the same would apply to some-one lost in the forest. They do not know what might become of them, and often, madly rushing about to find a way out, far from saving them, only thrusts them deeper into their misfortune. But this comparison does not occur to Burke, who sticks with darkness per se:

```
For in utter darkness, it is
impossible to know in what degree
of safety we stand; we are ignorant
of the objects that surround us;
we may every moment strike against
some dangerous obstruction; we may
fall down a precipice the first step
we take; and if an enemy approach,
we know not in what quarter to
defend ourselves; in such a case
strength is no sure protection;
wisdom can only act by guess; the
boldest are staggered, and he who
would pray for nothing else towards
his defense, is forced to pray
for light.[2]
```

At the same time, one might wonder what would prompt anyone to value this experience that Burke describes so negatively. There is a work in the exhibition that does indeed combine this aspect of fear with the theme of the forest. It is a large canvas by Albert Bierstadt, *Passing Storm over the Sierra Nevadas* (cat. 43). The approaching storm obliterates the outline of the mountains and, at the bottom of the composition, plunges into the forest's darkness.

Certainly, the dark is not the lone catalyst for the experience of the sublime to the mind of the eighteenth-century thinkers. Joseph Addison expressed more the common feeling by linking the experience of the sublime to vastness, without explicitly bringing in the element of terror that is so crucial for Burke.

```
By Greatness, I do not only mean
the Bulk of any single Object,
but the Largeness of a whole
View, considered as one entire
Piece. Such are the Prospects
of an open Champian Country, a
vast uncultivated Desart, of huge
Heaps of Mountains, high Rocks
and Precipices, or a wide Expanse
of Waters, where we are not struck
with the Novelty of Beauty of the
Sight, but with that rude kind
of Magnificence which appears in
many of these stupendous Works
of Nature. Our Imagination loves
to be filled with an Object, or
to graspe at any thing that is
too big for its Capacity … The
Mind of Man naturally hates every
thing that looks like a Restraint
upon it.[3]
```

Now we are getting nearer to the point. What Burke experiences as the loss of mileposts, a dive into the unknown, Addison views as freedom from constraints, the revelation of a field that will always exceed our capacities and thus proves an inexhaustible resource. A dangerous fantasy, as we now understand only too well, but the influence of the sublime as described by Addison delayed our awareness of this. The forest is not named. Yet, its immenseness—especially the American forest—would soon come to mind.

In a famous passage in the *Critique of Judgement*, while more or less adhering to the examples of Addison and Burke, Kant makes this ambiguity of the sublime better understood.

```
Bold, overhanging, and, as it were,
threatening rocks, thunderclouds
piled up the vault of heaven,
borne along with flashes and
peals, volcanoes in all their
violence of destruction, hurricanes
leaving desolation in their track,
the boundless ocean rising with
rebellious force, the high waterfall
of some mighty river, and the like,
make our power of resistance of
trifling moment in comparison with
their might.[4]
```

This is what Kant calls the "dynamic sublime," in which the idea of power is foremost. But even when he is thinking of the "mathematical sublime" and stresses the idea of quantity and largeness, his examples still illustrate the same thinking.

```
Who would apply the term "sublime"
even to shapeless mountain masses
towering one above the other in
wild disorder, with their pyramids
of ice, or to the dark tempestuous
ocean, or such like things? But in
the contemplation of them, without
any regard to their form, the mind
abandons itself to the imagination
and to a reason … and it feels
itself elevated in its own judgement
of itself on finding all the might
of imagination still unequal to its
ideas.[5]
```

The triumph of reason, the triumph of technology as it would soon be understood in the nineteenth century.

Then the extent of this annexation of the forest to the domain of the sublime was realized. It entailed its destruction, pure and simple. The voice of Ralph Waldo Emerson, for whom the forest reconciled man with his profound nature, would go unheard.

In the woods too, a man casts off his years, as the snake his slough, and at what period soever of life, is always a child. In the woods, is perpetual youth. Within these plantations of God, a decorum and sanctity reign, a perennial festival is dressed, and the guest sees not how he should tire of them in a thousand years. In the woods, we return to reason and faith. There I feel that nothing can befall me in life-no disgrace, no calamity (leaving me my eyes), which nature cannot repair.

The greatest delight which the fields and woods minister, is the suggestion of an occult relation between man and the vegetable. I am not alone and unacknowledged. They nod to me and I to them. The waving of the boughs in the storm, is new to me and old. It takes me by surprise, and yet is not unknown. Its effect is like that of a higher thought or a better emotion coming over me, when I deemed I was thinking justly or doing right.[6]

As you probably noticed, the word "sublime" does not come up, and the experience of the forest is described in terms of harmony rather than as a relationship of power, as with Kant.

The forest is an integral part of some of the landscapes in the present exhibition. Whether their main subject is the mountains or impetuously rushing rivers, the forest does not contribute directly to the effect of sublimity they seek to produce. In John Arthur Fraser's *At the Rogers Pass, Summit of the Selkirk Range, British Columbia* (cat. 38), it is clearly the Rogers Pass that troubles spectators with its mass and leads them to raise their eyes toward the sky. However, the foreground is completely filled by a pine forest.

The work that most strongly conveys the so to speak infinite character of the forest is a simple photograph by Benjamin Baltzly, *Forest trees on the North Thompson River, 165 Miles above Kamloops* (cat. 30), which

represents a densely wooded area: the viewer sees no limit to the trees, neither at the right, the left nor in the distance. It is as if Baltzly had led us to the middle of the woods and removed all the reference points that might orient us.

Niagara

The other theme that was appended to the domain of the sublime in the nineteenth century is Niagara Falls. When the eighteenth-century writers thought of water as a sublime phenomenon, they saw the ocean, the raging sea, that is, expanses of water stretching as far as the eye could see, horizontally. Niagara Falls, however, is a mass of water falling vertically, as apt to cause the holy terror described by Burke as the feeling of dynamic power dear to Kant.

Niagara Falls, which seems to combine the mathematical sublime with the dynamic sublime, to use the philosophical terms, became the subject par excellence of American and Canadian painters in search of the sublime. This did not occur without some groping and faltering. Not all the points of view chosen by painters and photographers were equally effective. In William Notman's photograph *The Horseshoe Falls and Terrapin Tower, Niagara, Ontario* (cat. 3), the camera is placed so far away that one might almost say the feeling of danger is non-existent. It is from Terrapin Tower, overhanging the abyss, that the view would obviously have been the most frightening.

Consideration of the proper distance from the phenomenon did not escape Kant. He mentions it in regard to the pyramids of Egypt, referring to the *Letters on Egypt* by the Orientalist, Egyptologist and translator of the Koran Nicolas Savary (1750–1788), who noted that "in order to get the full emotional effect of the size of the pyramids we must avoid coming too near just as much as remaining too far away."[7]

The same applies to Niagara Falls. The painter who best mastered the phenomenon is incontestably the American Frederic Edwin Church. In *Niagara* (see Brookman, fig. 3), Church is more convincing than Notman. Little separates us from the falls, and we imagine the painter setting up his easel on the slippery rocks in the foreground.

Niagara Falls, from the American Side (cat. 1) is a spectacular view of Niagara Falls painted by Church. We are literally drawn above the abyss, the foreground

blurring in the mist. The painter Thomas Cole (1801–1848), with whom Church studied from 1844 to 1846, admirably expressed the sublimity and beauty of Niagara Falls in his 1835 "Essay on American Scenery."

And Niagara! that wonder of the world!-where the sublime and beautiful are bound together in an indissoluble chain. In gazing on it we feel as though a great void had been filled in our minds-our conceptions expand-we become a part of what we behold! At our feet the floods of a thousand rivers are poured out-the contents of vast inland seas. In its volume we conceive immensity; in its course, everlasting duration; in its impetuosity, uncontrollable power. These are the elements of its sublimity. Its beauty is garlanded around in the varied hues of the water, in the spray that ascends the sky, and in that unrivalled bow which forms a complete cincture round the unresting floods.[8]

What this statement of Cole's makes clear is that the sublime is not in the thing contemplated but in the mind of the person contemplating it. It is in our minds that a "great void" has been filled. The painter is thus referring to a sort of symbiosis between viewers and the object of their contemplation. We are "a part of what we behold." Then the dangerous concepts of "immensity," "impetuosity" and "uncontrollable power" are born in our mind, the concepts that stirred industries the day they learned to harness the very power of Niagara Falls to make electricity. A formidable power indeed! The will to power, "the will to will," to use Heidegger's phrase apropos of Nietzsche's.

The sublime throws us off the trail. It makes us seem small before the immensity and force of nature. But once we witness the spectacle from afar—the Group of Seven painted their *lakeside pines* in the comfort of Dr. MacCallum's country house—we become aware that these powerful forces are at our mercy. Kant described better than anyone else the reversal of perspective proper to the sublime.

But, provided our own position is
secure, their aspect is all the
more attractive for its fearfulness;
and we readily call these objects
sublime, because they raise the
forces of the soul above the height
of vulgar commonplace, and discover
within us a power of resistance
of quite another kind, which gives
us courage to be able to measure
ourselves against the seeming
omnipotence of nature.[9]

Such is indeed the feeling of the sublime, which must be distinguished from the feeling of the beautiful. It is caused not by form but by the formless, the limitless, insofar as we are able to perceive it as a totality, as in experiencing the mountains, a coming storm or the power of Niagara Falls.

The sublime is no more found in nature than beauty—we put it there. The feeling aroused by objects we deem sublime, "when we are assured of our own safety, is not actual fear."[10] What we feel, through the imagination, is a combination of movement and repose before the sight of them, and so they make us experience the superiority of our mind over nature.

We understand that what surpassed us (even threatened us, but only theoretically, because we are at a safe distance, as we said) is also presented to us rationally as a whole, and thus, in an idea. We become aware that the notion of the sublime is in us or, if you will, that, without us, there would be no sublime. We have just experienced the limits of our senses and our imagination but we also realize that we have not lost our heads, that we have maintained control, that we are reasonable. Our vital powers, which were browbeaten at first, reassert themselves more strongly afterward. Whence the feeling of pleasure ultimately connected with the sublime, without which it would not be possible to talk of aesthetics. Whence, as well, the feeling of power that proclaims technology's hold over nature, immeasurably vast though it be.

So, the field of the sublime tends to shift with technology. Technological conquests are willingly accompanied by an extension of the sublime that, creating a sense of euphoria, makes us less aware of its grip and the destruction that comes with it.

* * *

1 Edmund Burke,
 *A Philosophical Enquiry
 into the Origin of Our
 Ideas of the Sublime
 and Beautiful*, David P.
 Womersley, ed.
 (London: Penguin
 Books, 1998), 102.
2 Ibid., 172.
3 Joseph Addison
 (Monday, June 23, 1712),
 in *The Spectator*, vol. 3,
 Donald F. Bond, ed.
 (Oxford: Clarendon
 Press, 1965), 540.
4 Immanuel Kant,
 Critique of Judgement,
 James Creed Meredith,
 trans., Nicholas Walker,
 ed. (Oxford: Oxford
 University Press,
 2007), 91.
5 Ibid., 86–87.
6 Ralph Waldo Emerson,
 "Nature," *in The
 Collected Works of Ralph
 Waldo Emerson*, vol. 1,
 Alfred R. Ferguson, ed.
 (Cambridge: Harvard
 University Press,
 1971), 10.
7 Kant, 82.
8 Thomas Cole, "Essay
 on American Scenery,"
 1835, quoted in
 Barbara Novak, Robert
 Rosenblum and John
 Wilmering, *The Natural
 Paradise: Painting in
 America, 1800–1950*
 (New York: Museum of
 Modern Art, 1976), 96.
9 Kant, 91.
10 Ibid., 99.

1 Frederic Edwin Church, Niagara Falls, from the American Side, 1867

In 1857 Church painted *Niagara*, his first monumental and panoramic view of Niagara Falls, from the Canadian side, in a horizontal format (see Brookman, fig. 3). Critically and publicly a tremendous success in both New York and London, that painting (now at the Corcoran Gallery of Art) established his international reputation as America's outstanding painter. Niagara Falls was appreciated by the contemporary American critics as fulfilling the role of a national icon in their reviews of the painting. It is not surprising that in essaying the same subject ten years later, having received a lucrative commission from Michael Knoedler, Church chose a vertical format and a different perspective, based on a sketch from his 1856 visit. The view is taken from the touristic Prospect Point, popular with artists since 1821. Interestingly, *Niagara Falls, from the American Side* reflects a reliance on photography, and the artist in fact referred to a sepia-toned photograph of the site that he had hand-coloured in oil. Church evokes the sublime, a sensibility with religious undertones, so cherished by the Hudson River School, by the scale of the work, the inclusion of the tiny figures and viewing platform contrasted with the towering falls, the brilliantly captured water spumes and mist dominating virtually the rest of the enormous canvas, and the foreground rainbow rising from the glistening rocks and vegetation. The picture was acclaimed in London but less enthusiastically received in the United States.

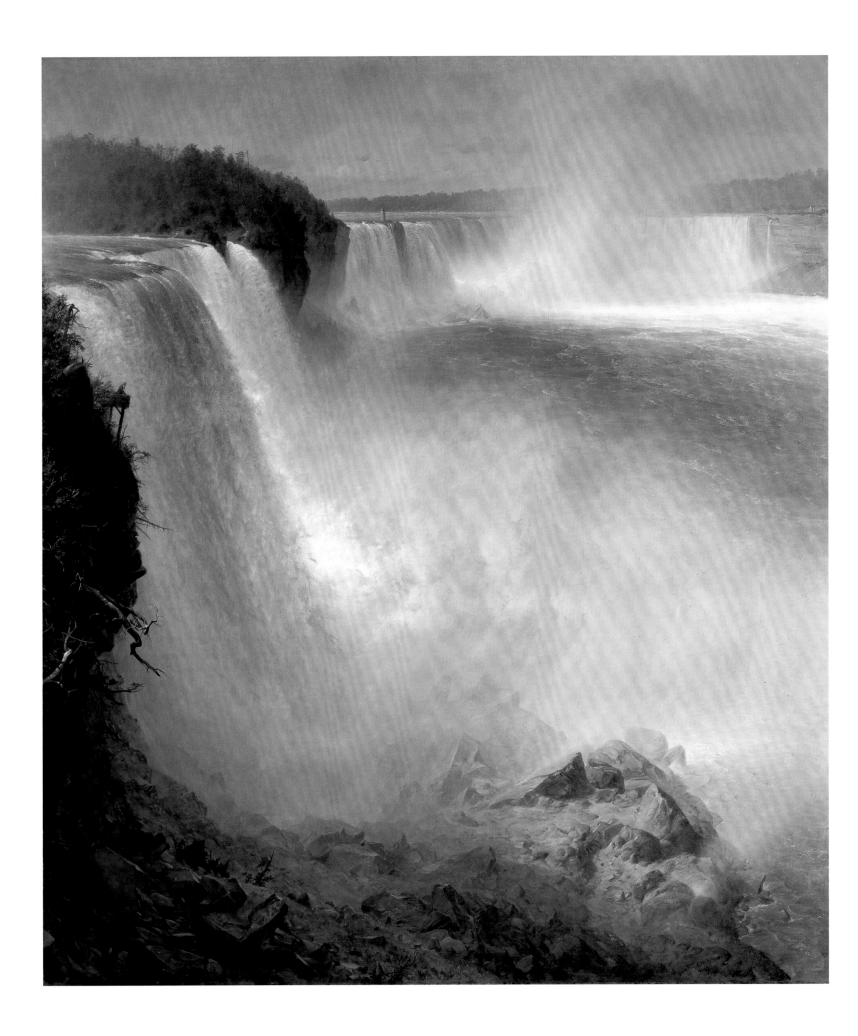

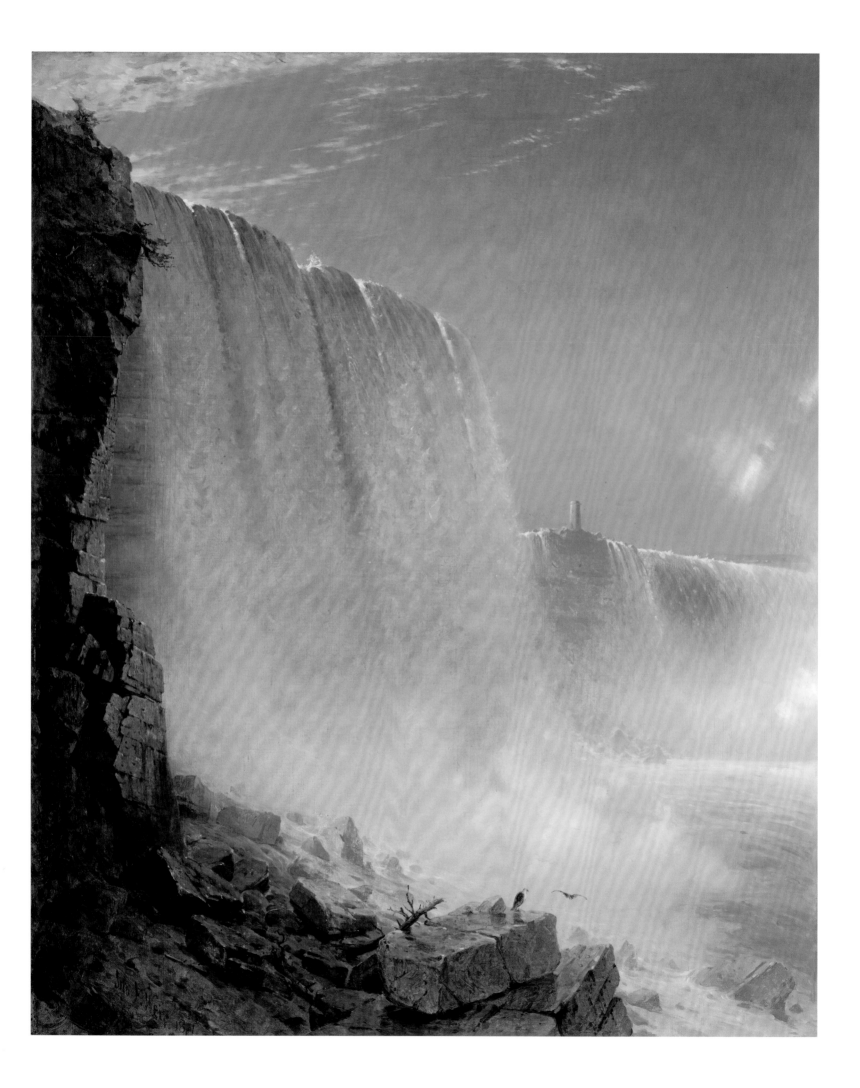

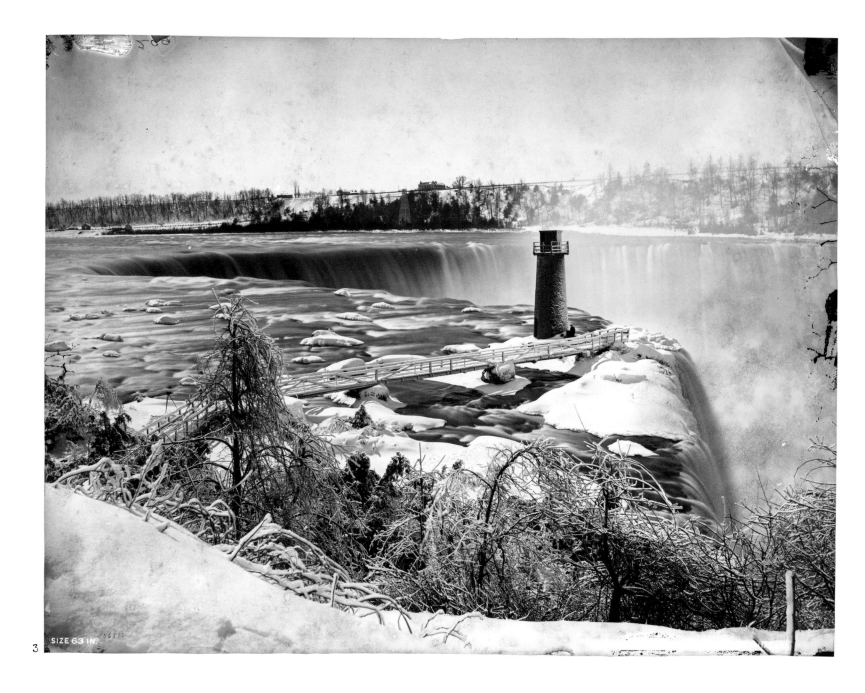

SIZE 63 IN.

OPPOSITE

2 John Ferguson Weir, Niagara Falls, 1871
Weir was the son of a professor of drawing at West Point, New York, and the brother of Impressionist painter Julian Alden Weir. His early landscapes reflect the influence of the Hudson River School painters, notably of Church, as is evident here, but his work increasingly was informed by the style and subjects of Impressionist artists.

3 William Notman, The Horseshoe Falls and Terrapin Tower, Niagara, Ontario, 1869
From 1816 until 1885, Goat Island was owned by the Porter brothers, who constructed a wooden toll bridge (without railing!) connecting the island to the mainland. For twenty-five cents, tourists could cross the bridge to gain a dramatic view of the falls. At Terrapin Point (Porter's Bluff), the brothers further constructed a ninety-metre walkway from Goat Island to the crest of the Horseshoe Falls. In 1829, Terrapin Tower was built on the island, atop the rocky promontory at the end of the walkway. The circular stone edifice was twelve metres high and three and a half metres in diameter, and, for ten cents, visitors could enter and climb up to an observatory balcony, offering a spectacular view. In 1872 the tower was demolished with gunpowder in favour of a new tower that was never built. The State of New York reclaimed the island in 1885 to create a state park.

4 William Notman, Niagara Falls, 1869

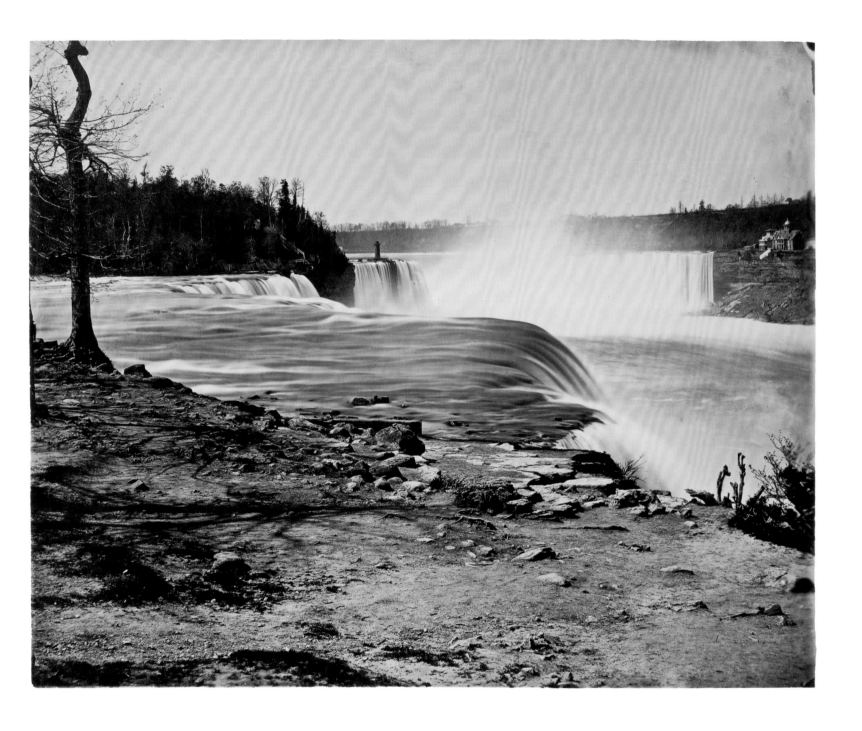

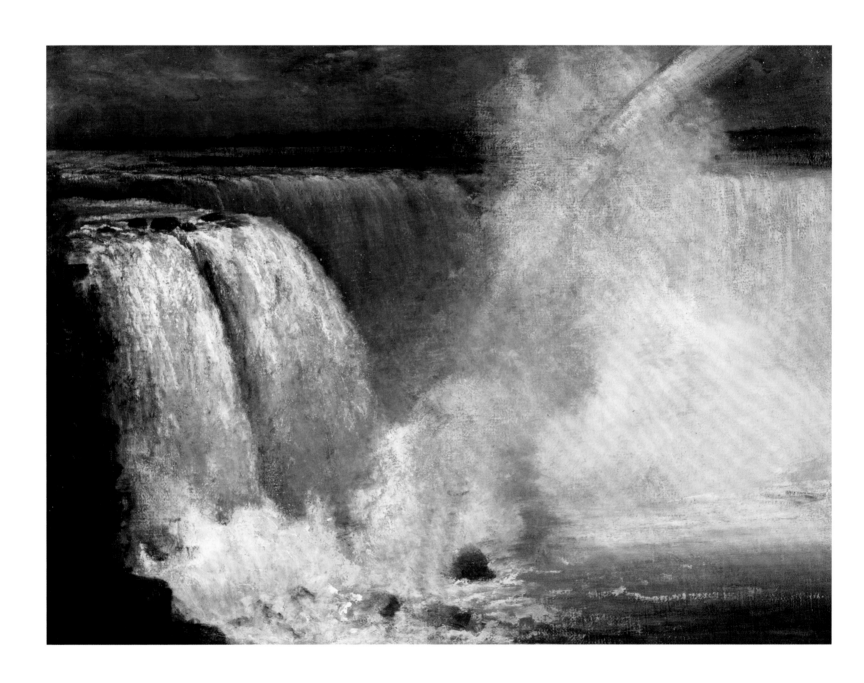

Hunt's *American Falls, Niagara*, taken from Prospect Point, inevitably recalls Church's rendition of over ten years earlier. In June 1878 Hunt visited the area, and the sight and sound of the falls (today 75 per cent of the water that cascaded over the falls has been diverted for hydroelectric power) inspired him spontaneously to undertake the painting during his month-long holiday, together with several drawings, pastels and other oils. Unlike Church's painting, however, Hunt's is intended neither as an evocation of the sublime nor as an expression of the Divine through natural forces. Rather, it is more closely tied with Impressionist concerns with the interplay of light and colour and the rendering of the subject matter with an open brushwork. The overall effect conveys the tension between the surface tactility of paint and the visual impression of the falls.

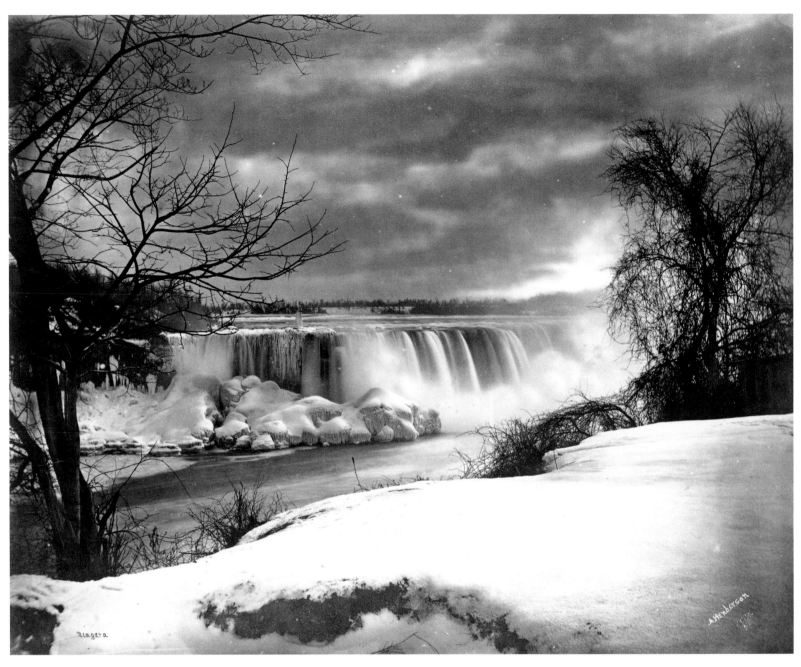

6 Alexander Henderson, Niagara, about 1870

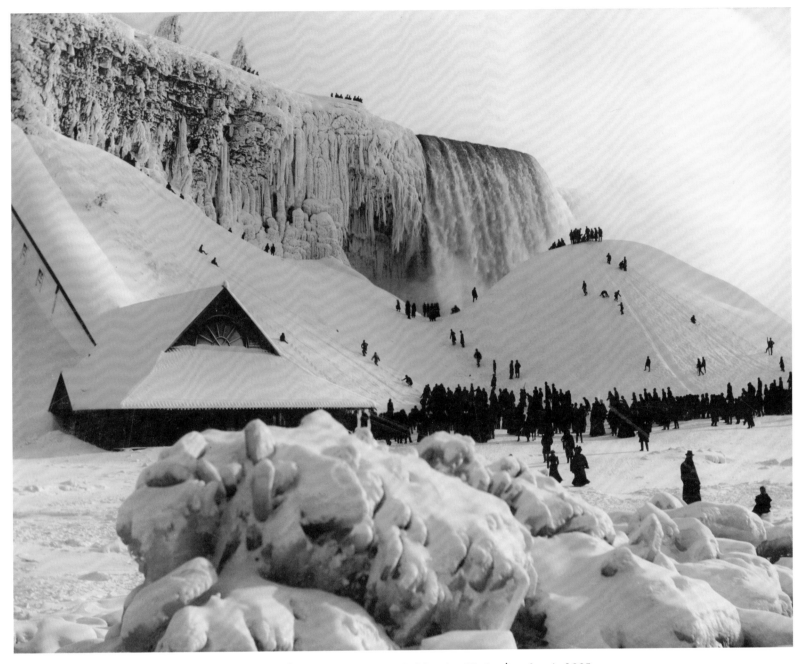

7 Herman F. Nielson, Winter Landscape (View of Niagara Falls in Winter), about 1885

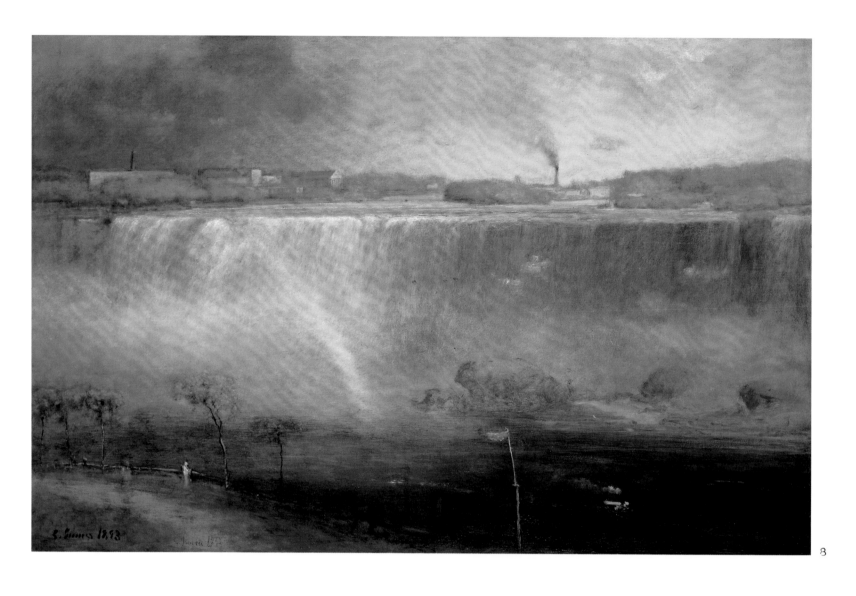

8 George Inness, Niagara, 1893
Between 1881 and 1893, Inness painted Niagara Falls seven times. His preferred view was from the Canadian side, looking toward the American bank. This large view is distinguished by its prominent inclusion of the smoking chimney of the Bath Island paper mill and the urban, industrial architecture on the far shore. This underlines a fundamental difference between Inness's interests and those of such artists as Church and early photographers. Inness was interested not in the picturesque, heroic or narrative aspect of the famous site but in rendering a highly personal response based on direct perception, in which the layered and mingled colours convey an atmospheric experience of a shifting and dissolving contemporary view apprehended amidst the water mist and humid atmosphere. Despite its dramatic scale, Niagara suggests the aesthetic of an oil sketch.

OPPOSITE
9 Alvin Langdon Coburn, Niagara Falls, about 1910
In 1910 Coburn returned to the United States from a visit to Ireland but arrived in Buffalo too late to attend the November 4 opening of the great Photo-Secession exhibition, which he had supported, but which Alfred Stieglitz and Max Weber had organized. Coburn took the opportunity to photograph the icy falls, demonstrating the same fascination with the effects of light and grand formal composition that would characterize his 1912 photographs of Yosemite and the Grand Canyon (cat. 50, 180, 182).

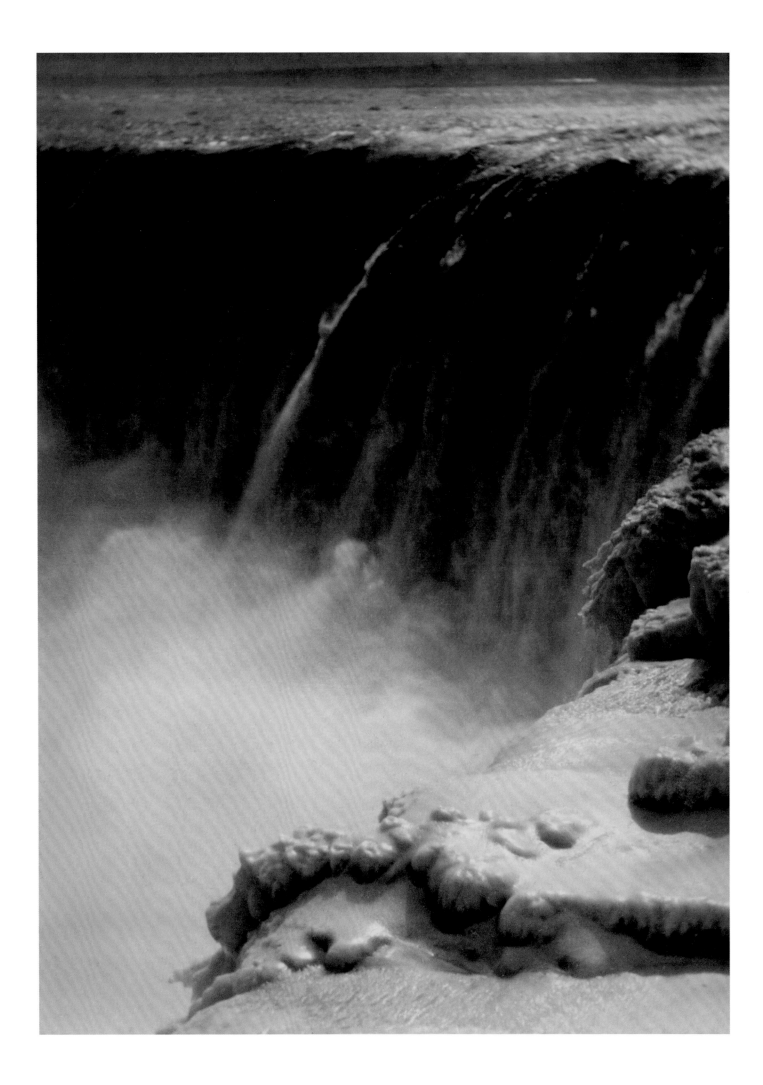

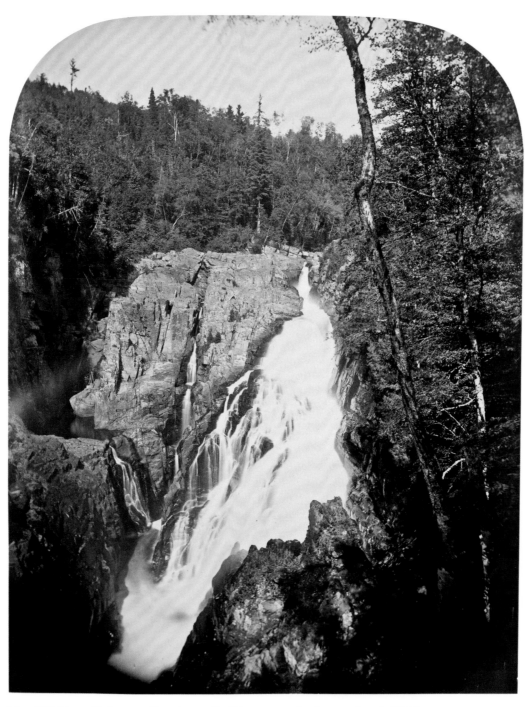

10 William Notman, St. Anne Falls, near Quebec, about 1860

Notman employed many photographic assistants as well as draftsmen and painters (including Henry Sandham, who hand-coloured photographs) in his highly successful Montreal studio. He also actively photographed paintings for popular distribution, including oils by Cornelius Krieghoff. It is not surprising, therefore, that Montreal painters turned to his photographs for visual reference and compositional sources. Otto Jacobi's *Falls of St. Anne, Quebec* is certainly based on, indeed virtually copied from, Notman's photograph of the same year, and Jacobi's *The Montmorency River* suggests likely reference to if less slavish dependence upon a Notman photograph.

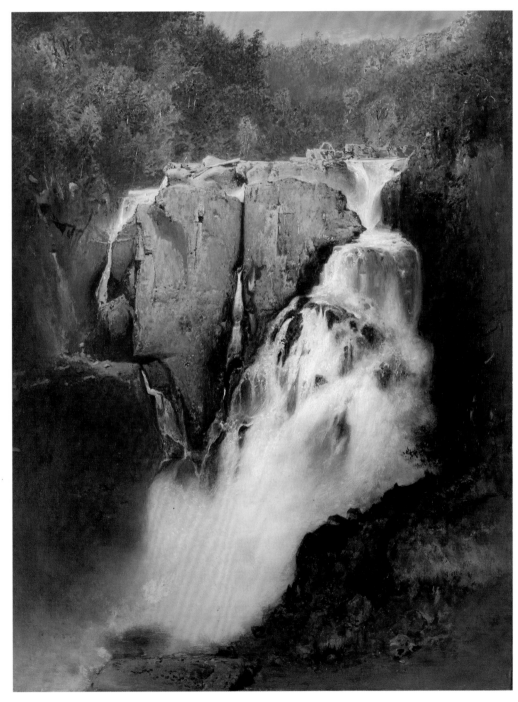

11 Otto Reinhold Jacobi, Falls of St. Anne, Quebec, 1865

12 William Notman, Natural Steps on the Montmorency near Quebec, about 1860

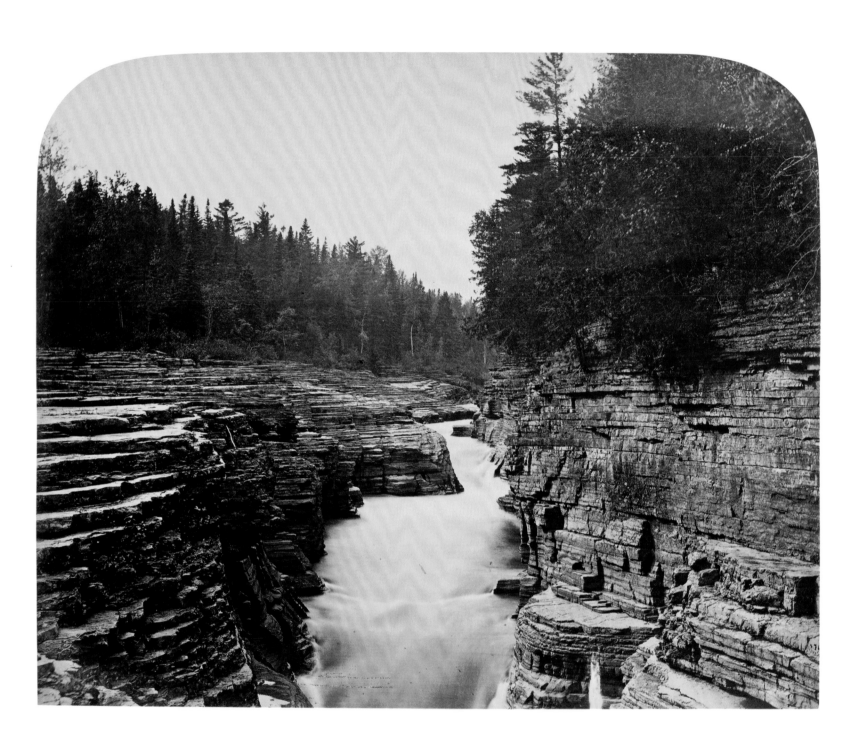

13 Otto Reinhold Jacobi, The Montmorency River, 1860

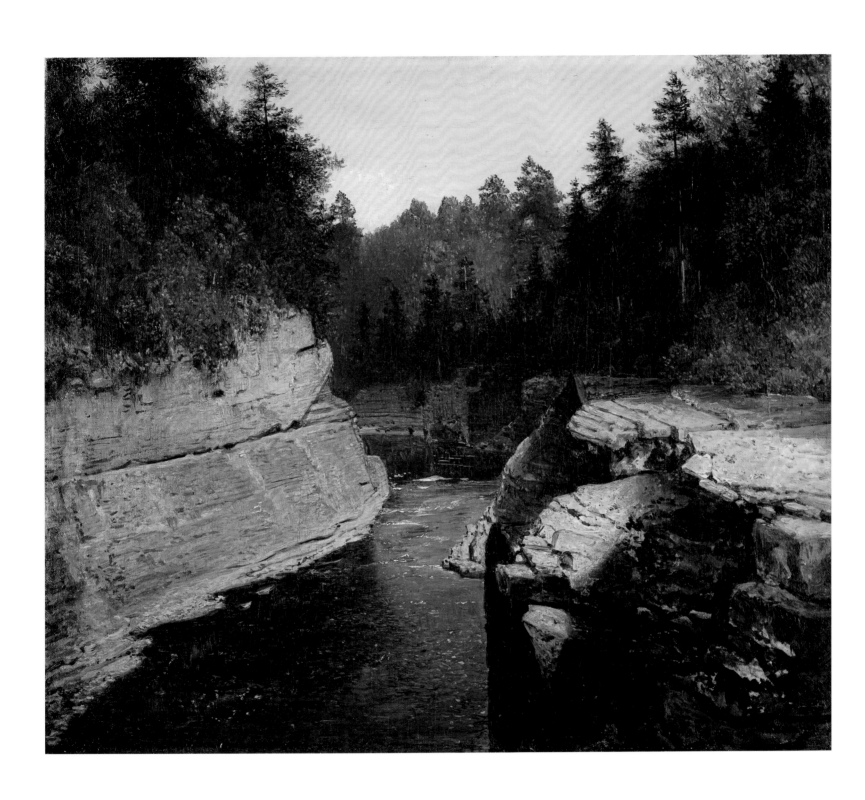

14 Alexander Henderson, Ice Cone, Montmorency Falls, 1876

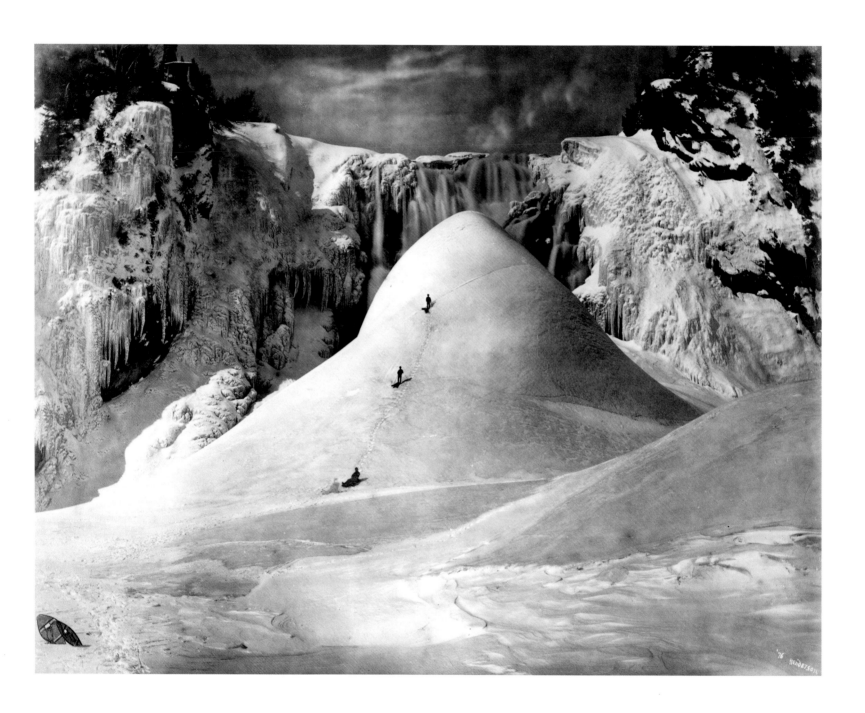

Born in Scotland and having settled in Montreal, Henderson came to specialize in photographic images of the Canadian landscape. In 1859 he became the first North American member of the Stereoscopic Exchange Club, England, and in 1865 published his *Canadian Views and Studies by an Amateur*. By 1867 the once amateur photographer had turned into a professional, ultimately directing the photographic division of the Canadian Pacific Railway. This photograph of 1876 would become among his most famous, embodying both an iconic image of the Canadian winter and associated leisure activity, and a well-known Quebec natural wonder, popular with tourists. The scale of the figures descending the slope dramatically enhances the cone, set against the background of the frozen falls. The photograph is also a masterwork of its time for its sophisticated tonal range within the remarkable limitations and challenges of the snow scene. The photograph was awarded the silver medal at the Paris World's Fair in 1878.

15 Lucius O'Brien, Kakabeka Falls, Kamanistiquia River, 1882

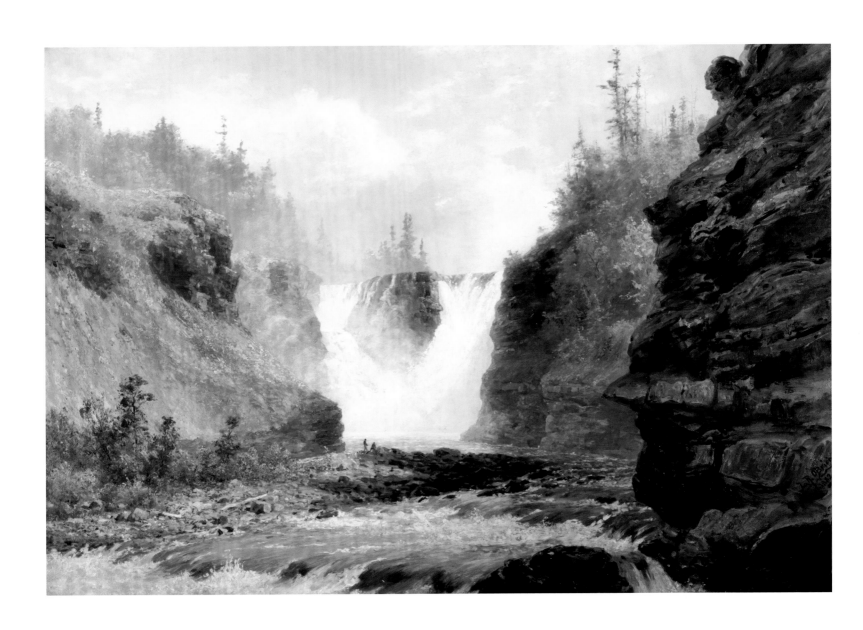

The scholar Dennis Reid has described O'Brien's dramatic and monumental *Kakabeka Falls* as a "breath-taking evocation of the sublime unequalled in nineteenth-century Canadian art. Technically his most accomplished oil, it is very possibly his single most affecting work of art." As such, it forms a remarkable and rare Canadian corollary to the ambitions of the second generation of Hudson River School painters. This powerful work, in which the intensity of the experience of the falls is so remarkably expressed through the brushstrokes and the fulcrum-like focus of the composition, records O'Brien's visit to Thunder Bay, above Lake Superior, a site synonymous to the contemporary public with the potentialities and promise of the Canadian Northwest. The painting was reproduced as a wood engraving that same year in the popular two-volume set entitled *Picturesque Canada: The Country as It Was and Is*, the successor to a comparable American publication of almost ten years earlier. O'Brien was the art director of the Canadian volumes, published by Howard and Reuben Belden, American brothers living in Canada.

16 Benjamin Baltzly, Cascade on the Hammond (Garnet) River, 1871

Baltzly was born and raised in Ohio and only moved to Montreal when he was thirty years old. Already a professional photographer, he worked for William Notman beginning in the early 1870s and in 1871 joined Alfred Selwyn's team for the Geological Survey of Canada. During the expedition in British Columbia, Baltzly documented the land with remarkable enthusiasm, given the extraordinary challenges encountered in exploring often trail-less and impenetrable forests, wild rivers and rugged mountain terrain. These challenges were exacerbated by his need to carry bulky wet-collodion-process equipment. The photographer even contracted frostbite during the arduous return. The presence of Baltzly on the team may reflect the impact of Timothy O'Sullivan and other photographers who had recently journeyed on similar surveys in the United States. Notman, who underwrote the costs for the presence of photographers on these arduous expeditions, appreciated picturesque compositions for his commercial public. Not surprisingly, Baltzly prioritized stunning perspectives, even when obtaining them involved great difficulty, yet remained sensitive to the geological purposes of the trip. In his travel account, he singles out the Garnet River Cascade for its tremendous beauty, romantically inspired by the scenery with an explicit religious fervour.

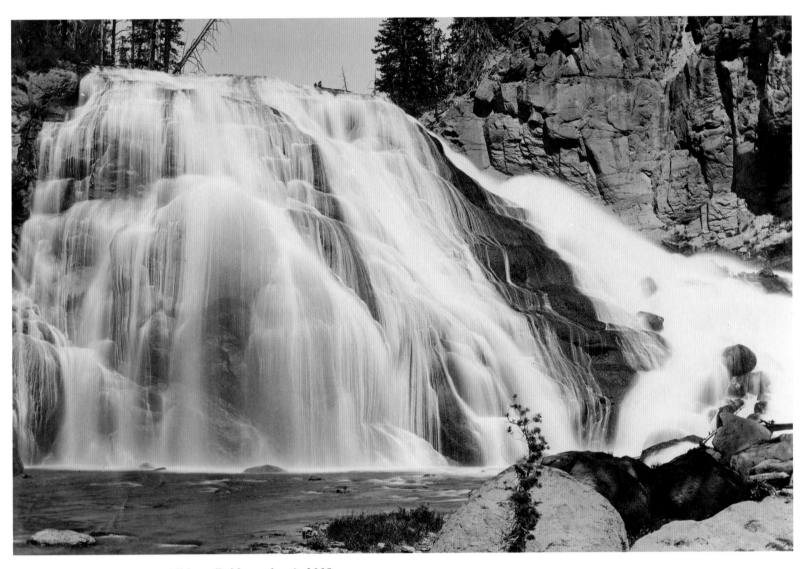

17 Frank Jay Haynes, Gibbon Falls, about 1885

Gibbon Falls is located in Yellowstone National Park. Growing up in Michigan, Haynes developed an early interest in landscapes through chromolithographs of Church's dramatic paintings. From 1876, Haynes was the photographer for the Northern Pacific Railroad, creating images to encourage tourism and settlement along the rail lines. He was appointed official photographer of Yellowstone in 1884.

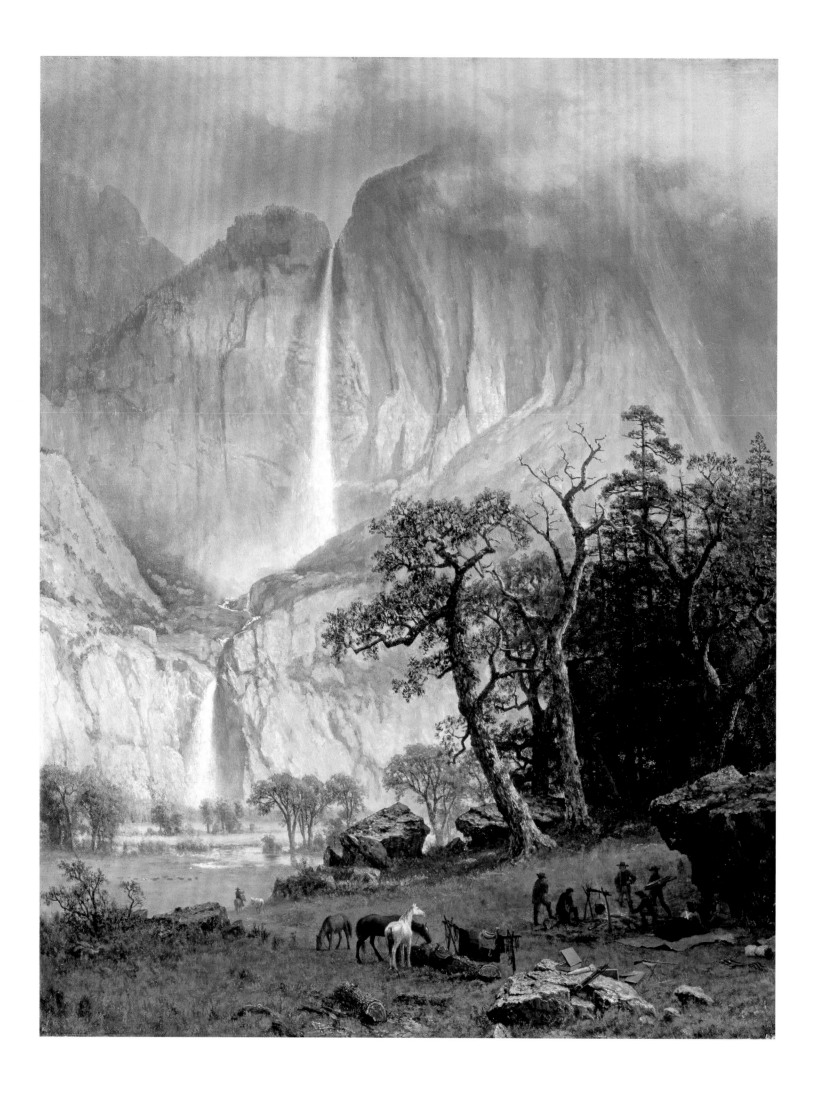

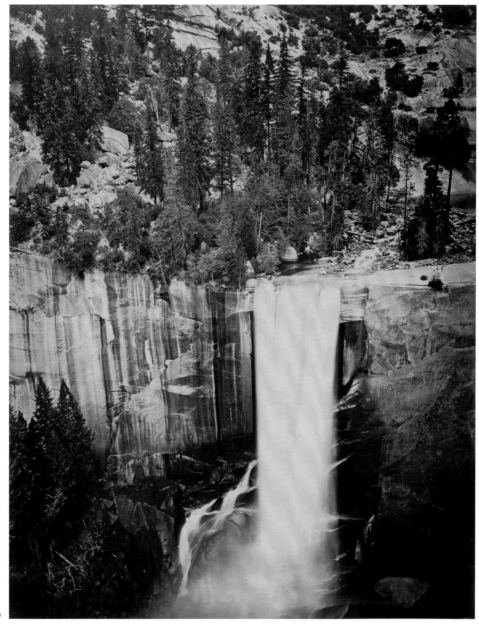

19

18 Albert Bierstadt, Cho-looke, the Yosemite Fall, 1864
Bierstadt visited Yosemite for the first time in August 1863, completing this idyllic, indeed paradisiacal view in his New York studio the following year. Set against the monumental scale of the falls, travellers (presumably the artist and companions), close by their grazing horses, prepare a meal at their camp. Painting-related materials are set on a nearby rock. Bierstadt's inspirational and Edenic view makes a striking juxtaposition with Sargent's more prosaic depictions of the Canadian Rockies fifty years later. The artist's idyllic sensibility profoundly appealed to the American public in the Union States, in the midst of a crucial and exceedingly bloody year in the Civil War—the battle of Gettysburg had taken place less than a month before Bierstadt's arrival at Yosemite and 1864 was a year of unparalleled carnage. The painting thus spoke not only to peace and the beauty and nobility of Nature, but also to the sweeping promise of California and, by extension, the Union.

19 Eadweard James Muybridge, Pi-Wi-Ack. Valley of the Yosemite, about 1870
This monumental photograph of the Vernal Falls (which actually drop close to a hundred metres) was taken during Muybridge's five-month trip to Yosemite in 1867. During this time the photographer created no less than 250 views, some stereoscopic, later developing them in his San Francisco studio and exhibiting them to an appreciative public.

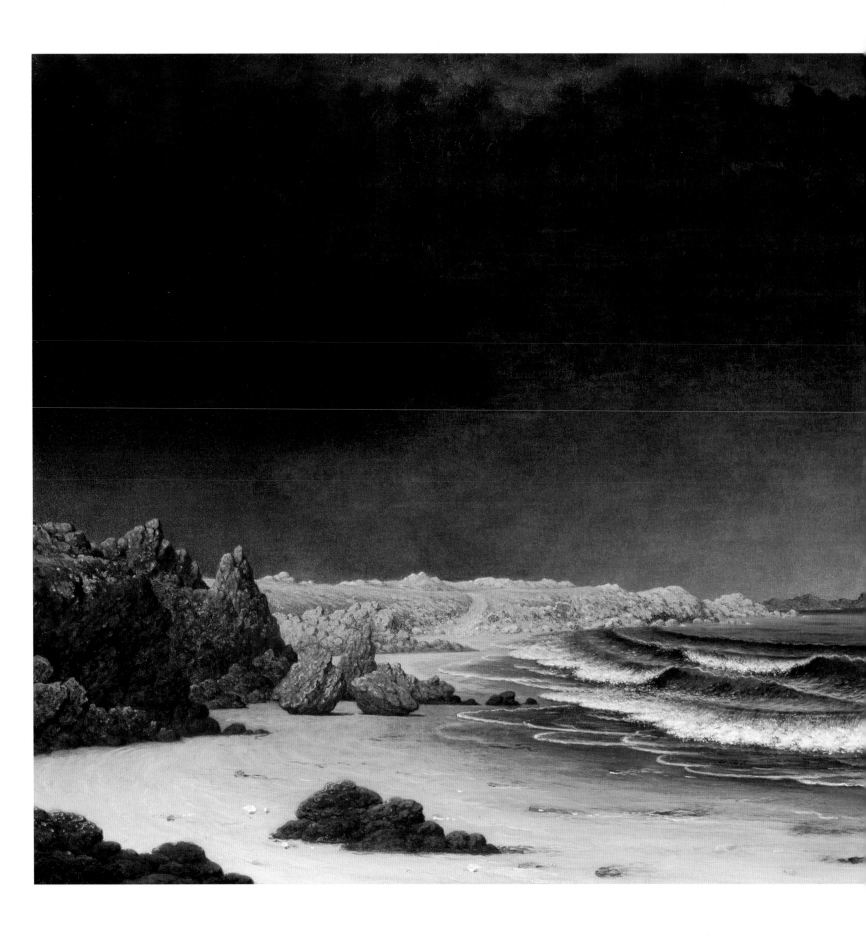

20 Martin Johnson Heade, Approaching Storm, Beach near Newport, about 1861-62

Heade's treatment of the beach and seascape, in which the deep grey tonalities and the tenebrous, brooding atmosphere are enhanced by his use of a thin, brown glaze, the foreground highlighted against the deep green and white-crested waves, creates a memorably threatening landscape. This effect is amplified by the intense colouration in a range of red-oranges to yellow-browns of the beach and rocks. The brushwork effectively renders the foam of the waves and the moving clouds above. The subordinate, indeed paltry presence of Man

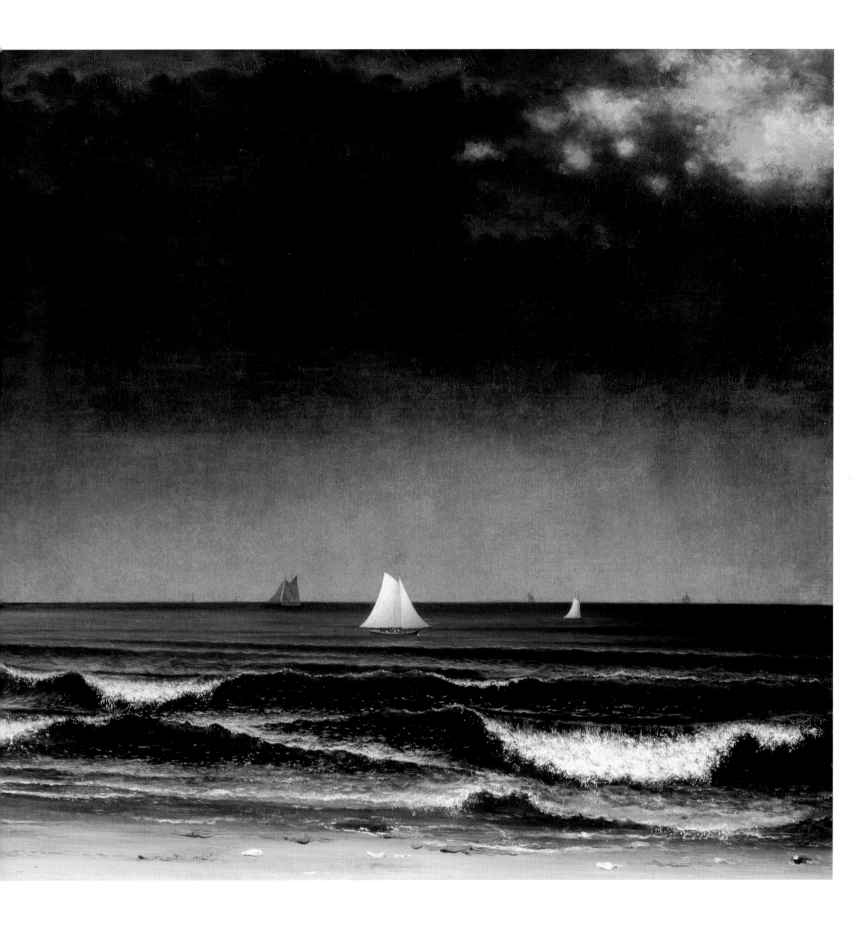

against the cosmic forces of Nature is underlined by the scale and translucence of the sails on the sea, so that they seem at once to emerge and dissolve within the palpably dense air. The most uncompromisingly minimalist and mysterious of the four essays in this subject that Heade executed between 1859 and 1870, from *Approaching Storm, Beach near Newport* has been interpreted as an evocation of Man's relation to God, an allegory of the recent Civil War and a Poussin-like observation on Man and Nature. Clearly this painting draws from the Hudson River School's focus on the spiritual in Nature and the experience of the sublime, and addresses the Luminists' personalized sensibilities and appeals to the inner world of experience.

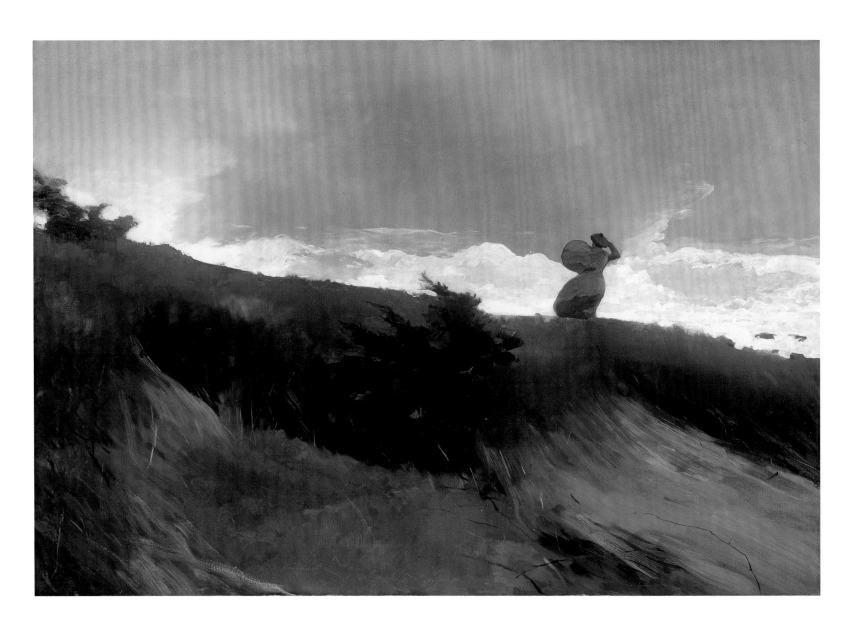

The West Wind was, by Homer's own admission, a painting executed as an exercise in browns (as he responded in a note to John La Farge's hundred-dollar challenge to successfully create such a picture). More seriously, however, this mature painting reveals the artist's creative response to the style and tonalities of the art of James McNeill Whistler and to the compositions of Japanese woodblock prints, notably the works of Hokusai and Hiroshige. Furthermore, Homer never loses contact with the fundamental character of the chosen motif: powerful gales along his beloved Maine coast. While the painting suggests a narrative, it also presents a veristic and vivid image of the forces of Nature, stripped of the reverent sentiment or allegorical poetry of the Hudson River School.

22 Lucius O'Brien, *Sunrise on the Saguenay, Cape Trinity*, 1880

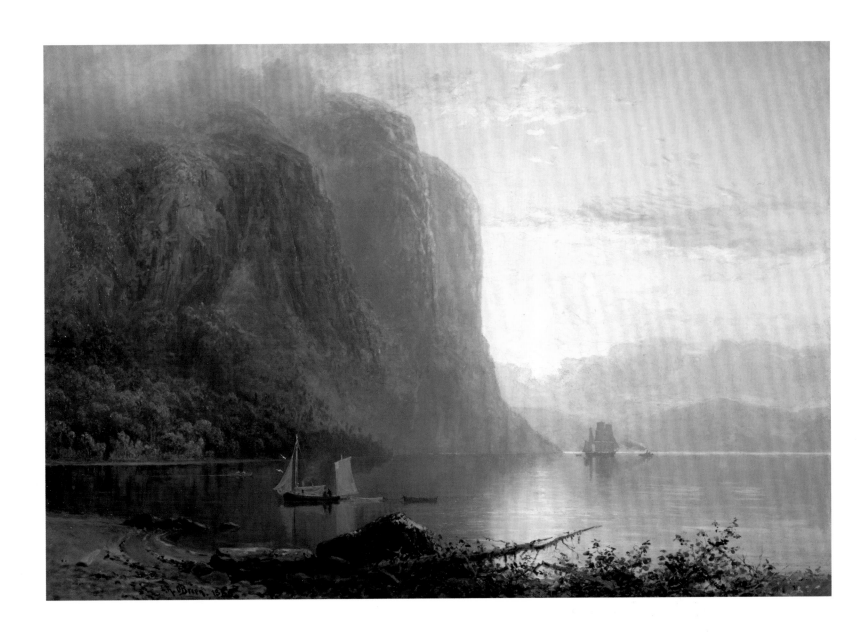

As J. Russell Harper has noted, this early painting by O'Brien demonstrates the artist's familiarity with recent American painting, the Indigenous people in the canoe reflecting his knowledge of George Caleb Bingham's work. The powerful, contrasting lighting of the cliffs of Cape Trinity against the rising sun and the sky also clearly allude to the art of Bierstadt. The painting, distinguished by its lower emotional key and enhanced by the enveloping atmosphere, navigates between the American aesthetics of the sublime espoused by the second generation of the Hudson River School—with its powerful composition, scale of Nature to Man and juxtaposition of the sunrise with the dark mass of the Cape—and the Romantic realism of the Luminists (such as Martin Johnson Heade and John Frederick Kensett)—with its poetic yet more introspective and personal character. Other artists in Montreal were also working in a Luminist style, probably influenced by American painters and indirectly by German painters, but none as successfully as O'Brien. Although rendering a specific site in Quebec, this painting, O'Brien's Royal Canadian Academy diploma piece, was immediately exhibited at and accessioned by the new National Gallery of Canada in Ottawa. It marks a turn in Canadian landscape painting to a more majestic vision of the nation.

23 Albert Bierstadt, Moat Mountain, Intervale, New Hampshire, about 1862

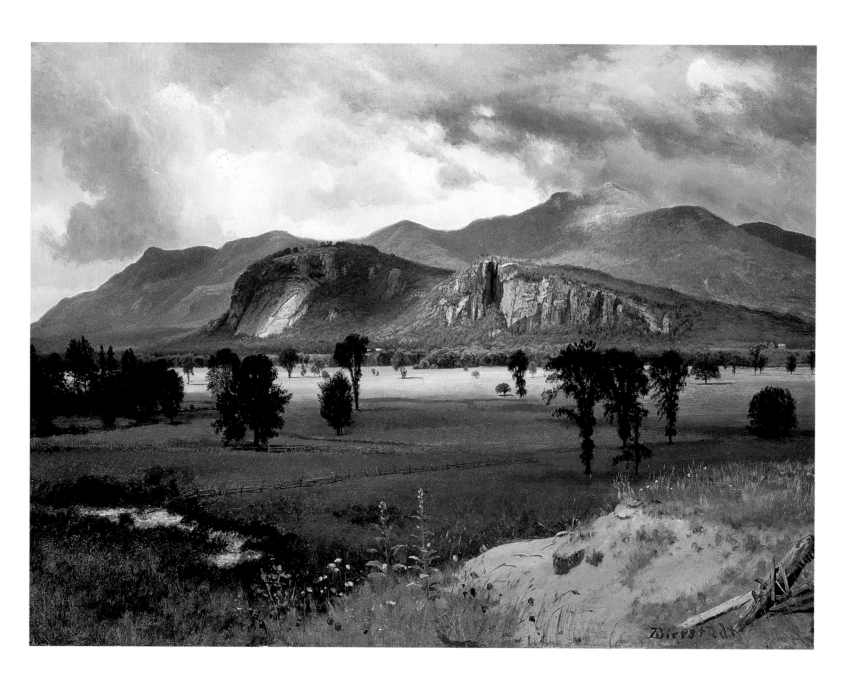

In 1862, in the midst of the Civil War, Bierstadt could not travel to the West Coast for painting motifs, as he wished, and instead visited the White Mountains. The natural beauty of this site, popular with tourists, nonetheless inspired him, and he executed many drawings and an oil sketch. *Moat Mountain* is one of several paintings executed after these studies. While featuring highly detailed vegetation, the modestly scaled painting, notable for its lack of human figures, depicts a broad sweep of landscape. The carefully observed dramatic effects of sunlight striking the pasture in the distance and the extraordinary range of cloud patterns and densities streaming across the sky unite a lyrical pastoral sensibility of cosmic serenity with vivid directness of vision.

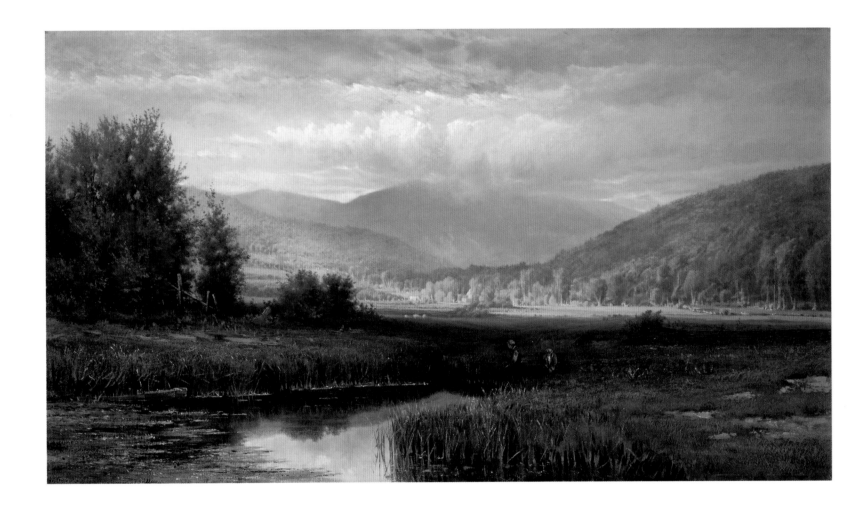

In this early work, Edson still reflects the powerful influence of the Hudson River School, but already his objective naturalism is displayed in his treatment of the foreground vegetation and the young figures moving about in the marsh. Edson preferred subjects of the Eastern Townships, the area in which he was born.

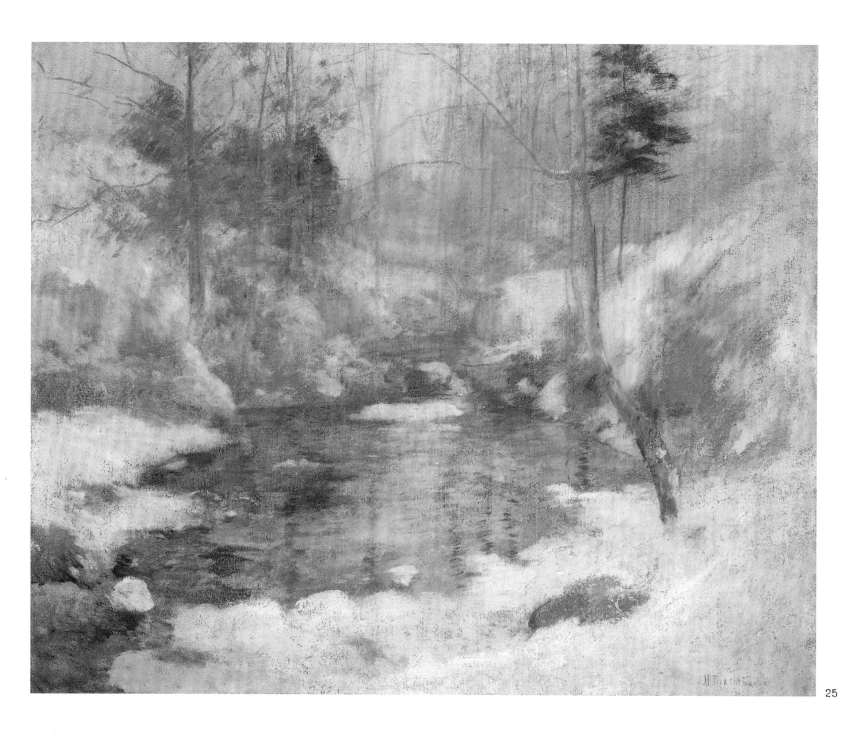

25

25 John Henry Twachtman, Winter Harmony, about 1890-1900
This winter scene depicts Hemlock Pool in Horseneck Brook on the artist's estate in Greenwich, Connecticut. Akin to the succeeding painting by Marc-Aurèle Suzor-Coté, the artist uses a diagonal, actually a chevron in the river turn, to draw the viewer's eye into the depths of the isolated and unpopulated landscape which so dominates the canvas. The influence of Impressionism is evident in the dissolving forms seen through the snowy sky and the reflections of colour tones onto the snow beneath. As has often been commented, the sought emotional response to the canvas is one of meditative calm and serenity, a contrast to the increasingly stressful demands of urban life in nearby New York City.

OPPOSITE

26 Marc-Aurèle de Foy Suzor-Coté, Bend in the River Gosselin at Arthabaska, about 1906
Suzor-Coté executed this painting in Paris based on studies he made during a winter visit to Canada in 1901–1902. It is a replica of one he successfully exhibited in Paris at the 1906 Salon des Artistes Français. Clearly influenced by his direct experience of Impressionism, the painting is a study of light reflections and muted tonalities beneath a brooding, leaden grey sky. A crisp realism and focus on solid forms distinguish this work from Twachtman's. The relatively low perspective, in which the horizon is set on the top quarter of the canvas, projects monumentality upon the snow-covered terrain and partly frozen river, an effect enhanced by the fact that the landscape is bereft of any figures.

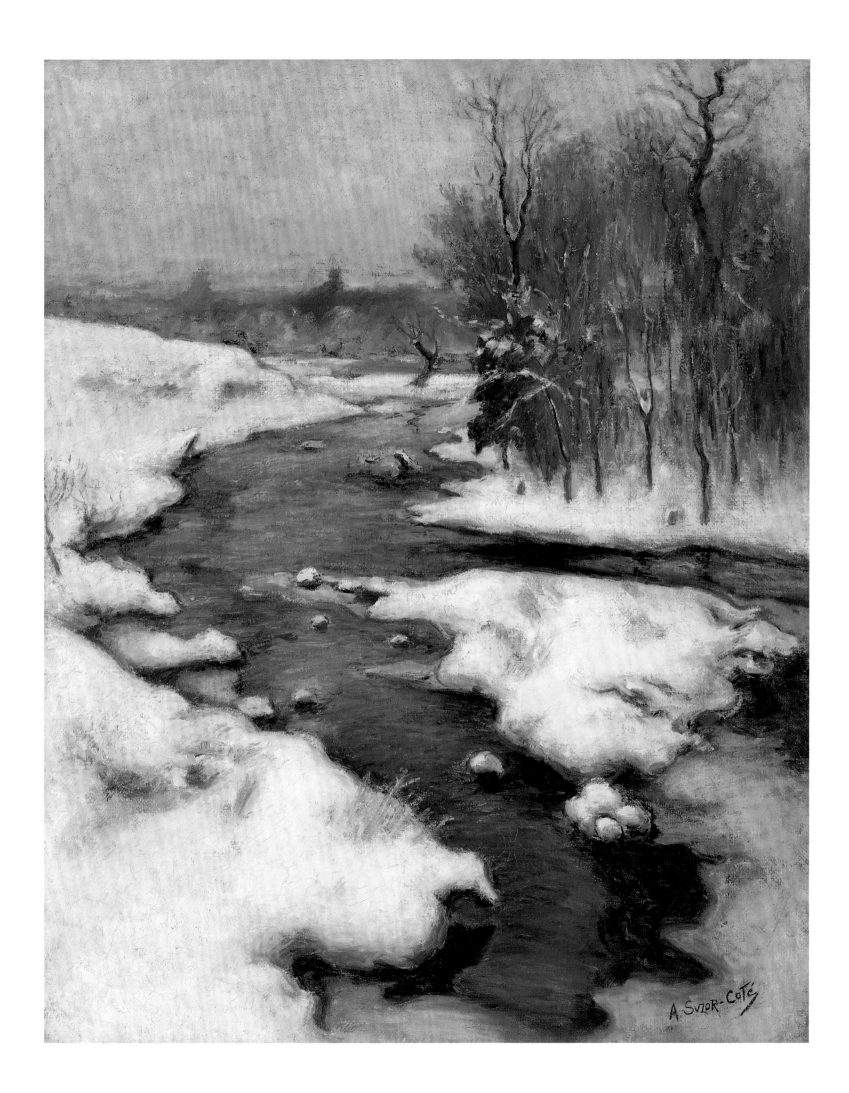

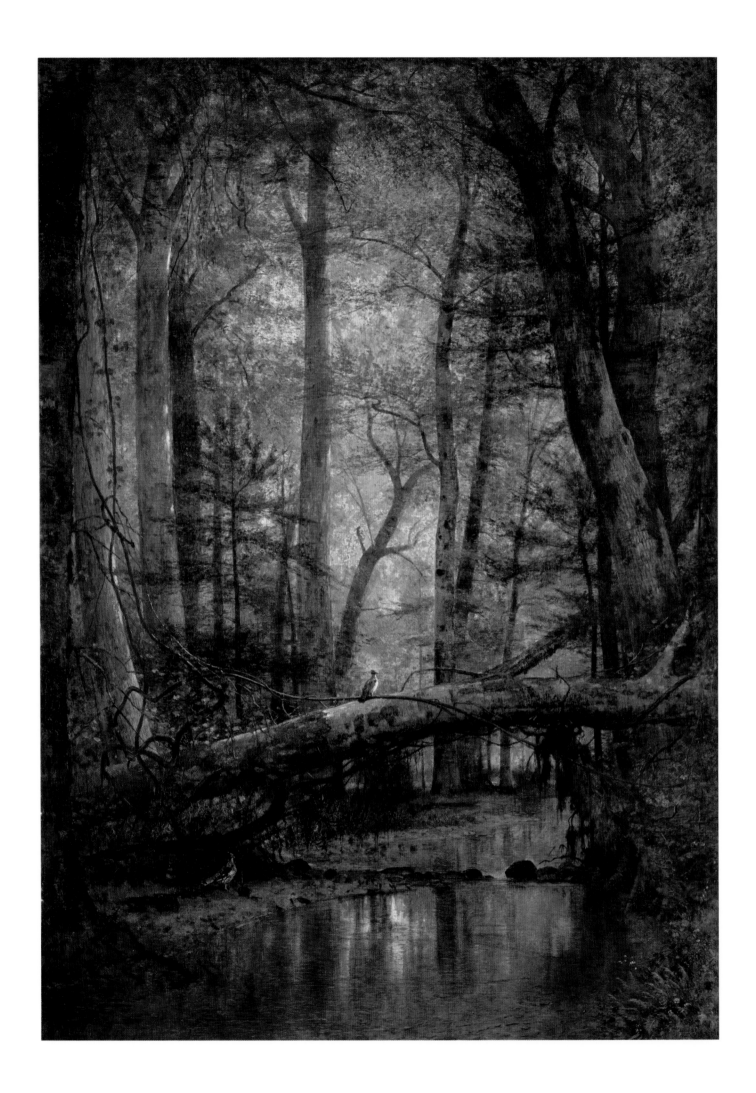

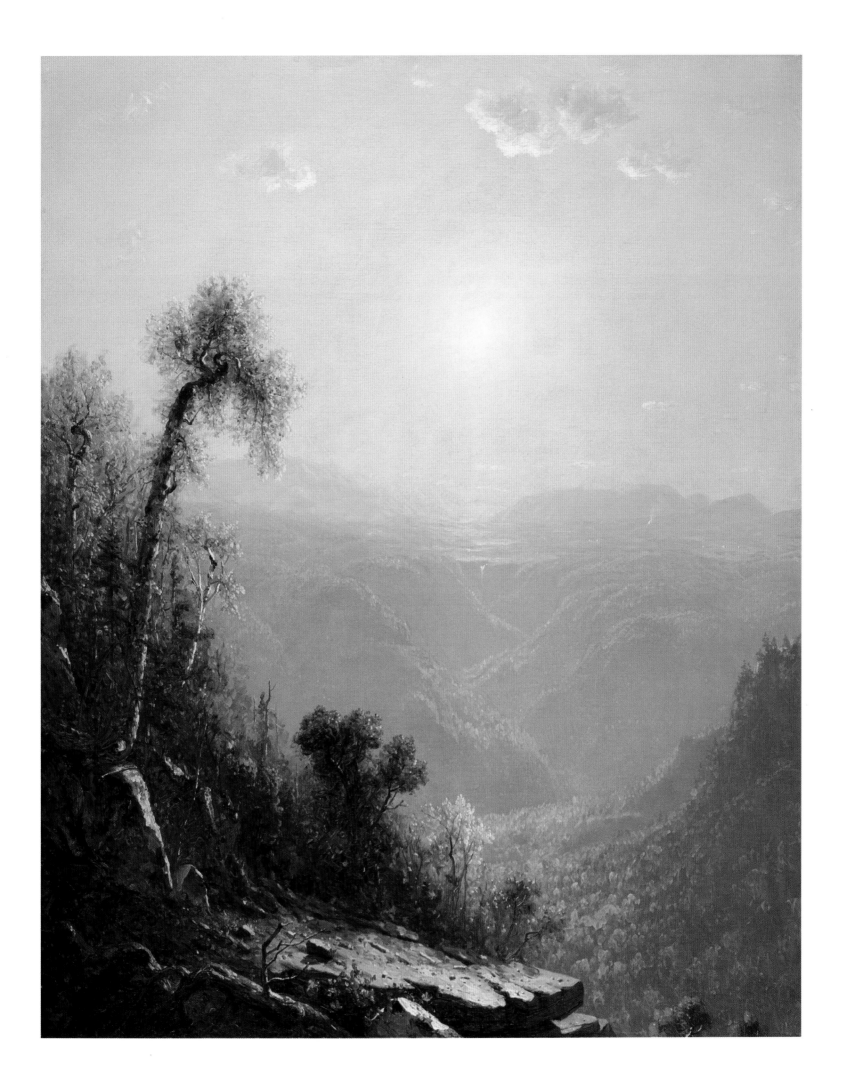

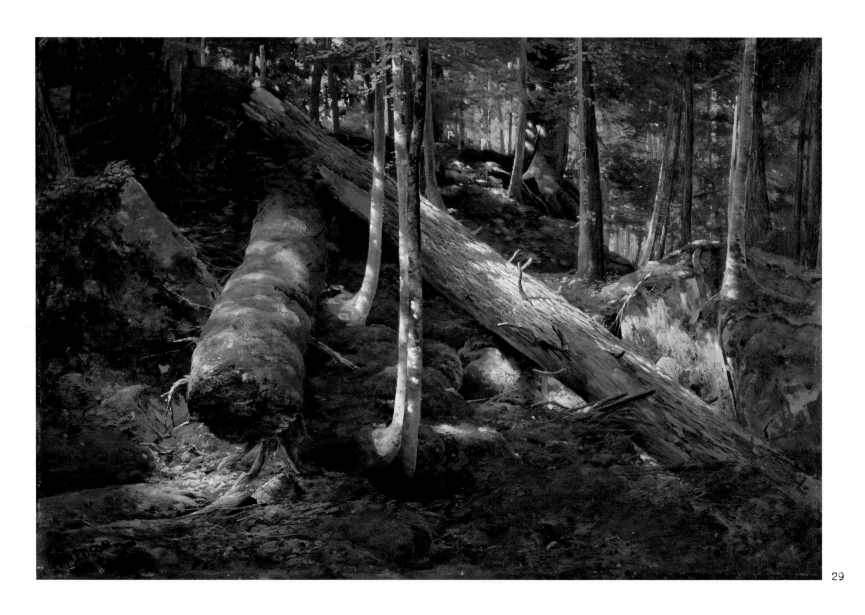

29

27 Thomas Worthington Whittredge, Woods of Ashokan, 1868
Set in the Catskill Mountains of New York State, this visionary scene of virgin Nature clearly demonstrates Whittredge's debt to first-generation Hudson River School painters, notably to Asher Durand. The autumnal view and its lighting suggest the course of human life in an elegiac and spiritual mode, a legacy of the artist's early study at the Düsseldorf Academy.

28 Sanford Robinson Gifford, October in the Catskills, 1880
The Kaaterskill Clove is a gorge near Palenville in the Catskill Mountains, a site close to Gifford's mother's home and beloved by Hudson River School painters. Here, the artist returned to a panoramic view he had essayed in 1862. This later work is a study of the palpable atmosphere of a late autumnal day. True to the School's propensity, the work primarily addresses, in personal terms, the spiritual implications of Nature and Divine promise. Gifford has altered the landscape, dissolving the contours of the horizon and stressing the isolated centrality of the symbol-laden, dazzling sun.

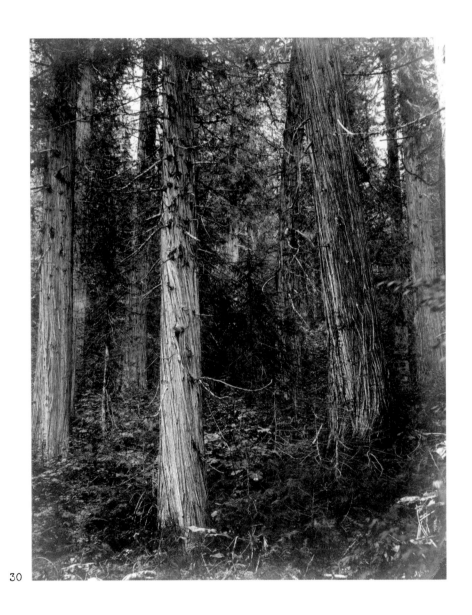

30

29 Aaron Allan Edson, Primeval Forest, 1870s
Despite his appreciation of the Hudson River School and the evocative title of the work, Edson approaches his subject with a far more trenchant naturalistic sensibility than Whittredge or the artists associated with that painting's style. The seemingly arbitrary cropping (the composition is actually carefully balanced by the wedge of the fallen trees and the central white birches) suggests the character of photography and the spontaneity of a watercolour sketch.

30 Benjamin Baltzly, Forest Trees on the North Thompson River, 165 Miles above Kamloops, 1871
See *Cascade on the Hammond (Garnet) River* (cat. 16). The photograph makes a striking comparison with the aesthetic of the preceding Edson.

31 Homer Ransford Watson, A Coming Storm in the Adirondacks, 1879

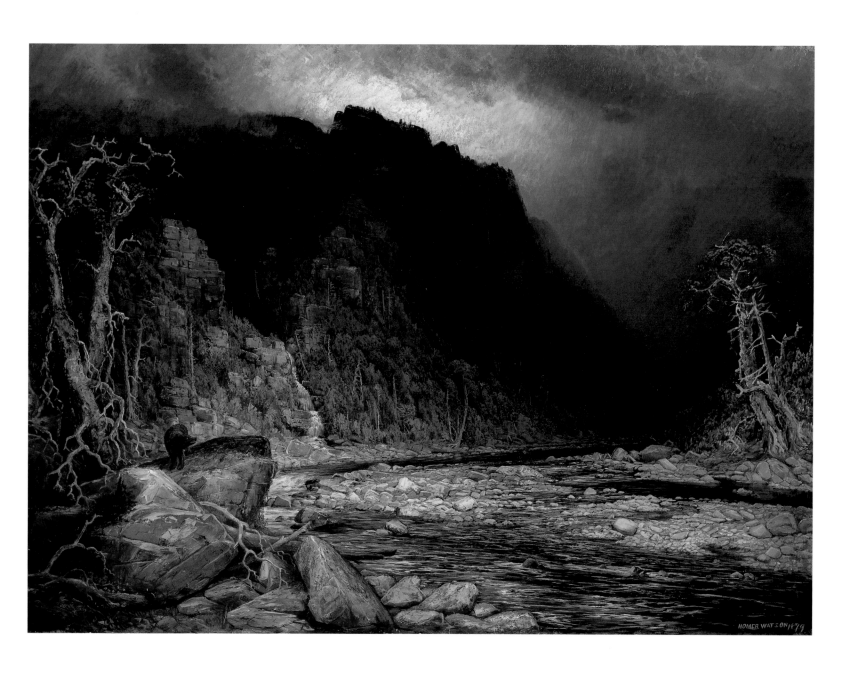

Watson was another artist whose early years were spent working in the photographic studios of William Notman, in this case in Toronto. His training, however, was profoundly enriched by work in the United States between 1876 and 1877, during which he became acquainted with the Hudson River School. Watson also held John Constable's landscape painting in high regard. Thus, it is no surprise that a certain Romanticism suffuses his paintings. *A Coming Storm in the Adirondacks,* one of his first major works, emphasizes the towering majesty of the rocky cliff contrasted with the brilliant white, crowning sky and the deep grey of the engulfing storm. The raw power of the landscape and the isolation of the setting are complemented by the solitary figure of the bear in the foreground.

32 John Frederick Kensett, Lake George, 1869

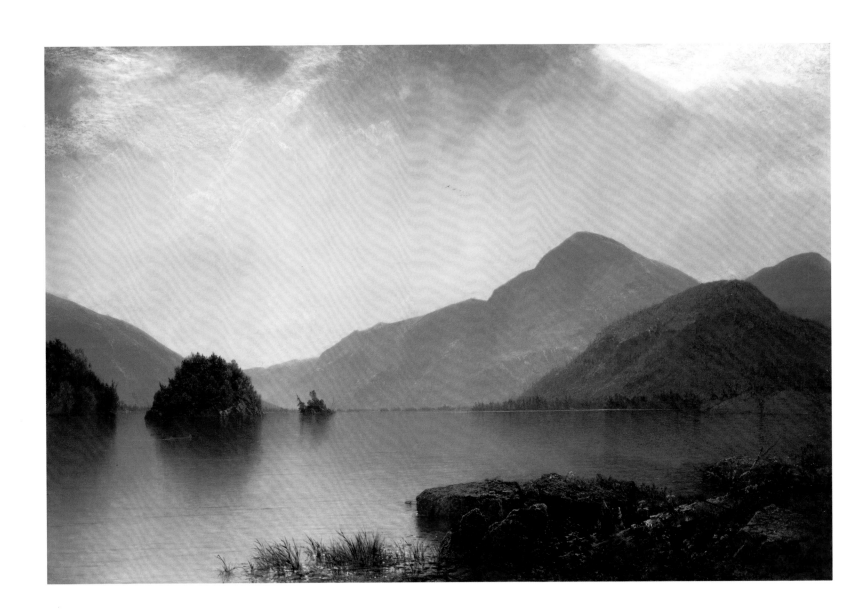

This renowned masterpiece is of an Adirondack subject Kensett returned to on many occasions between about 1850 and 1872. Kensett himself considered the painting particularly important, judging by its size and the price he charged his client. The power of its scale is all the more enhanced by the simplicity of the composition. The setting is the western prospect of Crown Island, with Mount Erebus gently rising in the distance. With neither intricate detailing nor over-arching spiritual ambitions, the picture moderates the aesthetic principles of the Hudson River School and finds parallels with contemporary English landscape painting of the Lake District. The sole human figure is a Native American in a canoe serenely passing the rocky up-cropping at the left—a nostalgic inclusion, since Indigenous populations had long since virtually disappeared from the region. In its restriction of palette, its refined, subtle tonal ranges and its emphasis on palpable, atmospheric lighting, this composition, despite its monumental scale, is fundamentally a private and meditational image.

33 Carleton E. Watkins, Fallen Leaf Lake, Looking South, 1860s
In his views of the West, including Yosemite, dating to the 1860s and 1870s, Watkins endeavoured to present panoramas that evoked virgin Nature, a wilderness with Divine promise ready for human penetration. This photograph is remarkable for its parallels with Luminist aesthetics: its controlled tonal range, the focus upon the effects of light and its reflections, the simple contours of the landscape, the chosen perspective expressing a serene natural order, and the personal apprehension of Nature's transcendent beauty. This approach differed from the more dramatic photographic ambitions commonly evident in the works of Timothy O'Sullivan and William Henry Jackson.

34 William Henry Jackson, The Upper Twin Lake, Sawatch Range, 1873
As part of his exploratory work for the Hayden Geological Survey in July 1873, Jackson and his team travelled to the Arkansas River and the Twin Lakes, with the Colorado Rockies rising in the background, sensitive to both the panoramas and the geological formations. This image was shot on July 26 at an elevation of about 2,800 metres. The site already featured a "house of entertainment," as Jackson described it, and was popular for lake fishing. Typically, the artist included a human figure to set the scale of the landscape and enhance its monumental effect.

35

36

35 Benjamin Baltzly, Selkirk Mountains as Seen from the Top of the Mountains
near the Confluence of the Blue and North Thompson Rivers, 1871
This remarkably atmospheric and evocative image is another one of the photographs taken by the artist in 1871 while working in British Columbia for the Geological Survey of Canada under the supervision of Alfred Selwyn. Baltzly's costs were underwritten by William Notman, who appreciated the commercial possibilities.

36 Charles George Horetzky, Canadian Pacific Railway Survey, Roche à Miette, 1872
Between 1871 and 1881 Horetzky worked as a photographer for the Canadian Pacific Railway Survey, accompanying teams on the northern Rockies route. In 1872, the year of this photograph, he served as guide to Sanford Fleming, who had been hired by the Canadian government to survey for a rail link between the East and Pacific Coast. Fleming played a major role in Canadian history. Not only did he survey and map the West, he also served as an engineer for the Canadian Pacific Railway in its westward program and created universal standard time, crucial for train scheduling. Pictured here is the Athabasca River Valley at the entrance of Jasper Park and the Rockies. A human figure sets the scale.

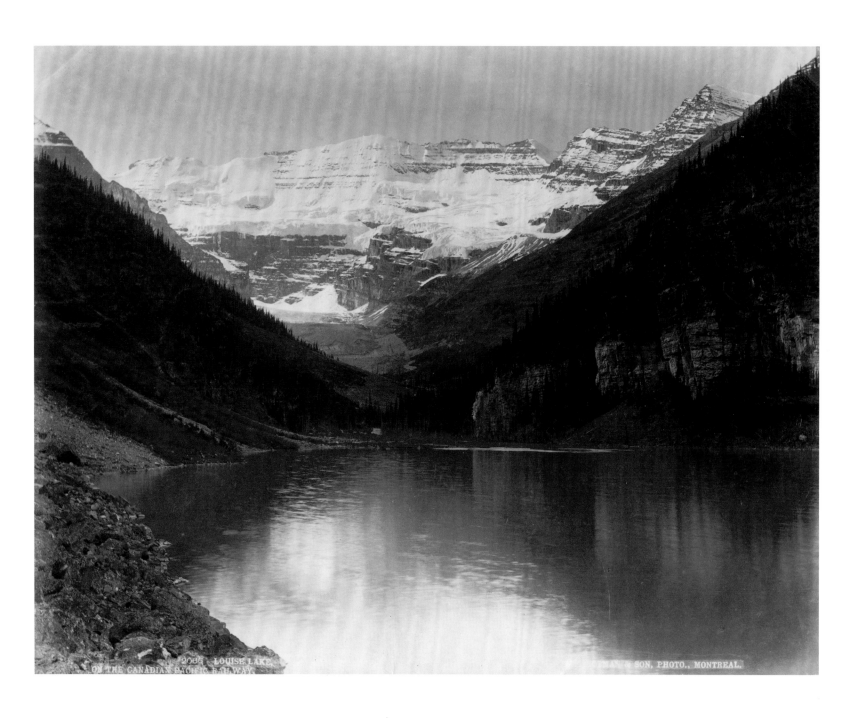

By 1889 the Canadian Pacific Railway was already promoting Lake Louise as a tourist destination. The following year Swiss guides were introduced to encourage upper-class visitors to venture to the Canadian "Alps." Notman worked closely with the Railway in developing markets for his photographic archives.

38 John Arthur Fraser, At the Rogers Pass, Summit of the Selkirk Range, British Columbia, 1886

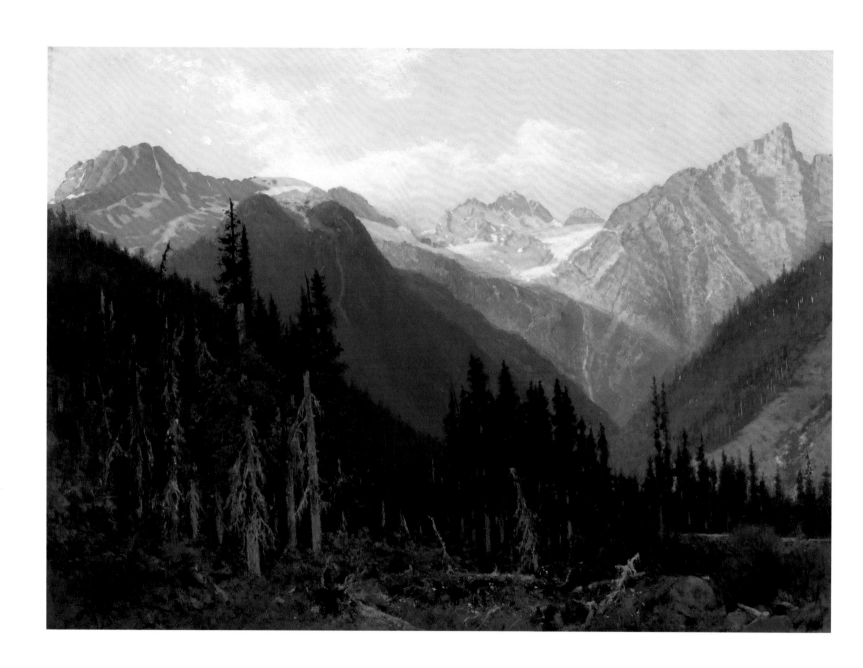

With its crisp outlines in the foreground and generalized details in the middle and distant landscape, Fraser's imposing view of this Rockies panorama is clearly indebted to the images obtained by contemporary photography. Indeed, the treatment of the generalized forms may well reflect his reliance on a specific photograph. Alexander Henderson's photographs, in particular, had previously served the artist as subject and compositional references. *At the Rogers Pass* is one of the few Rocky Mountain oil paintings by the artist (see also cat. 42). The perspective suggests the view a traveller might have from a railcar.

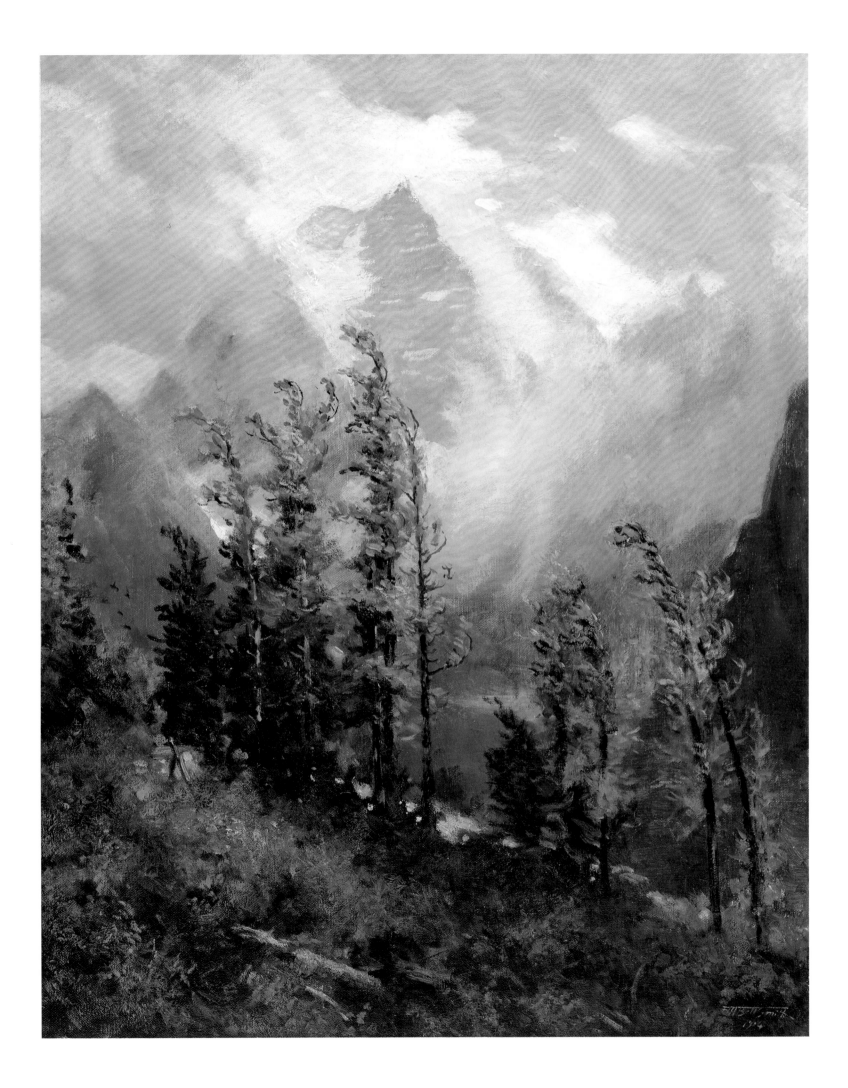

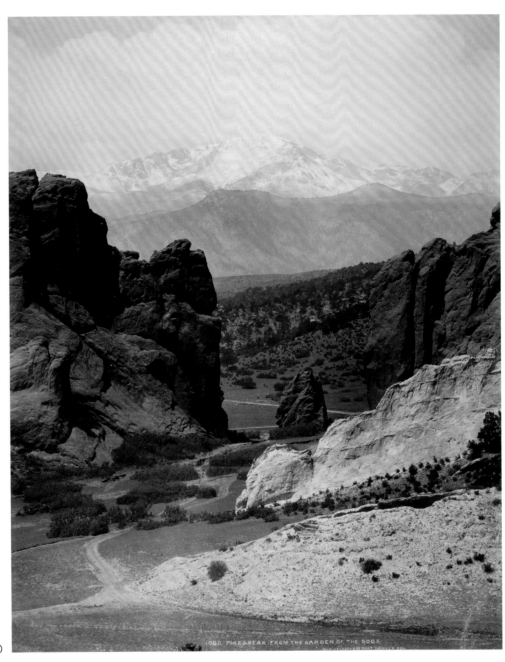

40

OPPOSITE
39 Frederick Marlett Bell-Smith, Coming Storm in the Rockies, 1914
In 1914 Bell-Smith journeyed on the Grand Trunk Pacific Railway to Prince Rupert. Travelling on the northern route through Yellowhead Pass provided him with new, dramatic subjects. During the years leading up to the First World War, the artist often visited the Rockies and the Pacific Coast, producing paintings for which there was a constant demand. Bell-Smith, who had worked as a photographer between 1867 and 1871 as well as an illustrator during the 1870s and 1880s, was particularly appreciated for his views of mountains and glaciers with mists and cloud effects.

40 William Henry Jackson, Pike's Peak from the Garden of the Gods, about 1880

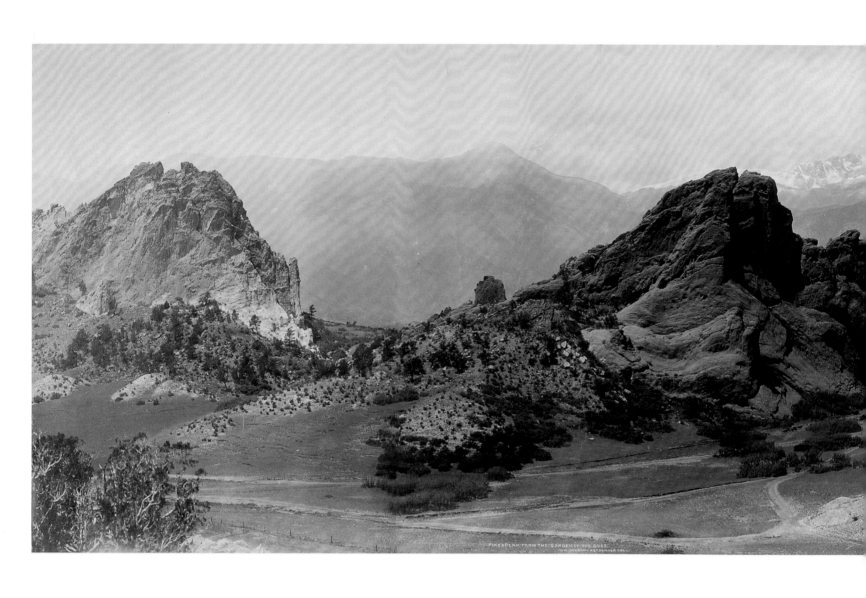

41 William Henry Jackson, Pike's Peak from the Garden of the Gods, 1883

Jackson's 1880s photographs (see also cat. 40) reflect his outreach to a market hungry for large, panoramic images of great American landscapes. Painted cycloramas dated back to 1785 and were used to present such historical events as the Battle of Gettysburg (Paul Philippoteaux's hundred-metre-long, eight-metre-high painting, exhibited in Chicago in 1883,

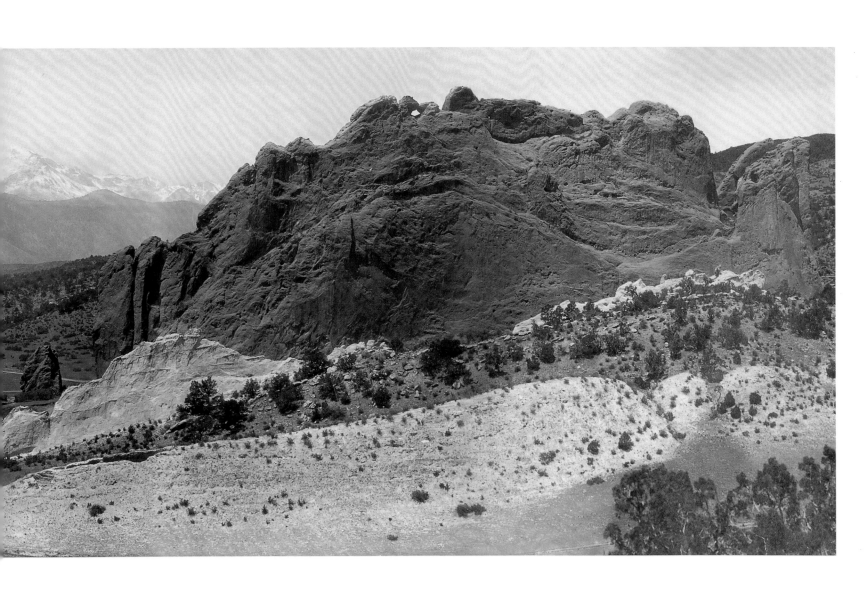

was so popular that a second version was created for Boston in 1884, now at Gettysburg). At the 1893 Chicago World's Fair, Charles Close would mount a monumental 360-degree, electrically driven cyclorama. With the advent of the Cirkut camera at the turn of the twentieth century, a single panoramic view could be captured on one long, continuously exposed large-format film. The Jackson photographs, however, were created through many individual images attached end to end.

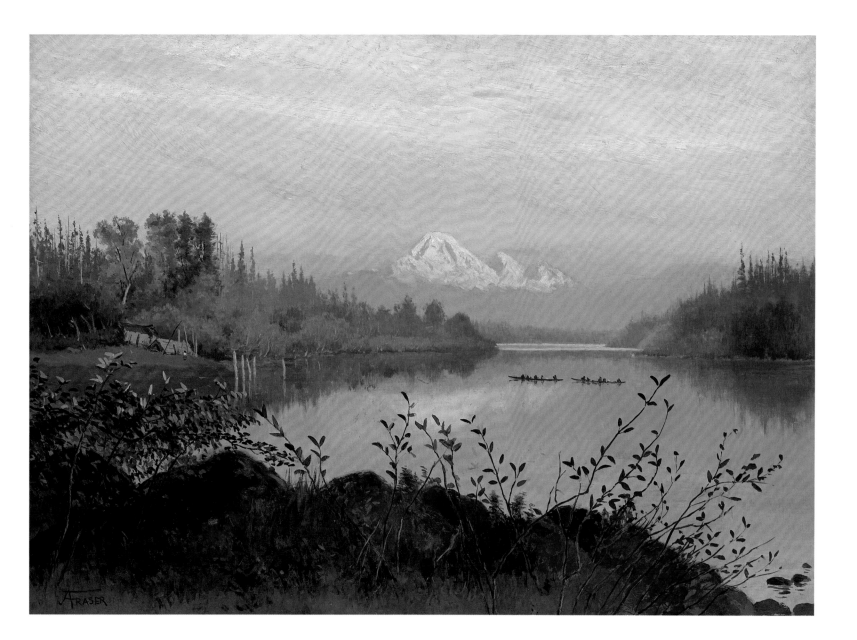

This work is based on a watercolour sketch the artist made during a visit to the site in 1886, sponsored by the Canadian Pacific Railway. The painting is remarkable for its natural yet luminous colourism, which establishes the depth of field, presenting precisely the sort of majestic view that appealed to Sir William Van Horne and the CPR officers. The directness of impression and vibrant tones reflect Fraser's dependence on the sketch and his own memory of the experience, while the seemingly arbitrary cropping at the right and left suggests that he also referred to a photograph.

43 Albert Bierstadt, Passing Storm over the Sierra Nevadas, 1870

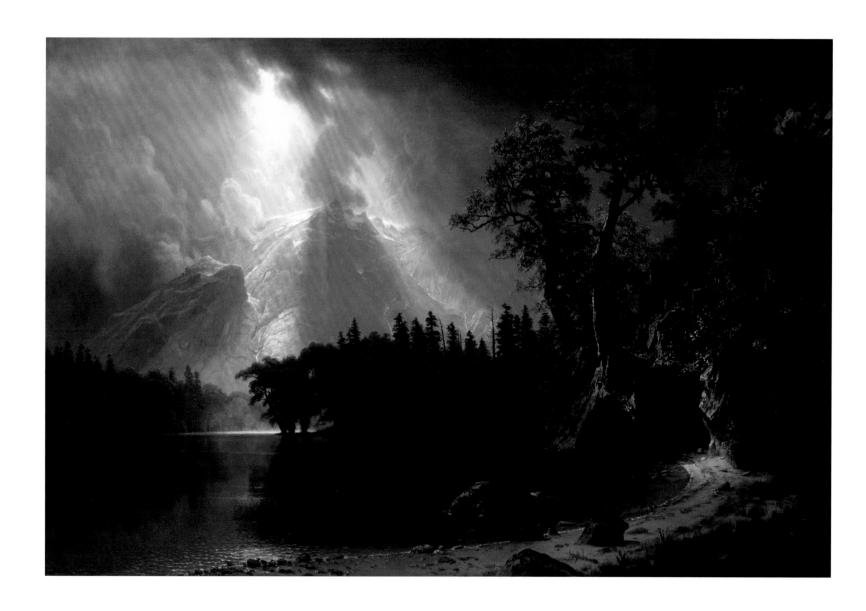

Bierstadt had last visited the West in 1863 and would depart for a two-year sojourn in California in 1871 to revitalize his visual repertoire. Nonetheless this painting from 1870 retains a remarkably vivid character. Fascinatingly, the artist includes no trace of humanity in this vision of virgin Nature, neither Europeans nor Native Americans; indeed, it is pure landscape. The sunlight penetrating through the passing clouds onto the mountain peaks of this sublime American vista clearly conveys the message of Divine promise and benediction upon a great nation in the wake of the horrors of the Civil War. It is noteworthy that Bierstadt's brother, Charles, was a photographic innovator who also travelled West and that Carleton E. Watkins's early photographs of the West, dating from 1861, encouraged the artist to undertake his first trip to California and Yosemite in 1863.

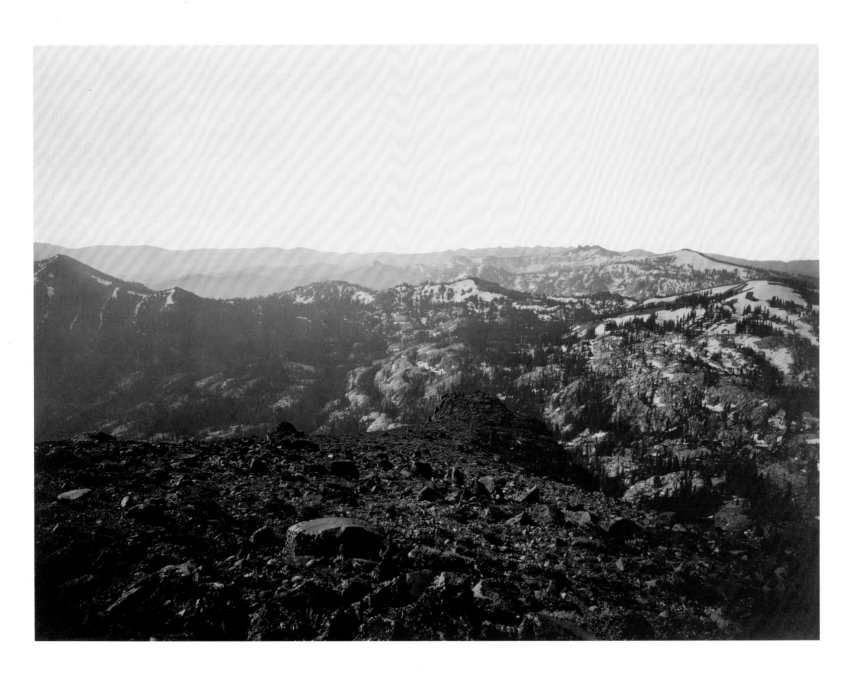

Watkins's photograph of the Sierra Nevada range provides both a sweeping panorama and the geological aspects of the area. In 1879 he was commissioned to photograph Mount Lola and Round Top for George Davidson of the United States Coast and Geodetic Survey.

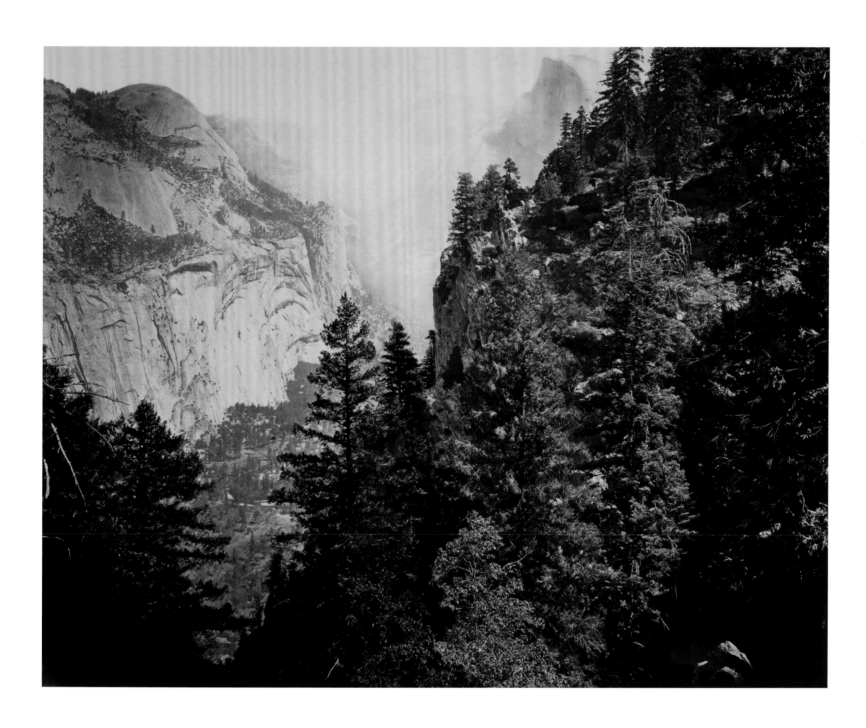

This is one of several views taken by the artist during his 1867 expedition to Yosemite (see cat. 19). The dark forested heights of the foreground set against the sunlit granite cliff of the middleground establish a wedge through which the viewer peers to the distant peak. Meticulously composed, the image seeks to evade the theatricality of Bierstadt's works.

46 John K. Hillers, View up Yosemite, with El Capitan on the Left and the Three Brothers on the Right, about 1891-92

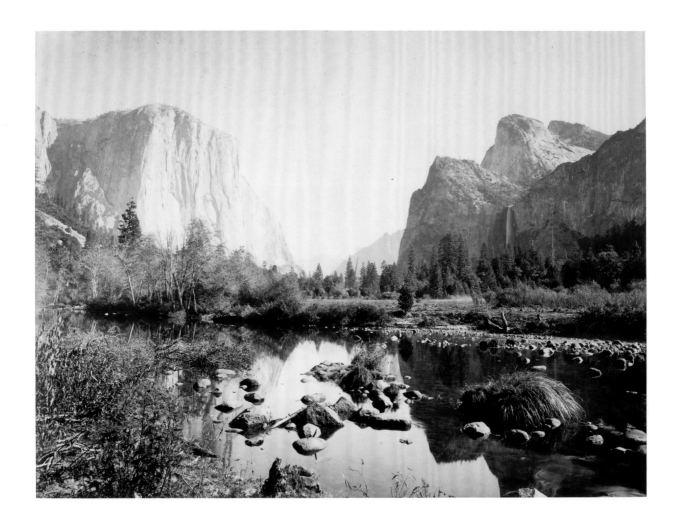

Hillers gained his reputation as a photographer when he joined Major John Wesley Powell's second expedition of the Rocky Mountain range (encompassing northern Arizona and the Grand Canyon, Utah, Colorado and Wyoming) in 1872. Rapidly mastering photographic technique, he became a leading photographer in the federally commissioned Geographical and Geological Survey of the Rocky Mountain Region and succeeding expeditions through 1879. Hillers continued to record sites until 1893, after which, limited by health, he turned to developing his negatives in his studio in Washington, D.C., where he worked for the United States Geological Survey until 1908. This photograph probably dates from his last expedition in the early 1890s.

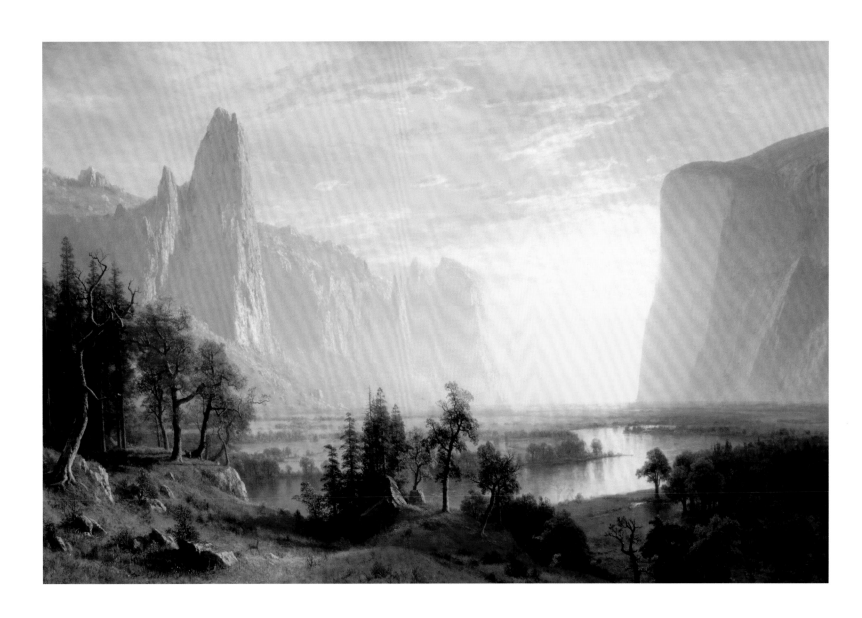

The Yosemite Valley was a subject Bierstadt would repeatedly paint. Impressed with Watkins's photographs of the region, exhibited in New York in 1862, he visited Yosemite for the first time in 1863 and began producing various oils the following year. Initial reaction to his first monumental panorama, executed in 1865, was one of scepticism, as critics questioned the veracity of the composition, accusing the artist of magniloquence and of creating "monstrous stage scenery," and attacked the melodramatic character of the work. Returning to the theme in 1868, the artist's Edenic view of the valley (Bierstadt himself referred to the site, in 1863, as a Garden of Eden), replete with the golden light of the setting sun between the granite cliffs reflected in the Merced River, was probably completed in Rome, together with *Sunset in the Yosemite Valley*, 1868 (now at the Haggin Museum), a dark and dramatically enhanced view which Andrew Wilton has aptly compared to Thomas Cole's *Expulsion from the Garden of Eden* (about 1828) and John Martin's mezzotints. One of Bierstadt's two paintings was exhibited in London and elicited critical wonder over the unimagined, vivid view. Again, no human trespasses into this vision of virgin Nature, both Native American and European presence eliminated in a rhapsodic vision of a primeval splendour.

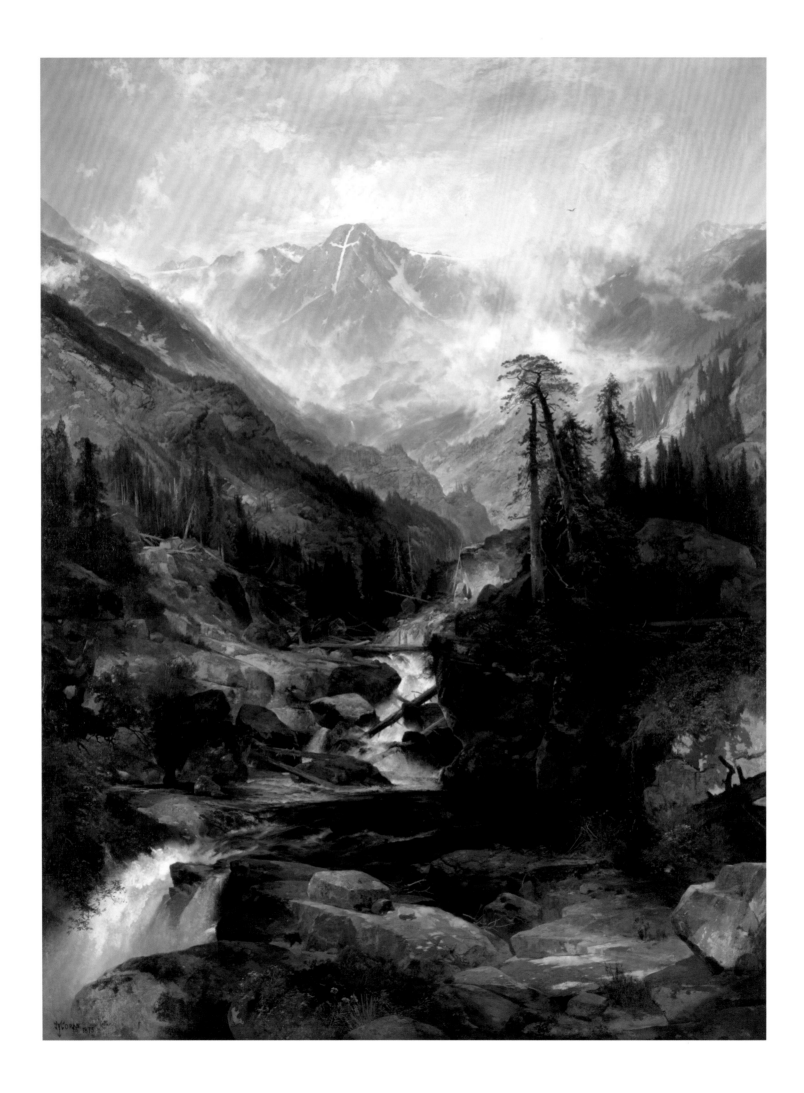

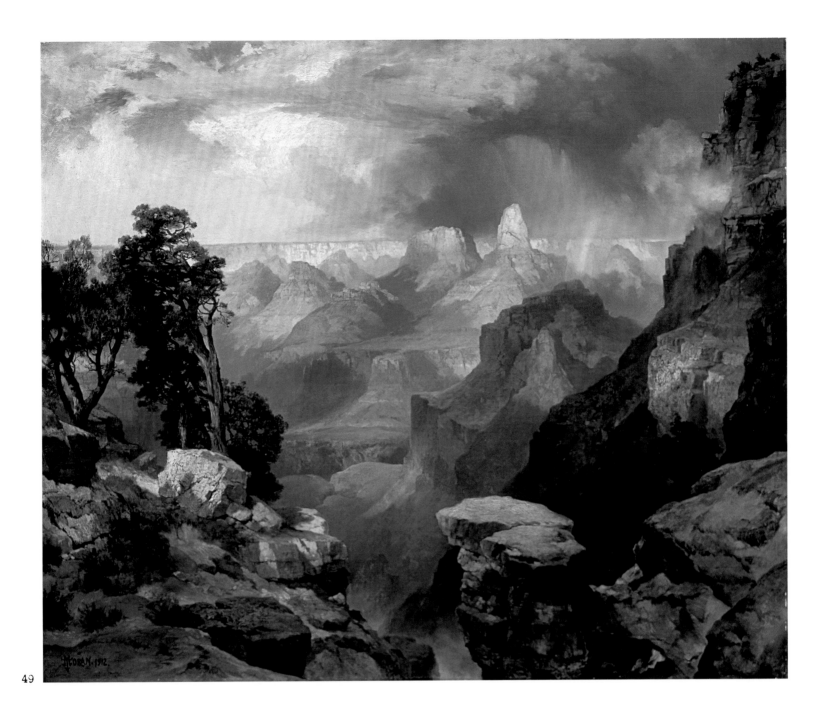

49

49

OPPOSITE
48 Thomas Moran, Mountain of the Holy Cross, 1875

There could hardly be imagined a more consciously inspirational image drawn from Nature than Moran's masterpiece, *Mountain of the Holy Cross*. The actual peak rises over 4,200 metres in central Colorado and exhibits the feature of a Latin cross on its south flank created by two intersecting courses of granite. With a stem over 450 metres long, the cross embodies a snow depth of between fifteen and thirty metres, and is visible throughout the year. The mountain had first been mapped by the Hayden Geological Survey team in 1873. Jackson, a member of that team, captured the formation in eight photographs, aided by proper sunlight and an unusually finely defined snow pack. Moran, however, who accompanied the Survey the following year with the express intent of making a "pilgrimage" to the mountain, was the first to artistically exploit its symbolism. Executing several sketches at the site, he subsequently created through its compositional setting, soaring from a majestic landscape, an emblematic image of human aspiration toward spiritual fulfillment. While the composition guides the eye ever upward toward the peak, a halo-like ring of clouds circles the cross, beckoning at a great distance. The many layers of cross-secting planes, radiant in sunlight against the dark, forested foreground, emphasize the inspiring grandeur of the setting. Like Bierstadt's paintings of Yosemite, *Mountain of the Holy Cross* speaks to the Divine promise and benediction upon the future of a nation so recently and bloodily divided. Since the late nineteenth century, part of the right arm of the cross has eroded.

49 Thomas Moran, Grand Canyon with Rainbow, 1912

Moran's attempts to evoke the experience of the sublime in the landscape of the West are perhaps most famously asserted in his many views of the Grand Canyon. The artist had first visited the site in 1873 with the Powell expedition. The previous year, his images of Yellowstone, together with Hayden's survey reports, had secured Congress's establishment there of the first national park. Moran returned to the theme of the Grand Canyon throughout his career, and some of the resulting works were commissioned by railway companies to promote tourism. The Atchison, Topeka and Santa Fe Railroad Company began using his compositions in their publicity as early as 1877 and paid the artist, along with photographer William Henry Jackson, for a week-long expedition there in 1892. Together with Jackson's photographs, the sketches and watercolours Moran executed during that visit served him in good stead as references for many years. In the masterful depiction of the shifting clouds and interplay of colour and light, intrinsic to the experience of the Canyon, Moran reflects his early and enduring appreciation of William Turner's paintings.

50 Alvin Langdon Coburn, The Amphitheatre, Grand Canyon, 1912

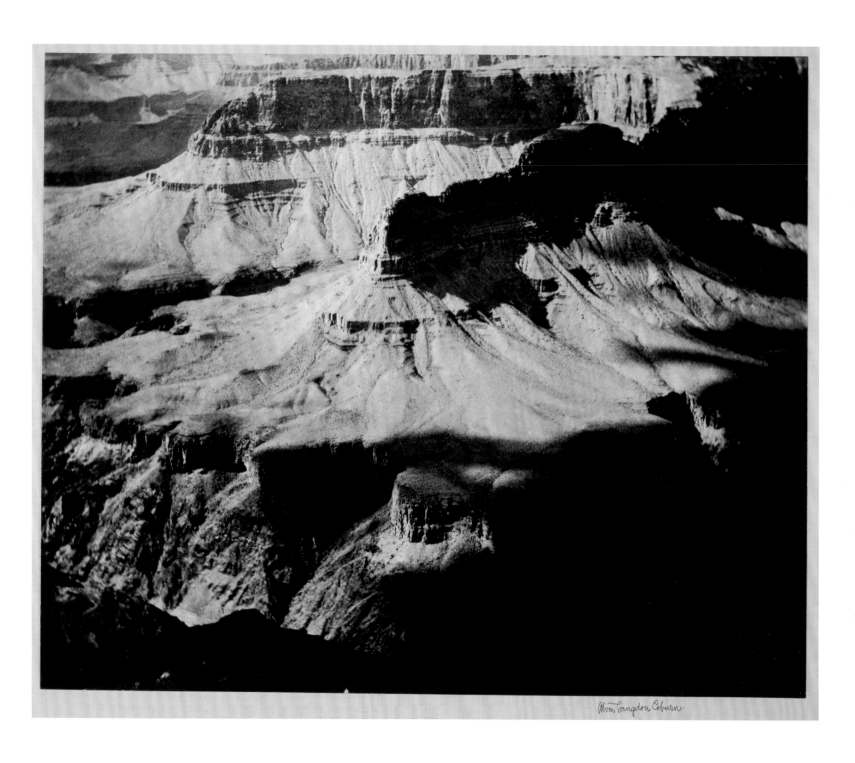

Throughout the first decade of the twentieth century, Coburn had been a close associate of Alfred Stieglitz and a supporter of the Photo-Secessionist movement. In September 1911, he ventured to the Grand Canyon accompanied by a guide and executed photographs from its rims and along the rough trails to its base. Despite the deprivations, he was inspired by what he described as the "isolated and awful grandeur ... under the glory of the stars." This platinum print, in which the tonality of the medium enhances the soaring effect, is a magnificent study of the Canyon in the raking sunlight, creating monumental blocks in a remarkably abstract compositional order.

The Stage of History and the Theatre of Myth

"You people have my lands. Let them send the buffalo back, and take their own people to the reserve where they come from. Give us the prairies again and we won't ask for food. But it is too late. It is too late; it is too late."

Foremost Man,
Cree chief

Looking at Landscape in the Age of Environmentalism

Lynda Jessup

We have known since Ruskin that the appreciation of landscape as an aesthetic object cannot be an occasion for complacency or untroubled contemplation; rather, it must be the focus of historical, political, and (yes) aesthetic alertness to the violence and evil written on the land, projected there by the gazing eye. We have known at least since Turner—perhaps since Milton—that the violence of this evil eye is inextricably connected with imperialism and nationalism. What we know now is that landscape itself is the medium by which this evil is veiled and naturalized.

W. J. T. Mitchell,
Landscape and Power

[Wilderness] is not a pristine sanctuary where the last remnant of an untouched, endangered, but still transcendent nature can for at least a while longer be encountered without the contaminating taint of civilization. Instead, it is a product of that civilization, and could hardly be contaminated by the very stuff of which it is made. Wilderness hides its unnaturalness behind a mask that is all the more beguiling because it seems so natural.

William Cronon,
Uncommon Ground: Toward Reinventing Nature

Writing at almost the same time, but from different disciplinary perspectives, W. J. T. Mitchell and William Cronon effectively complicated our view of landscape—in Cronon's case, of wilderness landscape, specifically—with the realization that it functions in ways that we often choose to ignore. In light of their work, it is now possible to make the seemingly simple observation that landscape is an expression of power, its appearance in paintings working to reproduce the social relations that created it in the first place, making them seem as natural as the landscape to which they give expression. In doing so, we are mindful of Mitchell's insistence that landscape, whether in the world or in paintings, does not merely reflect or symbolize social relations of dominance and subordination; it is a medium of cultural power. As Mitchell puts it, the question is not what landscape *means*, but rather what landscape *does*.[1] This is "the trouble with wilderness," Cronon explains; it does. And in doing what it does—what it has been doing since the late nineteenth century—wilderness actually works against the values of those who seek to both protect and promote it. As "wild" landscape that exists as such only insofar as it remains uninhabited, except perhaps temporarily by those in search of an intimate, semi-spiritual relationship with seemingly undisturbed natural beauty, by definition wilderness mitigates against the development of an ethical, sustainable place for humans in nature, even as current environmental concerns make the necessity of that development apparent.[2]

Those of us who look at landscape for enjoyment, whether in the world or in exhibitions, are thus implicated in the work of wilderness. We are beguiled. In the paintings of Albert Bierstadt (cat. 47), for instance, we look at views of the American West that depict wilderness as sublime, spiritual, or frontier—as a golden landscape bathed in the glow of promise and progress—but we take the wilderness itself as given, or at least most of us do. We do not see these as views of the non-human world *as* wilderness. Instead, we see a landscape of origination, a site of spiritual renewal, a place of pristine beauty and marvellous fecundity. (This is not the desolate wasteland of Old Testament wilderness, to be sure.[3]) We may suspect that what is being represented to us is a projection of these beliefs, values and ideas on the environment, that wilderness is the instrument through which they are made apparent to us, much as they were to audiences in the late nineteenth century. Used to the intimate association of western wilderness with national parks on both sides of the Canada–US border, we may have also become increasingly receptive in recent years to the history of its preservation as a story that involves the removal of Indigenous populations from the land to create this "uninhabited wilderness." Even if we are unaware that Native dispossession was part of the transformation of the wilderness concept that began in North American settler societies in the nineteenth century, it is not difficult for us to understand Cronon's assertion that "the myth of the wilderness as 'virgin,' uninhabited land had always been especially cruel when seen from

the perspective of the Aboriginal people who had once called that land home. Now they were forced to move elsewhere, with the result that tourists could safely enjoy the illusion that they were seeing their nation in its pristine, original state, in the new morning of God's creation."[4]

It is an ambivalence on our part that raises the question: if we still see wilderness as natural, despite our suspicion that it is not, could it be argued that we remain beguiled precisely because we have become satisfied with suspicion alone? Has the critical distance that suspicion registers lulled us into complacent belief that wilderness no longer works as well as it once did—that the hints of tarnish we now see on Bierstadt's bombastic images of western expansion mitigate against the continued effectiveness of wilderness? In other words, does our satisfaction allow us to suspend even our suspicion in untroubled contemplation when the view is a comparatively modest, seemingly innocuous wilderness landscape? We see Canadian artist Henry Sandham's painting *On an Eastern Salmon Stream* (cat. 59), for example, only as a pleasantly constituted scene offering a recuperative experience of nature, or at least most of us do. In relation to Bierstadt's sublime West, a corresponding view of the East as quiet, picturesque wilderness, it is "just a landscape"—what art history terms a "pure landscape"—free of the interpretative possibilities that come with human figures and narrative elements. Faced with what we have come to see as "the pure display of natural forms for their own sake" (as

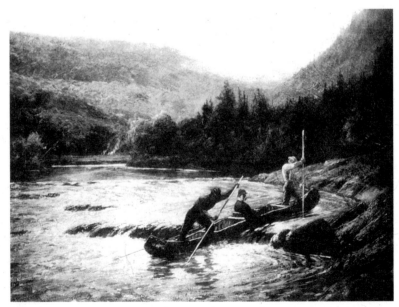

fig. 1

Mitchell puts it), we look in the painting for evidence to the contrary, but we do not see any; it is not there, or so it seems.[5]

But what if this seemingly pure landscape were tainted by interpretative possibilities, as it is in *Canoeing* (fig. 1), a slightly later work dating to Sandham's relocation in New England?[6] A portrait-cum-landscape with an uncanny resemblance to *On an Eastern Salmon Stream*, this second version contains elements that, in this instance at least, we might use to "unmask" the North American wilderness—to expose its unnaturalness. Specifically, it contains reference to the coterie of the urban elite that gave rise to a new moral economy of land use in later nineteenth-century North America, for the figure seated in the canoe between the two guides, physiognomy distinct and in sportsman's fishing gear, is one of the rank of recreational fishermen from central Canada and the northeastern United States who leased salmon rivers in Atlantic Canada for sport fishing.[7] His is the gazing eye through which we see the landscape in *On an Eastern Salmon Stream*, his proprietary presence in *Canoeing* claiming it in both its painted and worldly forms. Coming with the rise of elite male sports culture in the late nineteenth century, specifically, the "sportsman's club movement" that swept northeastern North America beginning in the 1870s, it reproduces this urban elite's aesthetic appropriation of the physical environment as landscape, in this case projected as uninhabited wilderness. Today, as it did then, it visualizes a recuperative environment, an escape from what was perceived to be the enervating effect of modern, urban industrial society.[8]

Of course, *Canoeing* also reveals the irony at the heart of this Romantic vision of nature—of the landscape as wilderness, an entity existing wholly apart from humanity. In reality an artifact of the capitalist conversion of the countryside and the rise of a tourism economy in post-Confederation Atlantic Canada, this wilderness "on an eastern salmon stream" was uninhabited only in the eyes of the tourist, in this case the sportsman at the centre of the picture. Best described perhaps as wilderness nostalgia, this sentiment was most pronounced among more educated and affluent urbanites—especially white male elites, whose very manliness was thought to be particularly afflicted by the ills and artificiality of modern life. Like other forms of antimodernism in this period, it embodied what T. J. Jackson Lears has described as a "recoil from an 'overcivilized' modern existence to more intense forms of physical and spiritual existence," giving expression to a perceived lack in the present that coexisted at this time with an enthusiasm for science, modernization and material progress. In effect a critique of the modern, such antimodernist nostalgia represented an attempt to come to terms with modernity, not by its wholesale rejection, but by its moderation through the inclusion of pre-modern physical and psychological zones of retreat.[9]

Recreational field sports facilitated this by combining Romantic ideas of nature as an entity wholly independent of human institutions, not only uninhabited, but also inherently stable, self-regulating and predictable—a place of cycles and "rhythms"—with nostalgic desire for what became, as a result of immersion in these rhythms, an authentic, "natural" existence. Advanced by the sportsman's club movement, the concept of hunting and fishing in North America was thus transformed into a dominant pursuit of the elite, the movement organizing its practitioners into private clubs for the pursuit of sport and for the "preservation"—later, the "conservation"—of game, which they saw as threatened by the same urban-industrial capitalism that compelled their periodic retreat to wilderness.[10] As historian Karl Jacoby points out, the wilderness idea fishermen advanced was central to the degradation discourse that would inform conservationist narratives about environmental change into this century, the concept of nature as an independent, self-perpetuating entity giving rise to the attendant belief that environmental decline was almost exclusively the result of human intrusion. (The cultivated, aestheticized activity of the fly fisherman aside.) It was this perceived relationship between nature and human activity that justified the sporting fraternity's dismissal of local-use rights to the environment, following what fly fishermen consistently portrayed as the reckless environmental practices of Native peoples and other local populations.[11]

In Canada, as in the United States and elsewhere, the removal of Indigenous rights to the animal world through the introduction of policies and laws restricting hunting and fishing technologies and access went hand in hand with this aesthetic appropriation of the environment as landscape. On an instrumental level, it was the effect of a program of natural resource management developed and enforced by the federal fisheries department in the decades after Confederation in 1867, when the Canadian government, building on two decades of colonial legislation, passed its first fisheries act. And that program was deeply influenced by the new ideology of conservation espoused by recreational fishermen, who not only actively pursued laws prohibiting spearing and other Native harvesting methods, but also reinforced their position of privilege among resource users by supporting the rehabilitation of salmon rivers and paying for the surveillance and prosecution of the "poachers" newly constituted by federal fisheries regulations.[12] Part of a larger process of Native dispossession of the environment that came with the rise of the modern administrative state and included contemporary efforts by the federal Department of Indian Affairs to promote agricultural settlement among Indigenous populations in the area. This both forced and facilitated the entry of Aboriginal men into a new, wage-based economy as fishing guides, effecting what has been described as the "transformation of Native people from active resource users to cultural commodities—there to enhance the wilderness experiences of the fly fishermen."[13]

Sandham's paintings are documents of this elite discourse about conservation, *Canoeing*, in particular, recording the entry of Mi'kmaq men into the new economy as wage labourers. They pole the fisherman upstream, their faces obscured in keeping with the subordinate role assigned them in both the painting and the new landscape vision it reproduced. The untamed masculinity Victorians attributed to those they identified as primitive men made such guides an attractive, ultimately authenticating, aspect of the wilderness experience through which sportsmen sought to revitalize their manhood. As contemporary guide books and sporting narratives attest, it was even possible within this way of thinking to glorify the masculine vitality of Native guides; at the same time, Gail Bederman reminds us, they were seen as lacking the racial ability to advance civilization, fettered by the Victorian belief that so-called primitive men were biologically incapable of cultivating, at least without ongoing tutelage, the moral attributes Victorians most admired in a man, or, to be more precise, in the most civilized of men. Instead, Native men were constituted as lacking the self-restraint identified with hegemonic ideals of manliness and, increasingly, with state regulation of the fishery, of natural resource use.[14] It is in this context that the Native encampment in *On an Eastern Salmon Stream* reproduces this new idea of wilderness, its location at a compositional nodal point catering to contemporary interest among fishing tourists in "Indianness." In other words, the presence of the encampment also masks what was in reality the increasingly restricted Aboriginal land use effected by the capitalist conversion of the countryside. It makes reference instead to what was in effect the performance and commoditization of Native ethnicity in this newly created wilderness.

On a theoretical level, this new vision of a "rational, state-managed landscape"[15] helped to establish the environment as a tourist space, which as a product of the differentiation of modernity—of dividing society into distinct areas of social activity—was being constituted as wilderness that now required management. Subsequently mythologized as an effort on the part of the emergent conservation movement to introduce order to an unstructured, chaotic situation, in reality such legislation effected the replacement of the local rules and informal customs used to manage the environment—the moral ecology of the place—with a formal set of laws, created and administered by the newly constituted state.[16] In other words, as the code of the sportsman became the basis for laws that reinforced the moral position of the sporting constituency, the state privileged a Romantic vision of nature and a recreational concept of land use that facilitated the production of tourist spaces as part of the process of commoditization that marked the extension of the general principle of capitalism into the realm of modern social life. In this sense, the "preservation" of wilderness was not confined to the establishment of national parks in the West; growing from the same conceptual premise as tourism, "conservation" was a transcontinental phenomenon. (And Bierstadt's operatic canvases should be identified with what was actually a culminating moment in the movement both geographically and conceptually, not its beginnings.) Like the creation of national parks to the west, natural resource legislation spawned by

the conservation movement in the east set about the separation of humans from the natural world, both physically and conceptually, rendering each subject at the local level to control by an alien elite.[17]

For this reason it can be argued that, in picturing Atlantic Canada as the recreational landscape of these elite tourists, contemporary paintings of the region are also documents of violence written on the land, "projected there by the gazing eye." Put another way, if it can be said that the history of conservation often evidences the pursuit of environmental quality at the expense of social justice (as Jacoby has noted), then it can also be said that *On an Eastern Salmon Stream* is an artifact of that pursuit.[18] The social power it works to naturalize was part of the aesthetic appropriation of land that came with the emergence of the elite "conservation movement" on both sides of the Canada–US border in the late nineteenth century. Now it also works to reproduce the dominance this landscape ideology achieved with the rise of middle-class tourism in the twentieth century and, with it, the legislative production of wilderness for increasing numbers of urban-based tourists. It is not "just a landscape" after all; working as wilderness, as it has since the nineteenth century, it advances nature as a world apart from humanity, promoting a premise now in question in an age of environmentalism. For this reason, it could also be said that it works at the expense of environmental justice as well.

So how do we look at wilderness in an age of environmentalism? Is it possible to reinstate the readability

of this landscape, to see in it the environment *as* wilderness? It would be difficult. That wilderness which still seems "so natural" to our eyes—there is seemingly no evidence to the contrary in the paintings at which we look—suggests that the gazing eye from which we seek liberation is our own. To see otherwise, we would need to situate ourselves as viewers in a different historical relationship to this landscape. Just as we now read one landscape in relation to the next, reinforcing and reproducing the seeming naturalness of each, we would need to reread a landscape such as *On an Eastern Salmon Stream* against other experiences of the environment, and, in the process, denaturalize what is still, for the majority of us, the landscape ideology of which it is an expression.

But perhaps we could. Perhaps we could reread landscapes such as this with an eye to historical production by Aboriginal peoples. In the case of *On an Eastern Salmon Stream*, for example, pieces of late-nineteenth-century Mi'kmaq tourist or souvenir art, in giving expression to animist beliefs, speak in contrast of Aboriginal traditions of land use and another relationship with the environment. Or perhaps we could free ourselves from our historically constituted subjectivity by looking through the lens offered by contemporary art—by a work such as Yinka Shonibare's *Mr. and Mrs. Andrews without Their Heads* (fig. 2). A piece such as this makes it difficult to read Gainsborough's famous portrait/landscape (fig. 3) with the complacency with which we might otherwise approach it; we are alerted to the presence of the gazing

eye, and of the inextricable link that nationalism and imperialism have with the violence it projects—much as we are when we sense the presence of the *Canoeing* fisherman in *On an Eastern Salmon Stream*. It would take some work, of course. But then, remaining alert, as Mitchell implies, requires some effort—at least more than that demanded of complacency or untroubled contemplation.

fig. 2 Yinka Shonibare, *Mr. and Mrs. Andrews without Their Heads*, 1998 (detail) **fig.** 3 Thomas Gainsborough, *Mr. and Mrs. Andrews*, about 1750

fig. 2

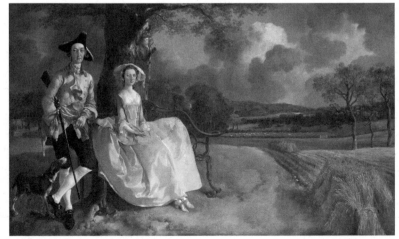

fig. 3

** * * *

1 W. J. T. Mitchell, "Introduction," in *Landscape and Power*, W. J. T. Mitchell, ed. (Chicago: University of Chicago Press, 1994), 1–4.

2 William Cronon, "The Trouble with Wilderness; or, Getting Back to the Wrong Nature," in *Uncommon Ground: Toward Reinventing Nature*, William Cronon, ed. (New York: W. W. Norton and Co., 1995), 69–90, 479–481.

3 For the biblical conceptualization of wilderness see Cronon, 70–71.

4 Ibid., 79; Mark David Spence, *Dispossessing the Wilderness: Indian Removal and the Making of the National Parks* (New York: Oxford University Press, 1999). The record of similar dispossession in Canada is contained in the Annual Reports of the Department of the Interior and, beginning in 1880, the Department of Indian Affairs.

5 W. J. T. Mitchell, "Gombrich and the Rise of Landscape," in *The Consumption of Culture 1600–1800: Image, Object, Text*, Ann Bermingham and John Brewer, eds. (London: Routledge, 1995), 104.

6 The work was reproduced in an account of the artist's career in Frank T. Robinson, *Living New England Artists* (Boston: Samuel E. Cassino, 1888), opp. p. 49, before it disappeared. Sandham's inclusion in the volume speaks to his adoption as an American artist following his move from Montreal to Boston in 1880.

7 A list of Sandham's "most important works," which he prepared for inclusion in Robinson's *Living New England Artists*, contains a number of paintings of recreational fishing owned by anglers from central Canada and the northeastern United States, among them portraits in wilderness settings. See Robinson, 151. Titled, like *Canoeing*, with reference to fishing rather than to the sitter,

is a large watercolour by Sandham, *Fishing Camp, Restigouche* (70 x 50 cm), a portrait in a landscape that was owned by C. F. Lawrence, of New York, who was a founding member of Restigouche Salmon Club. Lawrence's watercolour is now in a private collection in Toronto.

8 These ideas are developed at length in my essay "Landscapes of Sport, Landscapes of Exclusion: The 'Sportsman's Paradise' in Late-Nineteenth-Century Canadian Painting," *Journal of Canadian Studies* 40, no. 1 (Winter 2005–2006), 71–123. Full bibliographic references are given.

9 T. J. Jackson Lears, *No Place of Grace: Antimodernism and the Transformation of American Culture, 1880–1920* (New York: Pantheon, 1981), xv; Gail Bederman, *Manliness and Civilization: A Cultural History of Gender and Race in the United States, 1880–1917* (Chicago: University of Chicago Press, 1995), 10–23, 73–74.

10 John MacKenzie, *The Empire of Nature: Hunting, Conservation, and British Imperialism* (Manchester: Manchester University Press, 1988), 22–23. The sportsmen's club movement is dealt with in John F. Reiger, *American Sportsmen and the Origins of Conservation* (New York: Winchester Press, 1975). For discussion of the activities of fishing tourists in Atlantic Canada see Bill Parenteau, "'Care, Control and Supervision': Native People in the Canadian Atlantic Salmon Fishery, 1867–1900," *The Canadian Historical Review* 79, no. 1 (March 1998), 1–35.

11 Karl Jacoby, *Crimes against Nature: Squatters, Poachers, Thieves, and the Hidden History of American Conservation* (Berkeley: University of California Press, 2001), 2–3, 195–197. Although Jacoby's study deals with environmental history in the United States, his observations concerning the

relationship of tourism and conservation in the northeastern United States in the late nineteenth century are applicable to eastern Canada during the same period. For discussion of the "discourse of degradation" see also William M. Adams, "Nature and the Colonial Mind," in *Decolonizing Nature: Strategies for Conservation in a Post-colonial Era*, William M. Adams and Martin Mulligan, eds. (London: Earthscan Publications), 29–33.

12 Parenteau, "'Care, Control and Supervision'" and "A 'Very Determined Opposition to the Law': Conservation, Angling Leases, and Social Conflict in the Canadian Atlantic Salmon Fishery, 1867–1914," *Environmental History* 9, no. 3 (July 2004), 436–463.

13 Parenteau, "'Care, Control and Supervision,'" 3.

14 Bederman, 20–31; Parenteau, "'Care, Control and Supervision,'" 22–34; Patricia Jasen, *Wild Things: Nature, Culture, and Tourism in Ontario, 1790–1914* (Toronto: University of Toronto Press, 1995), 133–149.

15 Jacoby, 2.

16 Kevin Meethan, *Tourism in Global Society: Place, Culture, Consumption* (New York: Palgrave, 2001), 6–13; Jacoby, 195.

17 Jacoby, 2–3, 195–197; Parenteau, "'Care, Control and Supervision'" and "A 'Very Determined Opposition to the Law.'"

18 Jacoby, 198.

Richard
Hill

Too Silent to be Real

There was a time in this fair land when the railroad did not run,
When the wild majestic mountains stood alone against the sun,
Long before the white man and long before the wheel,
When the green dark forest was too silent to be real

Gordon Lightfoot, 1967

The Thunderers are kept busy with watching over us. The coming of wind and the approach of clouds are sure
signs of an immediate presence of the Thunder manitous. They grow angry at the sight of wrong done to us.
With great effort they restrain themselves when they behold the people driven to an extremity, when they behold
the people enduring wrongs beyond all endurance. Naturally there must be an end of this thing; it will be on a
day yet to come. The Thunder manitous will no longer withhold their patience. In that day they will crack open
this earth and blow it to pieces. Where the white man will be hurled, no one knows, and no one cares. After
this, the manitou will then create this world anew, and put the people back into it to live again.

An anonymous Meskwaki, 1911

I have begun with two quotations. In each, the speaker undertakes an act of imaginary genocide, ridding North America of an Other that stands in the way of a vision of his people's destiny. I want to remain faithful to this antagonism and its sources in real acts of colonial aggression toward Indigenous peoples, while at the same time drawing out the extent to which each imagined genocide remains haunted by its Other. The ambition is not to lay these ghosts to rest, but to draw them out, to get them talking, perhaps even tossing the furniture around the room, the way angry ghosts do. By "room" I of course mean the national narratives of Canada and the United States. The aim is not for a dialectical reconciliation of "opposite" cultural positions, but a further breaking down of the colonial categories that still encompass us.

The repressed ghosts at the heart of Gordon Lightfoot's ballad "Canadian Railroad Trilogy" allude to the idea of Indigenous people occupying as full human beings the territory that is now Canada. They are ghosts lost in the *idea* of wilderness. Lightfoot wrote his ballad at one peak of Canada's ongoing nation-building exercise, looking back to celebrate the union of Canada through the creation of the transcontinental railroad. Notice the complex way in which the lyrics both imply and deny an Indigenous presence. This romantic, primal wilderness existed "long before the white man," but not, we assume, before the figure to whom the "white man" is inevitably linked through the convenient device of chromatic contrast—the "red man." So we have the ghost of the "Indian," his quasi-presence. But this quasi-presence is bracketed

by two denials. The mountains stand "alone against the sun" and the "dark forest" is "too silent to be real." The logic is relentless: if the forest is silent it must be because the "Indian" is silent and that which is so profoundly silent cannot, we are told, be real. So we are left with a terrible ontological status—not merely an absence, but a spectral unreality or un-death. The intellectual tradition that makes this disavowal possible is the longstanding conflation of the "Indian" with nature. In 1609, for instance, Colonel Robert Johnson wrote in his *Nova Britannia* that Virginia was "inhabited with wild and savage people, that live and lie up and downe in troupes, like heards of Deare in a Forrest."[1] But why not read that line—"too silent to be real"—against the grain? Why not say to ourselves that it is *Lightfoot's* silence that is unreal? Some better listening is in order.

At the same time that Lightfoot was clearing the wilderness of "Indians" on behalf of Canadian national identity, the work of the Group of Seven was being actively revived for the same ends. The selling of the Group *to* Canada *as* Canada occurred with the desperate ideological energy reserved for particularly unconvincing doctrines. Providing Canada, a territory of many nationalities, ethnicities and regional ambitions, with a single identity rooted in an encounter with the wilderness is certainly an ambitious and, in retrospect, ridiculous, task.[2] The United States assembled an even more ambitiously fraudulent set of national narratives to buttress its triumphal expansion in the mid-nineteenth century and artists in that country participated in similar acts of imagined

ethnic cleansing. To give just one example, a pamphlet advertising Albert Bierstadt's *The Rocky Mountains, Lander's Peak*, 1863 (not reproduced), which includes an "Indian" village in the middleground, enthuses, "Upon that very plain where an Indian village stands, a city, populated by our descendants, may rise, and in its art galleries this picture may eventually find a resting place."[3]

The Cherokee artist Jimmie Durham (b. 1940) has summarized the set of narratives that the United States employs to manage its contradictions: "The Master Narrative of the US proclaims that there were no 'Indians' in the country, simply wilderness. Then, that the 'Indians' were savages *in need of* the US. Then, that the 'Indians' all died, unfortunately. Then, that 'Indians' today are (a) basically happy with the situation, and (b) not the real 'Indians.'"[4]

I would add another narrative to Durham's list, one that is especially prevalent in Canada. At the same time that many Canadians remain eager to offer their solutions to the "Indian problem," many are also quick, almost proud, to confess their lack of knowledge about specific aspects of Indigenous history or culture. This wilful, culture-wide lacuna, this "sanctioned ignorance," to use Gayatri Spivak's phrase,[5] is another way Indigenous peoples are reduced to spectral un-personhood. Some horizons are certainly in need of expansion.

The first task is to demonstrate the extent to which the North America encountered by Europeans was not any empty wilderness. I want to do this not with population statistics, but by giving a sense of how

territory was conceptually occupied, how space was filled by the imagination as all human spaces are. For the sake of brevity and specificity I will look at the Great Lakes region, further sharpening focus by keeping primarily to the linked cosmologies of various nations who speak related languages and call themselves Anishinabeg (or Anishinabe in the singular).[6] The Anishinabeg are comprised of groups known most commonly as Menominee, Odawa, Ojibwa, Oji-Cree, Chippewa, Saulteaux and Potawatomi. Those familiar with belief systems deriving from one or two canonical texts may benefit from being reminded of the lack of dogma in traditional Anishinabe thought and the diversity to be found in narratives from place to place. That said, there are enough core similarities that careful generalizations will not do violence to particularity, especially if the reader remains attentive to the cultural source of specific references.

The difficulty in conveying the peopled nature of the Anishinabe territories is not the lack but the over-abundance of evidence. In the traditional Anishinabe worldview the land was complexly and thoroughly peopled, from sky to underworld. Anishinabe languages reflect a fundamentally different sense of the ontological status of human beings and the "things" that make up the world. Nouns are modified not according to gender, as in Romance languages such as French, but according to the referent's status as animate or inanimate.[7] To complicate things further, the types of objects that can be encompassed by these two concepts of animate and inanimate might not be obvious to someone from outside the culture. In some Anishinabe dialects, stones are animate.[8] Just as significantly, the term "people" itself is not reserved for human beings. Along with the human people, there are also the bear people, the elk people and so forth. The sun and the moon are also people and even trees and shells can fall into this category. Spirit beings, the *manitouk* (or *manitou* in the singular) are also persons.[9] A. Irving Hallowell noted that for the Anishinabeg along the Berens River in Manitoba, each of the four cardinal winds is also a person and their personhood is so particular that no word has been developed to refer to wind in general.[10] Many of these people are spoken of as familial relations: "Our brother the bear, our grandfather the Thunder." Where a European painter may have seen an empty wilderness landscape, a traditional Anishinabe artist would have seen a space peopled with relatives. Likewise, one's relationship to the land is not one in which a human agent extracts and manipulates inanimate "natural resources," but a social relationship between human and non-human people.

Perhaps the most concise visual models of the Anishinabe cosmos are the hand-twined bags with sky and underworld imagery that were made around the Great Lakes and Eastern Plains until the nineteenth century. Finger woven from plant fibres, animal hair and eventually trade wool and cotton, these bags often have one side devoted to depictions of *animikeek* (*animiki* in the singular), or thunder-birds (fig. 1, 2), the most powerful *manitouk* of the sky world. On the other side are representations of Mishepeshu, or Great Lynx, the most powerful *manitouk* of the underworld, which appear on the bags in feline form (fig. 3), although they are known to have a serpent aspect as well. The *animikeek* and Mishepeshu are antagonistic and one of the roles of the *animikeek* is to keep the underworld *manitouk*, who live in lakes and underwater caverns,[11] off of the world's surface.

Peter Jones, a nineteenth-century Mississauga Anishinabe who converted to Christianity and became a Methodist minister, wrote (disapprovingly) of ideas about the *animikeek* that he encountered as a boy:

```
They consider the thunder to be a
god in the shape of a large eagle,
that feeds on serpents, which it
takes from under the earth and
the trunks of hollow trees. When
a thunderbolt strikes a tree or
the ground, they fancy that the
thunder has shot his fiery arrow at
a serpent and caught it away in the
twinkling of an eye … They believe
that the thunder has its abode on
the top of a high mountain in the
west, where it lays its eggs and
hatches its young, like an eagle,
and whence it takes its flight into
different parts of the earth in
search of serpents.[12]
```

fig. 1 Eastern Ojibwa, *Animiki Pouch*, 1800–1809

fig. 1

Jones goes on to tell a story of a human visitor to an *animikeek* nest who witnessed signs of predation upon the Mishepeshu. Scattered about were "bones of serpents, on the flesh of which the old thunders had been feeding their young; and the bark of the young cedar trees pealed and stripped, on which the young thunders had been trying their skill in shooting their arrows before going abroad to hunt serpents."[13]

Artworks bearing images of the *animikeek* invariably have a public aspect, with iconic features identifiable by anyone with even a passing knowledge of the culture, and a private aspect, with specific design features bearing symbolic meanings known only to the image's owner. The hourglass shape that composes the core element of the *animikeek*'s design would be recognizable, even in abstract form, to traditional Anishinabeg in the same way the abstract shape of a cross is to Christians. Because a human relationship to the *animikeek*, or a particular *animiki*, is personal and derived from visions and dreams, no two images of them seem to be exactly alike (until they become a decorative motif for sale).

The Mishepeshu are less straightforwardly benign beings. In some communities I have visited, these *manitouk* are discussed as the evil opposite of the *animikeek* and several scholars have followed this lead.[14] Ruth Phillips argues that this dualism may have been imported from Christianity, where the underworld is the realm of the devil.[15] I have spoken to a number of Anishinabeg who agree, including the late Rodney Bobiwash, an Anishinabe scholar and activist. For Bobiwash and others, Mishepeshu are certainly potentially dangerous—one of their iconic features is a long tail they can thrash in the water to make waves and whirlpools, and one ought not to speak their name aloud until winter when ice covers the lakes—but they can also provide great boons for the right human people. Bobiwash also told of hearing that a Mishepeshu once lived in Toronto harbour but eventually left in disgust at the pollution.

The hand-twined bags function as a model of the cosmos not only because they feature images of the sky world and underworld on opposite sides, but also because within their centre are held the medicines that we occupants of the middle world need in order to maintain our relationships with these powerful *manitouk*.[16] On many bags, strong vertical borders reinforce the separation of the *animiki* and Mishepeshu. Often these borders are the only place on the bag in which coloured twine is used, giving the separation additional emphasis. The distinction between the two classes of *manitouk* is also expressed through opposition in the presentation of their basic forms.[17] The *animikeek* are always presented with their bodies viewed frontally and their heads in profile. In contrast, the lozenge-shaped bodies of the Mishepeshu are typically presented in profile with their heads turned frontally toward the viewer. The direct gaze of the Mishepeshu toward the viewer may be an indication of the potentially frightening aspect of its power.

Ironically, a number of painters depicted images of "vanishing Indians" threatened by approaching thunderstorms as metaphor for the coming onslaught of the settler colonists. This romanticism helped to naturalize what was ultimately a political process. In *Indian Encampment on Lake Huron*, about 1845 (not reproduced), Paul Kane depicts a group of Anishinabeg in just such a predicament. Knowing that the people Kane depicted viewed the Thunders as their protectors sets up a subversive dissonance in our reading of such images.

On that note, I would now like to return to the second passage I quoted at the beginning of this essay.[18] The ghost at the heart of it is harder to locate, but for now we can call him Kent Monkman. Monkman is an artist of Cree heritage whose paintings raise questions that might haunt the anonymous Meskwaki speaker. I confess at the outset that I am more sympathetic to this statement than I am to Lightfoot's lyrics. It was made in self-defence and identified genuine wrongs that needed to be set right. Let him whose religion is without sin judge the actions of a protecting grandfather who blasts the settler colonists to, well, "no one knows, and no one cares." (Certainly there are passages in the Bible where Jehovah himself wreaks genocidal havoc on his follower's enemies, and when he was really angry he flooded the whole world.) But I imagine there is a ghost of the Other within the Meskwaki's statement as well, because I do not think it a coincidence that it puts one in mind of the Bible.

Let me explain. Its apocalyptic imagery evokes the Ghost Dance movement of the Plains Indians during

fig. 2 Potawatomi, *Storage Bag* (front), about 1890

fig. 2

the late nineteenth century, which also envisioned the sweeping away of colonial invaders. The Ghost Dance was a hybrid of Christian and Indigenous religious thinking and it is possible that the Meskwaki speaker also drew the apocalyptic aspect of the imagery from a biblical source. He seems confident that when the Thunders come they will know and spare their own. Yet his desire to purge the Other is likely visualized, in part at least, *through* the religious imagery of the Other. And when the Thunders come, what will be the fate of people like me who have both Indigenous and European parents? If the Thunders are to restore justice they will need a more subtle mechanism than simply blasting one group off the face of the earth. Indeed, the desire to return to a "pure" moment prior to contact has often been imposed on Indigenous peoples by salvage anthropology and other forms of Romanticism, and insofar as it locks us in the past it can be just as annihilating as wilful ignorance of our presence.

Kent Monkman (b. 1965) creates large, sublimely scaled landscapes (fig. 4) in imitation of painters like Albert Bierstadt and Thomas Cole. Monkman's landscapes are populated by "cowboys and Indians" engaged in homoerotic—often sadomasochistic— couplings (fig. 5). Monkman's interest in landscapes began in a previous series of paintings, *The Prayer Language*, 2001 (not reproduced), in which he played with the intersection of his personal history as the son of a Cree minister and his queer identity. Each painting took as its source one of the hymns from his

father's hymnals, which were written in Cree syllabics. Beneath a field of syllabics painted in transparent washes are barely discernible pairs of male figures pressed together in erotic encounters. Eventually, Monkman began to situate these figures in landscapes that became increasingly prominent, until the syllabics disappeared entirely.

Monkman's paintings work as a radical critique of both their landscape and pop cultural sources precisely because they insinuate themselves so deeply into the logic of the originals, the logic of fantasy and desire. We have already seen how Bierstadt's promoter used *The Rocky Mountains, Lander's Peak* to imagine the future glory of the state, rich in resources. And we know of the cowboy, the icon of heroic, individual masculinity and imaginary enforcer of Manifest Destiny. Together they are the stage and the figure of American national fantasy. But Monkman invests this fantasy with queer desire that is both latent in the image of the cowboy and inimical to it once made explicit. Just as importantly, his national loyalties are shifting and promiscuous, suggesting subjectivities that far exceed the complexities of their stereotyped sources. They are too messy and complex, too hot and noisy with desire to not be real.

If a close look at Lightfoot's effort at nation building shows us gaps and holes in our national narratives that one could drive a train through, Monkman reminds us that none of our subjectivities are pristine and that when we traffic in art and politics, we traffic in fantasy and desire.

fig. 3 Potawatomi, *Storage Bag* (back), about 1890

fig. 3

** * * *

1 Robert Johnson, *Nova Britannia* (London: Samuel Macham, 1609), unpaginated.

2 See Jonathan Bordo, "Jack Pine: Wilderness Sublime or the Erasure of the Aboriginal Presence from the Landscape," *Journal of Canadian Studies* 27, no. 4 (Winter 1992–1993), 98–128; Scott Watson, "Race, Wilderness, Territory and the Origins of Modern Canadian Landscape Painting," *Semiotext(e),* no. 6 (1994), 93–104.

3 Albert Boime, *The Magisterial Gaze: Manifest Destiny and American Landscape Painting c. 1830–1865* (Washington: Smithsonian Institution Press, 1991), 133.

4 Jimmie Durham, "Cowboys and...," in *A Certain Lack of Coherence*, Jean Fisher, ed. (London: Kala Press, 1993), 175.

5 Gayatri Chakravorty Spivak, "Can the Subaltern Speak?" in *Marxism and the Interpretation of Culture*, Cary Nelson and Lawrence Grossberg, eds. (Urbana: University of Illinois Press, 1988), 291.

6 The variations in terminology, including basic spelling, are so vast and complex that an essay longer than this one would be required just to clarify them all.

7 A. Irving Hallowell, "Ojibway Ontology, Behavior, and World View," in *Teachings From the American Earth: Indian Religion and Philosophy*, Dennis and Barbara Tedlock, eds. (1960; repr., New York: Liveright, 1975), 146.

8 Theresa S. Smith, *The Island of the Anishnaabeg: Thunderers and Water Monsters in the Traditional Ojibwe Life-World* (Moscow, Idaho: University of Idaho Press, 1995), 50; Hallowell, 147–148.

9 Hallowell, 143.

10 Ibid., 153.

11 Smith, 113–114.

12 Peter Jones, *History of the Ojebway Indians: With Especial Reference to Their Conversion to Christianity* (London: A. W. Bennett, 1861), 85–86.

13 Ibid., 86.

14 For example, Alanson Skinner, "Material Culture of the Menomini," in *Indian Notes and Monographs* 20, Frederick W. Hodge, ed. (New York: Museum of the American Indian Heye Foundation, 1921), 29–31; Lee Anne Wilson, "Bird and Feline Motifs on Great Lakes Pouches," in *Native North American Art History: Selected Readings*, Zena Pearlstone Mathews and Aldona Jonaitis, eds. (Palo Alto, California: Peek Publications, 1982), 433.

15 Ruth Bliss Phillips, "Dreams and Design: Iconographic Problems in Great Lakes Twined Bags," in *Great Lakes Indian Art,* David W. Penney, ed. (Detroit: Wayne State University Press and Detroit Institute of Arts, 1989), 58.

16 Ibid., 59.

17 Wilson, 440.

18 In William Jones, "Notes on the Fox Indians," *Journal of American Folk-Lore* 24, no. 92 (April–June 1911), 213–214.

fig. 4 Kent Monkman, *Trappers of Men*, 2006 fig. 5 Kent Monkman, *Artist and Model*, 2003

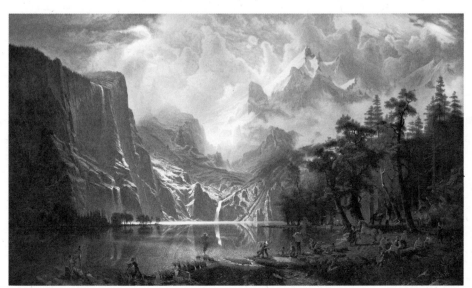

fig. 4

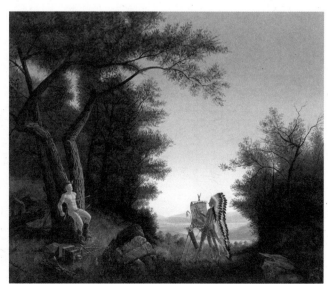

fig. 5

The carnage of the Civil War is hard to imagine, even by modern standards: over 360,000 deaths and about 275,000 wounded among Union forces of 2,200,000; and over 258,000 deaths and 137,000 wounded among Confederate forces of 1,064,000. With a population of roughly 30,000,000 in 1860, nearly every family was personally affected by the conflict. The Battle of Gettysburg (July 1–3, 1863) was the turning point in the northern advance of Confederate troops—at the cost of 23,000 casualties on each side. Photography brought these horrors to a concerned public with a new and unflinching verity. O'Sullivan was already employed by a leading Civil War photographer, Mathew Brady, before the outset of the War. This devastating landscape of the Confederate dead that seems to stretch to infinity was to be one of the most famous images of the conflict, marketed to a public which sought understanding during wartime. Among the poignant details are the missing shoes and the litter from the pockets about the corpses, witness to the "harvesting" by survivors. O'Sullivan and Gardner had waited until the morning of July 5 to be admitted to the field. They worked intensely through July 7, leaving with sixty images, mostly of the dead.

51　Timothy O'Sullivan, A Harvest of Death, Gettysburg, Pennsylvania, 1863

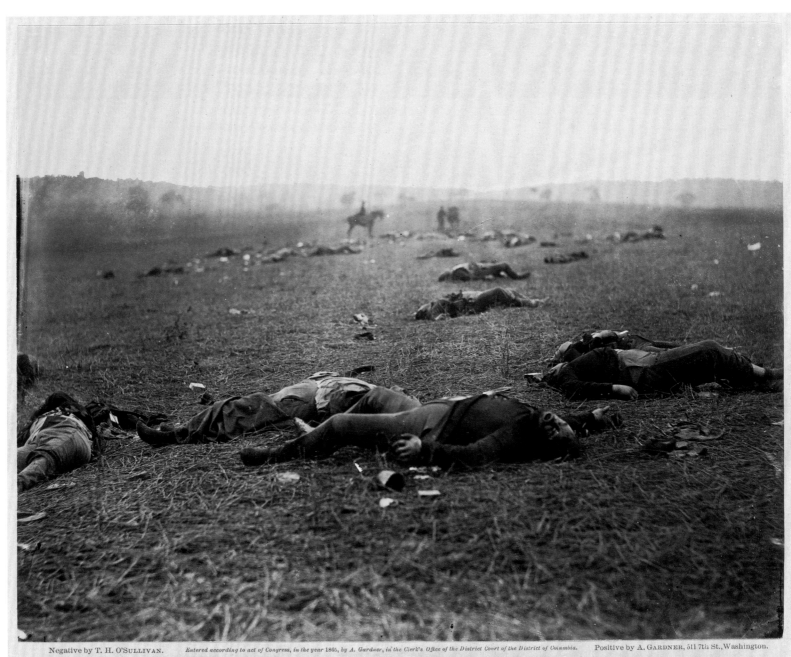

Negative by T. H. O'SULLIVAN.　　*Entered according to act of Congress, in the year 1865, by A. Gardner, in the Clerk's Office of the District Court of the District of Columbia.*　　Positive by A. GARDNER, 511 7th St., Washington.

A HARVEST OF DEATH, GETTYSBURG, PENNSYLVANIA.

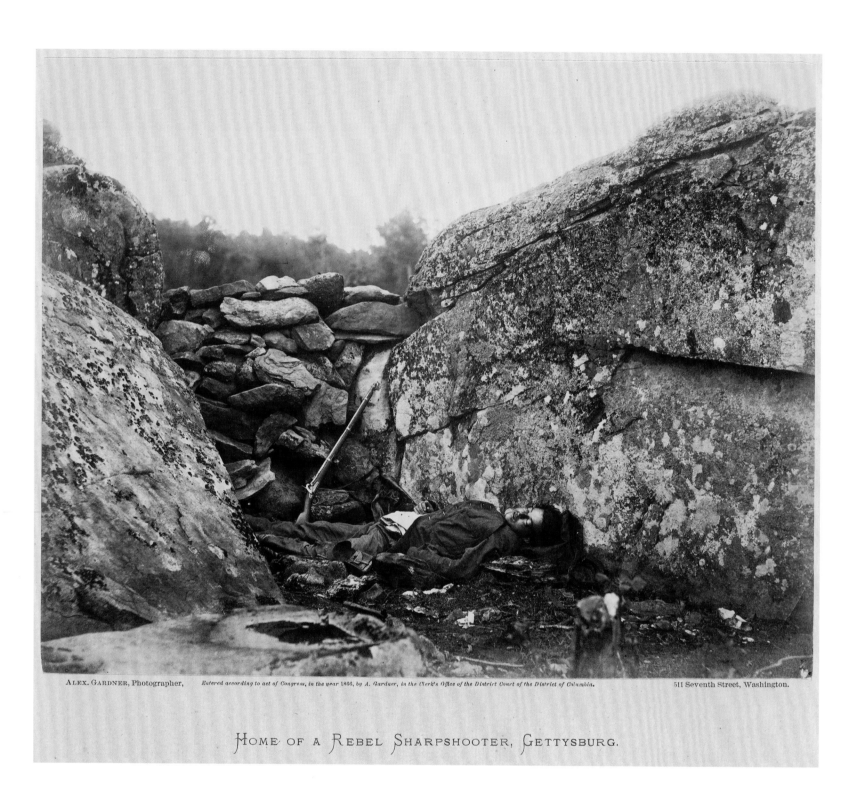

ALEX. GARDNER, Photographer, *Entered according to act of Congress, in the year 1866, by A. Gardner, in the Clerk's Office of the District Court of the District of Columbia.* 511 Seventh Street, Washington.

HOME OF A REBEL SHARPSHOOTER, GETTYSBURG.

Gardner began working in New York for Mathew Brady in 1856 and with the outbreak of the War struck out independently, being appointed official photographer of the Union armies. While esteemed for his trenchant portraits, notably of Lincoln, and his battlefield images, *Home of a Rebel Sharpshooter, Gettysburg* is apparently a contrived photograph. Modern scholarship has shown that Gardner used the same body of a Confederate sniper in multiple locations and likely set the poses himself. In 1866, O'Sullivan assisted Gardner in editing Gardner's *Photographic Sketch Book of the Americain Civil War, 1861–1865*, a two-volume collection of one hundred images, and contributed many of the finest photographs, including *A Harvest of Death*. However, the commercial prospects for such publications disappeared as rapidly as they had emerged as the postwar public had no desire for such imagery and the memories it evoked.

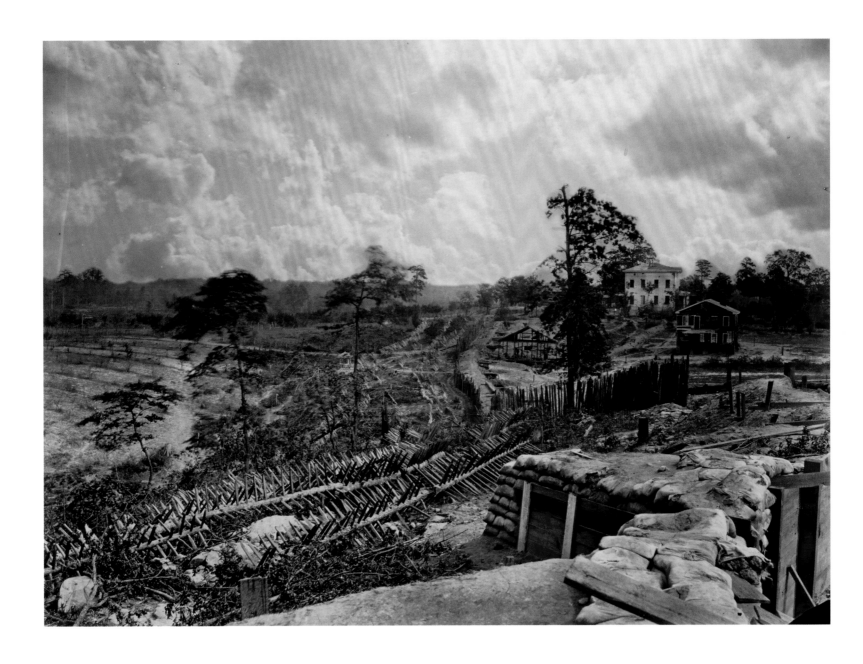

Barnard, a New Englander, had travelled through the South in his youth. As a Union Army photographer, he was sent to such early Civil War sites as Harper's Ferry and Bull Run, Virginia, and in 1863 was commissioned to lead the military division's photographic operations at Nashville. After the fall of Atlanta in the autumn of 1864, Barnard collected images of the fortifications and state of the city, then followed General Sherman's troops to Savannah. He continued his work through 1865 and into 1866, documenting Sherman's path from Tennessee to Atlanta and Savannah, and then through South Carolina. These views, including the one pictured here, were published in his *Photographic Views of the Sherman Campaign* of 1866.

54 Eastman Johnson, Union Soldiers Accepting a Drink, about 1865

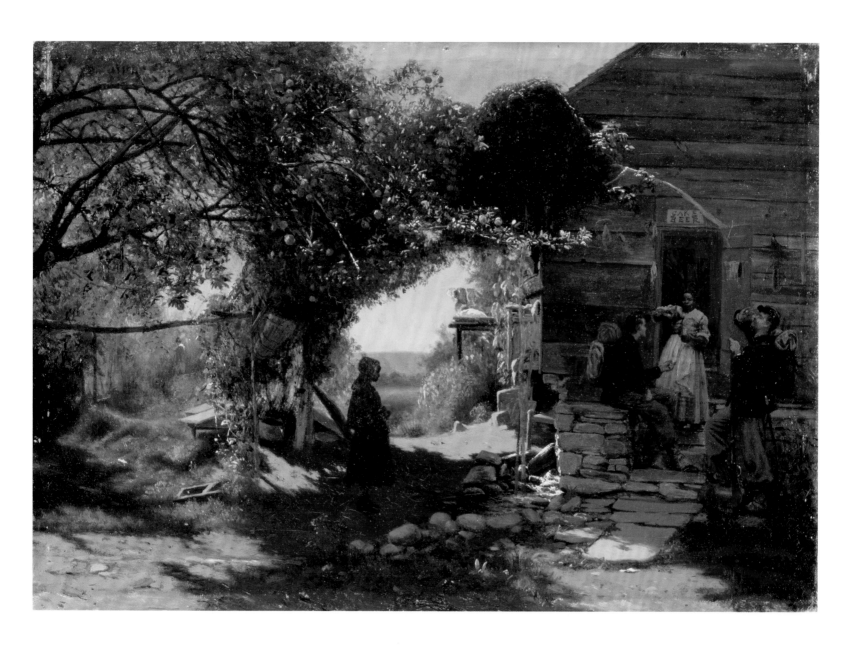

Johnson rarely approached subjects directly related to the conflict, but this modestly scaled painting is an exception. Created at the end of the War, it pointedly depicts Union soldiers accepting a drink from an African-American woman at a country inn. The painting was remarkable for its time in its informal rather than hierarchical mixing of races, the woman depicted standing slightly above the level of the soldiers.

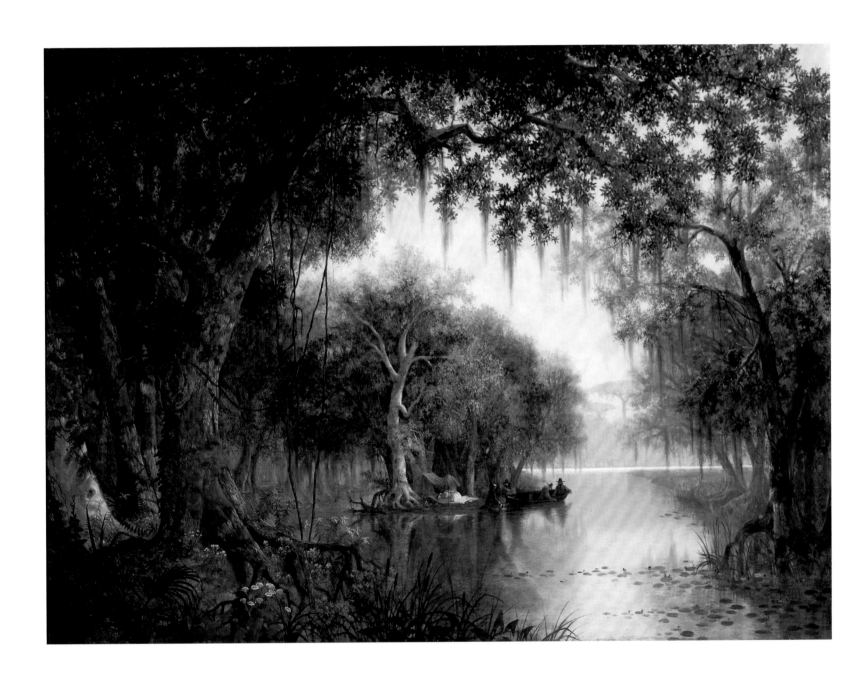

The subject of this painting is an episode from Henry Wadsworth Longfellow's extended narrative poem "Evangeline, a Tale of Acadie." That work is a haunting and mournful story of separated lovers and their search for each other, a totally fictional romantic account of the actual ruthless and tragic deportation of the indigenous French population of Acadia (encompassing Prince Edward Island, Nova Scotia and New Brunswick) by the British forces during the French and Indian Wars, which led to the establishment of the Acadian communities in Louisiana. The highly popular poem about loss and spiritual redemption became so entrenched in the minds of Acadians that the story was commonly believed to be true well into the twentieth century. Meeker depicts the moment when Evangeline, seeking her beloved Gabriel in the dense and exotic Louisiana bayous, rests beneath cypresses (associated with death), the trees creating an embracing bower about her, receiving a vision of hope that lightens her heart and raises her spirits.

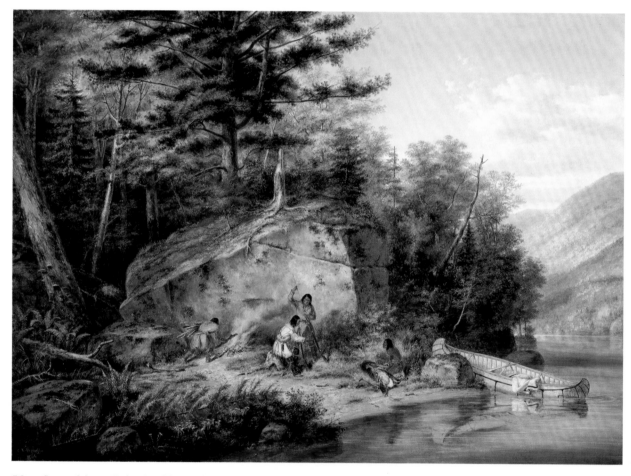

56 Cornelius Krieghoff, Chippewa Indians at Lake Huron, 1864

Krieghoff specialized in pictures of French Canadian and Aboriginal life in Quebec, making a virtual industry of his successful enterprise for an avid Canadian market, particularly in Quebec and Ontario. The artist painted no less than twenty-three versions of this painting, albeit with minor variations, showing a group of Chippewa hunters preparing a recently killed caribou. The rock formation itself appears in other Krieghoff compositions.

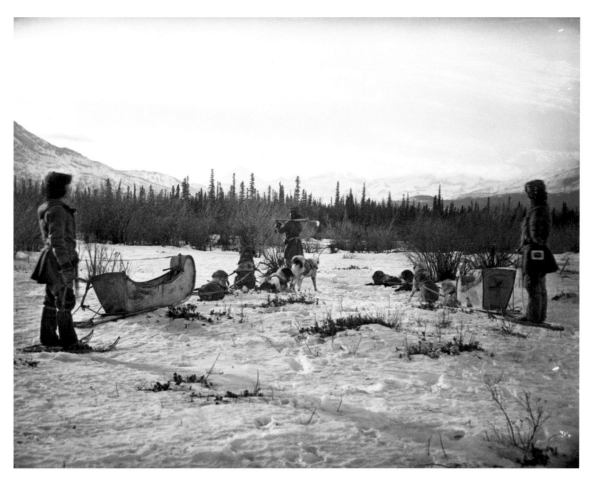

57 Charles George Horetzky, Jasper House Valley Looking South, 1872

To capture images in the bitter cold of winter, Horetzky used prepared dry collodion plates, a technique developed at this time. This image from Alberta is notable for its respectful and documentary approach to its subject.

58 William Raphael, Indian Encampment on the Lower St. Lawrence, 1879

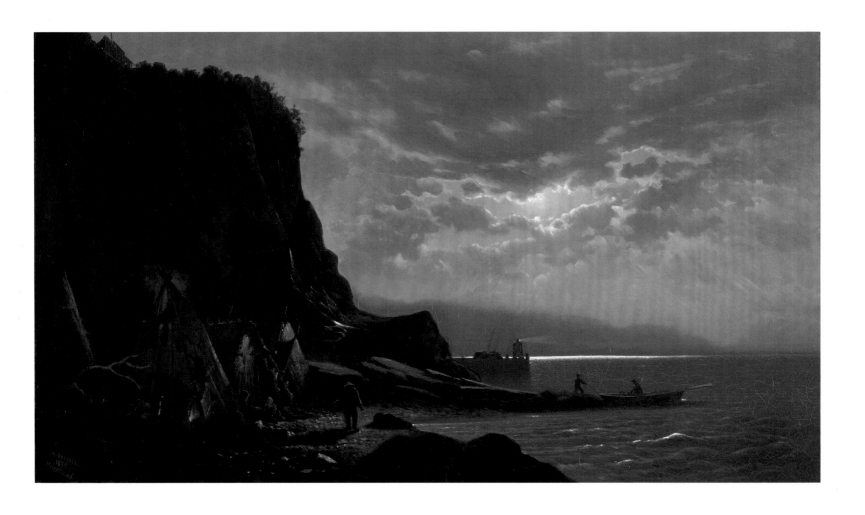

First exhibited in Toronto in 1879, this moonlit landscape, often described by critics as mysterious, combines seemingly disparate and discordant elements: the foreground settlement and figures in the canoe, the beacon-light and the house on the cliff create an open narrative, in which the presence of Aboriginal people primarily serves an anecdotal role and contributes to the dark and romantic mood.

59 Henry John Sandham, On an Eastern Salmon Stream, about 1874

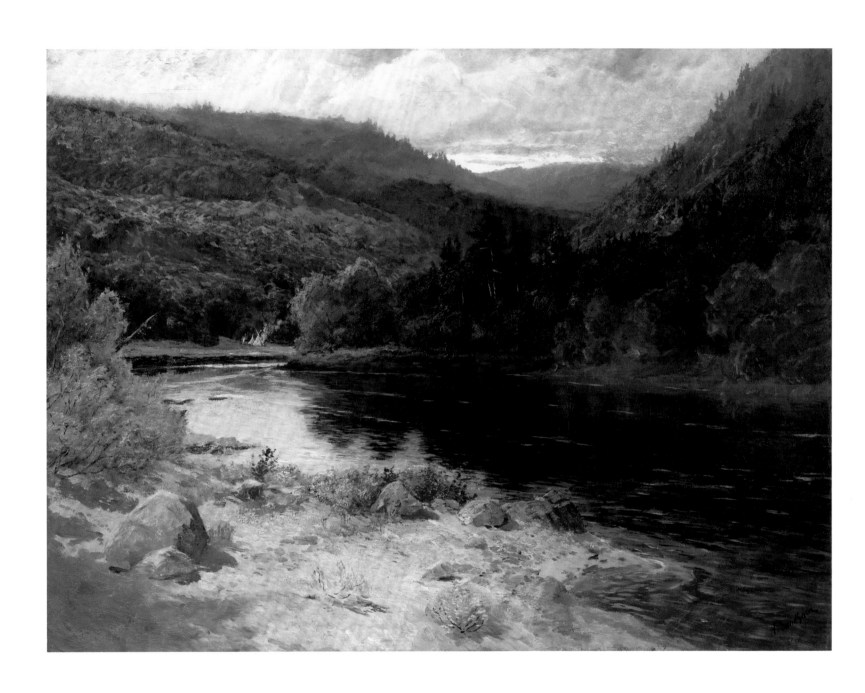

From 1870, Sandham worked closely with William Notman, colouring portraits, working on glass negatives and prints, and creating settings for composite images. This undoubtedly encouraged his sense of the picturesque. In 1872 he exhibited seven figurative oils, all featuring Aboriginal people, as well as landscape watercolours with small figures. Railroad expansion also encouraged the artist to seek venues afield from Montreal. In 1873 he travelled to Chaleur Bay in New Brunswick. This painting features one of these eastern salmon streams, the Restigouche River, on the border between Quebec and New Brunswick, with an encampment of teepees in the distance. Salmon fishing had become a male leisure sports activity in an increasingly urbanized society and the encampment nostalgically alludes to a pre-modern, primeval age.

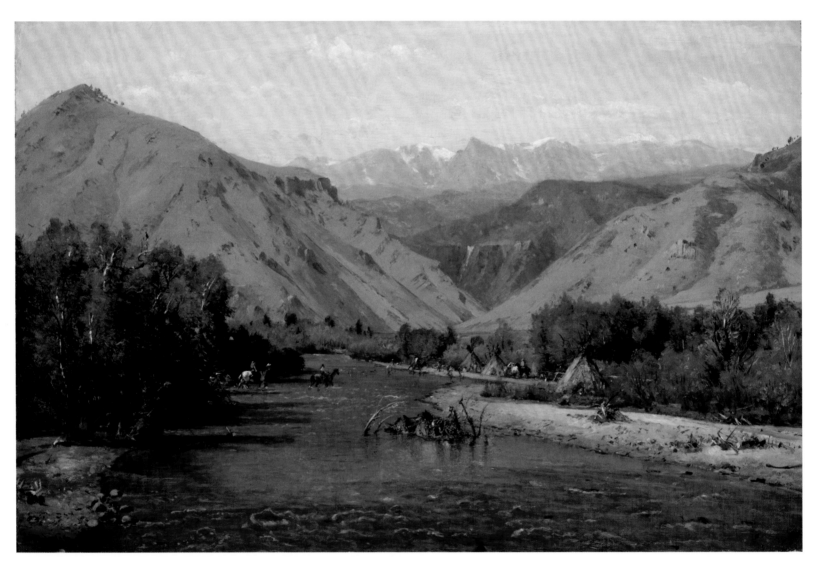

60 Thomas Worthington Whittredge, Indian Encampment, between 1870 and 1876

Born in Ohio, Whittredge received extensive artistic training in Düsseldorf and Rome before opening a studio in New York in 1859. In 1865–1866 and 1870 he travelled west to the Rocky Mountains in the company of Sanford Gifford and John Frederick Kensett. This painting resulted from the second trip. Structured with carefully controlled ranges of tone and light, it reflects a cool realist sensibility, without narrative interplay, that parallels photographic images. The foreground details are in crisp clarity and the vast panorama of the foothills and distant Rockies displays the artist's sense for vast spaces. While Whittredge associated with artists of the Hudson River School, his objective eye and subtle exploration of actual light and atmospheric effects over great distances, allying his work with Luminism, reflect a distinctive sensibility. Best known for his Catskill and New England landscapes, Whittredge responded more to the immense expanses of the plains than to the monumental Rockies, creating landscapes animated by passing moments of Native American experience stripped of allegory or artificial heroics.

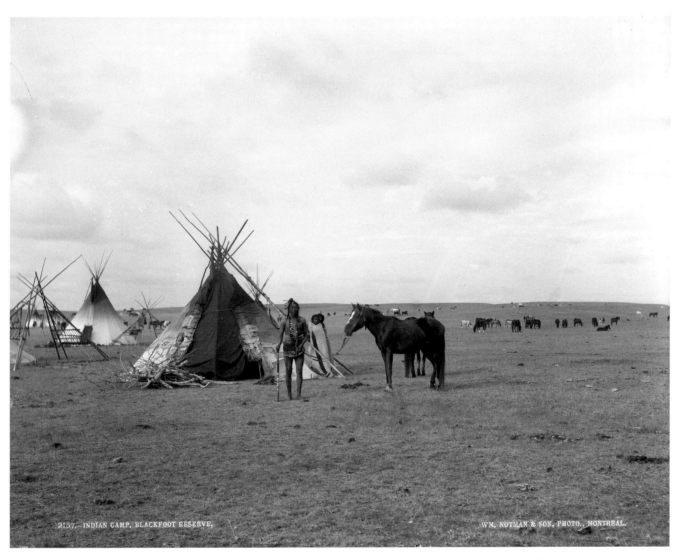

61 William Notman, Indian Camp, Blackfoot Reserve, near Calgary, Alberta, 1889

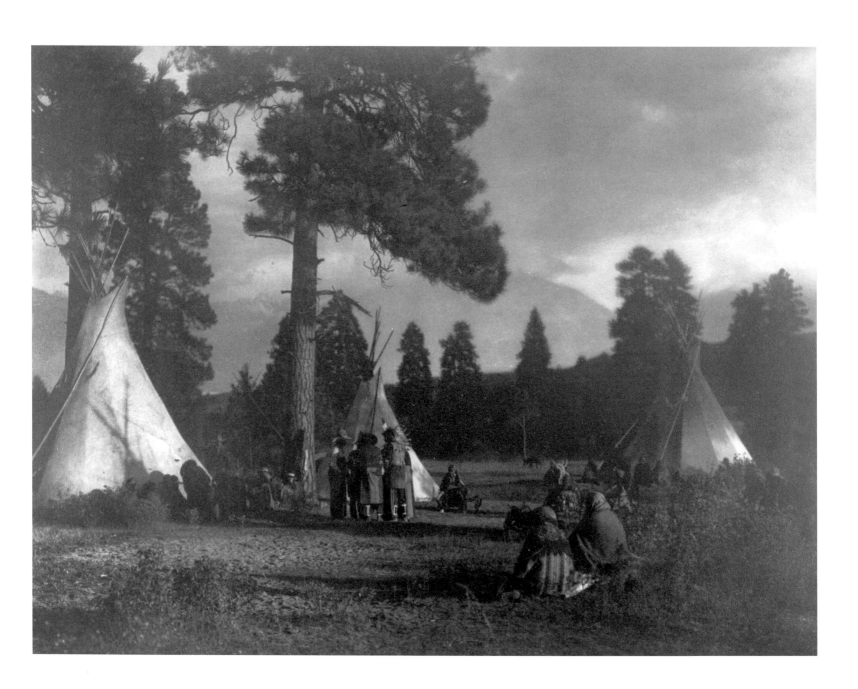

After establishing himself in Seattle in 1887, Curtis focused his photographic career on recording the lives of Native American peoples. He accompanied the Harriman Expedition to Alaska in 1899 and to Montana the following year, but it was in 1901 that he conceived of the major opus of his career: a documentary record of the diverse Native tribes of North America, their lifestyles, dwellings, customs and religious activities, along with a series of ethnographically oriented individual portraits. Encouraged by President Roosevelt and supported by financier J. P. Morgan, Curtis produced a handsome twenty-volume series of texts and portfolios between 1907 and 1930 entitled *The North American Indians*. In seeking to record these vanishing cultures, he took over forty thousand images of over eighty tribes and made cylinder recordings of languages and music. In the end, fifteen hundred photogravure illustrations and over seven hundred large photogravures were published. While the series has been criticized as mythologizing its subjects and embodying the prejudicial European view of the "Indian" as "noble savage"—Curtis sometimes cropped or erased contemporary references within the frame and used props, including ceremonial costumes out of context, to evoke a Romantic past and suggest a warlike view of the men and a passive view of the women—the images nonetheless are invaluable records of disappearing living cultures and are of great artistic merit as photographic compositions.

63 Edward Sheriff Curtis, [Sioux Warriors] at Sheep Mountain in the Badlands of Pine Ridge Reservations, South Dakota, 1908

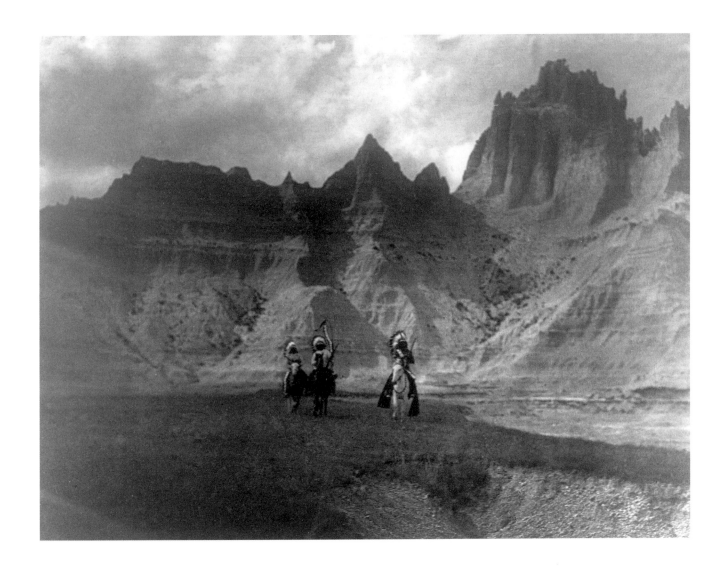

The figures in this famous image, shot on the reservation, were undoubtedly asked to pose with war bonnets.

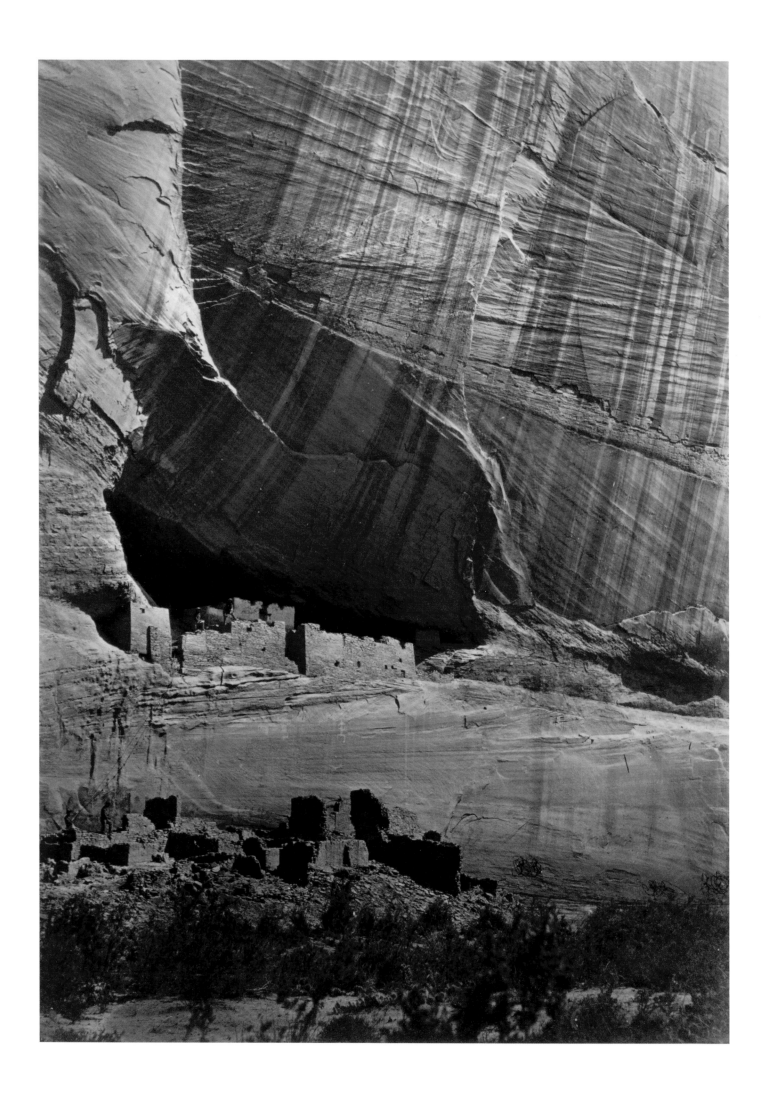

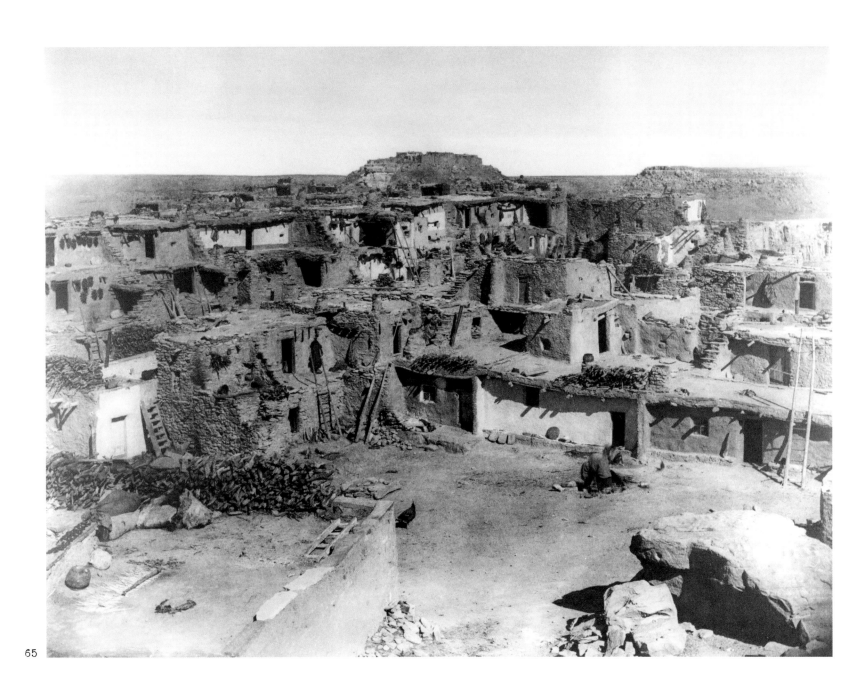

65

64 Timothy O'Sullivan, Ancient Ruins in the Canyon de Chelle, New Mexico, 1873
In 1871 O'Sullivan joined the Wheeler geological survey, a series of expeditions west of the hundredth meridian which would result in a multi-volume report, issued between 1875 and 1887. While the photographer exploited the pictorial possibilities of the sites, Lieutenant George Wheeler, focusing on the practical aspects of the survey to encourage future development, captioned the images. In 1873 O'Sullivan, accompanied by a small group, travelled to a Zuni pueblo (or dwelling) in Northeast Arizona and onward to the so-called White House Ruins—an Anasazi pueblo mostly dating from the eleventh century nestled into the walls of Canyon de Chelle on Navaho land. Capturing the view at a significant distance, he cropped the image to encapsulate the ruins, located in a niche about fifteen metres above the base, and the dramatically lit sandstone walls. Small figures standing among the ruins at the base lend scale to this unforgettable and monumental view.

65 Edward Sheriff Curtis, Mishongnovi Village Showing a Comprehensive View of This Middle Mesa Pueblo, 1900

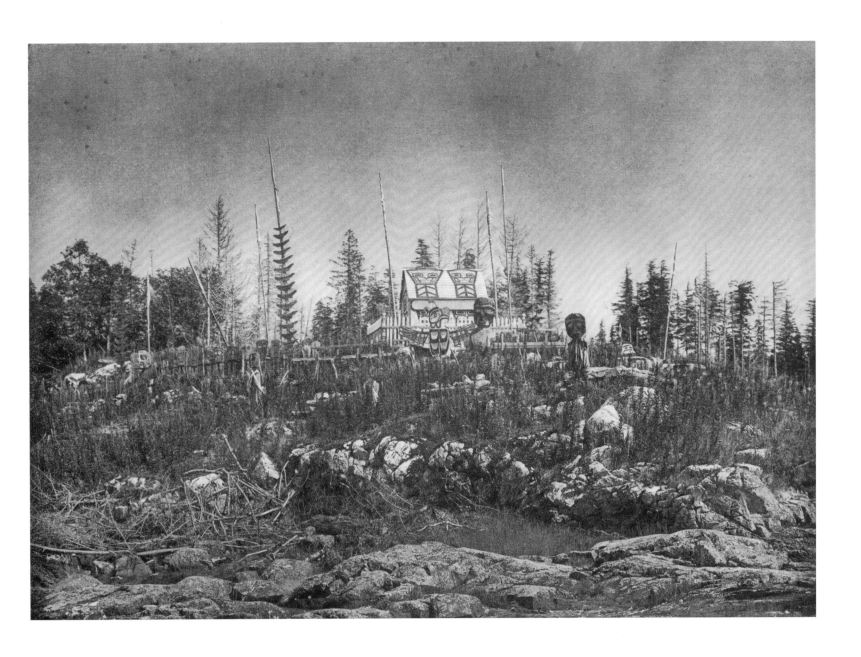

This photograph depicts the grave house of Lala Kyotsa, a Mamalelekala chief. The pole with sculpted canoes shown at the left represents canoes he gave as gifts, and the boards resting against the fence symbolize coppers he sold to pay for potlatches. The totems at the centre and right commemorate his family lineage.

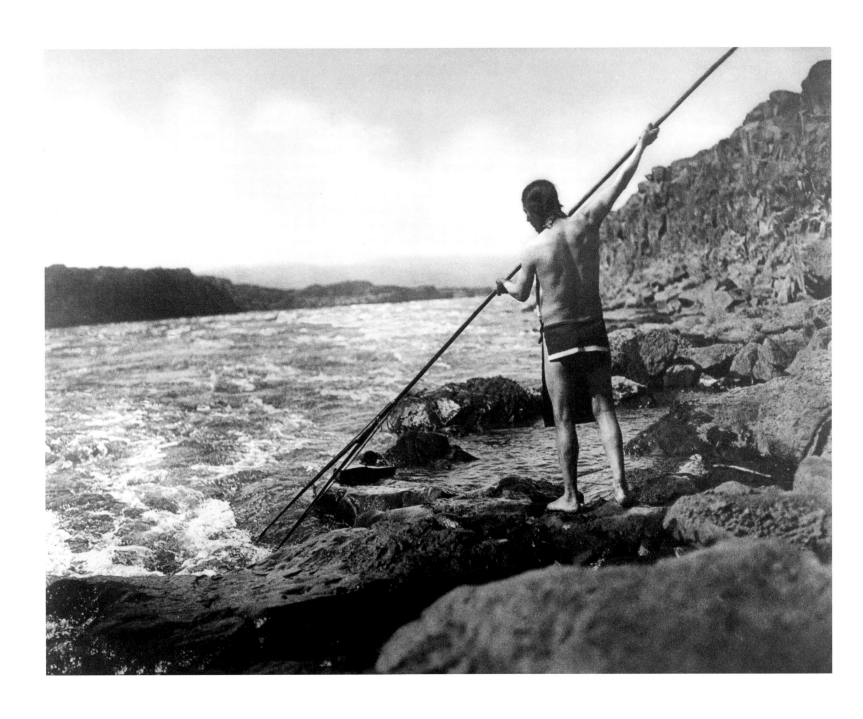

This image was taken along the Columbia River, at a point where the rocky promontory and the rapid upstream current permitted spearing of the salmon in large numbers.

68　Emily Carr, Totem by the Ghost Rock, 1912

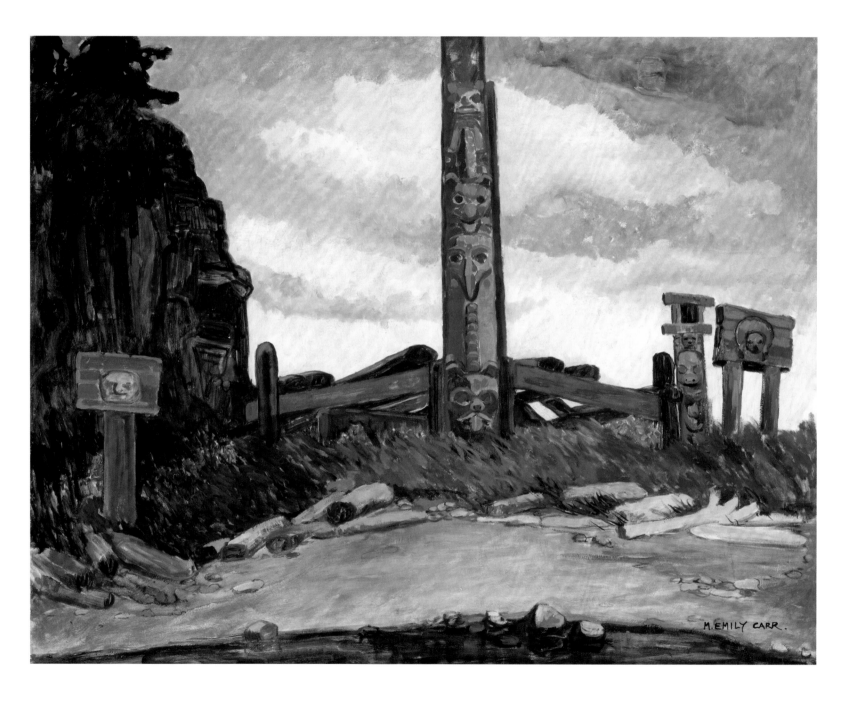

In 1912, travelling up the coast north of Vancouver with Clara and William Russ, Carr visited several villages in Haida Gwaii (the Queen Charlotte Islands), executing watercolours to record her impressions. Fascinated with the principles of Haida design and appreciative of the dynamic naturalism and careful observation underlying animal imagery, she created works which, while documenting the totems, also spoke to her own modernist and subjective interpretations of them. This artistic subjectivism created a dynamic between her curiosity and respect for Native peoples' heritages and ties to nature and her desire to record their visual culture. She first executed the composition as a large watercolour and then developed the painting Totem in her studio, eliminating some elements and applying the Fauvist palette she had adopted during her studies in France. The site is on Q'una, a village that had once been a settlement of 738 inhabitants, located along a curving beach. The composition depicts the far end of the village near a cliffside containing burial sites and considered haunted; thus the title of the work.

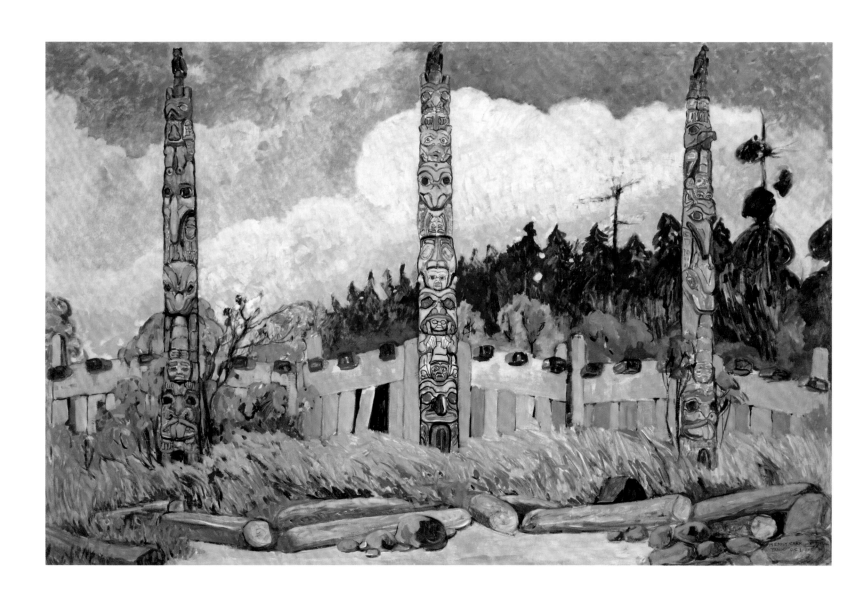

Carr visited this site with Clara and William Russ in 1912, and William photographed the site very much as it appears here. Together with her watercolour sketches executed on site, the photograph may well have assisted Carr in her depiction of the totems.

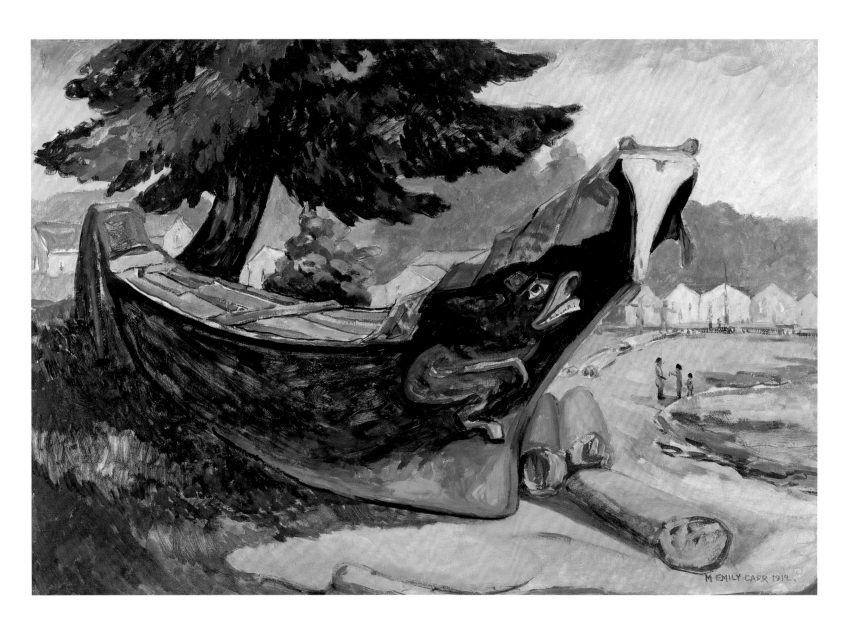

Executed in her studio, the painting has a note written by the artist on its verso stating, "Indian war canoe taken at Alert Bay during a potlatch." The painting is based on a 1908 watercolour sketch executed on Alert Bay, a small island between North Vancouver Island and the mainland. At the time, the canoe was installed at the entrance to the village. Carr's Fauvist palette conjoins with her interest and esteem for the Native American heritages, as she sensitively renders the forms and decorative schemes of the vessel. The historical artifact embodying the culture of the Kwakwaka'wakw people is no longer in use.

71 Frances Anne Hopkins, Shooting the Rapids, 1879

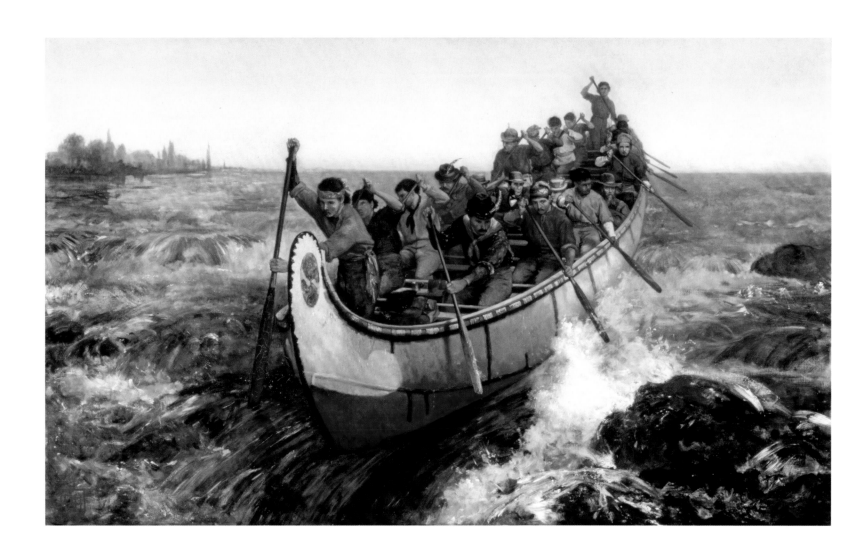

The Hopkins masterpiece is among her largest and most dramatic canvases. The composition is dynamically presented through the forward diagonal movement of the carefully rendered gunwale canoe, with its pitch-covered seams and detailed ornamentation, and the gushing rapids, water flashing over the oar blades. The work depicts an actual event. Seated at centre in their Victorian finery are Edward Hopkins, with his reddish beard and distinctive hat, the artist herself, fashionably attired with her modish bonnet, a man in bow tie and jacket, probably Alexander Grant Dallas, former Governor of Rupert's Land, and another figure visible only by his straw hat. In June 1863 the Hudson's Bay Company was acquired by the International Finance Society. Wishing to re-examine the company's fur trade, one of the trustees, Edward Watkin, met with Dallas, then Governor of Rupert's Land, on behalf of the board in Montreal. There, they agreed to travel to the Red River Settlement in the Governor's canoe manned by, as Watkin described, "eleven stalwart Indians, almost all six feet high." On July 23 the two Hopkinses, Watkin and Dallas canoed from Lachine to Montreal. This trip down the Lachine Rapids formed the basis of the painting.

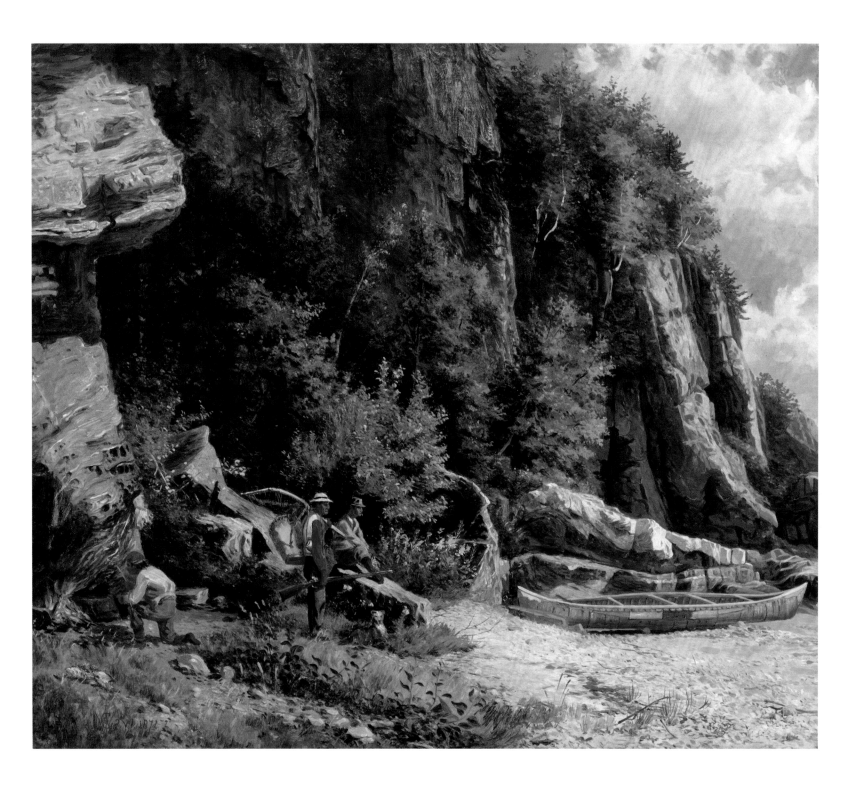

Born and trained in England, Way immigrated to Canada, settling in Montreal. There he worked with William Notman, who photographed some of his paintings. Typical of Way's romantic and picturesque depictions of landscapes and Native peoples, European hunter-explorers in their proper Western clothing are juxtaposed with their Native guide, shown kneeling with his back to us preparing the campfire.

73 Frederick Arthur Verner, Buffaloes on the Canadian Prairies, 1885

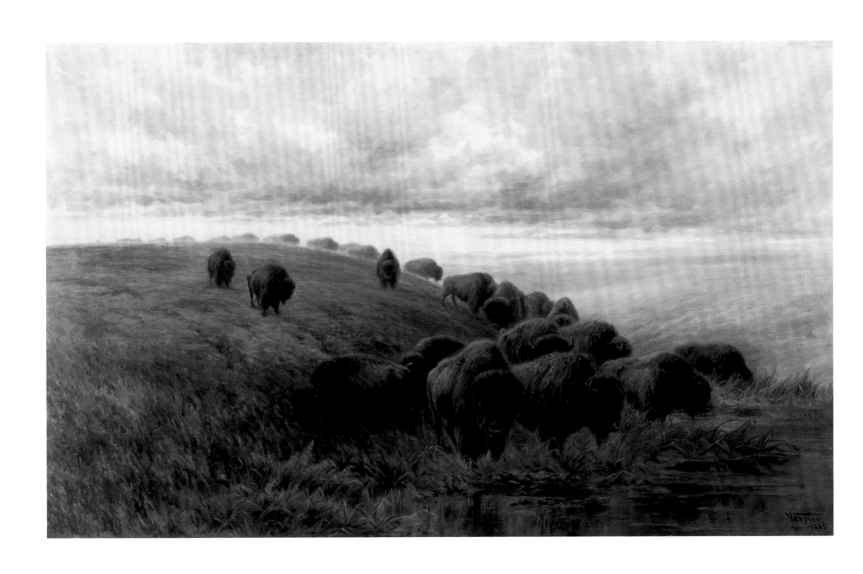

One of the most captivating aspects of this picture by Verner, an artist who specialized in animal paintings and watercolours, is that it was executed six years after the last buffaloes were recorded in Canada, which explains the brooding character of the sky and colour range of a modest herd disappearing into the distance. Verner had first travelled from Toronto to Manitoba in 1873 and his studies of the plains' broad spaces served him as references for many years, also encouraging his interest in Native populations. He could not have seen free herds of buffaloes at that time, however. A Romantic sensibility encouraged him to idealize and paint the bison, although he never saw any except in captivity. By the time he travelled farther west in 1890, buffaloes were on the verge of extinction. In its way, the painting constitutes a Canadian corollary to Bierstadt's celebrated *The Last of the Buffalo*, painted three years later.

74 Stanley J. Morrow, Gen'l Custer's Last Stand, Looking in Direction of Ford and Indian Village, about 1876
75 Stanley J. Morrow, The Monument on Custer's Hill, Containing the Bones on the Field, about 1876

In its aftermath, the public fascination with the Battle of Little Bighorn, commonly known as Custer's Last Stand, could not be exaggerated. The Seventh Cavalry was detested and attacked by the joined forces of the Lakota and Northern Cheyenne, led by Sitting Bull, on June 25–26, 1876, in the eastern Montana territory, resulting in the annihilation of General George Armstrong Custer's column of two hundred ten men. In overall forces, the warriors outnumbered the soldiers by three to one (about eighteen hundred to six hundred). Custer, whose vanity, ego and ambition were renowned, led his troops into open and unfamiliar terrain, and the situation was exacerbated by the earlier prudent retreat of Major Reno's initial attacking force. The Seventh Cavalry was subsequently reinforced by Captain Benteen's forces, while General Terry's column only arrived the next day. Over half of the Cavalry was killed or wounded. The initial public reaction, brought to a fury by sensationalist news coverage, was devastating toward Native populations. Congress immediately increased funding for expanded cavalry companies and the handsome Custer came to embody the heroic American soldier combating ruthless savages. Subsequent army inquiries, while bringing into question the conduct of those involved, did little to affect the popular imagination. Only in the later twentieth century did a general appreciation of the mistreatments of Native populations and the negative operations of the United States Cavalry come to be recognized. In the immediate aftermath, the popularity of the subject led to stereoscopic images to bring home the famous site, with its collected bones and monuments.

On December 29, 1890, about three hundred Miniconjou and Hunkpapa Sioux (Lakota) were attacked by five hundred troops of the Seventh Cavalry under Colonel James Forsyth, using four Hotchkiss guns. The troops had come with orders to escort to Omaha the last of the independent Sioux who had agreed to turn themselves in. The battle started over a hearing-impaired Lakota requesting payment for his weapon, not having understood his people's agreement to surrender. In the resultant confusion, twenty-five soldiers were shot (mostly from friendly fire) and over one hundred fifty Sioux, including women and children, were immediately killed while others fled into the bitter cold, resulting in further deaths from hypothermia. Preludes to the massacre were manifold: the December 15 murder of Chief Sitting Bull at his cabin by the Indian Police, who had arrested him on government orders; the dislocation of the Big Foot tribe (Big Foot himself ill with pneumonia) to Wounded Knee Creek on December 28 at the order of the Cavalry, whose General was upset over the recent celebration of the Ghost Dance, which had been misinterpreted as a War Dance; and the rumour among the Lakota that they would be taken to a worse detention camp, where they would starve to death. A further prelude was the United States' breaking of a treaty that year, dramatically reducing the Sioux reservations to accommodate homesteaders and enforcing their conversion to farmers, despite a very bad season. Native food rations were also cut by half. In the immediate aftermath, a photographer was brought to the site to take eight photographs, including a famous image of Big Foot frozen dead on his back in the snow. This image shows the Lakota camp after the massacre, moccasins of the dead visible at the edge of the covering blanket.

77 Laton Alton Huffman, *Working a Small Herd*, about 1890

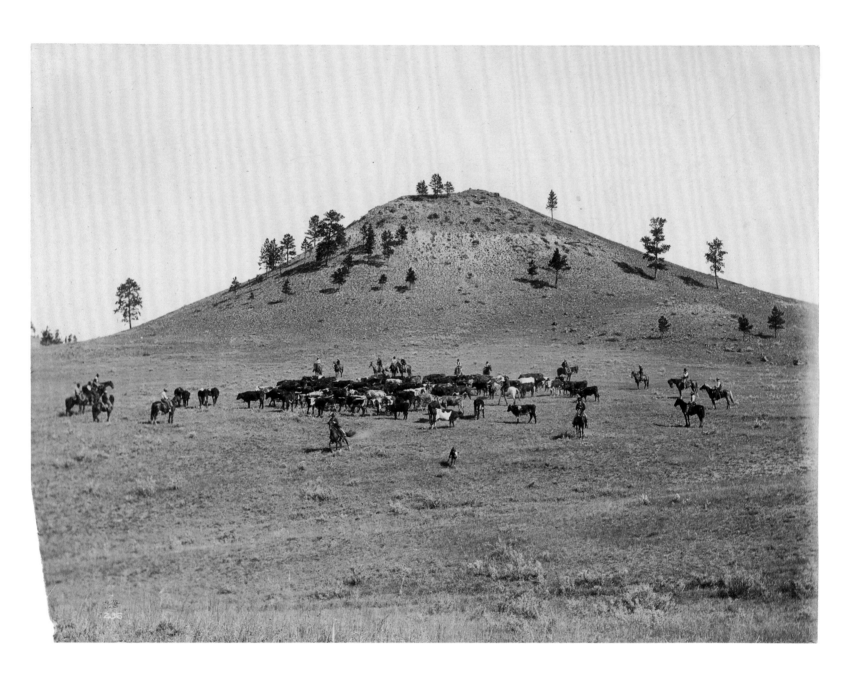

Huffman's life is reflected in his photographic subjects. The artist began his career as a photographer working in his father's studio in Iowa. However, early in his life he also worked in the frontier as a wrangler and became comfortable with the life of the cowboy. By 1880 he had settled in Montana, establishing his studio at Fort Keogh. He supplemented the income he gained from his photographs as a guide to hunting parties and eventually established a cattle ranch of his own.

MAN VERSUS NATURE

" We have seen the great forests
destroyed, the pure waters polluted,
the kindly climate changed,
the great aspect of nature's
beauty marred and obliterated.
We have brought about
all of this in the name of
civilization, and we call it progress."

Wilfred Campbell,
Canadian poet

Painting and Photography in British Columbia, 1871-1916: Some Observations

Ian Thom

On November 7, 1885, Donald Smith (later Lord Strathcona) ceremonially drove the last spike of Canada's transcontinental railway into place at Craigellachie, British Columbia. This event marked the completion of a monumental effort to connect the new province with the rest of Canada. It also heralded what was to become a booming tourist trade, bringing people across the expanse of the prairies to experience the magnificent scenery of the Rocky Mountains. During the building of the railway, an arduous fourteen-year process, the Canadian Pacific Railway (CPR) worked with many photographers and painters to document the railway and the natural wonders it now made accessible.[1]

This essay examines some of the photographs and paintings from the late nineteenth century that were commissioned or funded by the Dominion government, through the Geological Survey of Canada (GSC), or by the CPR itself, as well as a small group of works from the early twentieth century that were produced upon completion of the railway. It seeks to show that while photographs provided an invaluable factual record, paintings provided what might be described as a richer truth—a truth that elicited greater emotional engagement and emphasized the grandeur and magnificence of nature, rather than the realities of the railway and the destruction that it visited on the landscape. Often of similar if not identical subjects, some of these images can be placed in comparative perspective to highlight their different goals.[2]

The first step in the CPR's enterprise was to survey the land in search of the best route for laying track. In British Columbia, the surveying served the additional purpose of documenting the region's enormous mineral wealth. In the early 1870s, Notman studio staff photographers Benjamin Baltzly and John Hammond accompanied field geologist and GSC director Alfred Selwyn on one of these surveying expeditions. Baltzly's photographs, two of which are included in this exhibition, provide often startling documentation of the terrain and are a testament to the considerable grit of the photographer himself. When one considers that Baltzly had to transport his plates and other photographic equipment by canoe and mule train, and occasionally on his own back, the number and quality of his images are astonishing. The surveying crew began its mission on the Pacific Coast and worked its way into the interior—almost as far as Craigellachie. Baltzly's images are the earliest we have of many areas of the British Columbia interior.

The first photograph I want to consider is an almost impenetrable composition that seems deliberately artless. Everything about this work is direct, starting with the title, *Forest Trees on the North Thompson River, 165 Miles above Kamloops* (cat. 30). The subject is a relatively dense group of trees and the viewer is given little by way of visual introduction to the claustrophobic space of the image. The trees are ruthlessly cropped by the top edge of the image and there is no easy escape for the eye. It is difficult to imagine the image as anything other than a photograph, and indeed the abrupt framing, the shallow space and the almost excessive attention to the details of the bark suggest a level of engagement with raw nature that was a rarity, without a known equivalent in Canadian painting of the period. How then do we read this small image? Is it pretty? No. Is it telling, revelatory? Yes. Telling because it gives us a real sense of the challenges the forest landscape would present for the railway—mile after mile of thickly packed trees—and revelatory because it provides a direction for future photography associated with the CPR.

Baltzly kept a journal of this trip up the North Thompson River and it was published in the Montreal *Gazette* beginning in June 1872. Chapter 9 of the journal, "Slow Travelling," appeared in the July 25 issue and vividly reports on the landscape that we see in this photograph: "The forest is so dense, and the undergrowth so thickly filled up with the aralea, alder and tall cranberry trees, and fallen timber of every description, that it is impossible to make more than from one to four miles of trail per day. This, and the near approach of snow, and the small amount of provisions on hand, made our journey begin to look gloomy."[3] In the photograph, as in the text, there is no attempt at sugar-coating and one can readily imagine that engaging directly with the landscape, as Baltzly and his companions did, would have been a daunting, even harrowing, challenge.

While less forbidding than *Forest Trees*, Baltzly's *Selkirk Mountains as Seen from the Top of the Mountains near the Confluence of the Blue and North Thompson Rivers* (cat. 35), shot a few days earlier, also offers little in the way of delight to the viewers. However, Baltzly is somewhat more positive in reporting his impression: "The scene in a clear day must be grand and sublime. That day it was very gloomy, and a snowstorm was raging among the snow-clad mountains, and the atmosphere between them and us had a blue hazy or smoky appearance, and much of the beauty of the scenery was lost."[4] The thought of Baltzly and Hammond struggling with an 8 x 10 camera and wet collodion plates to record this rather bleak scene is astonishing. Clearly, such photographs were not taken to attract tourists!

Willam Notman also documented the railway. *Loop Showing the Four Tracks on the Canadian Pacific Railway* (cat. 88) shows a fascinating combination of the grandeur of the natural scenery and the quotidian elements of the railway itself. The Loop refers to the grand semi-circle the railway had to take to climb and descend through the pass. Careful examination of Notman's photograph reveals glimpses of four parts of this loop. Images like this one were, of course, designed for tourists, and therefore the magnificence of both the natural and man-made worlds is brought to the fore. The contrast between the stripped areas beside the trestle and the forested slopes is striking—a contrast which, as we shall see, remains constant in much of Notman's imagery.

Two other photographs by William Notman are equally striking from the point of view of framing the subject, or perhaps one should say not framing

fig. 1 Oliver B. Buell, *C.P.R. Track and Log Cabins at Lake Louise, Alberta*, 1885

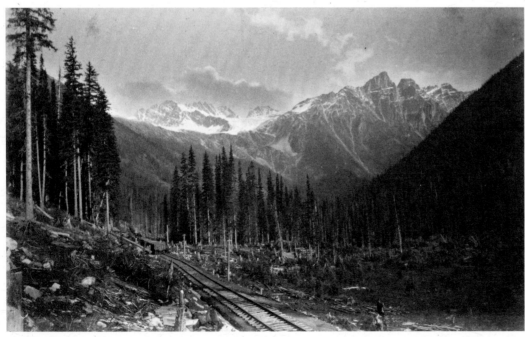

fig. 1

the subject. In each case the presence of the railway line is of major importance within the composition. In *Glacier Range, from Summit* (cat. 87), the glacier is an evanescent presence in the image, which presents a dark, ravaged landscape in the foreground. There is, at least to modern eyes, a striking disconnect between the title of the photograph and what we actually see. While we might imagine journeying to the distant peaks, the railway itself insistently drags the eye toward the right. *The Glacier, Mt. Sir Donald and C.P.R. Hotel* (cat. 89) is equally striking. Once more, the main subject of the work, far from being any of the natural or man-made features mentioned in the title, is the ravaged landscape in the foreground. Although it is unlikely that Notman intended to comment on the despoliation, it is hard to imagine how he could have been more successful if he had. It is also clear from such photographs why painters proved to be so important for the CPR: the focus of much of their work shifted from the railway in the landscape to the landscape itself.

John Arthur Fraser, who had been a partner of William Notman earlier in his career, visited the Rockies in 1883. By 1885 however he had left Canada and was living in Boston. He had met CPR general manager Sir William Van Horne in 1884 and the following year painted a small group of watercolours for him based on western landscape photographs taken by Alexander Henderson. Pleased with Fraser's work, Van Horne and CPR president Sir George Stephen commissioned three watercolours from him for the

1886 Colonial and Indian Exhibition in London. Since the exhibition opened in May, Fraser again relied on photographs as his source. We know that he was provided with photographs by both Alexander Henderson and Oliver Buell in order to complete this work. He first produced a watercolour, *The Rogers Pass*, 1886 (not reproduced), and then essayed the canvas *At the Rogers Pass, Summit of the Selkirk Range, British Columbia* (cat. 38).[5] The most likely source for the watercolour (and the subsequent canvas) is a photograph by Buell, *C.P.R. Track and Log Cabins at Lake Louise, Alberta* (fig. 1). While the photograph shares a similar vantage point with Fraser's canvas, the two views are strikingly different.

Buell's photograph, like those of Notman, places the railway securely in the centre of the image. Much of the foreground is denuded of trees. In their place we see stumps, rock and slash. In the middleground, the row of evergreens at the edge of the swath of destruction is sliced by the railway line. The title of the photograph highlights the location, the direction that we are looking and, of course, the presence of the railway ties. The composition begins abruptly and gives essentially equal visual weight to the foreground and the mountains beyond. The image seems neither to celebrate nor to decry what it records.

Fraser's painting takes the same subject matter and transforms it. *At the Rogers Pass* is almost ecstatic in tone. The image shifts relationships of scale and light, and removes all traces of the railway itself. The space has been compressed and the mountains

raised, and one can easily imagine that the few fallen trees in the foreground occurred as a result of natural processes rather than human endeavour. Dennis Reid has commented that Fraser's *At the Rogers Pass* and *Mount Baker from Stave River, at the Confluence with the Fraser on Line of CPR* (cat. 42) both retain "in their naturalistic handling of light, and in their direct, candid compositions something of the immediacy of his watercolours."[6] This immediacy and the sense of awe the work conveys are all the more remarkable because the painter almost certainly did not visit the site until later in 1886, when he travelled west on a second trip, this time commissioned by the CPR. Fraser was the first artist to be given a pass on the new railway, perhaps a measure of how highly his work was regarded by Van Horne and Stephen.[7]

Based on a watercolour now in a private collection, *Mount Baker* is one of Fraser's most satisfying and striking western images. The watercolour may have been begun in the field but was almost certainly finished in the studio. There seems to be no nineteenth-century photograph of this spot but this may be explained by the difficulty of capturing the distant peak on a glass plate and the fact that Mount Baker itself is often obscured by mist. In any case, the watercolour and canvas are both, as Kollar has commented, "broad, airy" compositions. The relatively abrupt foreground and the highly coloured distant landscape, complete with a somewhat enhanced Mount Baker, tend to counter Fraser's testimony that the watercolours he exhibited in New York in March 1887 "were begun and finished,

fig. 2 Burkewood Welbourn, *Mountains in the Rockies, British Columbia*, 1907

fig. 2

as far as you see them, out of doors, and in view of the subjects and objects depicted."[8] The important thing is that the image has the feel of truth, and the artfully placed canoes crossing the river suggest a land that is exotic, exceptionally beautiful and now, thanks to the CPR, accessible.

A similar sense of dramatic romance pervades Frederick Marlett Bell-Smith's canvas *Coming Storm in the Rockies* (cat. 39). Bell-Smith, who had first gone west on the CPR in 1887 (returning in 1888, and nine more times, including a trip to Lake Louise in 1889 with Albert Bierstadt), responded instantly to the landscape of the mountains. While inspired by the Rockies, he was far from a documentarian. John E. Staley described Bell-Smith's method in a remarkable essay, "The Premier Painter of the Rockies."

Rarely Bell-Smith paints from Nature: his "Rockies" are too tremendous, but, at the same time, absolutely inspiring. The fleeting effects of atmosphere cannot be fastened down there and then. A glimpse is sufficient for the execution of his scheme: he paints best with closed eyes—so to speak—in the dark room of his studio, for he paints there what he feels. Variations in effects of atmosphere are like zephyrs which move capriciously the foliage of the

trees. The contours and colors of Nature's shrines are ever changing—sometimes dissolving like iridescent bubbles: at others floating hither and thither incontinently like lightest feather-down. All this is surely true of the delicious poetry of painting! Bell-Smith's canvases express together the epic and lyric measures he has learned so well in the glorious mountain sanctuaries.[9]

It is hard to imagine a journalist describing a photograph with such hyperbole! Bell-Smith's work is patently staged and a search for comparable photographic imagery yields only works such as Burkewood Welbourn's *Mountains in the Rockies, British Columbia* (fig. 2). Although remarkably similar in composition, it shows none of the drama, none of the passion of Bell-Smith's imagery, and this surely is the point. The early photographic record could not hope to supplant the grandeur and power of painting and this is why works such as *Coming Storm in the Rockies* remained central to our understanding of the Rockies well into the twentieth century.[10]

The early work of Emily Carr is particularly interesting in relation to how photography was considered. Following a period of study in France in 1911, Carr returned to Canada and in 1912 produced an important body of work in which she sought to document some of the totemic art of the First Nations of British Columbia.

On her way north she visited Alert Bay, a well-known tourist destination, and in the summer of that year spent some time in Haida Gwaii (the Queen Charlotte Islands). Three of the canvases which resulted from this trip, *Totem by the Ghost Rock* (cat. 68), *Tanoo, Queen Charlotte Islands* (cat. 69) and *Indian War Canoe (Alert Bay)* (cat. 70), provide interesting comparisons with photographic records of the locations she visited. Carr did little sketching in oil while on this trip, working for the most part in watercolour and pencil. While these paintings have come to be regarded as fine examples of her work, as documentation, which was one of Carr's primary intents, they were and are a failure. An unattributed photograph, *Totem Poles at Skedans* (fig. 3), depicts the subject of *Totem by the Ghost Rock* and reveals the liberties Carr took. She eliminated some poles and moved others, adjusted the scale of the totems and diminished the landscape itself, collapsing the pictorial space. She used similar licence in *Tanoo, Queen Charlotte Islands*. A comparison of *Artist Emily Carr on the Beach at Tanoo* (fig. 4) with the painting reveals that Carr again brought the totems forward, making them more immediate and the setting more dramatic. A photograph by Richard Maynard, *Alert Bay (Photographer's Portable Darkroom on Left)* (fig. 5) shows that Carr took even greater liberties in *Indian War Canoe*. In the painting, the village is confined to the distance and the canoe itself assumes the dominant role in the composition.[11]

The railway opened the Rocky Mountains to a whole variety of painters, including John Singer

fig. 3 Anonymous, *Totem Poles at Skedans*, 1901 **fig. 4** Anonymous, *Artist Emily Carr on the Beach at Tanoo*, 1912

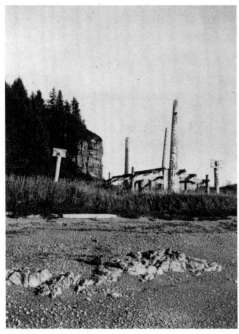

fig. 3

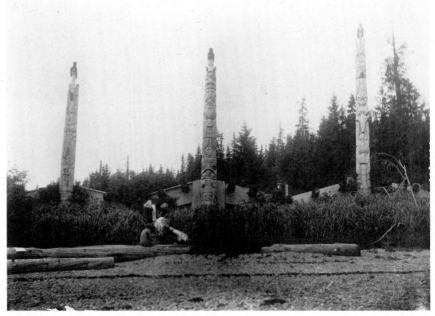

fig. 4

Sargent whose trip to the Rockies in 1916 resulted in a small but wonderful group of paintings.[12] *Tents at Lake O'Hara* (cat. 115) depicts perhaps a member of Sargent's party, seated with his back turned toward a campfire, with two tents behind. An almost solid band of trees in the background forces our attention to the tents and the camper. The whole work is flooded with light, and Sargent's quick touch and close focus give the work a striking immediacy and intimacy. Interestingly, William Notman's *Laughing Falls Camp, Yoho Valley, British Columbia*, 1904 (not reproduced), also shows two tents and a campfire, though the campers are on horseback. Not unlike the Sargent painting, the trees are cropped at the top of the composition and at either side. However, Notman's photograph conveys none of the sense of immediacy and intimacy so pervasive in Sargent's work. Far from being drawn into the space of the photograph, we remain distant spectators.

A similar parallel may be drawn between Sargent's *Yoho Falls* (cat. 117) and Notman's *Twin Falls, Yoho Valley, British Columbia* (fig. 6). While *Twin Falls* is a fine dramatic image—the tree in the left foreground seems to spring up directly from under the viewers' feet—again one does not feel engaged. One is looking at a distant spectacle rather than experiencing nature. Sargent's *Yoho Falls*, on the other hand, distills the drama of the falls into a tight, almost claustrophobic composition.[13] The eye cannot escape the power of the falls. The contact is immediate, nearly tangible. We can imagine ourselves getting wet. We are part of

the composition rather than simple spectators and we know instinctively that Sargent was there on site.[14]

Photography and painting contributed greatly to an appreciation and understanding of the landscape in British Columbia in the late nineteenth and early twentieth centuries. The Canadian Pacific Railway provided an important impetus to the photographers and painters who explored the region. However, their goals were often quite different. While photographers provided invaluable factual records, painters often enhanced these realities in search of a richer truth. As Allan Pringle has pointed out, the painters were "to first paint those images which would best flatter the CPR and promote tourist traffic."[15] Without perhaps being aware of it, later artists such as Emily Carr and John Singer Sargent continued to "enhance" the natural world and, ironically, the image they left us of this landscape is the one we now take to be authentic.

fig. 5 Richard Maynard, *Alert Bay (Photographer's Portable Darkroom on Left)*, undated **fig.** 6 William Notman, *Twin Falls, Yoho Valley, British Columbia*, 1904

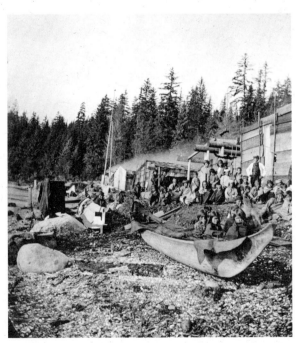

fig. 5

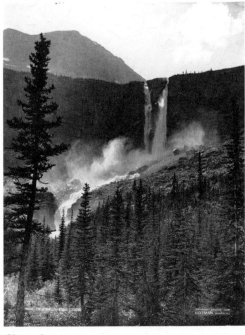

fig. 6

**** * * ***

1 Works from the present exhibition as well as from three Canadian collections are examined: The British Columbia Archives, Royal British Columbia Museum, Victoria; The Notman Archives, McCord Museum of Canadian History, Montreal; and The National Gallery of Canada, Ottawa.

2 For a discussion of the CPR's role in the development of nineteenth-century Canadian art see, among others, Dennis Reid, *Our Own Country Canada* (Ottawa: National Gallery of Canada, 1979); Lynda Jessup, "Canadian Artists, Railways, the State, and 'the Business of Becoming a Nation'" (PhD diss., University of Toronto, 1992).

3 Repr. in Andrew Birrell, *Benjamin Baltzly* (Toronto: Coach House Press, 1978), 136.

4 Ibid., 130–131.

5 Kathryn L. Kollar suggests that the watercolour was one of the works produced for the London exhibition.

See Kollar, *John Arthur Fraser (1838–1898): Watercolours* (Montreal: Concordia Art Gallery, 1984), 7–8.

6 Reid, 406.

7 Kollar, 8.

8 Quoted in Kollar, 8.

9 John E. Staley, "The Premier Painter of the Rockies," *Maclean's Magazine* 25, no. 2, (December 1912), 88–97.

10 Indeed, it could be argued that it took the work of the Group of Seven (Harris and MacDonald in particular) to shift the popular perception of the Rockies.

11 To Carr's disappointment, the Government of British Columbia declined to purchase them for the Provincial Museum. Maria Tippett, *Emily Carr: A Biography* (Toronto: Oxford University Press, 1979), 110–113.

12 Hilliard T. Goldfarb discusses these paintings more fully in "John Singer Sargent's Adventurous Summer in the Canadian Rockies: The Visit to the Yoho Valley in 1916," 183–188.

13 Here, one might say, we finally see a counterpart to the experience suggested by Baltzly's photograph *Forest Trees on the North Thompson River, 165 Miles above Kamloops.*

14 Sargent was indeed there. See Hilliard T. Goldfarb, Erica E. Hirshler and T. J. Jackson Lears, *Sargent: The Late Landscapes* (Boston: Isabella Stewart Gardner Museum, 1999), back cover photograph.

15 Allan Pringle, "National Park Landscape Painting and the Canadian Pacific Railway," cited in Elizabeth Brown, *A Wilderness for All: Landscapes of Canada's Mountain Parks, 1885–1960* (Banff: Whyte Museum of the Canadian Rockies, 1985), 27, n. 4.

Krieghoff, who specialized in popular Quebec genre subjects, painted at least six versions of this theme between 1859 and 1862. It is a remarkable anecdotal image of human struggle against ice floes and blockages on the upper St. Lawrence River. The surprising number of figures is explained by the fact that, during the winter, voyagers between Quebec City, located on the north shore of the St. Lawrence, and Lévis, on the south, travelled aboard the Royal Mail canoes. The boatmen commonly pushed the canoes over ice floes. One woman passenger is seen holding her lap dog.

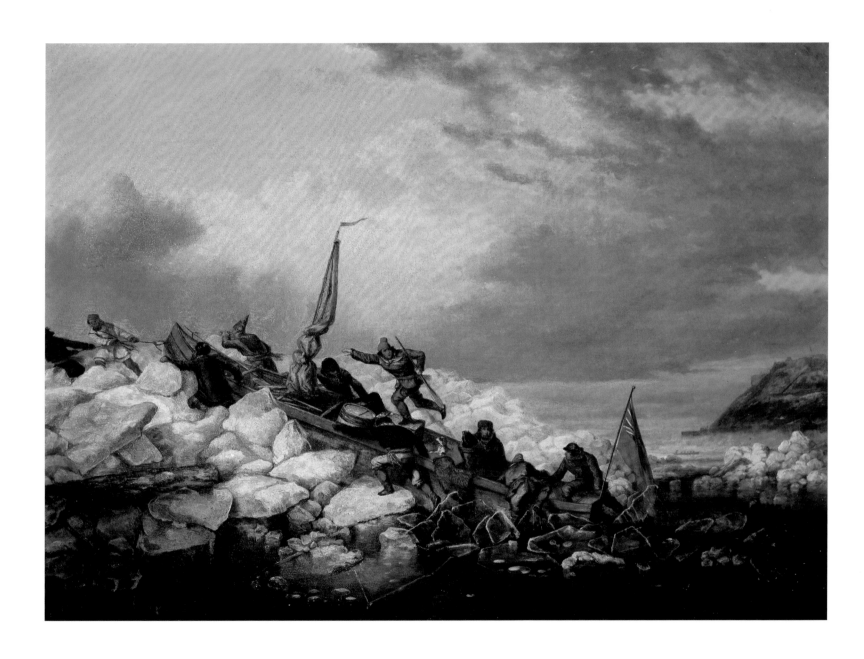

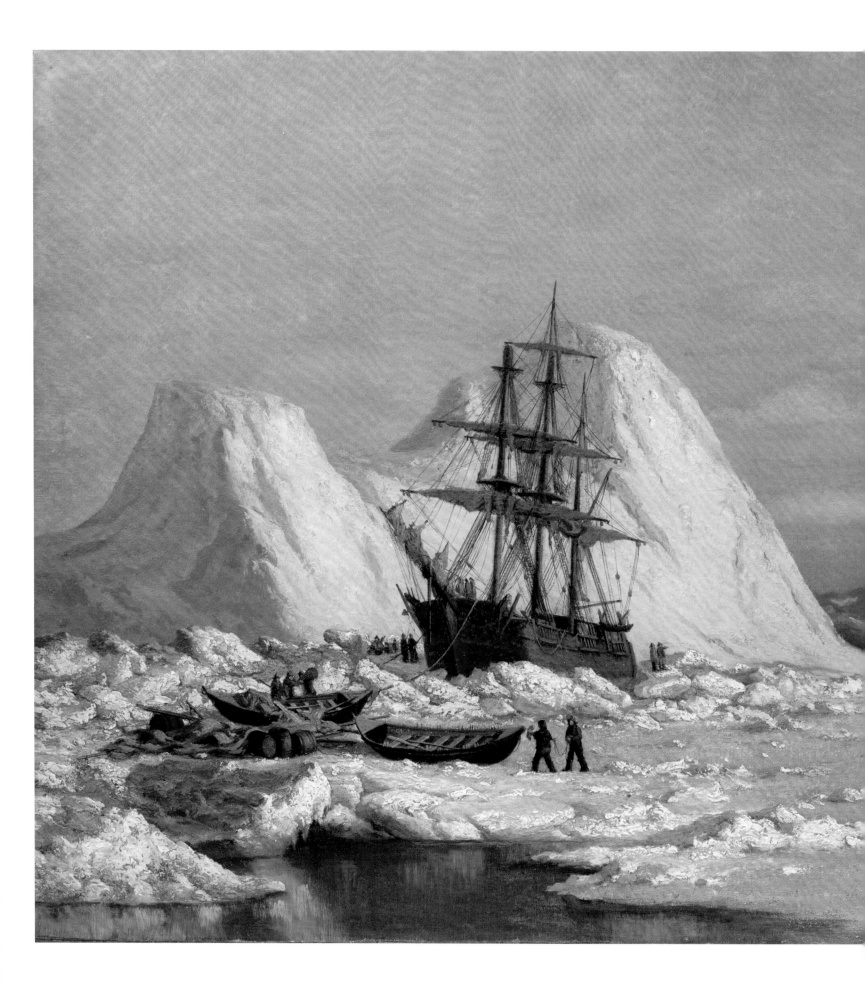

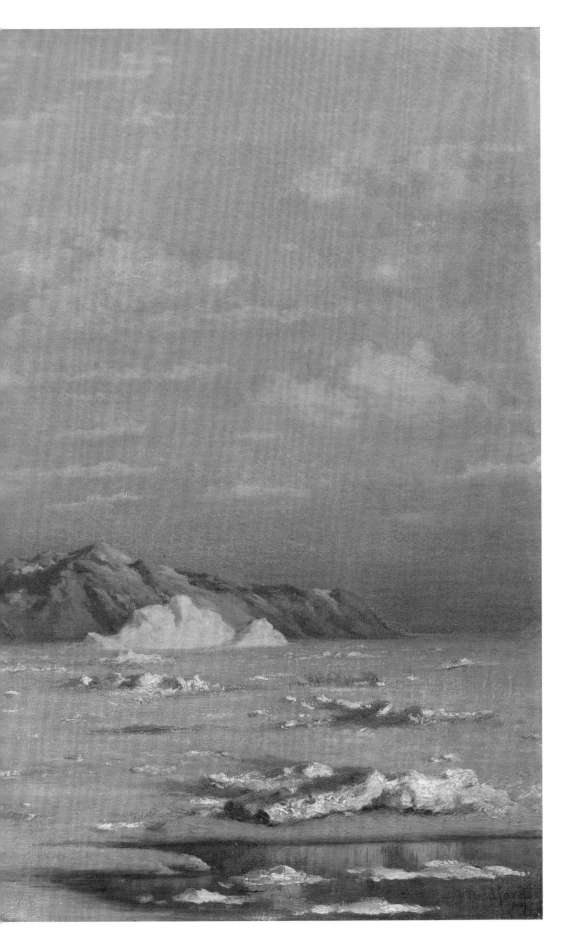

**79 William Bradford,
An Incident of Whaling, undated**

Bradford's passionate interest in the difficult lives and careers of the men centred about the Arctic was reflected in many of his paintings. In this undated work, probably completed after 1869, the artist mixed motifs from diverse sketches and photographic references, as was his custom. The ship trapped in the ice floes and the small figures of the whalers are contrasted against the solidity and scale of the iceberg.

30 John L. Dunmore and George Critcherson, under the supervision of William Bradford, The Glacier as Seen Forcing Itself Down over the Land and into the Waters of the Fiord

In the spring of 1861 Bradford first visited the Labrador coast, although he had become interested in the Arctic regions several years earlier. Of his nine trips to the Arctic, the one in 1869 proved to be the most important. Over the course of four months, he travelled along the Labrador coast and out to Greenland, encountering icebergs, polar bears, whalers, sealers and Inuit. The trip was made in the company of the scientist Isaac Hayes. Two Boston photographers, John L. Dunmore and George Critcherson, who worked directly under Bradford's supervision, executed most of the images (a third, William Pierce, who worked for the same Boston photographic firm, recorded thirteen of the images). One hundred forty-one albumen print photographs were employed in his deluxe book *The Arctic Regions* (see Pepall, fig. 4), published in London in 1873 in an edition of three hundred, one hundred twenty-five of them with original photographs. While Bradford took many sketches during the expedition, several of which were published in the book, he confirmed that he later found the photographs indispensable in executing his paintings. Interestingly, however, the artist never directly repeated any of the photographs as a painting composition. In this image, the romantic vision of Nature's sublimity and scale, emphasized by the diminutive human figure in the middleground, reflects the painter's sensibilities.

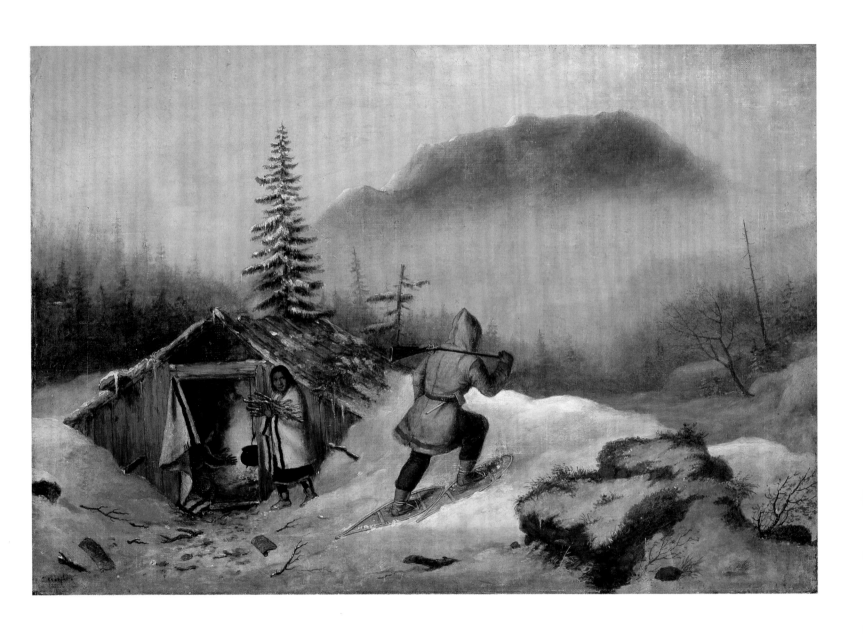

This image of an Aboriginal family in winter, the husband venturing out in his snowshoes to hunt, appears to be situated in the district of Lake Beauport, a mountainous area just north of Quebec City.

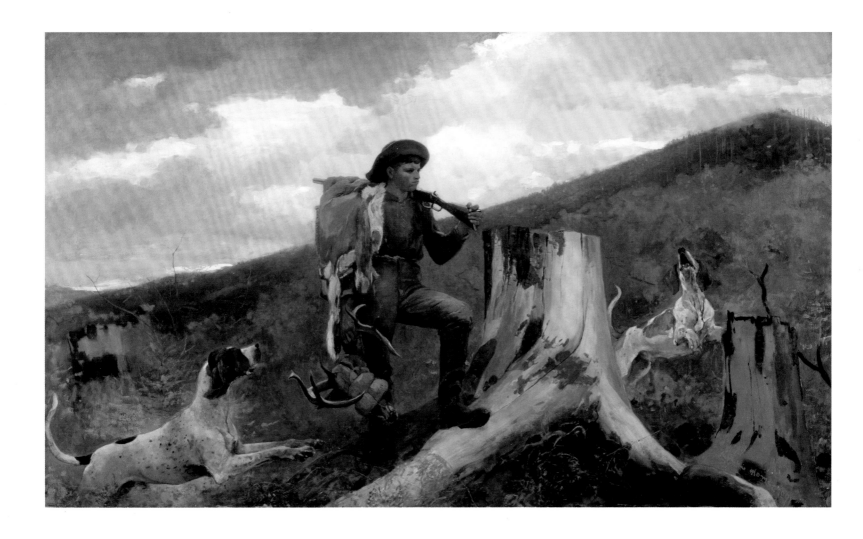

A Huntsman and Dogs comes out of Homer's own experience in the northern Adirondack woods. As in other works of the artist's later period, the structure of the composition is strongly influenced by the Japanese colour woodblock prints of Hokusai, evident in the diagonal mountain profile against the foreground figure of the returning huntsman, his head silhouetted against the sky, and the cropping of the right edge of the canvas just beyond the mountain peak. The cold, unsentimentalized view of the rough rural hunter, with his baying dogs and a deer carcass slung over his shoulder, seemed harsh to contemporary viewers. One critic attacked the painter for his treatment of the huntsman as "low and brutal in the extreme," as a "sort of scoundrel ... who hounds deer to death up in the Adirondacks for the couple of dollars the hide and horns bring in."

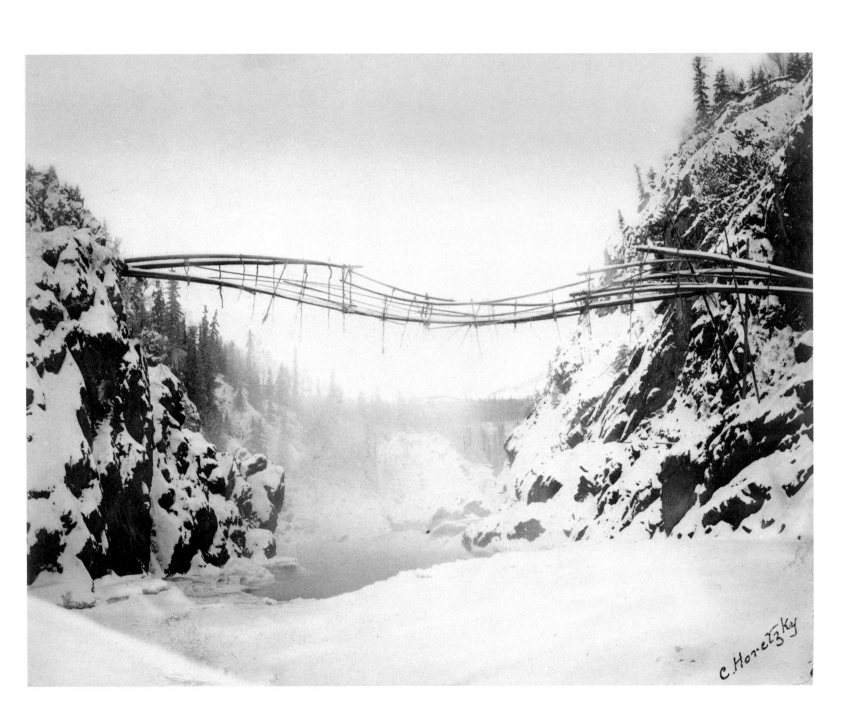

This site is in British Columbia. Although Horetzky ceased working for the Canadian Pacific Railway Survey in 1881, after persistent arguments with management regarding proposed rail routes, the Western frontier and the Northern Rockies continued to fascinate him.

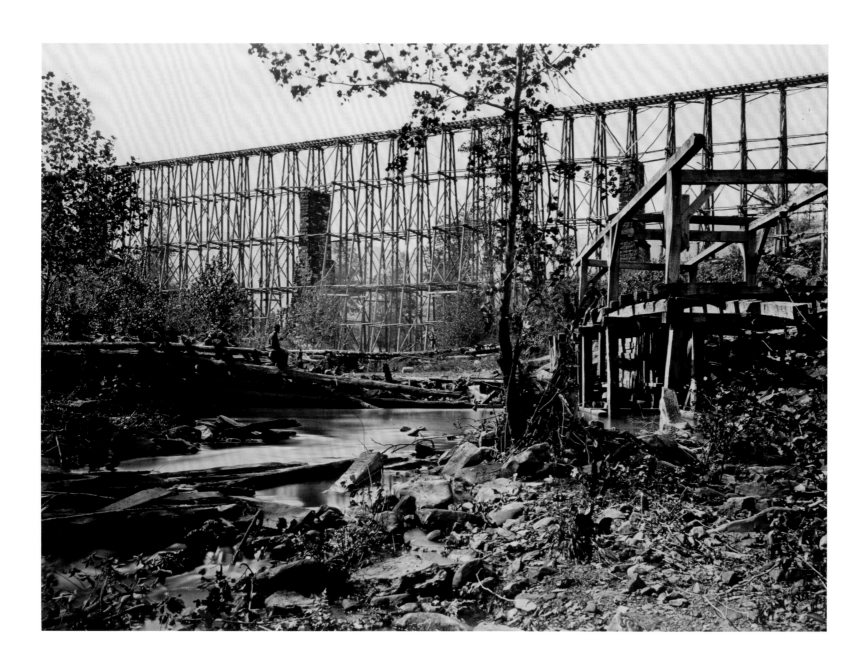

Taken in 1864 as part of the series of photographs that would be published in 1866 as *Photographic Views of the Sherman Campaign* (see cat. 53), this image shows a newly constructed four-tiered, 240-metre-long railroad trestle bridge built by the Union engineers at Whiteside, Tennessee. A guard camp was set up along one of the riverbanks.

85 Jasper Francis Cropsey, Study for Starrucca Viaduct - Autumn, mid-1850s - early 1860s

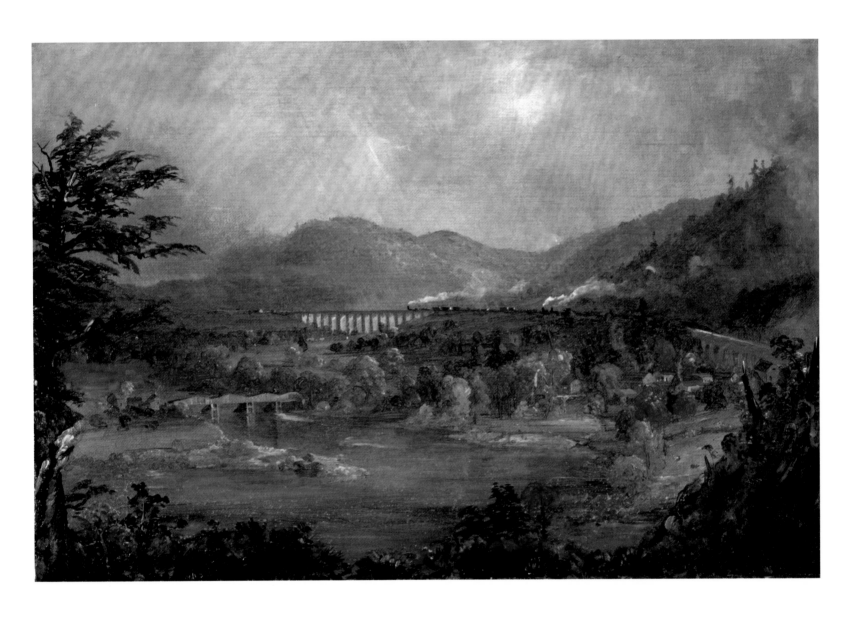

This vibrant, little-known oil sketch is closely related in composition to Cropsey's famous painting *Starrucca Viaduct, Pennsylvania*, 1865 (now at the Toledo Museum of Art). In fact, the artist executed at least four paintings of the subject around 1864–1865. The date for this work, however, remains conjectural, and it could have been created any time between the mid-1850s and early 1860s. The viaduct, 317 metres long and 30 metres high, with 17 supporting arches, had been constructed for the New York and Erie Railroad in 1848. While Cropsey shared the Hudson River School's vision of the sublimity and harmony of Nature, he was also capable of expressing the wonder of Man's achievements within it. In this sense, there is an almost Claudian character to this pastoral panorama, replete with railroad and steam locomotive. Technological advances are depicted as integrated within the natural order, without detracting from its surroundings. Indeed, the work implies Divine benediction upon America's accomplishments. This is expressed through the use of several devices, including the dominating colour harmonies, encompassing both the viailroad and the autumnal mill̇sides; the distant view, with its curved, horizontal sweep, corresponding to the curve of the land around the river bank; and the relatively small scale of the immense viaduct. Only the train smoke, itself puffy white and cloud-like, asserts distinctive human accomplishment.

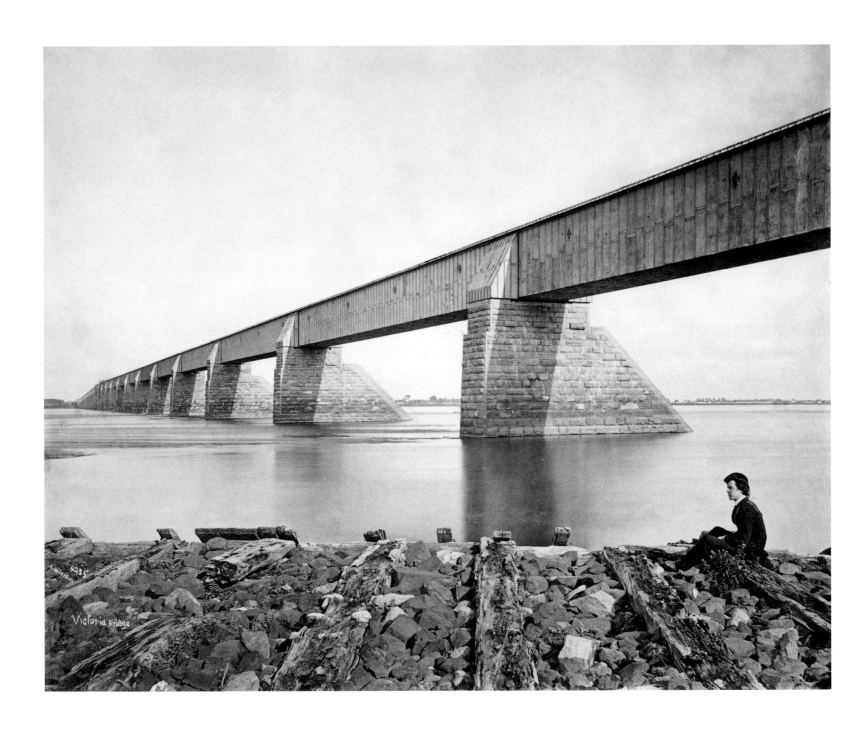

The construction of the Victoria Bridge, which crosses the St. Lawrence River at Montreal, connecting the island with the South Shore, began in 1854 and was completed in 1859. Created as part of a two-thousand-kilometre route from Sarnia, Ontario, to Portland, Maine, the three-kilometre bridge rests on twenty-four stone piers. In the summer of 1860, the Prince of Wales visited Montreal and formally inaugurated the passage, although the first train had actually crossed the previous November. The longest in the world at the time, the bridge (then covered) was considered an engineering marvel. Nonetheless, its design rapidly proved to be obsolete and its route unprofitable. In 1897 the bridge was substantially renovated and remains in use, now serving both as a roadway and for railway connection to Halifax.

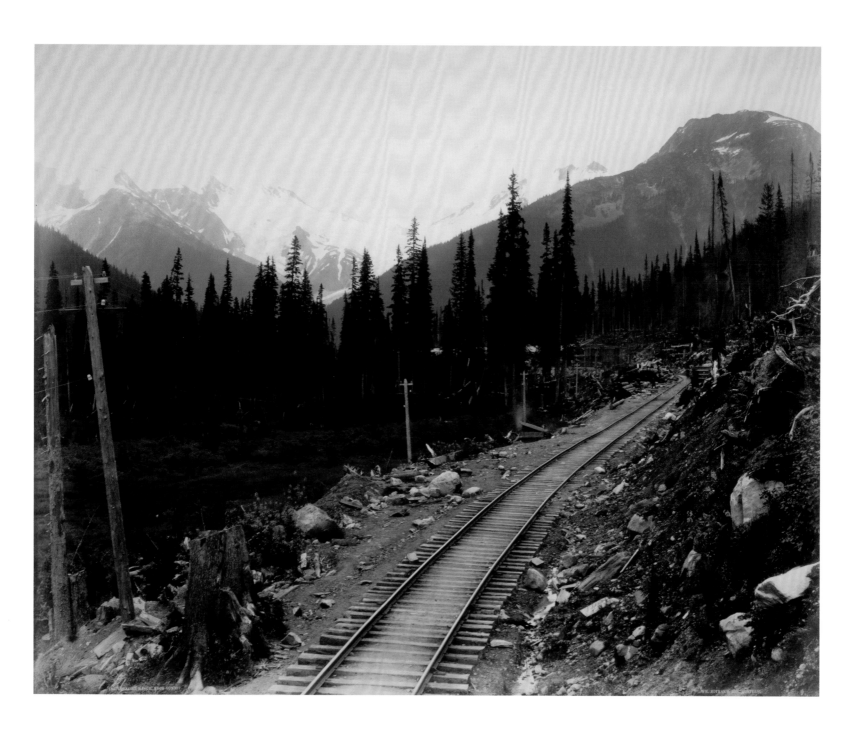

British Columbia had been brought into Confederation in 1871 with the promise of a transcontinental railroad, and the construction by the Canadian Pacific Railway began in 1881. By 1885 a connection between Ontario and the coast of British Columbia at Fort Moody had been achieved. The track was extended to the newly incorporated city of Vancouver in 1886, as the western terminus of the line. In 1889, completion of a connection with Maine established the CPR as the first transcontinental railway company in North America. Through the construction of the railroad, Canada confirmed its claim on all land north of the fiftieth parallel against the United States' territorial ambitions. The process tore through virgin forests and the untamed wilderness of western Alberta and British Columbia.

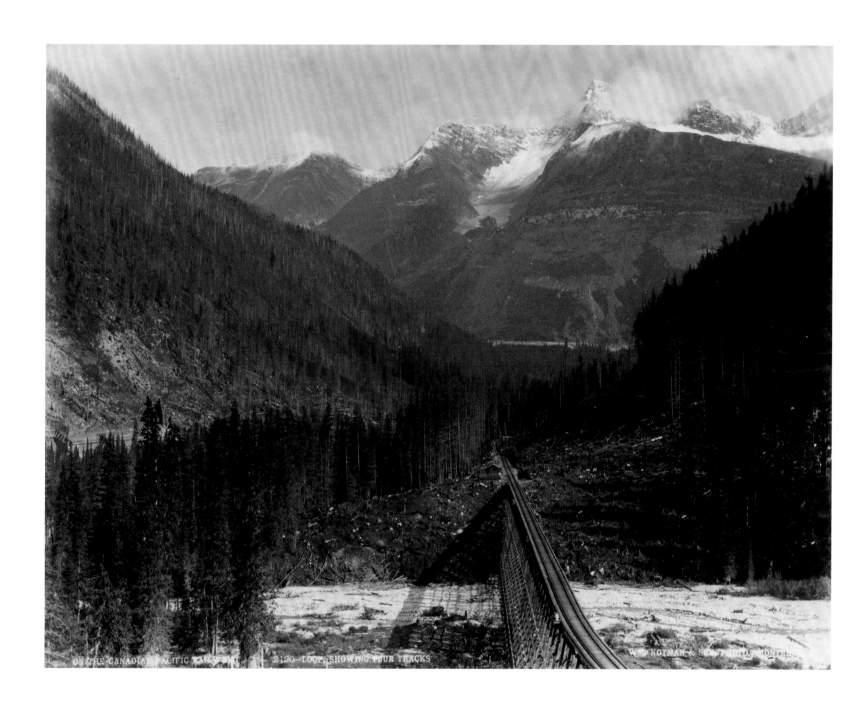

89 William Notman, The Glacier, Mt. Sir Donald and C.P.R. Hotel, about 1887

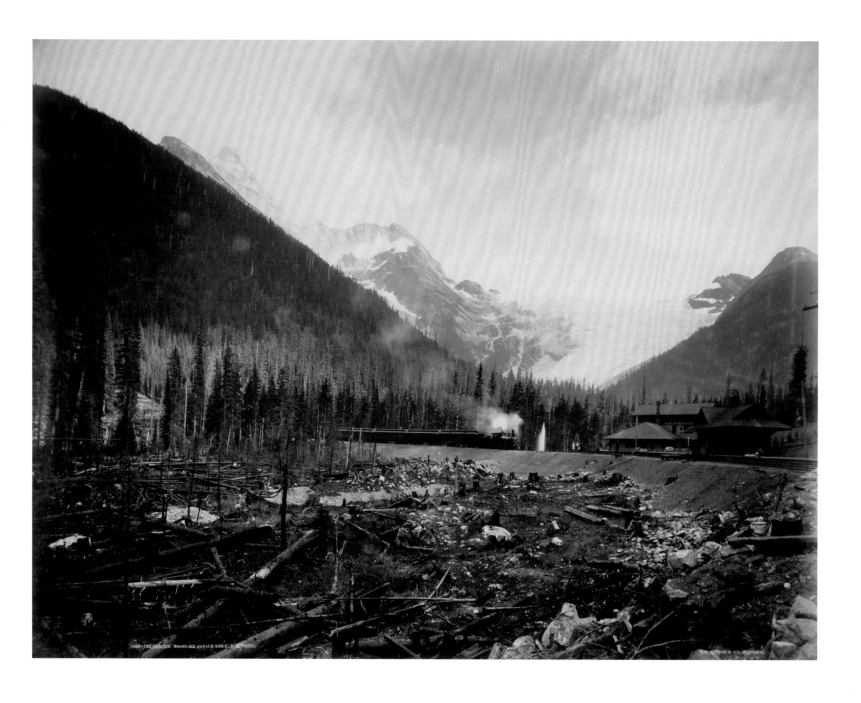

From the outset, railway officials recognized the potential of gaining access through the Rocky Mountains, not only for its commercial possibilities and the opening of the West to development but also for the establishment of tourist destinations. Notman, for his part, recognized the potential for dramatic images of a magnificent and unfamiliar Canadian frontier for clients on the East Coast, as witnessed by his underwriting of the costs for the presence of photographers during the surveying and construction of the railway, including Benjamin Baltzly. The achievement was extraordinary, considering the extreme climates, rough conditions and bulky wet-collodion-process equipment required.

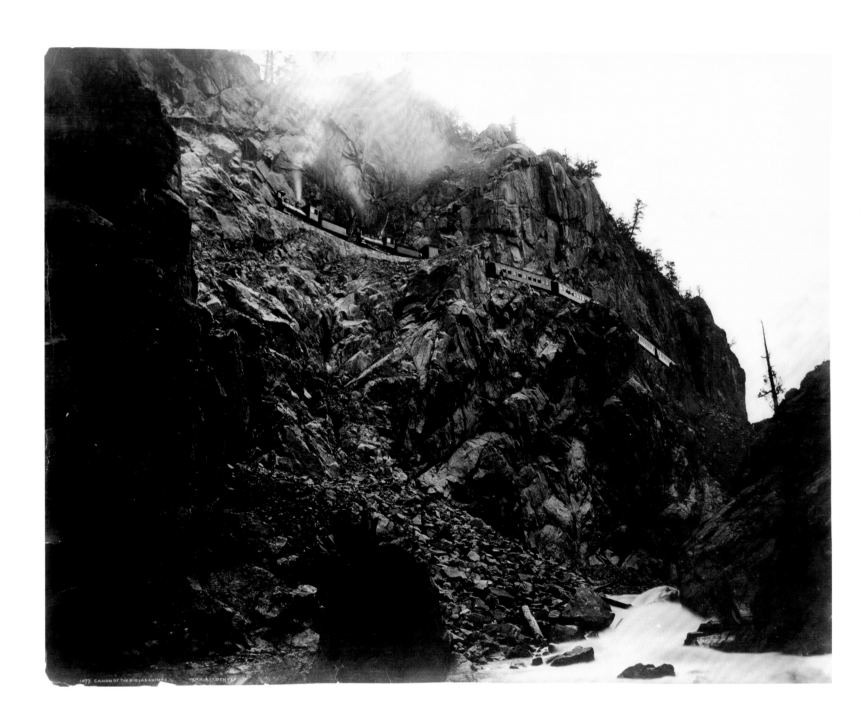

Jackson's photograph was among those published in the 1880s by the railway companies, anxious to encourage tourism with dynamic and picturesque imagery. By this time, the main rail connections between the coasts were being completed and trunk lines to new areas of settlement and potential tourist venues were being laid. During this decade Jackson came to specialize in rail images, travelling sometimes with his friend, the artist Thomas Moran. With an open travel pass and private car on the railroads, the photographer captured a wide range of subjects, which he then printed in large formats for exhibition in train stations, railway offices and travel offices, and in smaller formats for sale to individuals. This dramatic photograph, taken in the summer of 1882, records a turn along the Las Animas Perdidas River in southwestern Colorado, the train seemingly teetering along a sheer cliff. The powerful puff of steam from the engine confirms the conquest of natural obstacles by human ingenuity and the carriage windows suggest magnificent panoramas permitted by modern rail transport—the promise of secure, comfortable travel yet excitement and novelty to lure the East Coast tourist.

91 Darius Kinsey, Four Logs from One Fir Tree Scaled 27,000 Feet.
Cherry Valley Timber Co., Stillwater, Washington, about 1918

8963
144B. Four logs from one fir tr

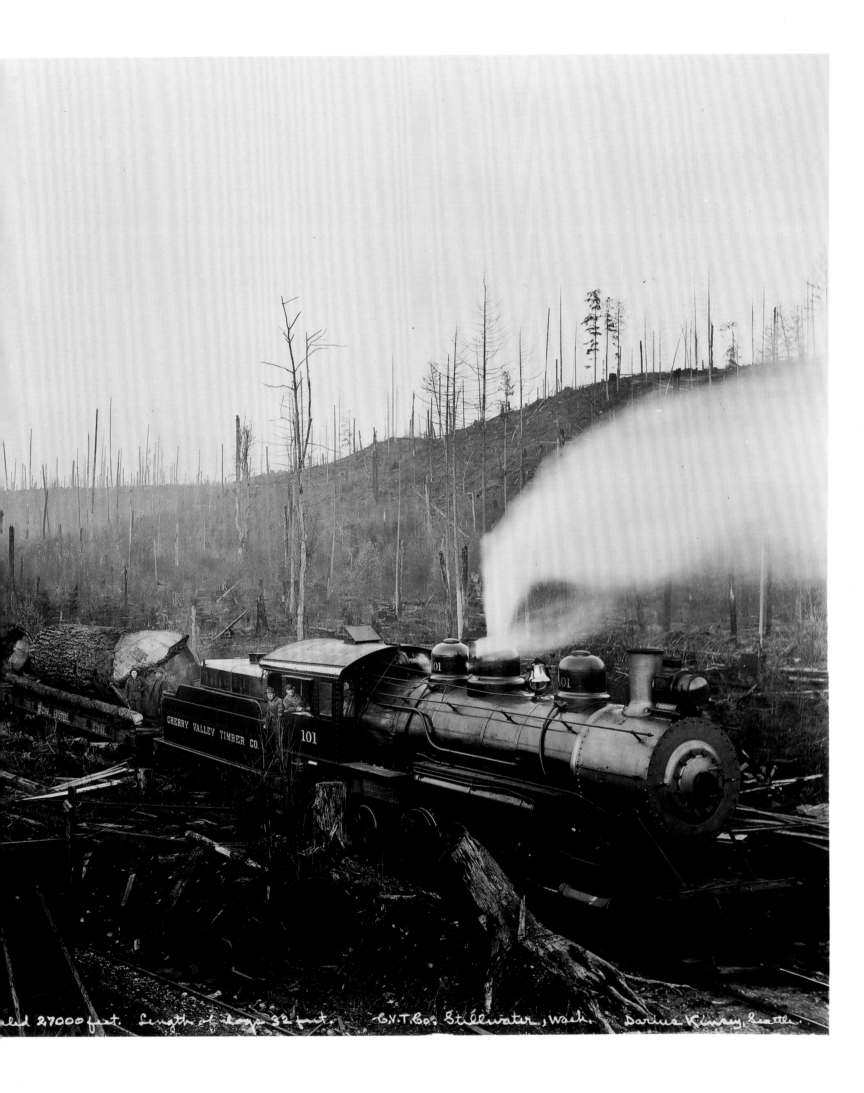

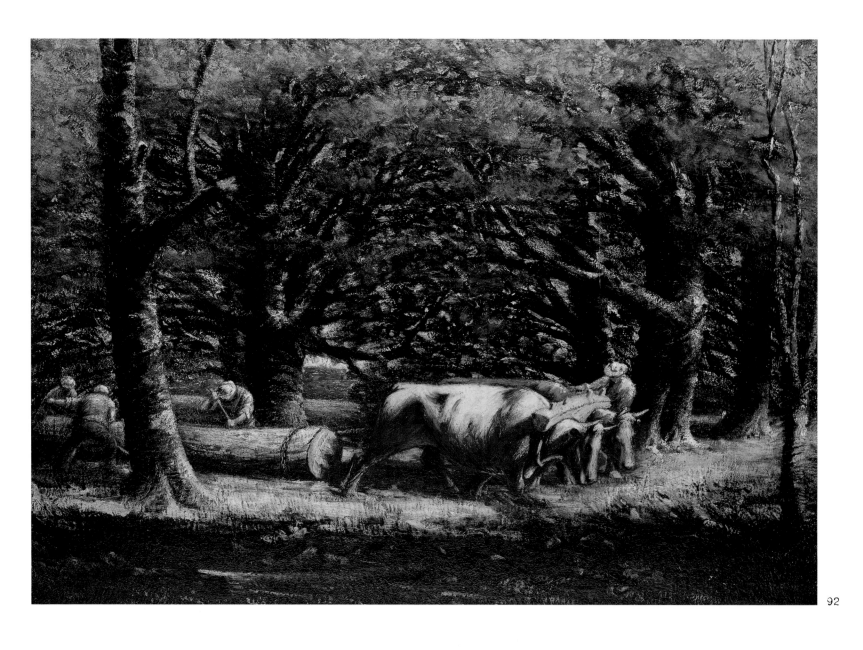

92 Homer Ransford Watson, The Loggers, about 1902

Watson was influenced both by the Barbizon School in France and the American artist George Inness. *The Loggers* marks a development in his work from earlier landscapes of Nature itself to later, more densely populated landscapes that incorporate active narratives. Images of the traditional rural labours taken from the Ontario countryside become elegies to the nobility of such work, set here beneath the arching embrace of a bower. Such comforting images of the lower classes were highly sought after among collectors in Montreal and Toronto society.

OPPOSITE

93 Darius Kinsey, Three Loggers Felling a Fir Tree, Washington, 1906

Kinsey was one of the outstanding photographers of the Pacific Northwest logging industry. He had moved from Missouri to Washington State in 1889, at which time he began his photographic career. Together with his wife, Tabitha, whom Kinsey met at a logging camp and who became his photographic printmaker, they created an enormous archive of thousands of images devoted to logging and its culture. In 1906 the Kinseys established their studio, Timber Views Company, in Seattle, creating photographs of remarkable clarity, subtlety of tone and compositional structure. The Kinseys worked out a production process they followed well into the twentieth century: he would expose the glass plate negatives at the isolated sites, using his large Empire State camera and special tripods, and take orders from the loggers. At the end of the day he would send the negative plates to his wife for development and mounting, then sell the prints (at the price of fifty cents per print) at the logging camps. Kinsey was popular with the loggers over the course of many years. His photographs were appreciated not only for their portraiture of individual loggers and of their labours, but also for their dramatic compositions and anecdotal themes.

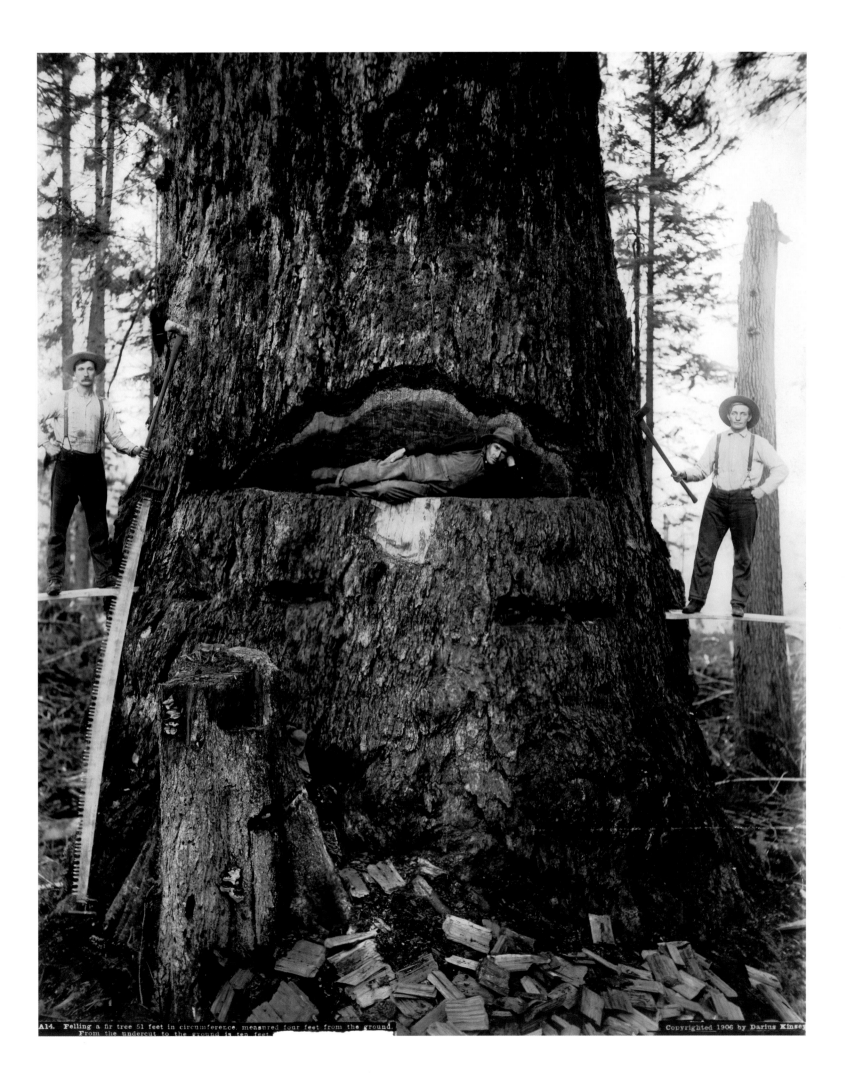

A14. Felling a fir tree 51 feet in circumference, measured four feet from the ground. From the undercut to the ground is ten feet.

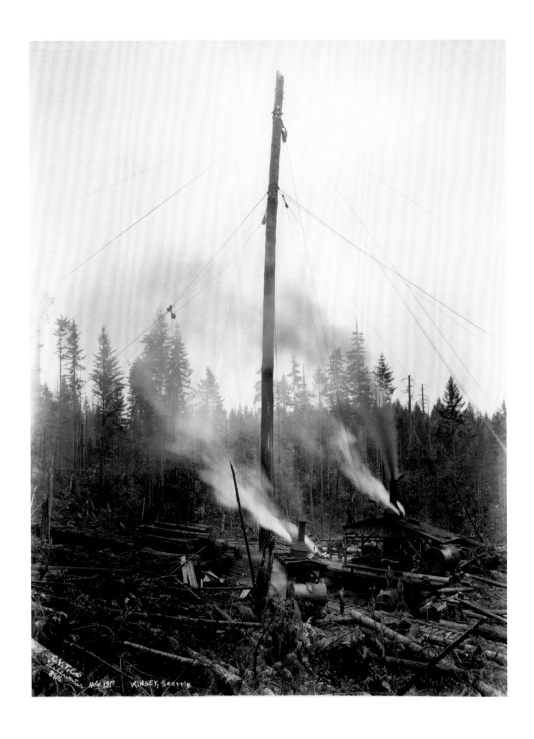

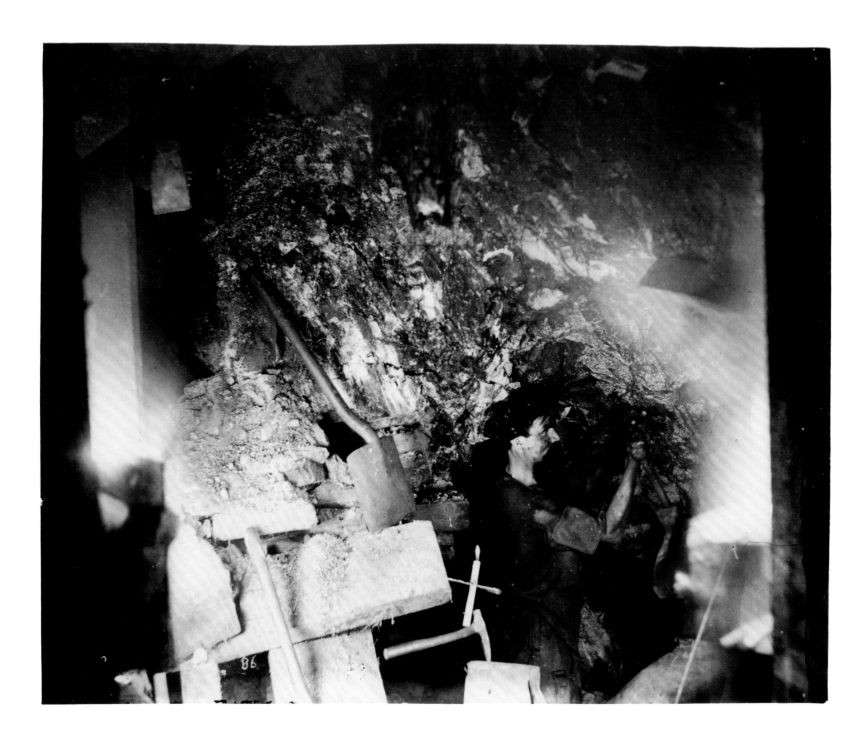

While working with the geological surveys, O'Sullivan shot images at once geologically informative and aesthetically dramatic, emphasizing the grandeur of untamed Nature and the great promise of westward expansion. This image was directed to a distinct and commercially focused audience. The first major vein of silver ore in the United States was discovered in Nevada (then part of western Utah Territory) in 1858. The discovery created a sensation in California and soon throughout the Union. The result was a stampede of prospectors and the opening of mining camps throughout the region. Pursued to a depth of a thousand metres, the deposits afforded great wealth, estimated at four hundred million dollars in silver and gold. In 1867 O'Sullivan was appointed official photographer to the US Geological Exploration of the Fortieth Parallel under the supervision of Clarence King. It was at the beginning of the expedition in Virginia City that he created this photograph. His recent Civil War battlefield photography experience certainly aided him in creating this trenchant, even brutal image, which he took with cumbersome equipment in the confined space of the mine shaft. After about 1874, the deposits began to dwindle. Mining in the region effectively ceased in 1878.

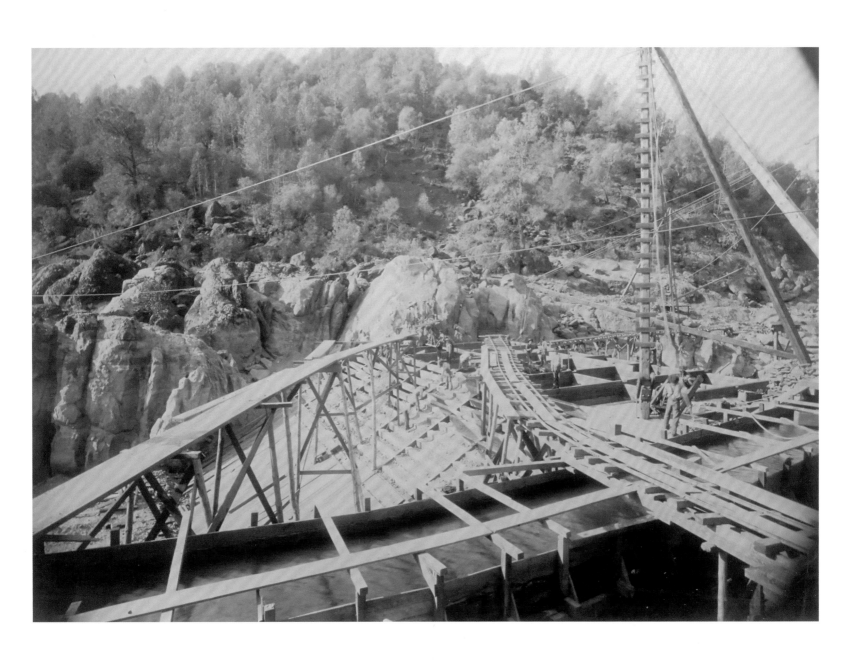

In 1891, Watkins undertook his last commercial project, photographs of the Golden Feather and Golden Gate Mines, in Butte County, California. The images were exposed onto

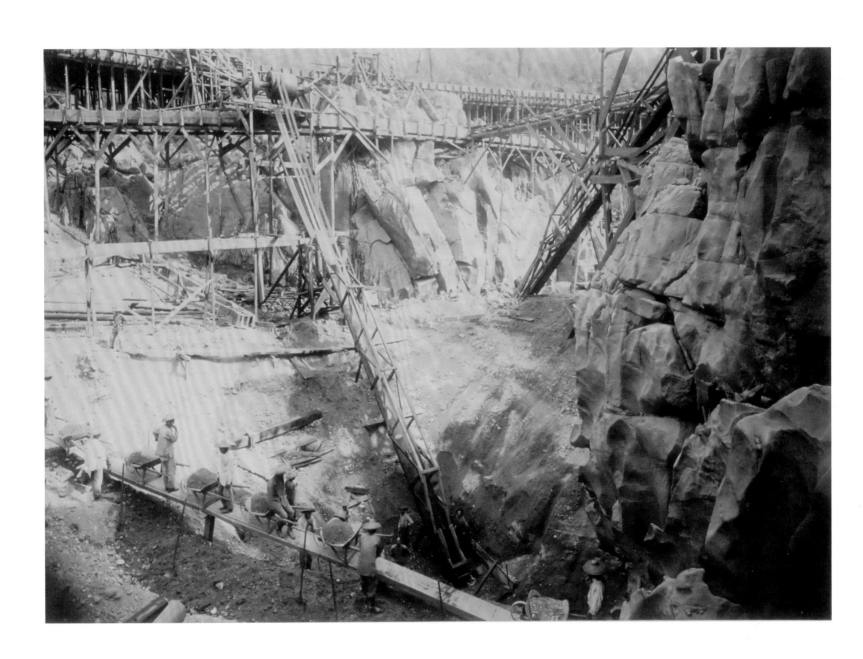

mammoth-scale collodion wet plates. His earlier experiences in documenting geodetic surveys and the Southern Pacific Railroad served him well.

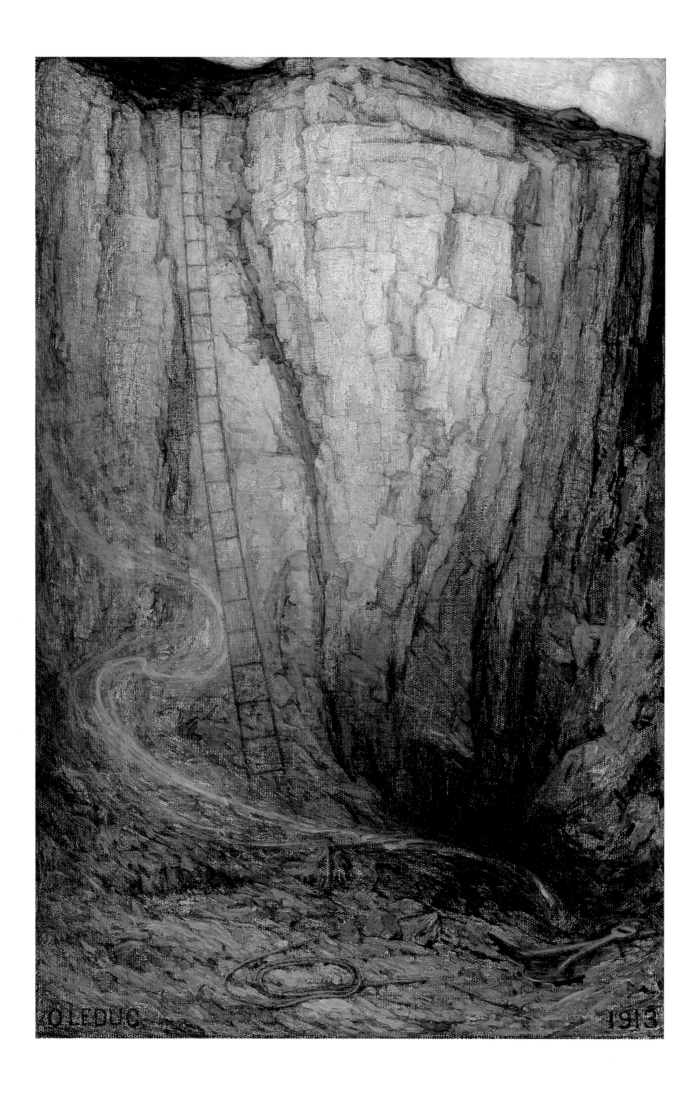

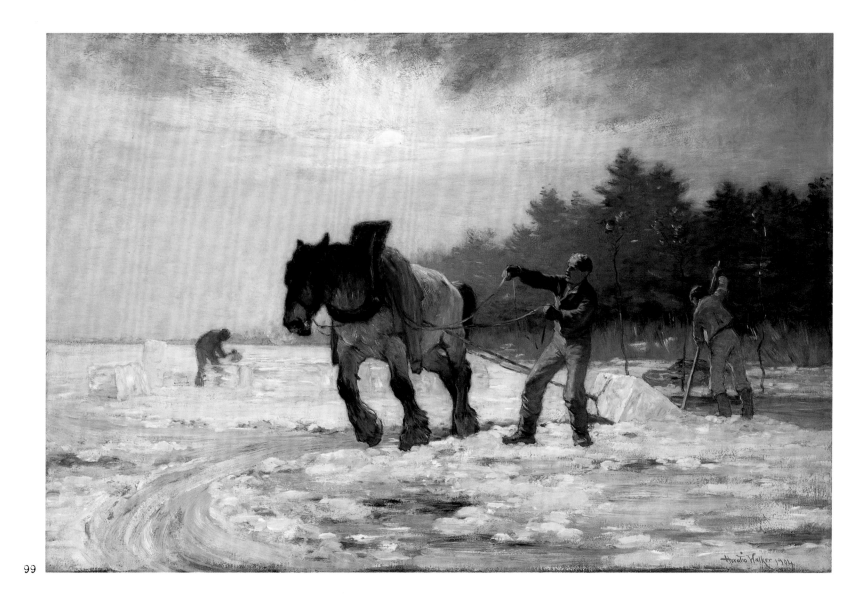

99

98 Ozias Leduc, Day's End, 1913
Leduc's profound spiritualism and symbolist leanings are evident in this painting, which also originally bore the title *The Iron Gates*. In this mysterious and disquieting composition, a rope ladder hangs down a rock or a quarry face, with shovels and mining tools in the foreground. A curious wisp of smoke, presumably from a recently abandoned fire, ascends from the hollow of the rock. The painting is derived from studies Leduc made of the Demix and Poudrette quarries, near Sainte-Marie-Madeleine, an area rich in iron and manganese deposits. The subject is symbolically one of Man's descent into the earth and the possibility of ascent from its dark realm.

99 Horatio Walker, The Ice Cutters, 1904
Ice cutting was introduced to rural Quebec in the nineteenth century. The three men are shown cutting, loading and hauling ice for storage in an icehouse. The bluish-tinged ice block, cut with handsaws and squared with axes, is carted by the workhorse. As in Homer Watson's *The Loggers* (cat. 92), Walker focuses on traditional labours of rugged rural figures, their unity of effort with the horse spiritually "exalted" under a benevolent sunlight. As Watson's paintings served an appreciative clientele in Montreal and Toronto that found comfort and social validation in images of the Ontario countryside, so Walker's focused on scenes of rural Quebec. The works of both artists are reminiscent of the evocation of ennobled peasant life found in the paintings of Jean-François Millet.

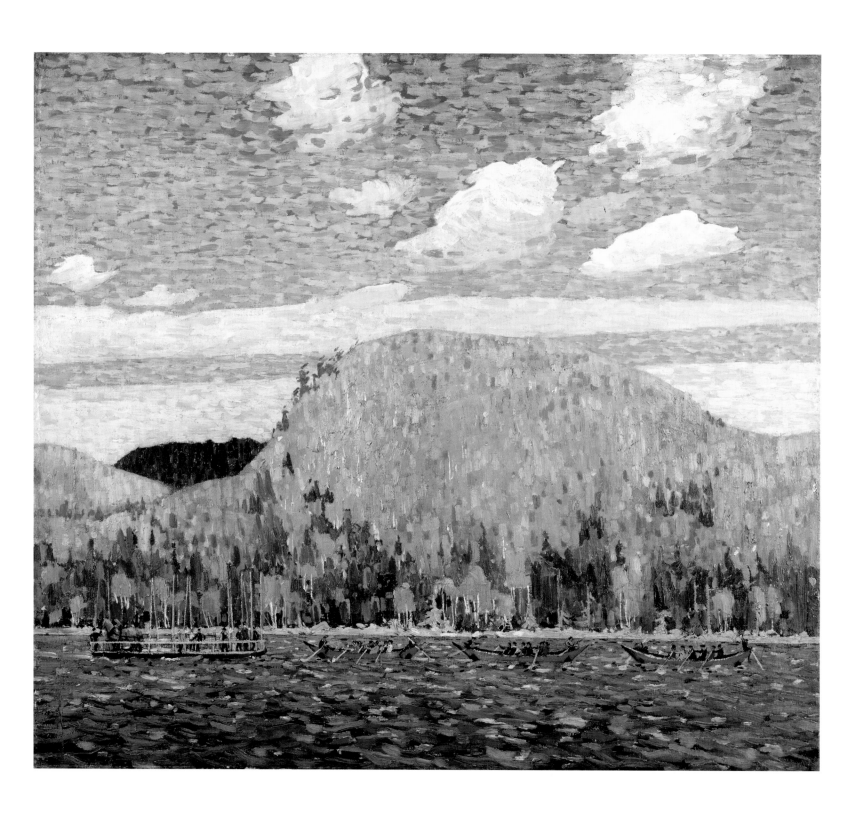

Thomson's knowledge of Post-Impressionism and use of Divisionist brushstrokes are most clearly exemplified in this painting. The artist likely became familiar with Divisionism through the art of Giovanni Segantini, whose paintings had been reproduced over a decade earlier in the widely distributed German cultural magazine *Jugend* and had earlier interested such painters as Marsden Hartley (cat. 171, 172). Pointers, or pointed-prowed portage boats, were used by the northern Ontario logging companies to carry supplies and horses to the loggers before the winter ice set in. The subject also reflects Thomson's fascination with the wilderness areas of the province. The assertive brushstrokes energize the painting, and the composition's vast expanse of sky and the dominant mound of the hill on the far shore, radiantly coloured by Nature's fall foliage, contrast both in scale and spirit with the Lilliputian efforts of Man.

NATURE

DOME
STIC
ATED

"The time will come when New York will be built up, when all the grading and filling will be done... the Island will have been converted into formations for rows of monotonous straight streets and piles of erect buildings... with the single exception of the few acres contained in the Park. Then the priceless value of the present picturesque outlines of the ground will be more distinctly perceived. It therefore seems desirable to interfere with its easy undulating outlines, and picturesque, rocky scenery as little as possible."

Frederick Law Olmsted,
designer of Central Park

Word and Image: North American Landscape in Nineteenth-century Illustrated Publications

Brian
Foss

Landscape painting was central to nineteenth-century national self-definition in the United States and Canada. It was, according to James Jackson Jarves in 1866, "the thoroughly American branch of painting."[1] Yet for much of the century, North American landscape was associated, in novels, poetry, travel narratives and tourist guides, with picturesque aesthetics informed by established European conventions that encouraged viewers to idealize, poeticize and appreciate landscapes as works of art. *The Home Book of the Picturesque: or, American Scenery, Art and Literature* (1852) was part of the deluge of material that, from about 1820, rode to popularity with the fast-growing reading public by giving verbal and visual expression to the specificities and promise of the North American landscape while situating it in familiar aesthetic categories.

Exemplary of this phenomenon were the most influential synopses of North American terrain to be published before mid-century: *American Scenery: or, Land, Lake and River Illustrations of Transatlantic Nature* (1840) and *Canadian Scenery Illustrated* (1842), the first significant overview of Canadian landscape for a mass audience. Issued in inexpensive parts that were later bound together as monographs, these publications were the work of American journalist Nathaniel P. Willis (1806–1867) and English artist William Henry Bartlett (1809–1854). Bartlett, who had previously illustrated volumes on Great Britain and Continental Europe, made on-the-spot sketches and watercolours in the United States between 1836 and 1841, and in Canada in 1838, then worked these into sepia drawings that were later transformed into steel engravings by two dozen artists. More than one hundred engravings, each occupying a full page facing the relevant text by Willis, were included in each publication.

Interest in Bartlett's illustrations was secured by his close observation and unfailingly picturesque approach to landscape and to the human activities that took place within it. In this he was in accord with painter Thomas Cole (1801–1848), who dominated the burgeoning American landscape art movement by including picturesque references in his views of the northeastern states. Both *American Scenery* and *Canadian Scenery* are replete with images of dead or gnarled foreground trees (fig. 1), for example, and with the constantly changing prospects associated with rivers, lakes, rapids and waterfalls. Indeed, despite Bartlett's loyalty to the specificities of individual locales, his North American scenes show a considerable similarity of viewpoint and composition with his hundreds of representations of European landscape.

Publisher George Virtue ensured that *American Scenery* and *Canadian Scenery*, frequently reprinted, found vast audiences on both sides of the Atlantic, and that individual prints were made available as art for the home. Moreover, Bartlett, a British citizen, had little copyright defence against the many North American companies that published versions of his images in various popular magazines and in travel literature such as *The United States Illustrated* (1855) and *Tuttle's Popular History of the Dominion of*

fig. 1 William Henry Bartlett, *The Chaudière near Bytown* (*Canadian Scenery Illustrated*, vol. 1, 1842)

fig. 1

Canada, with Art Illustrations (1877). Currier & Ives, North America's most prolific lithographic concern, also offered sentimental and generalized prints based upon Bartlett views. Bartlett's images even ruled the market for chinaware decorated with North American landscapes—a market in which Staffordshire firms were pre-eminent.[2]

However, from the 1860s onward, as North American society underwent radical growth and development, Bartlett's unindustrialized landscapes with human figures dwarfed by the scenery around them seemed increasingly anachronistic. More up-to-date representations were now available in the many illustrated magazines that exploited wood rather than steel engraving (Bartlett's medium of choice). Wood engraving allowed illustrations and text to be printed on the same plate at the same time, whereas steel engraving did not.[3] Among the outstanding American periodicals to have adopted the technique were *Harper's New Monthly Magazine* (1850–1900), *Frank Leslie's Illustrated Newspaper* (1855–1922), *Harper's Weekly* (1857–1916), *Scribner's Monthly* (1870–1881; transformed in 1881 into *Century Magazine*) and *The Aldine: The Art Journal of America* (1868–1879). These and other large-circulation serials with inexpensive subscription rates were aimed squarely at the rising middle class and were vital to the post-Civil War attempt to create an educated population that would guarantee the enlightened and democratic culture appropriate to North America. *Scribner's Monthly* alone had a circulation of more than one hundred thousand by 1880, and during that

same decade *Harper's Monthly*'s hundred and eighty-five thousand readers paid only three dollars for their yearly subscriptions.

Engravings of landscapes, originally conceived in that medium or adapted from oil paintings, appeared in the illustrated periodicals, although markedly less often than did engravings of portraits, urban scenes and military, political and social events of the day. In the United States, native scenery also vied for attention with "exotic" views from abroad. Even so, the number of published engravings of American landscapes was appreciable. High-quality images routinely appeared in *The Aldine* and prints after landscapes painted by George Inness were published in 1882, first in an April issue of *Harper's Weekly* and then in the May issue of *Century Magazine*. *Harper's Weekly* was among many to publish both American and Canadian views (the cover illustration of a February 1893 issue shows the frozen Montmorency Falls) (fig. 2), along with inhabited landscape scenes, such as Winslow Homer's portrayals of urbanites at leisure in the great outdoors. *Scribner's Monthly* was particularly noteworthy for its extensive overviews of large swaths of American geography. The magazine's April, May, June and August 1874 issues, for example, featured articles surveying scenery of the American North and South. Moreover, *Scribner's* gave substantial employment to Thomas Moran, a regular contributor to *The Aldine* (fig. 3) who would soon be famous for his paintings of the West (cat. 48). Many artists were also given the opportunity to republish their magazine work in mass-market books. Such was the

case of William Hamilton Gibson (1850–1896), whose engravings in *Harper's Monthly*, *Scribner's Monthly* and *Century Magazine* formed the basis for his *Highways and Byways, or Saunterings in New England*, published in 1883 by Harper and Brothers.

In Canada, only eight of the close to fifty illustrated periodicals founded before the turn of the twentieth century survived for five years or more.[4] None achieved the longevity and influence of their better-known American cousins, illustrations were often limited and representations of Canadian landscape infrequent. (A frustratingly rare indulgence in imagery occurred in the September, October and November 1877 issues of *Belford's Monthly Magazine*, when the editors splurged on illustrations for a three-part narrative of a voyage not in Canada, but along the Thames River, in England.) Canadian artists Henry John Sandham and John Arthur Fraser consequently spent portions of their careers in the United States, Sandham producing graphic work for *Scribner's*, *Century Magazine* and *Harper's Weekly* during the 1880s and Fraser working for *Century Magazine*. Publishers were bedevilled by Canada's small population (less than four million in 1872) scattered across a vast geographical expanse. Artists and publishers were also hamstrung by the ease with which American publications crossed the border, especially before Canada implemented a domestic periodicals postal rate of four cents per pound in 1880.

Canada's first great serial promoters of the visual were the weekly *Canadian Illustrated News* (1869–1883)

fig. 2 Anonymous, *Tobogganing at Montmorency Falls, Canada* (Front cover of *Harper's Weekly: A Journal of Civilization*, February 18, 1893) fig. 3 Thomas Moran, *Colburn's Butte, in Kannarro Canyon* (*The Aldine: The Art Journal of America*, 1874–1875)

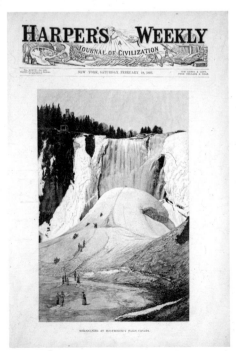

fig. 2

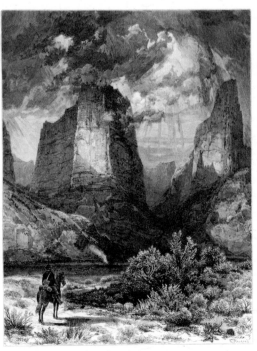

fig. 3

and its sister publication, *L'Opinion Publique* (1870–1883). Sharing illustrations and making extensive use of the new Leggotype half-tone reproduction process, these magazines featured large selections of Canadian scenery. This was appropriate for Confederation-era magazines that, as their publisher George E. Desbarats wrote, aimed to teach Canadians "to know and love [their country] better."[5] *Canadian Illustrated News'* first volume included some forty Canadian landscapes covering sites from Nova Scotia to the Northwest (fig. 4). Among them—perhaps to give readers a sense of familiarity—were several Bartletts from *Canadian Scenery*. At the same time, Christmas cards showing Niagara Falls, Montmorency Falls and other dramatic views provided what *Canadian Monthly* magazine later described as "an agreeable change from the sickly medievalism, and the tiresome repetitions of religious art, of which we have long had a surfeit from the Old World."[6] After the demise of *Canadian Illustrated News*, the weekly *Dominion Illustrated* (1888–1891) became the flagship of lavish photography-based illustration in Canadian magazines, exploiting the late-nineteenth-century fascination with the country's newly accessible western mountains.

One of the most dynamic North American illustrated magazines was *Appleton's Journal of Literature, Science, and Art*. By the early 1860s its parent firm, D. Appleton & Company of New York, had established a reputation for both popular education and luxury books filled with steel engravings borrowed from other publications. Launched in November 1870 (the

inaugural month of *Scribner's Monthly*), Appleton's commissioned artists to create images of a wide range of American landscapes and then published them as wood engravings printed to higher standards than those of such rivals as *Harper's Weekly*. Appleton's competitors responded by increasing the amount and quality of their own visual coverage of American landscape, thereby inaugurating the halcyon days of the country's wood-engraved book and magazine illustration. In 1871 *The Aldine* countered by augmenting its own visual coverage of landscape, announcing plans for an American views project which, when it appeared shortly thereafter, comprised illustrations of dazzling quality.

Appleton fought back by cutting short its American landscape series in *Appleton's Journal* and transforming it into a forty-eight-part bi-weekly publication entitled *Picturesque America: or, The Land We Live In*.[7] Consisting of twenty-four pages, each part was made available at a subscription price of fifty cents. The subscriptions underwrote the costs of hiring artists to produce the on-the-spot work that accounted for most of the publication's images. As of 1872 Appleton gave subscribers the option of having the forty-eight parts bound in gilt-stamped turkey morocco (or in half morocco for the less extravagant) and thus to own a handsome and informative two-volume monograph. William Cullen Bryant (1794–1878), long famous for his romantic, nationalist writings about the uniqueness of American vistas (Nathaniel Willis had quoted him liberally in *American Scenery*), was cannily appointed

editor, although much of the writing and editorial work was done by Oliver Bell Bunce (1828–1890), an editor of *Appleton's Journal*. Upon completion, *Picturesque America* had drawn together descriptive and historical texts by twenty-eight authors with nearly a thousand illustrations. These ranged from the excellent to the workaday and consisted mostly of wood engravings (fig. 5), along with a few steel engravings. By far the most prolific of the participating artists was Harry Fenn (1837[?]–1911), who had previously worked for serials such as *Frank Leslie's Illustrated Newspaper* and *Harper's Monthly*.

A similar two-volume monograph entitled *Picturesque Canada: The Country as It Was and Is* was published in 1882—almost exactly ten years after the completion of *Picturesque America*, one year after the publication of more than two dozen landscape engravings in John Dent's *The Last Forty Years: Canada since the Union of 1841*, and only months before the final issue of *Canadian Illustrated News*. Created by Howard and Reuben Belden, American brothers who had moved to Canada in 1876, *Picturesque Canada*, like its American prototype, consisted of separate parts that appeared over the course of two years. However, the series contained thirty-six rather than forty-eight parts and only half as many illustrations, all but one from wood engravings. Queen's University president George Monro Grant (1835–1902) edited the publication and wrote six of its twenty-seven chapters. A champion of Canada's political, social and spiritual unity, and preaching a moralist definition of patriotism, Grant

fig. 4 Anonymous, after a sketch by A. J. Russell, *On the Restigouche, Looking Towards the Bay Chaleurs* (*Canadian Illustrated News*, December 4, 1869) **fig. 5** Harry Fenn, engraved by W. J. Lindon, *The "Spouting Horn" in a Storm, Maine* (*Picturesque America*, vol. 1, about 1872–1874)

ON THE RESTIGOUCHE, LOOKING TOWARDS THE BAY CHALEURS. From a sketch by A. J. Russell, Esq.—SEE PAGE 77.

fig. 4

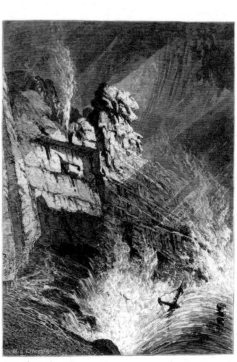

fig. 5

was as appropriate for the task as Bryant had been for *Picturesque America*. In 1880, shortly before the Beldens issued the first instalment, Grant had published the four-part series "The Dominion of Canada" in *Scribner's Monthly*. Beautifully illustrated by Henry John Sandham, the *Scribner's* series "coincided so closely with the projected model for *Picturesque Canada* that there could have been no doubt in the Beldens' minds that Grant would be the perfect choice."[8] Unfortunately, expectations that *Picturesque Canada* would do for Canadian artists and engravers what *Picturesque America* had done for their counterparts south of the border were dashed when art director Lucius O'Brien concluded that few Canadian artists other than himself had sufficient experience in creating drawings with the depth of tone-to-tone transition that was necessary for translating them into engravings. In the end, and to the consternation of John Arthur Fraser, only a handful of Canadian artist contributed designs, and most of the engraving work was done by American specialists.[9]

Picturesque America and *Picturesque Canada* were spectacular successes in no small part because of their illustrations. The centrality of illustrations to both enterprises is clear: Bryant and Grant were hired as authors and editors only after the acquisition of visuals was well advanced. Images frequently overlap or cast shadows as if the viewer were seeing a selection of pictures, each on its own sheet of paper, informally arranged on a flat surface. In addition, thanks to the one-plate nature of wood-engraved illustrated

publications, text and image were interrelated in ways that emphasized the dynamism of the landscape (fig. 6). The illustrations were very different from Bartlett's full-page rectangular steel engravings, which had a conventional and unengaging physical relationship to Willis's essays. The richness and novelty of much North American scenery was thus accentuated in the *Picturesque* volumes not only by the enthusiastic texts and high-quality illustrations but also by the formal relationships established between these two modes of communication. In addition, the extraordinary emphasis on light and tonal suggestiveness in Bartlett's illustrations—qualities inherent in steel engraving— was to a noteworthy extent replaced by the essentially linear qualities of wood engraving, a medium that by the 1880s enjoyed critical praise for its suggestion of the immediacy of drawing.

Picturesque America and *Picturesque Canada* were also lauded because they responded to the optimistic self-images of their respective countries. On the one hand, both readily incorporated enduringly popular picturesque elements: view-framing trees, moving water, foreground rocks, and variety and irregularity of form. However, whereas Bartlett's images recorded two countries in their relatively undeveloped youth, with human figures generally subordinated to nature, the *Picturesque* projects frequently supplemented their "pure" landscape views with others that sanctioned the United States and Canada as countries of the future, in this way mirroring the phenomenal railway, urban and industrial growth that had been shaping

the North American landscape since Bartlett's day (fig. 7). Even more important, *Picturesque America* manifested the hopes of a nation that had barely escaped being torn apart by the Civil War. The series' first two instalments focused on Maine, Florida and the Columbia River, establishing *Picturesque America*'s unifying, national ambitions and, in a nod to the popularity of illustrated accounts of exploration, its endorsement of the ethos of inevitable westward expansion. As Bryant phrased it in the series' preface, the publication offered its readers "many strange, picturesque, and charming scenes" that would "for the first time, become familiar to the general public through these pages." Also essential was *Picturesque America*'s subjective approach to locating meaning in landscape. In this Harry Fenn's works were ideal—they "evoked sentiment but were perceived as faithful to the actual scenes."[10] This "sentiment" was conveyed through such devices as dramatic viewpoints and stirring atmospheric effects, which meshed with the post-Civil War propensity to seek a theistic essence in the landscape.

Picturesque Canada was as opportune as its sister publication in the relationship it proposed between landscape and nationalism. The Confederation era demanded proof that the fledgling Dominion had a distinct physical, intellectual and moral unity, as well as an optimistic view of national, industrial and civic progress. *Picturesque Canada*, like *Picturesque America*, endorsed both ideals. "Winnipeg," wrote Grant with more than a little exaggeration in his chapter

fig. 6 Shell and Hogan, engraved by R. Schelling, *Snubbing* (*Picturesque Canada: The Country as It Was and Is*, vol. 1, 1882) fig. 7 Frederick Marlett Bell-Smith, engraved by H. Baker, *St. Thomas, from Kettle Creek Bridge* (*Picturesque Canada: The Country as It Was and Is*, vol. 2, 1882)

fig. 6

fig. 7

on Manitoba and the Northwest, "is London or New York on a small scale."[11] Other chapters dwell upon the close relationship across the country between landscape on the one hand, and economics, work and leisure on the other. Equally important was the conviction of unity and equality in diversity; it was no accident that the first volume of this unilingual, Toronto-based publication began with three chapters that put French-Canadian history and daily life at the centre of Canadian selfhood. A cohesive national identity was precisely the ideal at the core of Grant's philosophy, of the *Canadian Illustrated News'* mandate and of the continent-spanning Canadian Pacific Railway. Whereas Willis and Bartlett's *American Scenery* and *Canadian Scenery* were geographically limited to a quadrilateral bounded by Niagara Falls, Quebec City, Halifax and Virginia, *Picturesque America* and *Picturesque Canada* were—with some exceptions— pan-continental in coverage.

Unsurprisingly, both publications were greeted enthusiastically, the only exception being John Arthur Fraser's print war waged against Lucius O'Brien's minimal employment of Canadian artists. Each country's population, enthusiastic about having tangible evidence of their nation's achievements and cultural pretensions, subscribed in large numbers. In 1882 Grant estimated that *Picturesque Canada* had twenty thousand subscribers,[12] while in the more populous United States some one hundred thousand subscriptions to *Picturesque America* had been sold by 1880, with worldwide sales of various editions and versions ultimately reaching nearly a million copies.[13] "No person of refined or artistic taste can afford to be without 'Picturesque Canada'" was the *Quebec Morning Chronicle*'s view in May 1882, while the same newspaper insisted three months later that "it is impossible to speak too highly of this noble book."[14] Critical response to *Picturesque America* had been equally glowing, with no less a luminary of wood engraving than the artist William James Linton (1812–1897) describing the monograph as "the most important book of landscape that has appeared in this country."[15] Published a few years before photography would eclipse wood engraving for the illustration of mass-market books and periodicals, the two *Picturesque* undertakings stand as the most ambitious and successful projects to acquaint nineteenth-century North Americans with the extent, aesthetics, symbolism and potential of the landscapes that surrounded them.

** * * *

1 James Jackson Jarves, *The Art-Idea: Sculpture, Painting, and Architecture in America*, 3rd ed. (New York: Hurd and Houghton, 1866), 231. Quoted in Tim Barringer, "The Course of Empires: Landscape and Identity in America and Britain, 1820–1880," in *American Sublime: Landscape Painting in the United States 1820–1880*, Andrew Wilton and Tim Barringer, eds. (Princeton: Princeton University Press, 2002), 39.

2 See especially Mary-Ellen Earl, *William H. Bartlett and His Imitators* (Elmira, NY: Arnot Art Gallery, 1966); Elizabeth Collard, "Bartlett's Canadian Scenery" and "Morley's Bartlett Views," in *The Potters' View of Canada: Canadian Scenes on Nineteenth-Century Earthenware* (Montreal and Kingston: McGill-Queen's University Press, 1983), 44–51, 52–60.

3 For concise histories of wood-engraved illustrations in nineteenth-century North American periodicals and books, see Jim Burant, "The Visual World in the Victorian Age," *Archivaria*, no. 19 (Winter 1984–1985), 110–121; Albert F. Moritz, *America the Picturesque in Nineteenth-century Engraving* (New York: New Trend, 1983); Albert F. Moritz, *Canada Illustrated: The Art of Nineteenth-century Engraving* (Toronto: Dreadnought, 1982).

4 Michael Large, "Artists and Industry: Illustration in Transition in Toronto, 1880–1910" (master's thesis, Carleton University, 1986), 15.

5 Quoted in Peter Desbarats, *Canadian Illustrated News: A Commemorative Portfolio* (Toronto: McClelland and Stewart, 1970), 4.

6 Quoted in Elizabeth Collard, "Canada's Victorian Christmas Cards," *Canadian Antiques Collector* 9, no. 6 (November–December 1974), 38.

7 The inter-magazine competitions that resulted in the *Picturesque America* project are detailed in Sue Rainey, "*Appleton's Journal* and the Mission to Civilize" and "The 'Picturesque' Subject and Artist Harry Fenn," in *Creating Picturesque America: Monument to the National and Cultural Landscape* (Nashville: Vanderbilt University Press, 1994), 3–18, 19–45.

8 Dennis Reid, *"Our Own Country Canada": Being an Account of the National Aspirations of the Principal Landscape Artists in Montreal and Toronto 1860–1890* (Ottawa: National Gallery of Canada, 1979), 300.

9 Ibid., 298–344.

10 Rainey, 43.

11 George Monro Grant, "The North-West: Manitoba," in *Picturesque Canada: The Country as It Was and Is*, vol. 1 (Toronto: Belden Brothers, 1882), 288.

12 George Monro Grant to Sandford Fleming, January 7, 1882, Sandford Fleming papers, vol. 18, file 13, Library and Archives Canada.

13 Rainey, 274; Frank E. Camparato, "D. Appleton & Company," in *Publishers for Mass Entertainment in Nineteenth Century America*, Madeleine B. Stern, ed. (Boston: G. K. Hall and Co., 1980), 19.

14 "Picturesque Canada," *Quebec Morning Chronicle* (May 13, 1882), 1; "Picturesque Canada," *Quebec Morning Chronicle* (August 14, 1882), 2.

15 William James Linton, *The History of Wood-engraving in America* (Boston: Estes and Lauriat, 1882), 37.

John Singer Sargent's Adventurous Summer in the Canadian Rockies: The Visit to the Yoho Valley in 1916

Hilliard T.
Goldfarb

Exploring Sargent's Canadian landscape paintings of 1916, it is inevitable that one would ask what the artist himself said about his choice of destinations and his underlying concerns, artistically or philosophically, in coming to his personally selected sites and compositions for his landscapes. How do his words reflect his cultural context and his specific stylistic concerns? How did the tremendous social and political upheavals of these times impact his landscape themes and what did he write about these issues? Typically, the answer, unfortunately, is: he wrote little, indeed. In general, the laconic Sargent did not expatiate to any significant extent regarding his travels and artistic concerns during his search for exotic venues in the opening decades of the new century, travels that included an extensive tour of the Middle East in 1905–1906 and annual summer travels to the Alps and northern Italy between 1907 and 1914 (awkwardly culminating in being confined as an alien for several months in the Austrian Tyrol when war broke out in August 1914, before he was finally permitted to leave on his American passport in November). He would, however, become rather exceptionally and divertingly anecdotal, even loquacious, regarding the unprecedented rigours and challenges he encountered during his 1916 journey into Canada, as outlined below.

Sargent's dramatically increased focus on landscape painting from 1905 to 1918 reflects an artist seeking relief from what he openly asserted to be the tedium, however profitable, of society portraits

and group subjects in London. To Lady Lewis in 1906, he wrote, "I have now a bombproof shelter into which I retire when I sniff the coming portrait or its trajectory."[1] In 1907, in a letter to Ariana (Mrs. Daniel) Curtis, of the prominent Boston family that possessed the Palazzo Barbaro in Venice, where he often sojourned, he wrote, "I have vowed a vow not to do any more portraits … it is to me positive bliss to think that I shall soon be a free man."[2] To her son, Ralph, he wrote, "no more paughtraits [a spelling adopted in derision of the affectations of his London society clientele] whether refreshed or not. I abhor and adjure them and hope never to do another, especially of the Upper Classes." In yet another letter to Ralph Curtis, of March 27, 1907, he exulted,

It does not bore me to write that
I can't paint a pawtreet, on the
contrary it is the greatest joy
in life–but I prefer writing it to
you than the lady [Mrs. Lowther],
if you will be good enough to tell
her that I have retired from the
business. Tell her that I now only
paint landscapes and religious
decorations, that I am a waltzer
to delerium tremens or whatever
you think may make her congratulate
herself on her refusal. I really
am shutting up shop in the portrait
line.[3]

Sargent's hundreds of surviving letters rarely provide personal insight into the artist. Generally they comprise introductions of acquaintances, confirmations of engagements, thank-you notes, laconic updating of business matters and some superficial commentary on his sister's family. Only the occasional letter to an intimate number of friends and relations provides evidence of his dry, witty personality, his vacation pleasures and his priorities in painting during his travels. Most notable among these epistolary clues are isolated letters to his English friend and biographer Evan Charteris; his cousin Mary Hale; his London friend Mary Hunter; and his Boston friend, the architect Thomas Fox. Otherwise, we are reliant upon the slim, recorded recollections and assertions of his travelling companions, including Nicola d'Inverno, who worked for Sargent for a quarter of a century.[4] D'Inverno had come to Sargent's London studio as a nineteen-year-old model in 1892, the third in a succession of Italian models, succeeding his brother. He continued serving as a model (Sargent paying for his gymnasium fees) for several years; but after about a year, he also became a member of the artist's household, serving as a studio assistant, personal valet, travelling companion and aide, and amateur photographer, eventually settling, independently, toward the end of World War I, in Boston. D'Inverno asserted that their spring 1918 parting in Boston, shortly before Sargent's return to England, was due to his interest in staying in the United States; in reality, he had become involved in a drunken fight with a hotel bartender at the city's elegant Hotel Vendome. Whether he was dismissed as a result of this altercation—seemingly slim grounds after a quarter of a century of service—or out of general self-interest and a recognition that returning to Europe would have made him eligible for war service (d'Inverno was given passage fare and ultimately a bequest by the artist), we will never know, and d'Inverno always spoke highly of Sargent.

Given Sargent's considerable clientele and social circle of friends in Boston and New York, and his evident desire to escape the war (in which his sister Violet's son-in-law, Robert-André Michel, had lost his life in 1914, and Violet's widowed daughter Rose, who had served as a model for Sargent and travelled with him and her mother on his pre-war Swiss tours, would ultimately be killed when a German bomb struck a church in which she was praying on Good Friday 1918), it is not surprising that the artist, accompanied by his valet, decided to return to his country of citizenship in the spring of 1916. Perhaps d'Inverno's eligibility for the draft also played a role in the length of the American sojourn: Sargent subsequently returned to England in April 1918.

In the course of his travels during his prolonged stay in North America, Sargent's preserved correspondences dramatically increased in number, as did his written candidness, permitting us to know more clearly about his daily experiences and his responses to his surroundings than was his general practice previously in his life. Having returned to working on commissions for the Boston Public Library and subsequently the Museum of Fine Arts, Boston—projects that occupied him from 1890 until his death in 1925—he departed New England by train in July of 1916 to paint picturesque sites in the Canadian Rockies.[5] As always, he was accompanied by Nicola d'Inverno. Sargent's route carried him via Chicago, Montana and the Northwest Coast to Seattle, and then to Canada. He had been attracted to Yoho National Park by a postcard of the Twin Falls given to him by Denman Ross, a Harvard University professor, collector and painter. Yoho National Park (established in 1886), on the eastern border of British Columbia, abuts Banff National Park in Alberta. It has been suggested that Sargent's London clients, with diverse financial and personal connections to the Canadian West, also played a role in his selection of vacation venue.[6] The promotion of the Canadian Rockies as North America's Alps (replete with Swiss guides brought over in the early years by the Canadian Pacific Railway to aid campers and mountaineers in the areas of Banff and Yoho, and a Canadian Alpine Club which held its first camp at Lake O'Hara in 1909 in the "Alpine Meadow" with 190 visitors in tents) must also have appealed to the artist,[7] who had been spending his summers annually in the Alpine ranges until the outbreak of the war. Apart from relaxed diversion, the Alps had provided the artist with welcome subjects for a significant number of paintings and watercolours between 1907 and 1914,[8] and no doubt a mingling of interest in finding a similarly inspiring mountain subject matter, a nostalgia of his pre-War summers in the Alps with family and friends,

fig. 1 Marc Pinel, *Twin Falls, Yoho National Park*, 2006

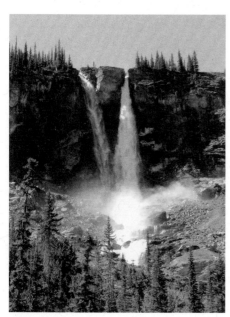

fig. 1

and his desire to get away from the social demands of the East encouraged him to undertake the challenging trip. As we have noted, the prospect of crossing the Atlantic twice during that wartime summer could not have appealed to him either.

Sargent received advance commissions for landscapes from Yoho from Isabella Stewart Gardner, the great art collector and personal friend, whose Fenway Court in Boston she had built to her specifications to serve as a museum, as well as her residence, and from Edward Forbes, director at Harvard University's Fogg Art Museum. With remarkable premonition, Isabella Gardner gave Sargent a farewell present of some handkerchiefs. He departed in mid-July. The travel letters begin rather lamely with commentary on the weather during his travel west. The East Coast and Midwestern United States were enduring a heat wave. Sargent later praised the refrigerated dining room at the Blackstone Hotel in Chicago: "It is worth while flying there from any part of America during a heat wave. You sit in a perfect temperature over an excellent dinner and watch the crowd dying like flies outside of the window. Nero or Caligula could not have improved on it."[9] Having arrived in Glacier National Park in Montana, he wrote to Charteris:

```
After the heat of the last days in
Boston and of the many days railway
journey across the endless plains
it is delicious to be here among
crags and glaciers and pine woods.
-
```

fig. 2 John Singer Sargent, *Lake O'Hara*, 1916 fig. 3 John Singer Sargent, *Lake O'Hara*, preparatory study, 1916

```
But I shall make my way further
north to the Canadian Rockies,
where the scenery is grander still.
I have two pleasant companions
[Colonel Livermore of Boston and his
wife, who, to Sargent's pleasure,
was a chess player] and we take
daily rides on Indian ponies.[10]
```

By mid-August, Sargent had reached the Twin Falls (fig. 1). He had travelled, beginning August 2, by way of Seattle to Field, British Columbia, staying at a hotel there and procuring the guide, tents and supplies for the expedition, arriving several days later at the falls that had been his object. At that time, the setting was nearly totally undeveloped wilderness, and he had to make do with what he, his Swedish guide Carl, and d'Inverno brought along. D'Inverno does not seem to have been occupied as an amateur photographer on this trip, as he had been during the Alpine excursions. The absence of family and close friends, and the more demanding responsibilities of the trail and campsites probably are accountable for this; in any case, no photographs related to the trip survive. On August 20, Sargent wrote to Isabella Gardner:

```
I am camping under the waterfall
that Mr. Denman Ross gave me a
postcard of. It is magnificent when
the sun shines which it did the
first two days. I began a picture-
```

```
that is ten days ago-and since then
it has been raining and snowing
steadily-provisions and temper
getting low-but I shall stick it
out till the sun reappears. Tell
Mr. Ross that he was quite right,
but that now there is only one
fall of the "Twins", thanks to some
landslip above … Your handkerchiefs
are in constant use and still hold
out in spite of a dripping nose and
cold feet.[11]
```

Sargent's depiction of the base of the Twin Falls is remarkably accurate. Yoho is the Cree word for magnificent and several dramatic waterfalls are located in the Yoho Valley near the settlement of Field, British Columbia. Following a trail constructed in 1901 by a Canadian Pacific Railway crew, running 8.5 km from Takakkaw Falls, near Emerald Lake, one reaches the Twin Falls. They noisily descend over 180 metres from a cliff, atop of which the Twin Falls Creek, from the glacier plateau, is divided in two by a limestone block as it plummets before braiding back together 80 metres below and continuing the descent to the cascade at base. Occasionally the left channel of the creek used to be obstructed and shut off, and would be cleared again by the CPR trail crew using dynamite. The region had first been opened for surveying in connection with the CPR development of the area in 1886, and early visiting mountaineers climbed from

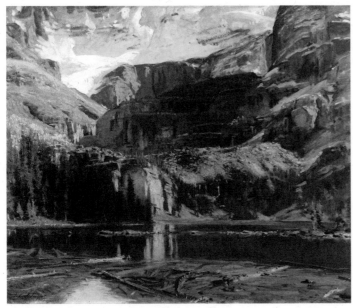

fig. 2

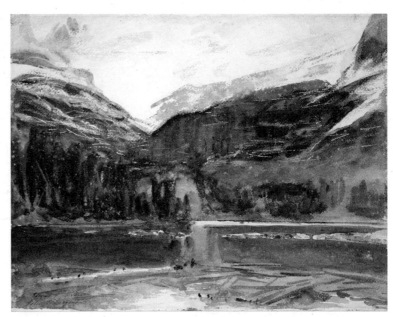

fig. 3

Field and Glacier in 1886, 1890 and 1891. The first guided party occurred in 1897, led by Peter Sarbach, a professional Swiss guide. Discovered by European Canadians in 1890, Lake O'Hara was named after Colonel Robert O'Hara of Ireland, the first tourist to visit it and a frequent visitor to the region. Conditions remained primitive in Sargent's time. A small log cabin erected at Lake O'Hara of unpeeled logs and built for the Dominion government in 1911 was the only accommodation, some distance from the Twin Falls. Only in 1920 did construction of a second, more extensive camp at the lake begin. The camp opened in 1921, the same year a small chalet was built near the Twin Falls. The central chalet followed at Lake O'Hara in 1925–1926.[12] The trail itself was very narrow and bears were a constant nuisance, and even today, the Yoho Valley road is open to traffic only between mid-June and early October. On August 28, he wrote to Thomas Fox, in Boston:

```
I am about to move on with my
tents to some other valley within
the reach of Field-two things have
got my nerves-one the roar
and hissing and pounding all
night long of a tremendous
waterfall that I am near, the
other the alighting snowflakes
on my bottom when it is bared once
a day. Perhaps this is the poetry
of camping out.[13]
```

On August 30 to Mary Hale:

```
It was raining and snowing, my tent
flooded, mushrooms sprouting in my
boots, porcupines taking shelter
in my clothes, canned food always
fried in a black frying pan getting
in my nerves, and a fine waterfall
which was the attraction of the
place pounding and thundering
all night. I stood it three weeks
and yesterday came away with a
repulsive picture. Now the weather
has changed for the better and I
am off again to try the simple life
(ach pfui) in tents at the top of
another valley, this time with a
gridiron instead of a frying pan
and a perforated India rubber mat
to stand on. It takes time to learn
how to be really happy.[14]
```

The next day, he wrote to Isabella Gardner, having returned to the Mount Stephen House hotel at Field, British Columbia, preparing to venture to Lake O'Hara (rejecting Lake Louise as too much of a tourist attraction). He informed her that "I have done a picture of a fantastic waterfall (*Yoho Falls*, cat. 117), somewhat the sort of nightmare as Mrs. Sears' picture—and I am off camping to another place near here where I expect to find other awful sights."[15] That site was Lake O'Hara.

While there, besides painting the oil now at the Fogg Art Museum (fig. 2) and its preparatory watercolour study, also at the Fogg (fig. 3), he worked on other canvases, including the Wadsworth Atheneum's *Tents at Lake O'Hara* (cat. 115), which featured his Swedish guide, Carl, in the foreground.[16] A possible preparatory watercolour for the painting, focusing on the campsite, is in the collection of the Gardner Museum (*A Tent in the Rockies*, fig. 4). A watercolour in the collection of the Metropolitan Museum of Art (*Camp at Lake O'Hara*, fig. 5) offers a different view of the same Lake O'Hara site, with d'Inverno in the middleground, while a watercolour at the Newark Museum (*Camping near Lake O'Hara*, fig. 6) appears to record an alternate campsite, based on the positions of the tents, apparently with Carl and d'Inverno depicted. Finally, yet another handsome watercolour in the collection of the Metropolitan, showing the campsite at the Twin Falls, with the complete cascading falls presented dramatically and monumentally in the background, attests to the primitivism of the living arrangements and the magnificence of the falls themselves (*Camp and Waterfall*, fig. 7).[17]

Both the Fogg and the Gardner paintings are remarkable for the manner in which the views are arbitrarily cropped. In the former the artist rejected a more traditional, monumental, panoramic view which would have included the peaks of Mount Victoria and Lefroy; in the latter he shows only the base of the falls. In both cases the direct spontaneity of the view, as one would experience it at close range without incorporating the

fig. 4 John Singer Sargent, *A Tent in the Rockies*, 1916 **fig. 5** John Singer Sargent, *Camp at Lake O'Hara*, 1916

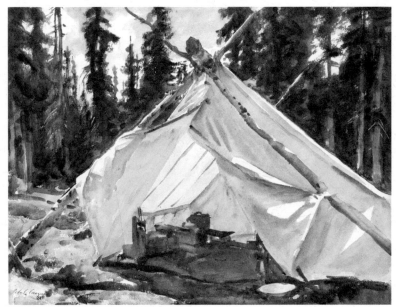

fig. 4

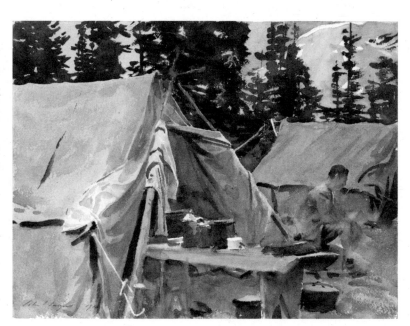

fig. 5

broader vision gained through incorporating multiple perspectives, is quite modern in its aesthetic. It is precisely that directness of approach, complemented by the roughness of his brushstrokes that evokes the intensity and monumentality of the experiences. This informality in subject and composition and immediacy of painting, remarkably approaching the qualities of a watercolour, are ably conveyed in his depiction of himself reclining and reading by lamplight in his cramped and primitive shelter in *Inside a Tent in the Canadian Rockies* (cat. 116). Casual photography had been very much a part of his travels in the Alps and elsewhere, and the artist was certainly at home with its compositional aesthetics and arbitrary cropping from the viewpoint of the photographer's lens, evident in the painting of the campsite in the Wadsworth Atheneum, the painting *Inside a Tent* and the related watercolours.

Also on August 31, from his hotel at Field, British Columbia, he wrote to Mary Hunter, asking after his sisters, Violet and Emily.

```
I have just got back to civilization
after camping out for three weeks
in the wilds … I don't remember
whether I wrote you or not from
Twin Falls where I have been
camping-one has to do that here,
there is nothing to paint near
these fine enormous hotels along
the C. P. Railway. I am off in a
-
```

```
day or two with tents again in
search of some Alpine nightmare to
paint-one ought to be a party-it is
monstrous alone, and camping out in
bad weather is dismal. Porcupines
eat up one's boots-one wishes they
would help one to eat one's canned
food instead. I stuck it out for
three weeks & have brought back
a landscape of a fine waterfall,
probably for Mrs. Gardner.[18]
```

The artist returned to Boston in the early autumn, continuing his work for the Boston Public Library and beginning his work on the major commission of the decoration rotunda of the Museum of Fine Arts, Boston. He had produced only four paintings and six watercolours during his Canadian adventure, yet the paintings would include among his most successful and most modernist landscapes.

Perhaps recalling all too well the discomforts of the Canadian trip, Sargent remained in the United States the following year, choosing the more sultry attractions of Florida for his next working vacation. The impetus for the travel was a portrait of John D. Rockefeller, on which he worked at Ormond Beach, near where Rockefeller was staying. From there, he travelled to visit Charles Deering and his brother at the latter's unfinished residence, Villa Vizcaya, a pleasure palace built in the style of an Italian Renaissance villa and reminiscent of Isabella Gardner's Fenway Court in Boston.

Although the spectacular beauty of Lake O'Hara and the waterfalls of Yoho undoubtedly were brought to the attention of the broader public by Sargent's paintings, he actually was not the first painter to depict the region. Frederick Marlett Bell-Smith probably deserves that honour. He had met the eponymous Colonel O'Hara camping by lake Louise and subsequently visited the site with the mountaineer and explorer Walter Wilcox in 1899. Later Canadian painters, including J. E. H. MacDonald, Lawren Harris and A. C. Leighton, were also inspired to depict the scenery about the lake, but Sargent's paintings—and his correspondences—remain those that most evocatively capture the experience itself.

This essay is edited and significantly revised from an earlier essay I wrote: "Sargent in Pursuit of Landscapes, in His Own Words: 'I am off again to try the simple life (ach pfui)…,'" in *Sargent: The Late Landscapes* (Boston: Isabella Stewart Gardner Museum, 1999), 93–110. I am grateful to the Isabella Stewart Gardner Museum for permitting me to substantially rework my essay on this occasion.

fig. 6 John Singer Sargent, *Camping near Lake O'Hara*, 1916 **fig. 7** John Singer Sargent, *Camp and Waterfall*, 1916

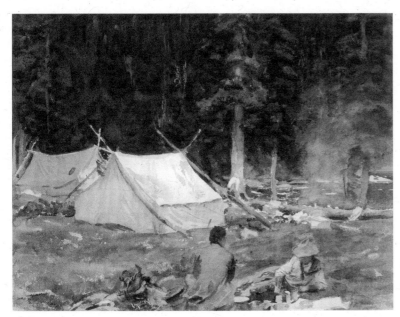

fig. 6

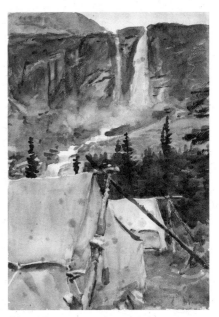

fig. 7

* * *

1 Sargent to Lady Lewis, in Charles Merrill Mount, *John Singer Sargent: A Biography* (New York: W. W. Norton and Co., 1955), 299.

2 Sargent to Ariana Curtis, in Stanley Olson, *John Singer Sargent: His Portrait* (New York: St. Martin's Press, 1986), 227.

3 Sargent to Ralph Curtis, in Mount, 299.

4 Nicola d'Inverno's recollections and photographs are published in "The REAL John Singer Sargent, as His Valet Saw Him," *Boston Sunday Advertiser* (February 7, 1926).

5 The details of this trip were first published together and much of the related correspondence first assembled and cited (although without bibliographical sources) in the highly readable and useful article by Bruce Hugh Russell, "John Singer Sargent in the Canadian Rockies: 1916," *The Beaver* 77, no. 6 (December 1997–January 1998), 4–11.

6 Ibid., 5–6.

7 For discussion of the Alpine promotion of the Canadian Rockies, see the essays in this catalogue by Brian Foss, "Word and Image: North American Landscape in Nineteenth-century Illustrated Publications," and Ian Thom, "Painting and Photography in British Columbia, 1871–1916: Some Observations."

8 See Richard Ormond, "In the Alps," in *Sargent Abroad: Figures and Landscapes* (New York: Abbeville Press, 1997), 63–112.

9 Sargent to Mary Hale, August 30, 1916, in Evan Charteris, *John Sargent* (New York: Charles Scribner's Sons, 1927), 205.

10 Sargent to Evan Charteris, July 25, 1916, in ibid., 207.

11 Sargent to Isabella Stewart Gardner, August 20, 1916, archives at the Isabella Stewart Gardner Museum, Boston. Cited in Russell, 7.

12 The early history of the discovery and tourist development of Lake O'Hara and its environs is well outlined in the short book by Lillian Gest, *History of Lake O'Hara*, 4th rev. ed. (1961; Lake Louise, Alberta: privately printed, 1989).

13 Sargent to Thomas Fox, August 28, 1916, in Russell, 8. See also Olson, 250.

14 Sargent to Mary Hale, August 30, 1916, in Mount, 334. See also Patricia Hills, et al., *John Singer Sargent*, exhib. cat. (New York: Whitney Museum of American Art, 1986), 202.

15 Sargent to Isabella Stewart Gardner, August 31, 1916, archives at the Gardner Museum. Cited in Mount, 335, and Russell, 8.

16 Russell relates an amusing, if possibly apocryphal, story of the guide's reluctance to show the canvas to a Montreal artist, Charles Simpson, who visited the Lake O'Hara campsite during Sargent's absence, until Carl's reservations were allayed by some Scotch whisky. The story is third-hand, related in an unpublished manuscript of a friend of Simpson. See Russell, 9.

17 The group of works executed by Sargent in Canada includes one other watercolour, a fast sketch, *Lake Louise, Canadian Rockies*, in a private collection.

18 Sargent to Mrs. Charles Hunter, August 31, 1916, in "John Singer Sargent Letters, 1906–1921," Boston Public Library, microfilm roll D169.

Like his contemporary, the American artist Robert S. Duncanson, with whom he studied in Montreal around 1863, Edson combined the romantic vision and detailed realism of the Hudson River School with a greater naturalism in lighting and a more bucolic sensibility. While he usually depicted scenes from his beloved native Eastern Townships in the countryside south of Montreal, he occasionally turned to Quebec sites north of the city, as in this work. The cropping and planar structure of his compositions, unified by the effects of sunlight, reflect the increasing influence of photography. Moreover, as Dennis Reid has noted, the manner in which Edson applied paint in meticulous, individual daubs to define foliage shows he studied the technique of Otto Jacobi. It is also worth recalling that Edson had visited Europe in 1864 and certainly had become directly acquainted with the works of Claude Lorrain and John Constable.

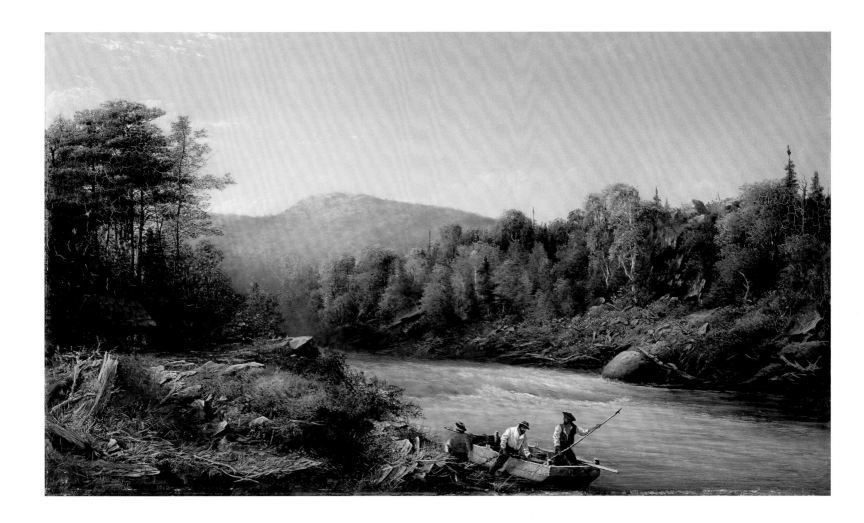

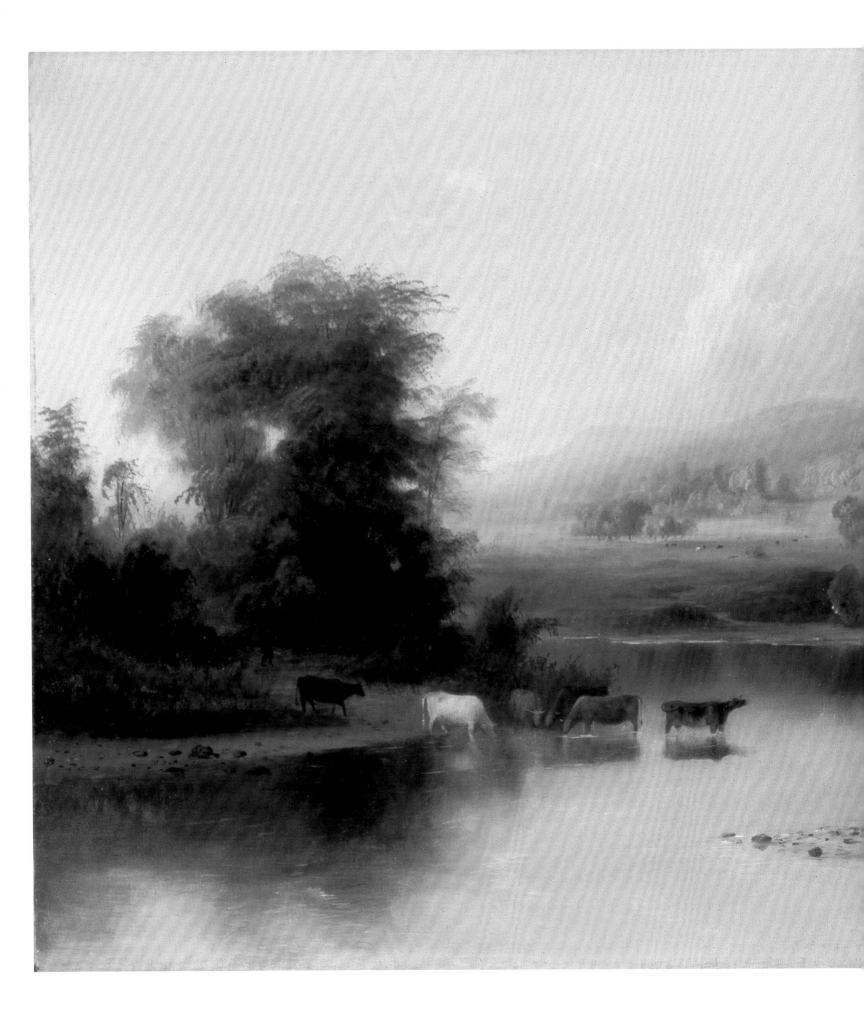

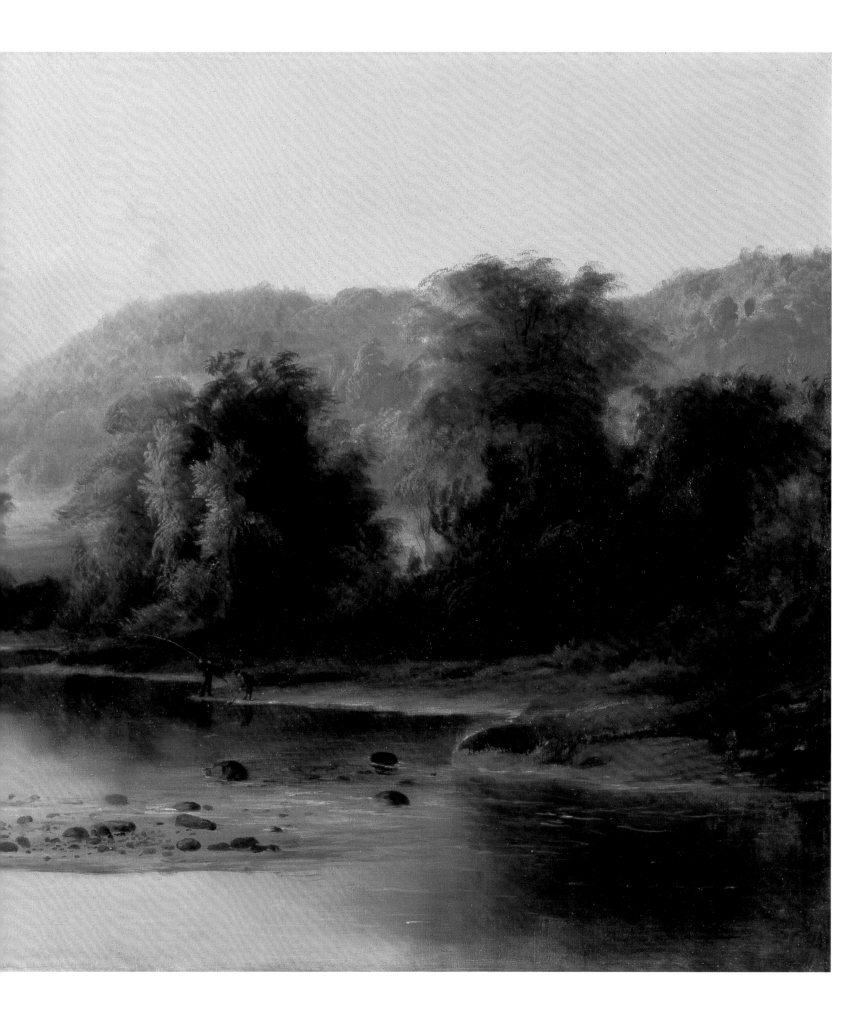

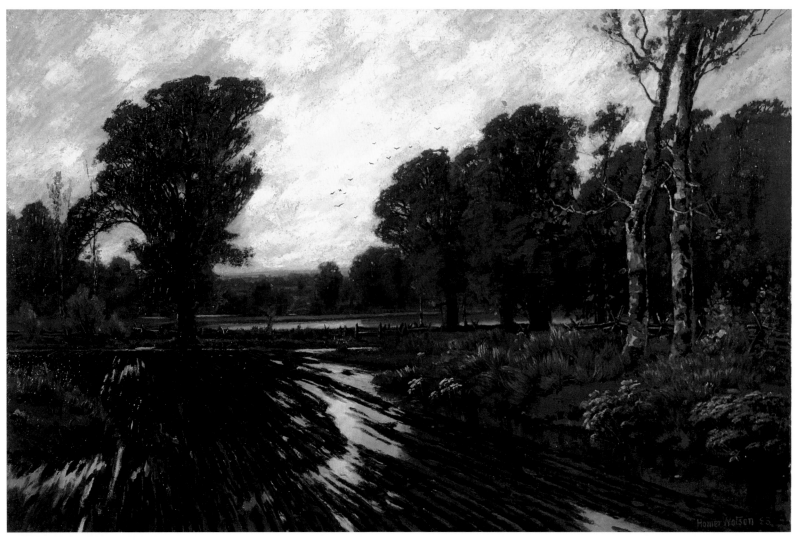

103

PREVIOUS PAGES

102 Robert S. Duncanson, View of the St. Anne's River, 1870

Duncanson's career as a black artist closely tied to the Hudson River School is a remarkable one. Born to a free family in Michigan in 1821, he was the first African-American artist to gain an international reputation. A self-taught painter, he began as a daguerrotypist, and his exposure to the work of Thomas Cole and especially of William Lewis Sonntag, with whom he travelled to Europe in 1853, encouraged his development and specialization as a landscape painter, equally adroit at producing European scenes in a romantic vein and more naturalistic American landscapes. In the midst of the Civil War, upon returning from exhibiting his work in Europe in 1863, he chose to settle in Montreal rather than go back to the United States. Here he experienced significant success and critical acclaim, advancing Canadian landscape painting. Duncanson exhibited internationally as a Canadian in 1865, returning that year to Great Britain to a triumphal reception by critics and society, including the aristocracy. The following year he resettled in Cincinnati. His later landscapes, blending wilderness settings with pastoral sentiment, mark a softening of his more detailed earlier style and show less direct influence by the Hudson River School while retaining something of its lyricism of colour. This painting is among his last before succumbing to mental illness and death in 1872.

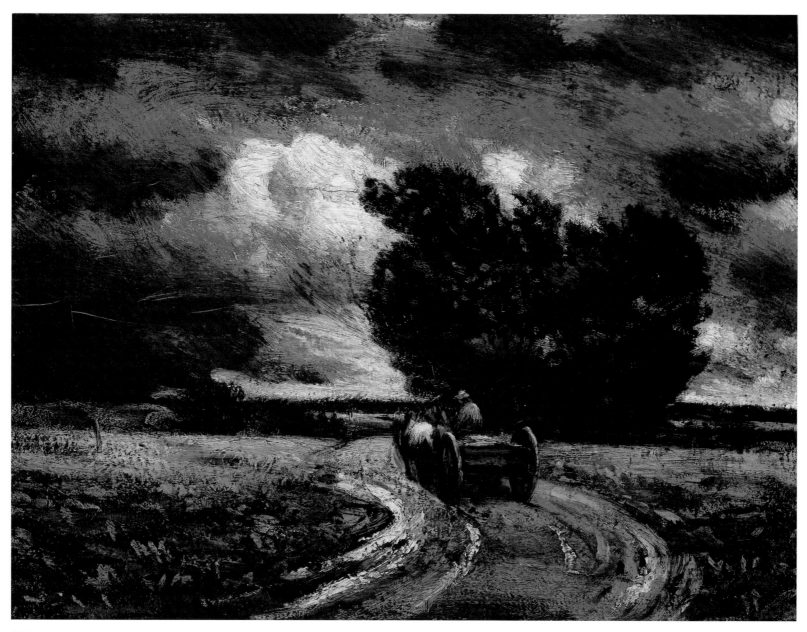

104

104

103 Homer Ransford Watson, After the Rain, 1883

Watson's profound and early appreciation of the Hudson River School was conjoined with the influence of George Inness's rural scenes and palette, and in this painting the latter influence is more apparent. The scene is taken near Doon, in southern Ontario, a rural area near Kitchener where Watson's father had owned a mill, to which he returned in 1877. His sale of *Pioneer Mill* (1879), also from that site, to Queen Victoria had advanced his career and encouraged him to continue painting such motifs, often featuring brooding skies or rain effects and rutted roads.

104 Homer Ransford Watson, Country Road, Stormy Day, about 1895

In the 1890s Watson persisted in focusing on the subjects of his earlier works (cat. 103), replete with a farmer's cart, another of his preferred motifs. His compositions were reinvigorated however by travel to Europe in 1887. That trip included his first visit to England, exposing him to the art of John Constable, whose handling of clouds and trees he admired, and to France, where he studied the works of the Barbizon painters, whose aesthetic he found particularly sympathetic. The rich application of paint on this panel is noteworthy.

105 Thomas Eakins,
Three Fishermen Mending Nets, 1881

106 Thomas Eakins, Tree near
the Delaware River, 1881

107 Thomas Eakins, Geese with Tree and
Two Men in Background, 1881

108 Thomas Eakins, Benjamin Eakins and
Man Sitting Under a Tree, 1881

Eakins's passion for photography and his rapidly acquired expertise as a photographer are universally recognized. He began actively taking pictures at precisely this period. The medium, which reduced his dependence on posed models, profoundly informed his painting aesthetic in many ways: for subjects and compositions, planar construction and perspective, detailed analysis of the nude, references for portraiture and even—as in the painting *Mending the Net* (cat. 109), for which these photographs taken in Gloucester, New Jersey, served as studies—to suggest varying focuses. The softer-focus images of the geese (of which he took eighteen negatives) in the foreground of the painting correspond to the moving figures in his photographs. Other prints also apparently inspired the distinct crispness and focus for the figures of the fishermen. Indeed, Eakins experimented with a wide range of lenses in the course of his photographic studies. The artist exposed no less than thirty-one negatives in preparation for the painting. They all provide details out of which he pieced together and modified his composition. The seated figure reading the newspaper beneath the tree is Eakins's father.

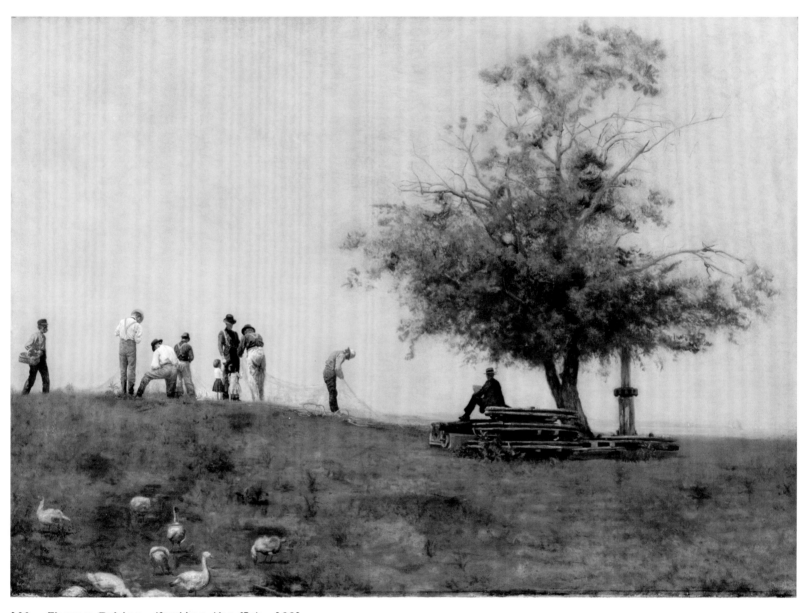

109　Thomas Eakins, Mending the Net, 1881

Shad fishing along the Delaware River was the major industry in Gloucester, New Jersey, an area where Philadelphians vacationed in the later nineteenth century, enjoying both the beaches and the opportunities for more urbane diversions. This famous painting, Eakins's most monumental picture of the site, plays with the social dynamic between tourists, their activities and preoccupations, and the engaged shad fishermen in this carefully composed yet seemingly spontaneous view.

110 Martin Johnson Heade, Newbury Hayfield at Sunset, 1862

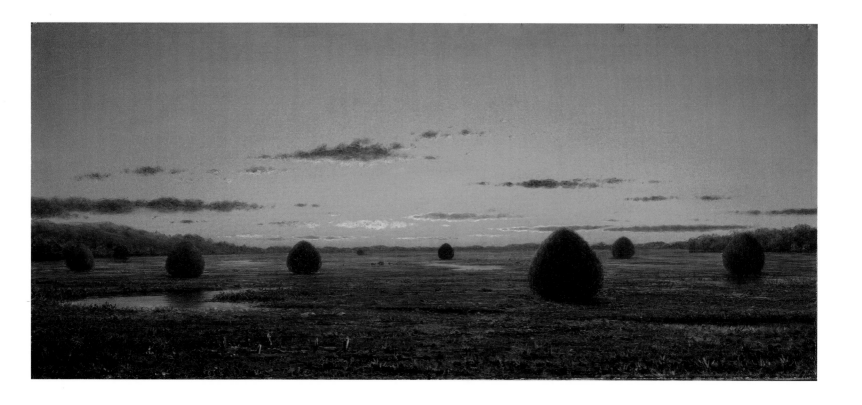

Heade began painting images of haystacks and salt marshes in the late 1850s but continued working the theme until about 1890, producing roughly 120 marsh scenes. He lived in New England, in Rhode Island and later in Boston between the mid-1850s and 1863, and the marshland about Newburyport, up the coast from Boston, fascinated him. The raised viewpoint provides a low horizon, and the strictly planar composition, measured by the heavy, dark profiles of the haystacks set in decreasing size, the cloud still radiantly lit by the departed sun at precise centre, is balanced by the watery paths subtly drawing the eye cursively into depth. The entire landscape is illuminated by the richly atmospheric light, the golden and orange-toned sunset conveying serenity to the scene. The introspective, meditative character of the work and its appeal to personal sentiment through its simplified composition and its tonal effects characterize Heade as a Luminist painter. The painting, with its aura of Divine benediction expressed in nature, was created in 1862, the darkest period for the Union during the Civil War.

111 Charles William Jefferys, Wheat Stacks on the Prairies, 1907

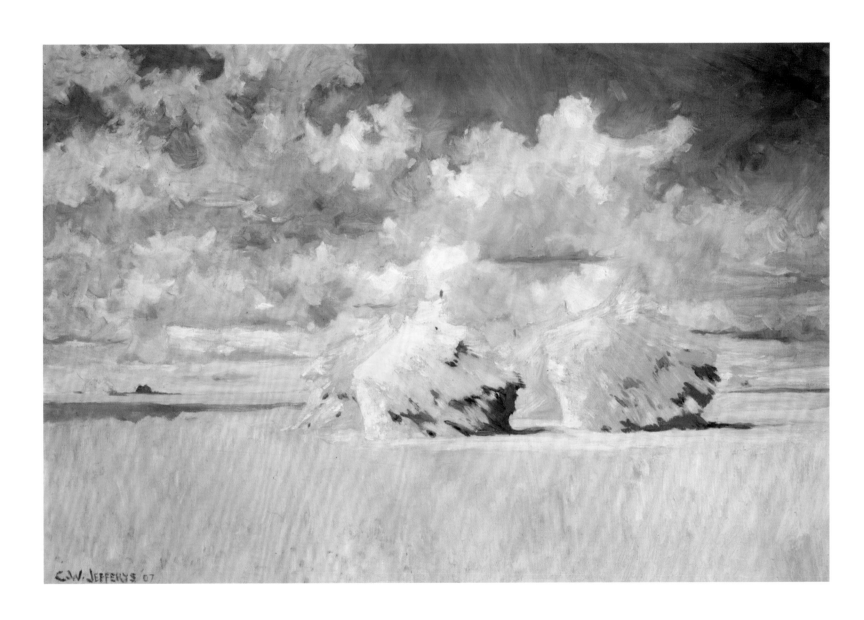

Evidently influenced by Claude Monet, Jefferys distinguishes himself from that master in the freedom and self-declarative independence of his brushstrokes and in the rejection of Impressionist rules for the use of reflected and complementary colours. Fascinated with prairie landscapes, he executed photographs as well as drawings and paintings of the broad expanses, unapologetically including grain elevators, silos, barns and multiple other indications of human civilization and the harvesting of Nature. This picture is a result of his first Western trip, which carried him to central Manitoba in 1906. The subject is limited to the haystacks themselves, which stand in monumental grandeur against the field and sky. The painting, a paean to the radiant golden harvest and fertility of the prairie, is one of a series of works on the Manitoba plains painted by the artist during 1906 and 1907.

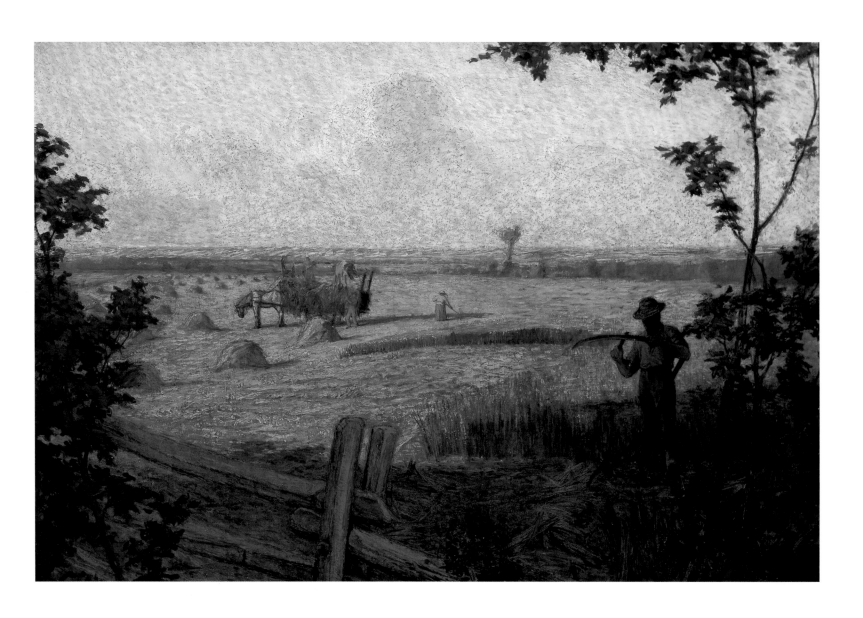

These works constitute the first two of a trilogy completed by Leduc in 1901, the third being a winter scene, *The Choquette Farm, Beloeil*. All three were painted at the commission of the Honourable Philippe-Auguste Choquette. Leduc, who often turned to rural subjects in the Richelieu Valley in Quebec, was, at the time, friends with the extended Choquette family, including the Abbé Choquette and his brother, Ernest, who had recently written a novel which was serialized in 1899, *Claude Paysan*, illustrated by Leduc. That work of fiction spoke to the rigours and loneliness of rural life but also to the venerable farming traditions and local customs along the banks of the Richelieu River. These themes resonated profoundly with the religiously infused sensibilities of Leduc. *The Choquette Farm* replicates a photograph taken by Leduc, and *The Hayfield* also relies

113 Ozias Leduc, Fall Plowing, 1901

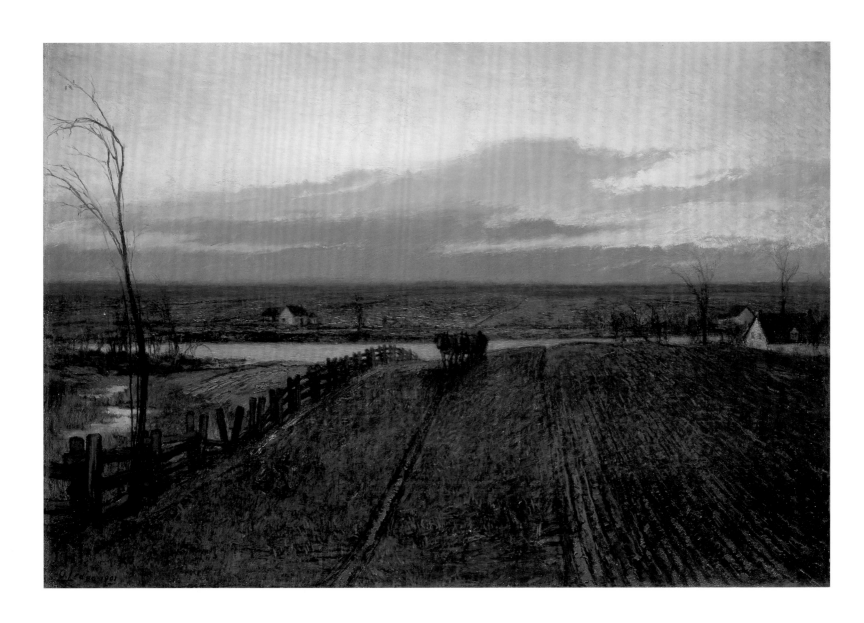

on photography. Through the minimalist landscapes and controlled tonalities of the paintings Leduc evokes a world of serene and comfortingly returning cycles. As Pierre L'Allier has noted, the radiant promise and fecundity of Nature evoked in *The Hayfield* balances the darker, more brooding moods of the other two works. L'Allier also observes that the prominence of the human figure in that painting comes closer to the aesthetic of the 1899 book illustrations. In all three paintings, as in the illustrations, trees and fences establish the spatial grid within which the compositions are laid out. *The Hayfield* entered the collection of Ernest Choquette directly from the studio, while the other two went to Philippe-Auguste, a prominent Liberal member of parliament, who at the time was serving as a superior court judge, before being appointed a senator in 1904.

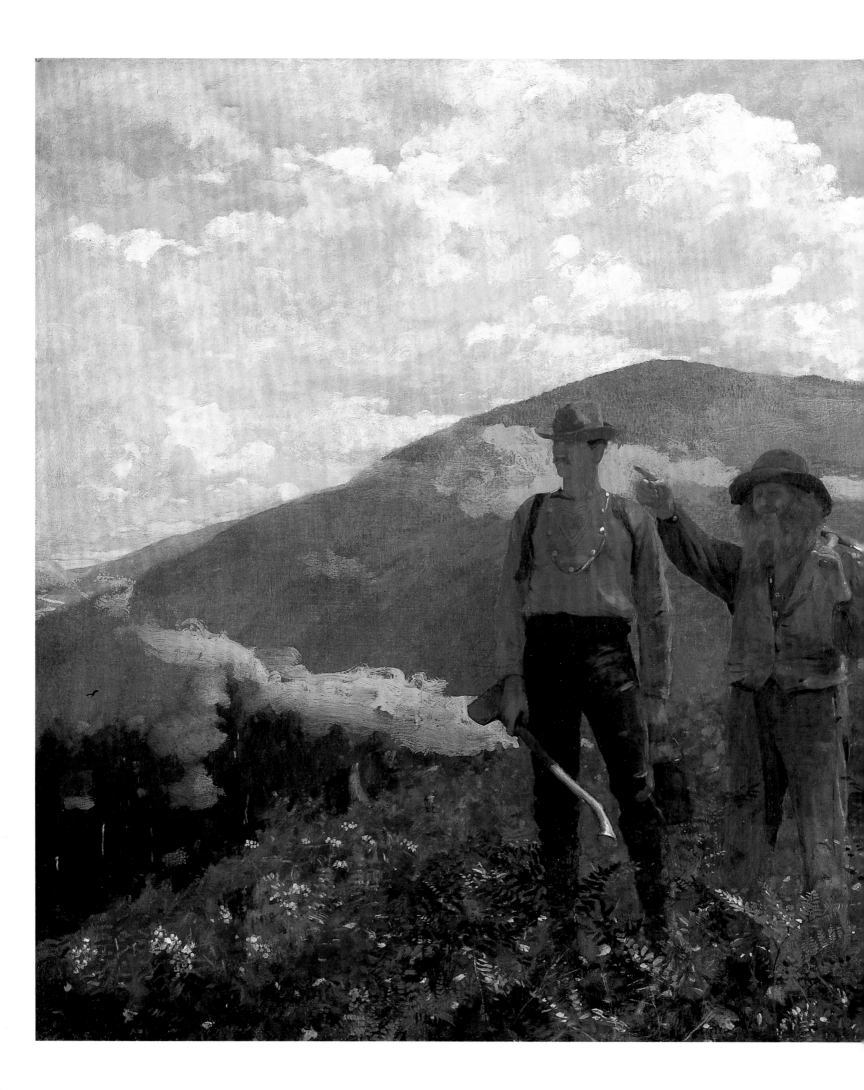

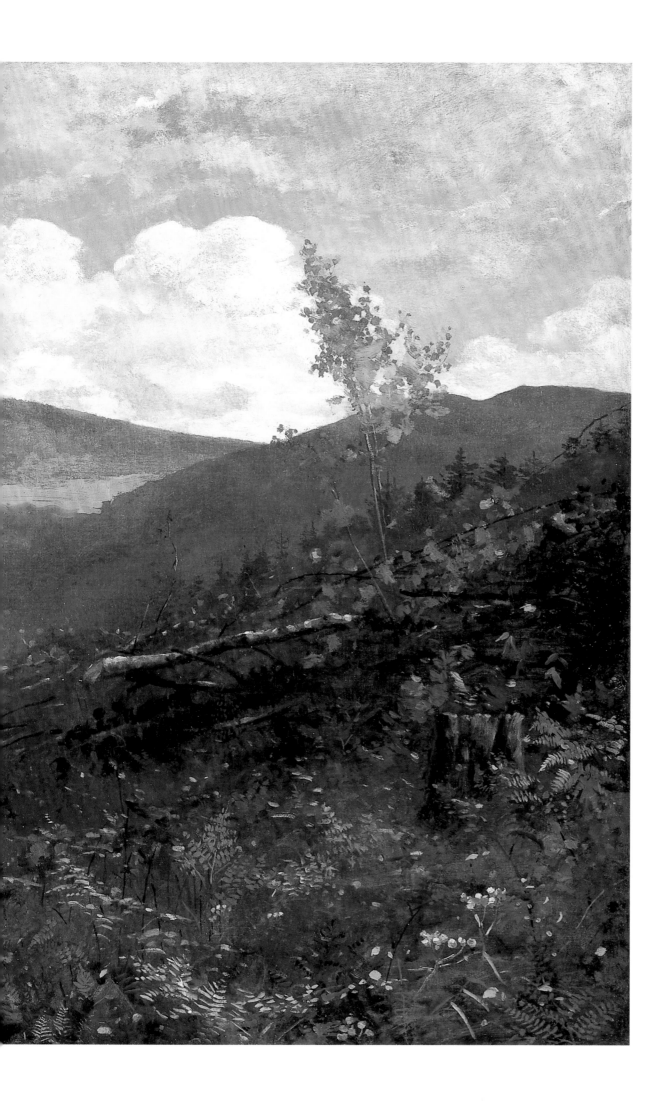

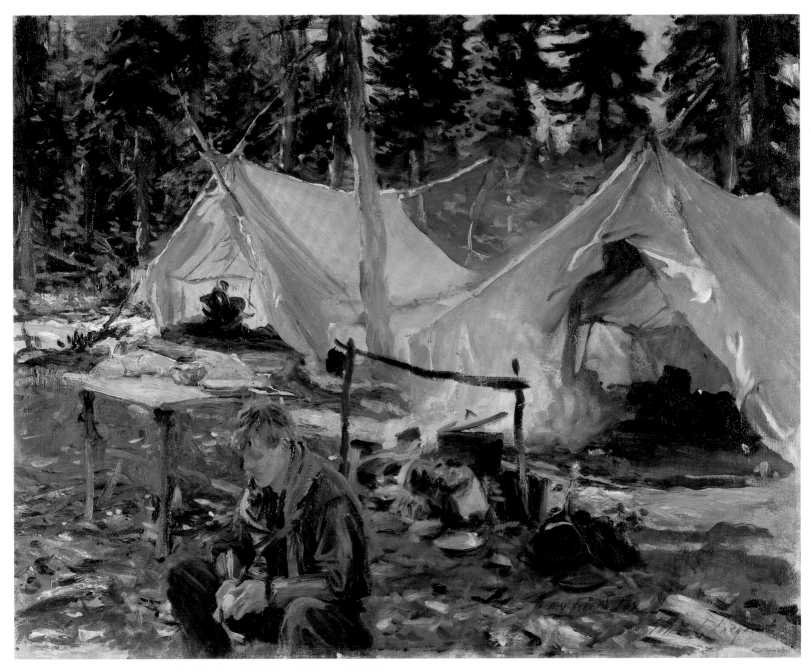

115 John Singer Sargent, Tents at Lake O'Hara, 1916

PREVIOUS PAGES

114 Winslow Homer, Two Guides, 1877

The two figures in this painting, based on Homer's studies executed the previous year, have been identified as the young guide Monroe Holt and his elder, Orson Phelps, standing before a composite view of the Adirondacks, including the Keene Valley and Beaver Mountain. The elder figure, Phelps, was a renowned mountaineer, guide and cartographer of the region whose family had settled in the Keene Valley in the 1840s. He carries a pack derived from those of Aboriginal origin. Based on a contemporary description of Phelps published in *Atlantic Monthly* in 1876, Amy Ellis has suggested that the rustic figure forms a conceptual bridge between the direct and intuitive relation with Nature of primitive men and the activities of the sophisticated travellers and leisure seekers of the 1870s whom they guided and initiated into the outdoors and who would have purchased such a painting. The picture was thus directed to the increasingly urban, upscale male population of the nation, who sought outdoor activities as catharses and assertions of their masculinity in distinction to the daily stresses and unnatural office environments they habituated.

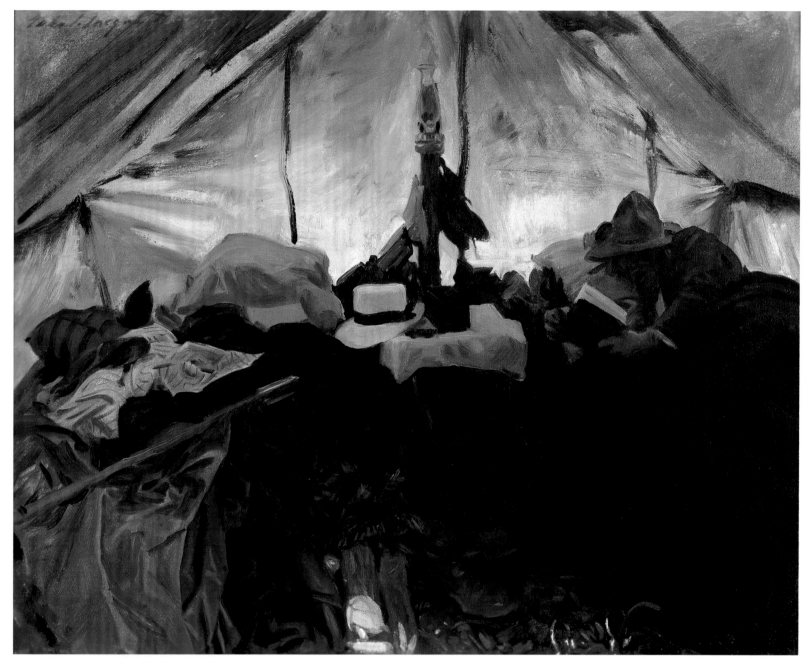

116 John Singer Sargent, Inside a Tent in the Canadian Rockies, 1916

115, 116

During the summer of 1916 Sargent, avoiding return to England from Boston during the midst of the First World War, ventured West and North to the Canadian Rockies, trekking with his manservant and a Swedish guide to paint the Twin Falls in the Yoho Valley. He had been alerted to the site by Denman Ross at Harvard University. He also painted the nearby Lake O'Hara, armed with commissions from his friend and patroness Isabella Stewart Gardner and from Edward Forbes, director of Harvard's Fogg Art Museum. The artist avoided the developed resort of Lake Louise as the site had become too much of a tourist attraction. Hoping to evoke his earlier summers spent in the Alps (an analogy actively advertised by the Canadian Pacific Railway's promotions), Sargent found the expedition more demanding and inhospitable than he had anticipated. Nonetheless he returned with four paintings, three of which are included here, and five watercolours. His trip is the subject of an essay in this catalogue.

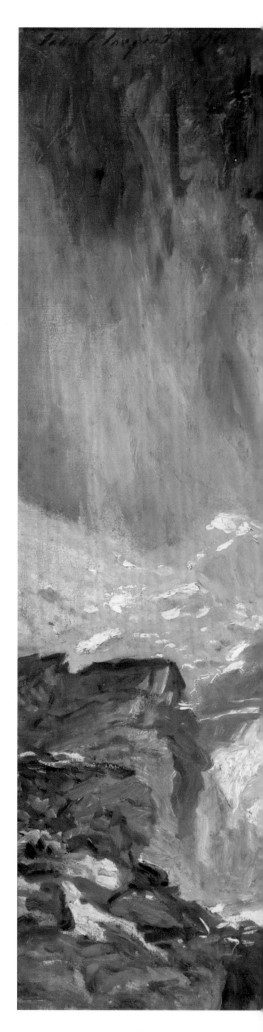

117 John Singer Sargent, Yoho Falls, 1916

On August 31, 1916, Sargent wrote to his Boston patron, Isabella Gardner, having returned to his hotel suite and preparing to venture to Lake O'Hara. "I have done a picture of a fantastic waterfall [*Yoho Falls*]" he informed her in the letter. The Gardner painting is remarkable for the manner in which this view of the Twin Falls in Yoho Valley, British Columbia, is arbitrarily cropped. The falls noisily descend over 180 metres from a cliff, atop of which the Twin Falls Creek, from the glacier plateau, is divided in two by a limestone block as it plummets before braiding back together 80 metres below and continuing the descent to the cascade at the base. Sargent, however, only shows the base of the falls. The direct spontaneity of the view, as one would experience it at close range without the broader vision gained through multiple perspectives, is quite modern in its aesthetic. It is precisely that directness of approach, complemented by the roughness of his brushstrokes, that evokes the intensity and monumentality of the experience. Casual photography had been very much a part of Sargent's earlier travels in the Alps, and the artist was certainly at home with its compositional aesthetics and arbitrary cropping from the viewpoint of the photographer's lens.

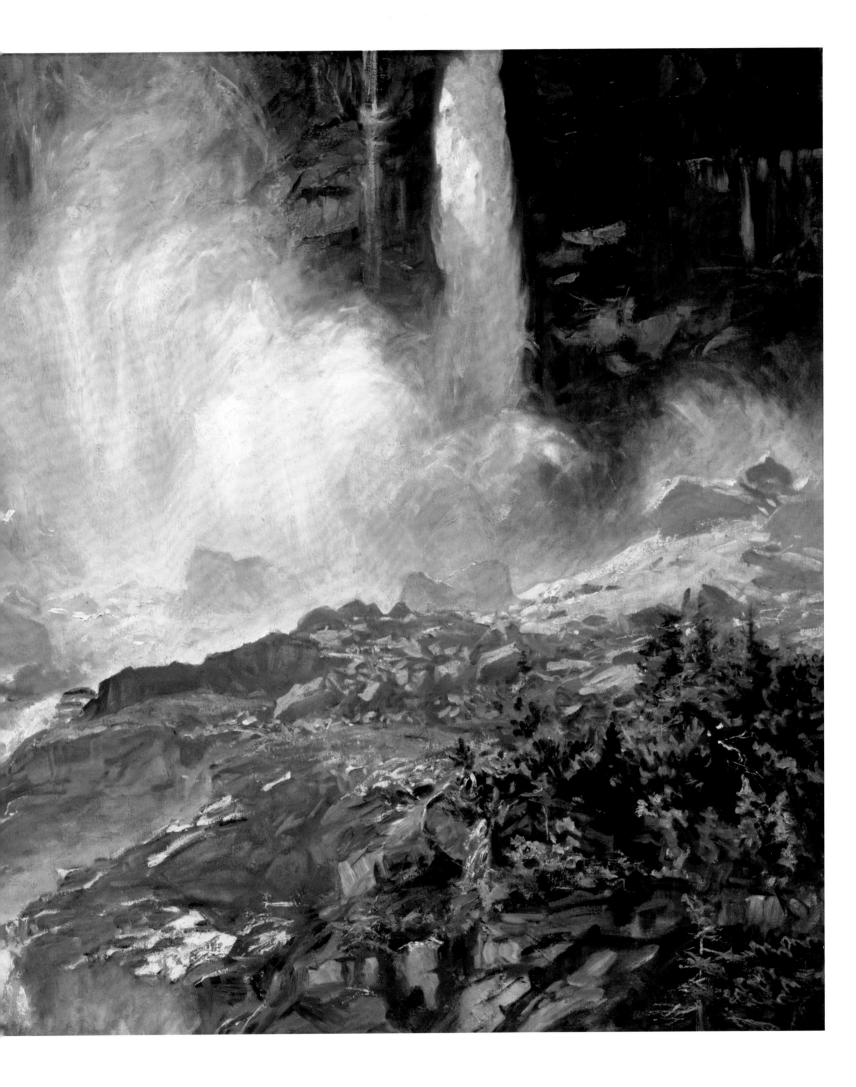

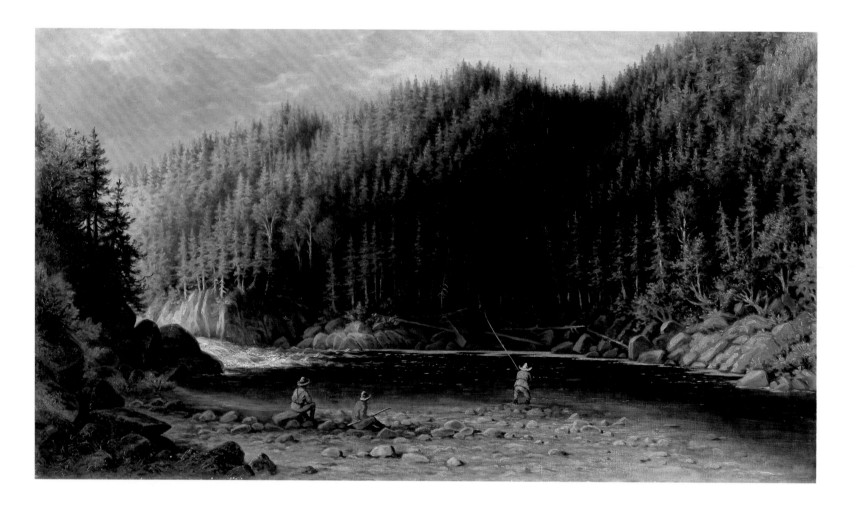

This painting illustrates fishing in a salmon pool on the Godbout River, north of the St. Lawrence. More fundamentally, it is a depiction of what had become a leisure activity of sportsmen, with contemporary, informal, rustically clothed figures set amidst a wild and seemingly unspoilt Nature.

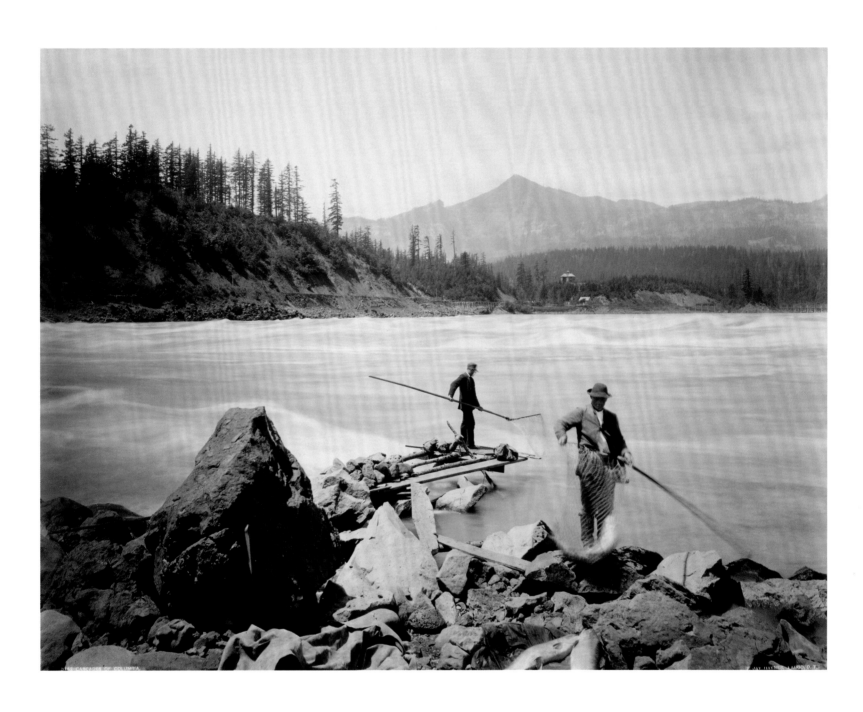

In this photograph, taken only a few years after the painting by Verner, the emphasis is quite altered. Haynes held the post of photographer for the Northern Pacific Railroad from 1876, creating images to encourage tourism and settlement along the rail lines. He was appointed official photographer of Yellowstone in 1884 (cat. 17). This image speaks precisely to that promotional concern. Civilized gentlemen are shown in their fishing attire, assuming the roles of sportsmen, venturing out to the dynamic river and capturing a large salmon in a net, asserting themselves through recreation in the wilderness, engaged in invigorating "masculine" activity.

120 William Raphael, With the Current, 1892

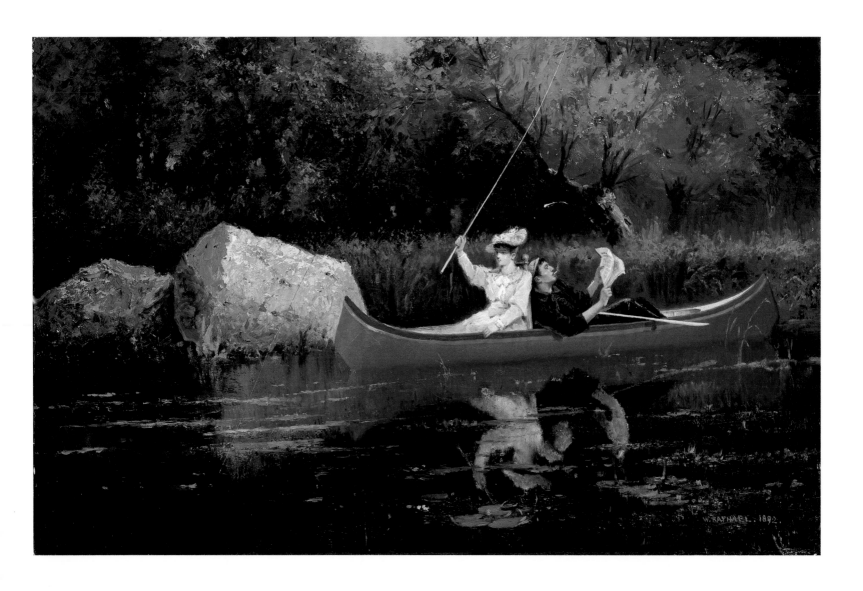

121 Eastman Johnson, Hollyhocks, 1876

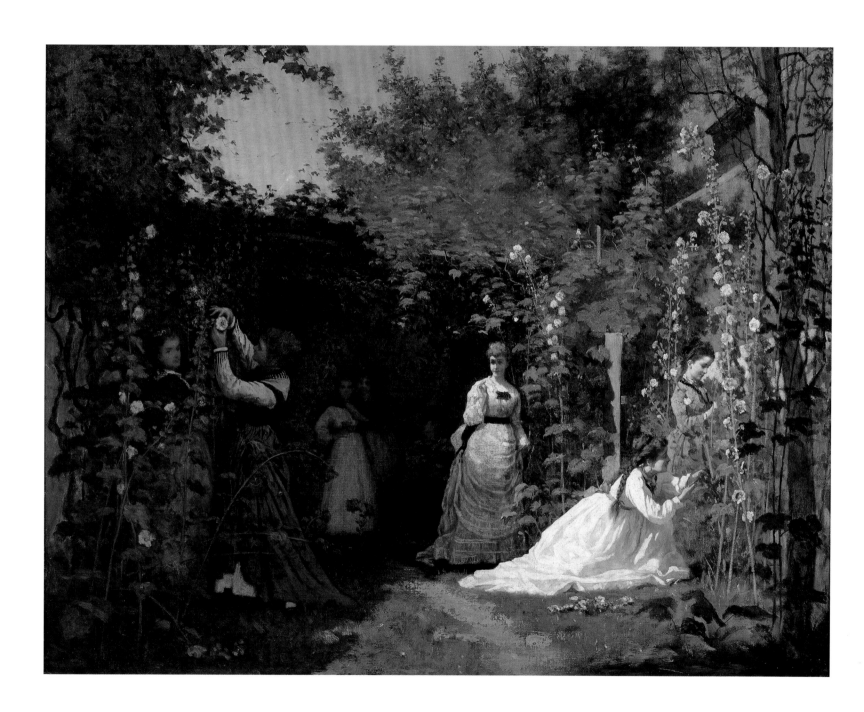

The mid-1870s were a period of transition for Johnson. Upon the heels of a successful early career as a lithographer and draftsman in Boston, the artist had trained at the Düsseldorf Academy. He solidified his reputation as a painter in the 1860s with genre paintings appropriate to the Civil War period (cat. 54) and images of New England rural life. *Hollyhocks* marks an essay at a new career venture: specifically feminine subjects. As the May 27, 1874, issue of the New York *Evening Post* noted, the painting depicts "a country school yard," albeit, given the fashionable attire the ladies are modelling, a quite upscale academy indeed!

122 William Brymner, Champ-de-Mars, Winter, 1892

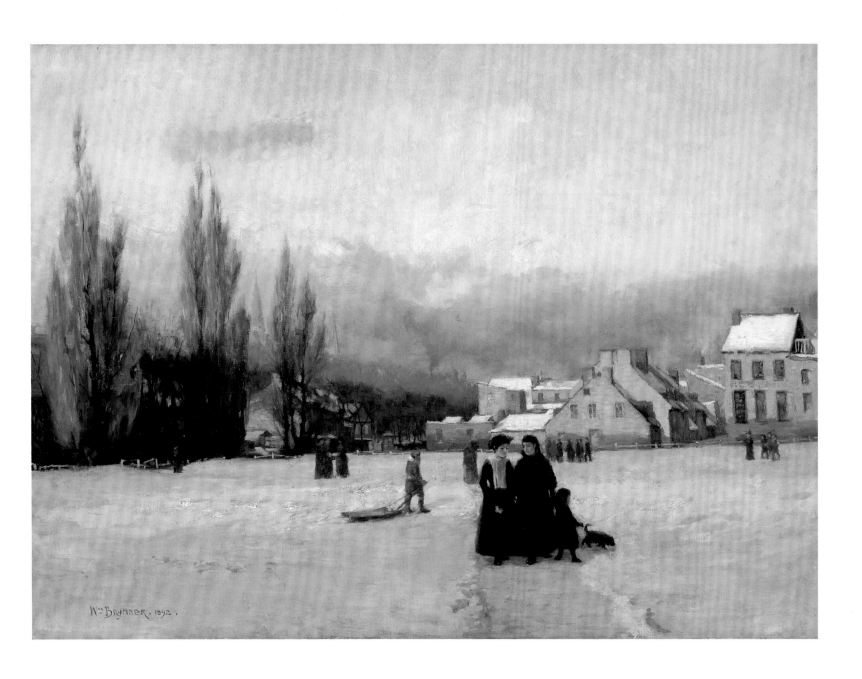

The composition of Brymner's casual winter scene of the central square, or commons, of Old Montreal behind the City Hall, featuring such vignettes as well-dressed ladies accompanying a child walking her dog along the snow path, a youth tugging a sleigh across the field and other small gatherings, is quite evidently influenced by contemporary photography. With the advent of Eastman Kodak's quick-exposure and easy-carry Brownie camera, amateur photography had itself become a popular activity. Snow was a common theme for Canadian artists of the period, and Brymner, who studied for five years at the Académie Julian under such artists as William Bouguereau, was a strict academic painter, if a more open-minded director and professor of the Art Association of Montreal from 1886 to 1921. He avoided industrial views in favour of the more picturesque and traditional, even in his urban scenes. *Champ-de-Mars, Winter* both reflects contemporary techniques and activities while responding to conservative tastes.

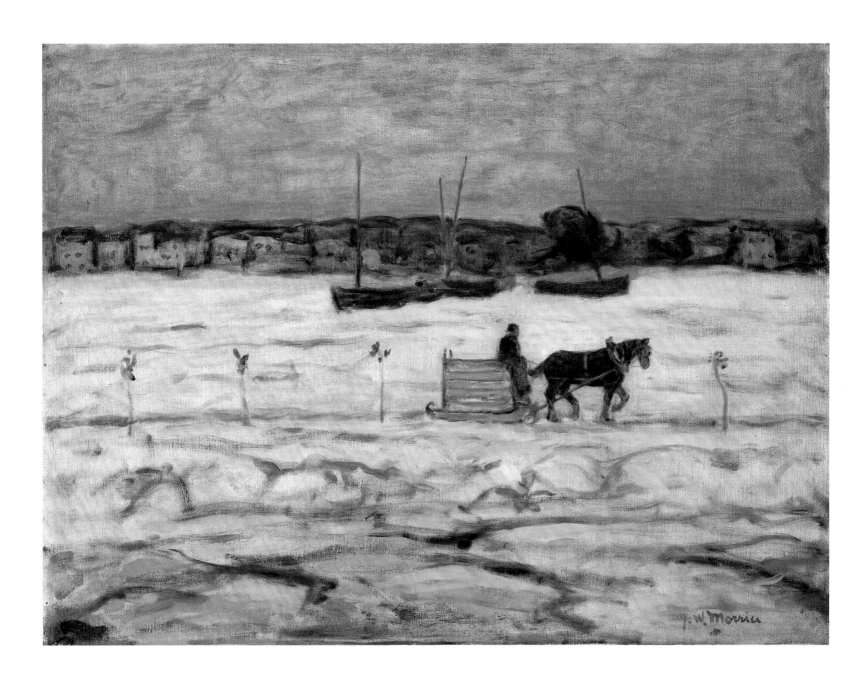

Morrice's paintings of Canadian subjects present contemporary life while evoking regional identity. In this painting, he unsentimentally juxtaposes the traditional image of a local resident crossing the partially frozen St. Charles River along a route marked by fir branches with the unromanticized buildings along the bank. Well acquainted with current trends in Paris, including the directness in the treatment of subject matter of Impressionism and the evocative use of colour and simplification of profile of Post-Impressionism, Morrice had studied at the Académie Julian in 1891, after a period in England, and revisited Europe throughout his life. The art of James McNeill Whistler and Walter Sickert, the latter a personal friend in Paris, profoundly influenced his style in the 1890s. Morrice also came to know Maurice Prendergast and, in the new century, would become more familiar with Paul Gauguin's art. Toward the end of the first decade he developed a personal friendship with Henri Matisse. In this painting of 1908, Morrice creates a tonal unity through thin applications of paint rubbed onto the canvas with a handcloth in a style still reminiscent of Whistler, but with a more open, abstract and assertive surface brushstroke, and enhanced colouristic range.

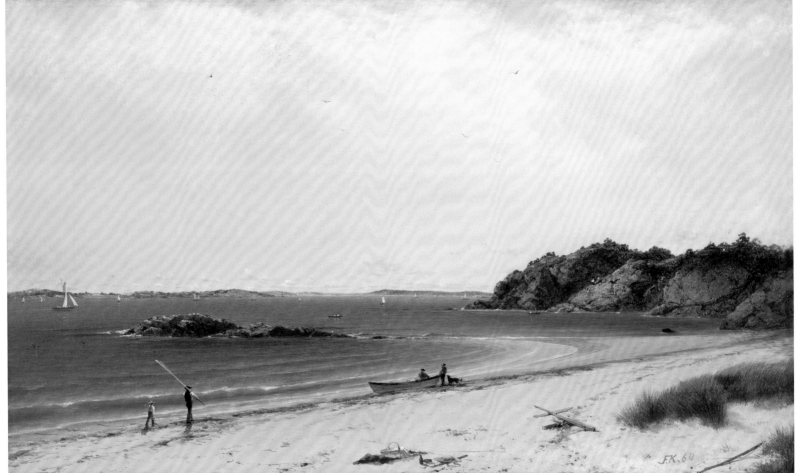

In this painting, Kensett responds to the tradition of the Dutch seventeenth-century masters. Simplifying the composition to its essentials to create a unified, harmonious vision of Nature, the painter included a wide range of leisure activities, suggested by the crossing marks in the sand, the casually strewn driftwood and the picnic items.

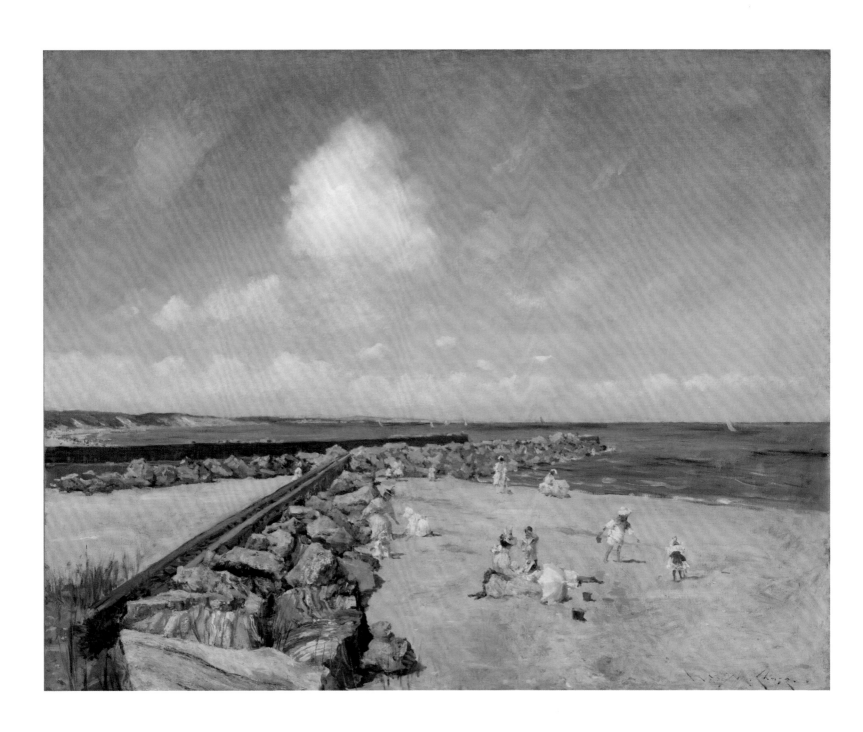

While Chase's Impressionism emerged in the late 1880s in images of New York City parks, it was in the 1890s, in his scenes of Shinnecock near South Hampton, Long Island, that he explored, with a more brilliant colour range, congenial images of summer leisure activities, sunny flower-bedecked open fields, and the comfortable existence of the middle class at rest and play. Chase found both inspiration and pleasure in Shinnecock, establishing an art academy there in 1891, where he taught until 1902. As Nicolai Cikovsky has noted, the site of this picture is in the immediate area of Chase's home and the figures are probably his wife and children. Although he painted outdoors like his French counterparts, his American Impressionism is distinct from the French model in its clear structure and crisp linearity.

126

126 Henry L. Rand, Somes Sound, Looking South, 1893
Rand was a Boston-area resident and fine amateur photographer who summered in Southwest Harbor, Maine, and ultimately retired there. Many years after his death his widow presented about fourteen hundred meticulously inventoried photographs by him to the Southwest Harbor Library. They include images of Maine and elsewhere in New England, as well as other sites, views of ships and portraits of Victorian ladies posed elegantly in formal attire. Somes Sound runs along Mount Desert Island, a favoured location for the photographer. The image combines his interest in recording the landscape of that island with his taste for decorously presenting finely attired Victorian women.

OPPOSITE
127 Clarence H. White, Jane White with Crystal Globe, Newark, Ohio, 1906
Co-founder of Photo-Secessionism in 1902, Clarence H. White worked closely with Alfred Stieglitz, who published his photographs in *Camera Work*. White's Pictorialist photographs reflect the influence of James McNeill Whistler in their softening of details and of Japanese prints in their compositions. Reacting against "straight" photography, his images were admired by critics particularly for their demonstration of previously unimagined aesthetic potentialities of the medium and their evocative, luminous effects which White achieved through controlled and manipulated lighting. Here he records his wife in 1906 near their home in Newark, Ohio. The artist permanently moved to New York City later that year and became an influential teacher, whose students would include such renowned photographers as Margaret Bourke-White, Laura Gilpin, Dorothea Lange, Karl Struss and Paul Outerbridge.

128 Julian Alden Weir, The Red Bridge, 1895

Weir's adoption of Impressionism was encouraged by travel to Europe in the 1880s. His subsequent life was divided between New York City and his wife's family's summer houses in Connecticut. *The Red Bridge*, a site near Windham, Connecticut, reflects the artist's adherence to Impressionist aesthetics, both in its modern subject (the iron bridge over the Shetucket River had replaced a covered bridge) and its allusion to Japanese woodcuts in its high horizon, compositional design, cropping and decorative devices, including the extended, curving branch in the foreground.

129 Willard Leroy Metcalf, Midsummer Shadows, 1911

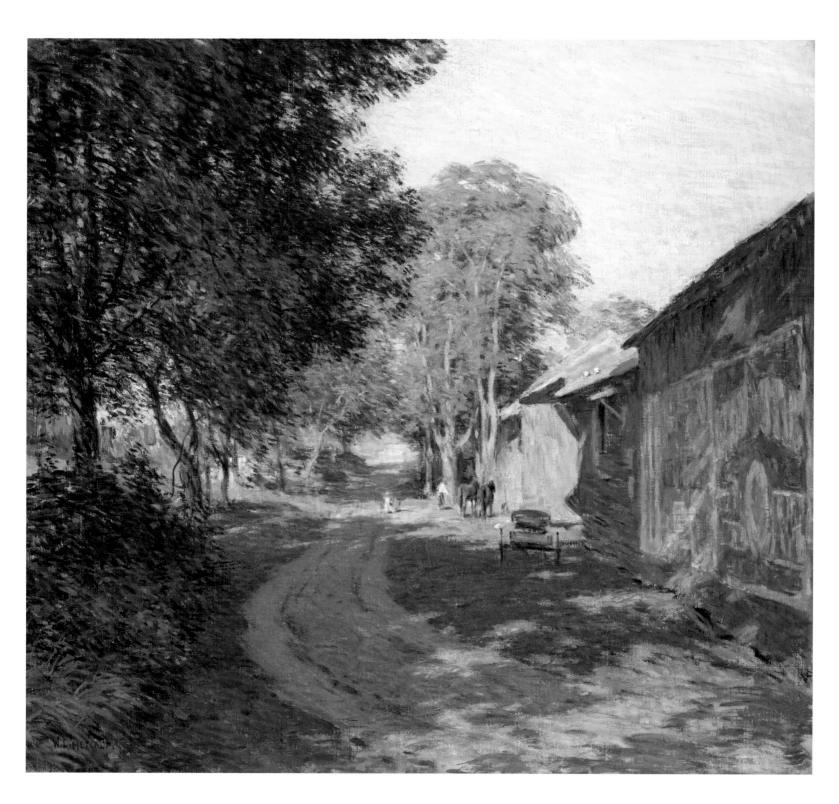

Metcalf grew up in various New England towns, studying at the Lowell Institute before setting up a studio in Boston in 1876. He travelled to France in 1883, where he studied at the Académie Julian in Paris, but also visited England and Pont-Aven in Brittany. During this period, his circle came to include John Henry Twachtman and Theodore Robinson. In 1886 he visited Giverny, returning the two successive years. Metcalf's subjects featured rural scenes, landscapes and farm life, and the artist responded increasingly to the Impressionist palette, a conversion encouraged by his association with Childe Hassam and The Ten, a group of American artists formed in 1898 in protest against the rigorous exhibition standards of the National Academy of Design. During the summer of 1903 he painted in the company of Hassam at Old Lyme, Connecticut, before continuing on to Maine. He returned to Old Lyme for a more prolonged stay in the summer of 1905. These sorts of naturalistic, informal and gentle scenes, bathed in warm sunlight and culled from the New England countryside, found a ready market.

130 William Brymner, Summer Landscape, 1910

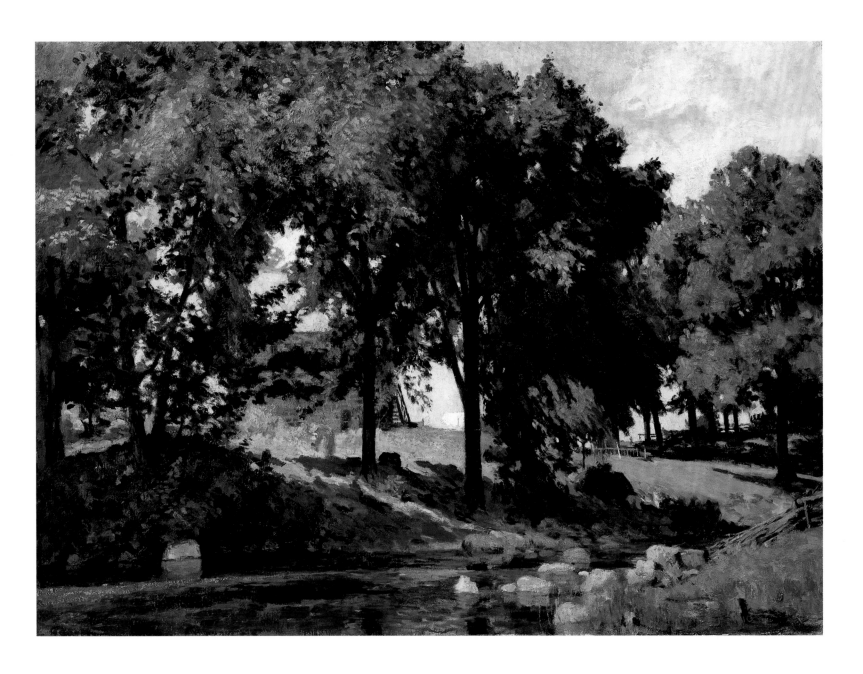

The exceptionally large format of this painting is reminiscent of the sort of academic "machines" so popular over a generation earlier among Americans. Such monumental Brymners were generally the result of specific commissions from the Canadian Pacific Railway and other commercial enterprises. It is not coincidental that Brymner had travelled to Paris in 1878, spending five years at the Académie Julian and working under William Bouguereau. The artist, who also painted Native and Western subjects after travel in these regions with a CPR pass in 1886 and 1892, remains true to his taste for the picturesque and pastoral, if on an uncongenial magniloquent scale (see cat. 122).

131 Ernest Percyval Tudor-Hart, Springtime in Canada, 1903

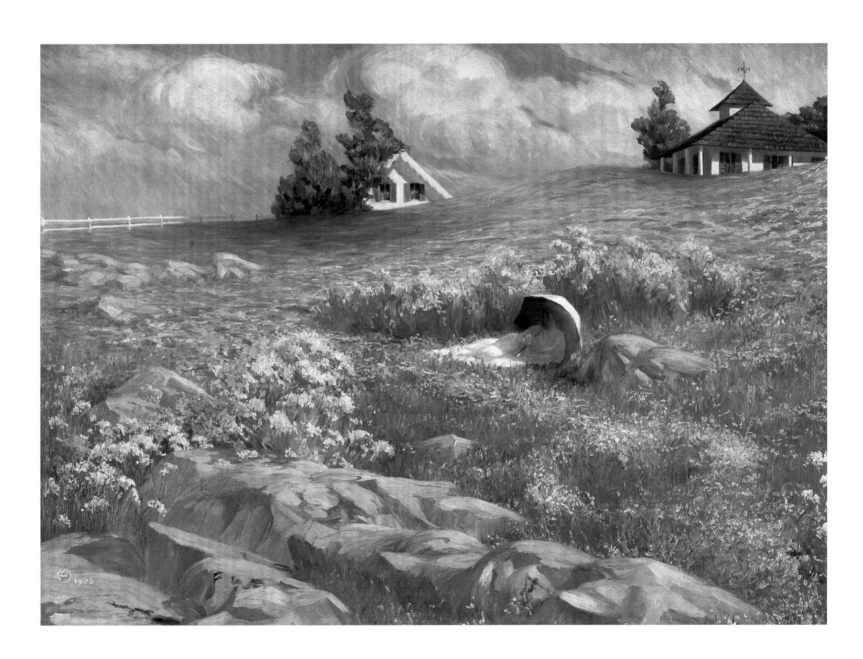

Born in Montreal, Tudor-Hart was a student of Jean-Léon Gérôme and lived much of his life in London, also retaining a residence in Dinard, France. His interest in Impressionism, especially in the work of Edouard Manet and Edgar Degas (he also came to be an admirer of Paul Cézanne), is evident in this canvas, with its treatment of the sunlit countryside of his native Quebec and its brilliant, exuberant colourism, open brushwork and remarkably high horizon line. Indeed, the artist sent the work to be exhibited in Paris in 1903.

132 James Wilson Morrice, The Terrace, Quebec, 1910-11

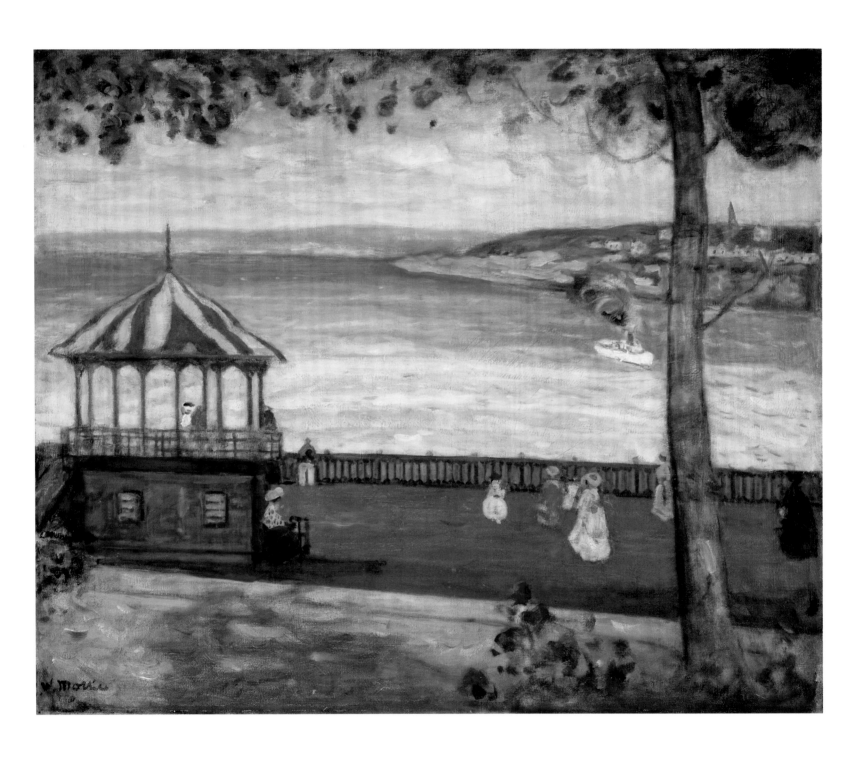

Dufferin Terrace in Quebec City was constructed in 1879 along the plateau abutting the Chateau Frontenac, overlooking the St. Lawrence. Morrice spent the summer of 1910 in Canada. For all the informality of its subject matter, the painting, reflecting the brighter colourism he had discovered in his travels and artistic exposure to the Nabis and Fauves in France, together with his Whistlerian application of a thin base layer of paint, is a very carefully controlled composition, established by the horizontal planar bands and by the dominant tree in the right foreground with its foliage running the entire width of the canvas. As earlier noted (cat. 123), Morrice responded to a range of English and French artistic influences in the late nineteenth and early twentieth century during his years in Paris, including Whistler, Walter Sickert, the Nabis and Henri Matisse. He also came to know American painters, notably Robert Henri and Maurice Prendergast. The stylistic parallels yet distinct sensibilities between Morrice and Prendergast are very striking and an exhibition exploring the two personalities remains to be organized.

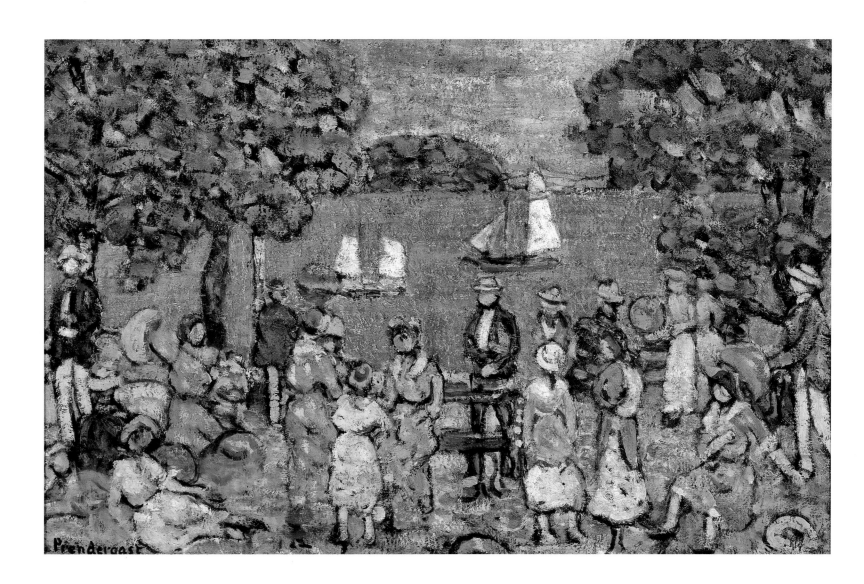

In comparison with Morrice's style, Prendergast's is generally less linearly conceived and more open, with his application of blocks of unmodulated colour, reflecting his passion and extraordinary talent as a watercolourist. His figural images often focus on women and children in activity, on the streets or in public spaces, but never in domestic settings. He had, like Morrice, studied in Paris, travelling there in the early 1890s and studying at the Académie Julian, but he also appreciated the work of Manet and was influenced by Whistler and the Nabis, executing many watercolours and painting outdoors. He returned to Boston in 1895 and by the end of the decade travelled to Italy, notably Venice, where he experienced Italian fifteenth-century art, which gave greater structure and solidity to his later works. This is visible in the horizontal bands of this composition, *Summer Hotel, Maine* (cat. 134), and particularly *Central Park* (cat. 135), all from the mid-1910s.

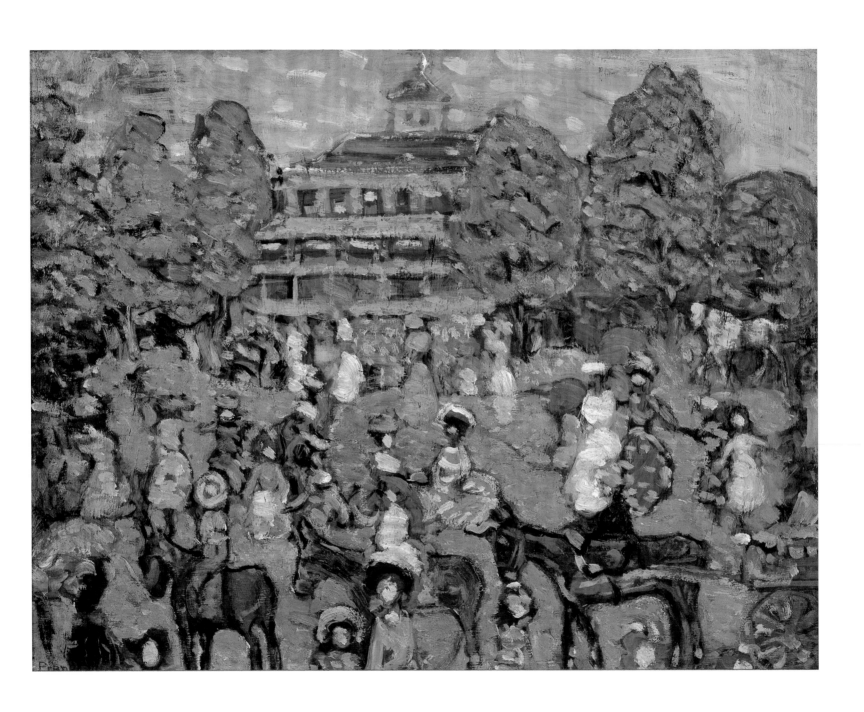

In July 1914 Prendergast went to Ogunquit, Maine, for his summer vacation.

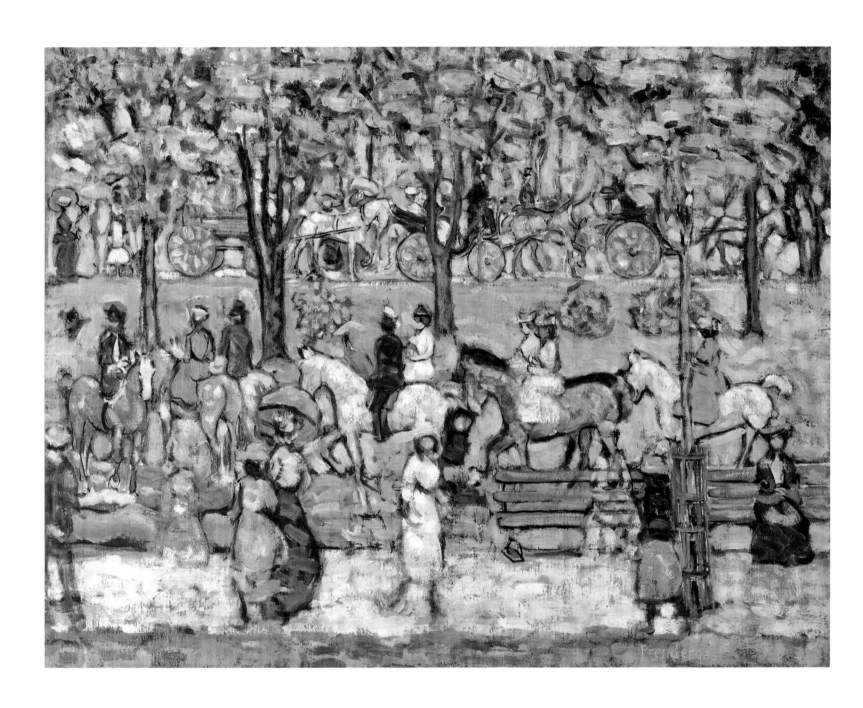

Prendergast executed a number of promenade scenes in Central Park, both in watercolour and oil, during this period. Although not among his most popular works, the Park offered the motifs and compositional structures that so interested him (see cat. 133).

136 Clarence Gagnon, The Wayside Cross, Autumn, 1916

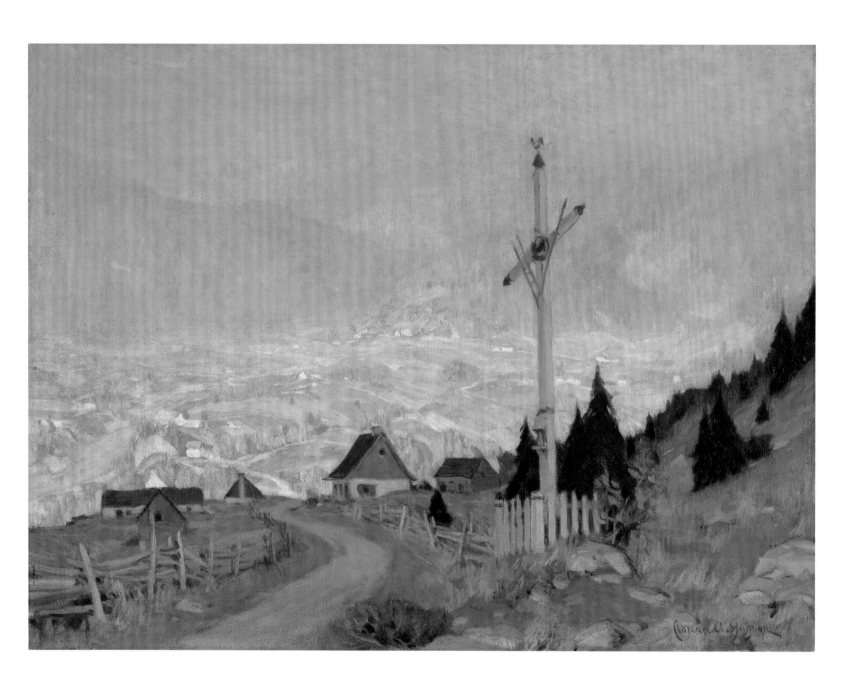

Gagnon trained under William Brymner (cat. 122) in Montreal, travelling to France in 1904 and studying at the Académie Julian. He also visited Italy. During this period, apart from the major impact upon him of Impressionism, he became influenced by the canvases of James Wilson Morrice. Gagnon would often visit Paris in the succeeding years, settling there in the 1920s. Upon returning to Montreal in 1908, he focused for several years on scenes of rural Quebec, applying a more modernist aesthetic. However, rather than simplifying his compositions to give them structure, as did Morrice, Gagnon favoured a brilliant panoply of orchestrated colours and tonal gradations. The strikingly and naturalistically presented subject, replete with a wayside cross with the instruments of the Passion, the detailing of the sunlit middleground and the atmospheric haze and shadows of the encroaching overcast, is balanced with the abstracting, tapestry-like patterns of vivid colours suggested by the autumnal landscape. The view is from the Charlevoix region of Quebec.

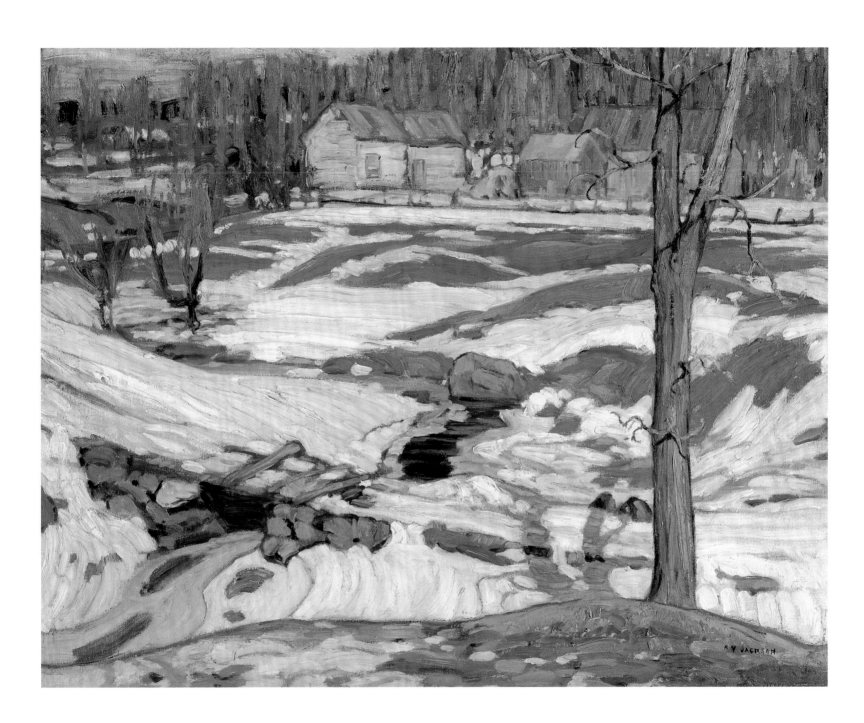

Jackson was one of many young artists of his generation who studied under William Brymner at the Art Association of Montreal, in his case succeeded by training at the Art Institute of Chicago, the Académie Julian and travel throughout Europe. When he left France in 1911, he was painting in a style indebted to the Impressionists. Snowy landscapes, already explored by such established contemporaries as Maurice Galbraith Cullen and James Wilson Morrice, also attracted him. His return to Montreal that year was not marked by commercial success and, considering emigration to the United States, he travelled to Émileville, Quebec, to sketch and paint. During this trip he received a letter from J.E.H. MacDonald, who offered to buy one of his pictures on behalf of Lawren Harris. In 1913 Jackson moved to Toronto, where he associated with the artists who would constitute the original members of the Group of Seven and worked in Harris's studio, while Harris, of independent means, built the Studio Building to house young artists. In 1914 Jackson would share a studio in that building with Tom Thomson. His earlier interest in the Canadian countryside, conjoined with an appreciation for linear expressiveness, reminiscent of Art Nouveau, and an increasingly liberated palette, inspired by the Fauves and his interaction with his colleague Lawren Harris, is evident in this picture, which marks a moment of transition between traditional Canadian landscapes and the new aesthetic.

138 James Wilson Morrice, The Old Holton House, Montreal, about 1908–09

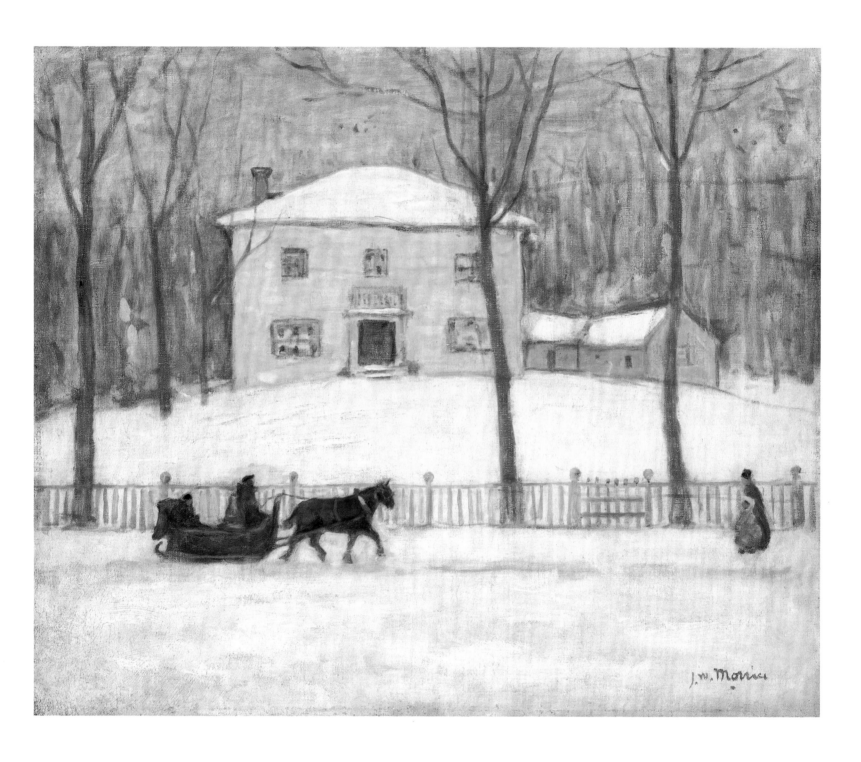

The anecdotal details in this painting—the horse-drawn sleigh, a favoured device of the artist, and the woman and child—do not appear in the artist's significantly earlier preparatory drawing for the painting. Morrice spent his winters in Montreal until 1914, when his parents died. Located on the north side of Sherbrooke Street, the Holton House was destroyed in 1912 to make space for the building now known as the Hornstein Pavilion of the Montreal Museum of Fine Arts. The work is carefully constructed in a grid defined by the centrally placed house, the verticality of the trees and firm horizontality of the fence, both running the length of the picture, and the genre elements. The paint is applied quite thinly in areas, still reflecting a Whistlerian influence.

139 Lawren Stewart Harris, Red House and Yellow Sleigh, about 1920

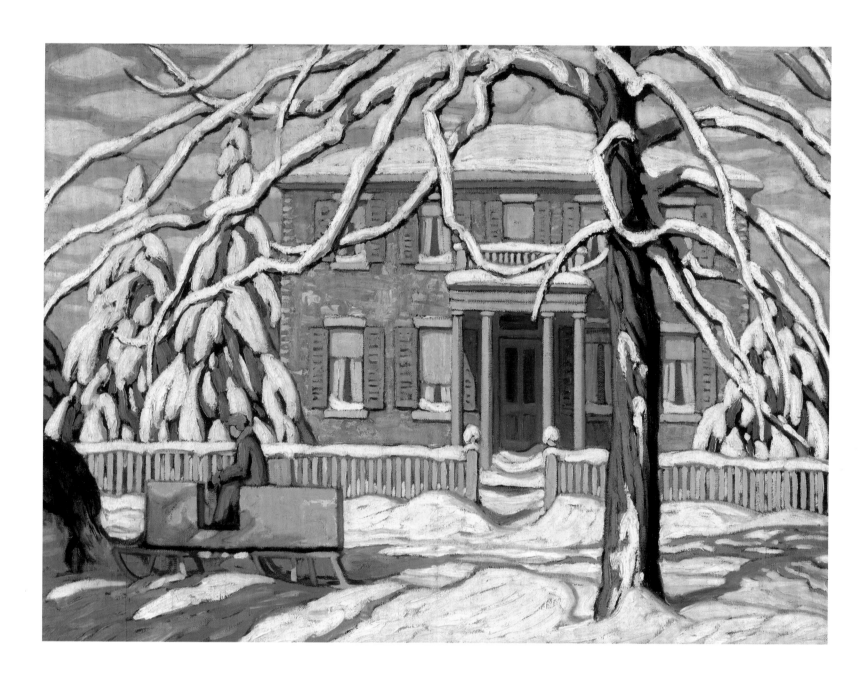

This particularly controlled and geometrically gridded painting of a Toronto house by Harris makes a fascinating comparison with the preceding Morrice. Indeed, both artists relied on the horizontal elements of the fences and houses to anchor their compositions and used the vignette detail of a sleigh. Harris's composition, however, adopts a dramatic, modernist lattack upon Neature, and his dynamic trees, deeply influenced by his experience of the 1913 modern Scandinavian landscape painting exhibition at the Albright-Knox Art Gallery in Buffalo, New York, are the true actors in the work. Nonetheless, as demonstrated by the contrasting vividness and raw colourism of the snowy trees, the blue reflections and the cloud-dappled sky, Harris felt constrained by such urban subjects and expressed himself most freely in the wilderness.

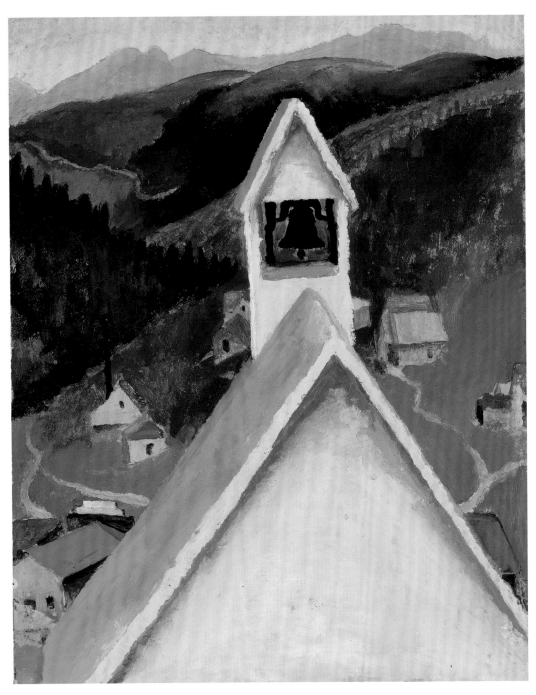

140 Georgia O'Keeffe, Church Bell, Ward, Colorado, 1917

Following her return to New York in 1914, O'Keeffe rapidly gained exposure and a sophisticated understanding of the tenets of European modernism, seeing works by Pablo Picasso, Georges Braque and Francis Picabia at Alfred Stieglitz's Gallery 291 and studying Wassili Kandinsky's theory of colour and spirituality, which encouraged a simplification of expression into geometrically reduced, colouristically resonant forms. After an exhibition with Stieglitz in 1916, O'Keeffe returned to Texas, where she had worked earlier in the decade, heading an art department at Canyon. The Southwest landscape proved to be fertile ground for her to synthesize these stylistic influences and articulate a mature style. That aesthetic is dramatically asserted in *Church Bell, Ward, Colorado*, with its powerfully vertical composition, the roof and steeple towers resembling assertive arrows, hovering in brilliant colours against the landscape, which picks up accents of their bright oranges and yellows. After a one-woman show at Gallery 291 in 1917, O'Keeffe returned to New York in 1918, staying there for a decade before definitively moving to New Mexico.

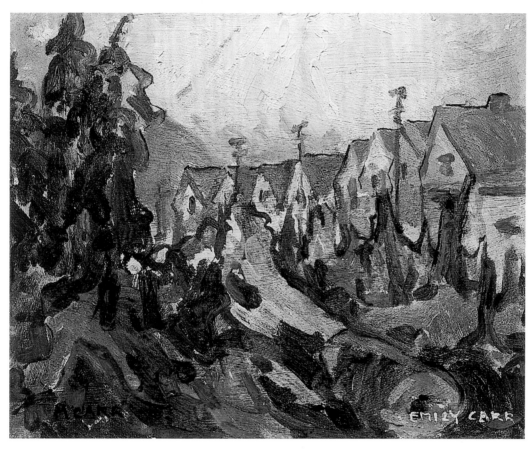

141 Emily Carr, Vancouver Street, 1912-13

In 1910, Carr visited France, returning to British Columbia in the fall of 1911 and settling in Vancouver in 1912. That visit proved essential to the future direction of her art. Her palette and her freedom in defining forms reflect the profound influence of the Fauves. Over the succeeding years she would bring increased discipline to her compositions as well as clarity and monumentality to her subjects. This painting is a dazzling exemplar of the intensity of her first response and reinvigorated style following her recent European travel.

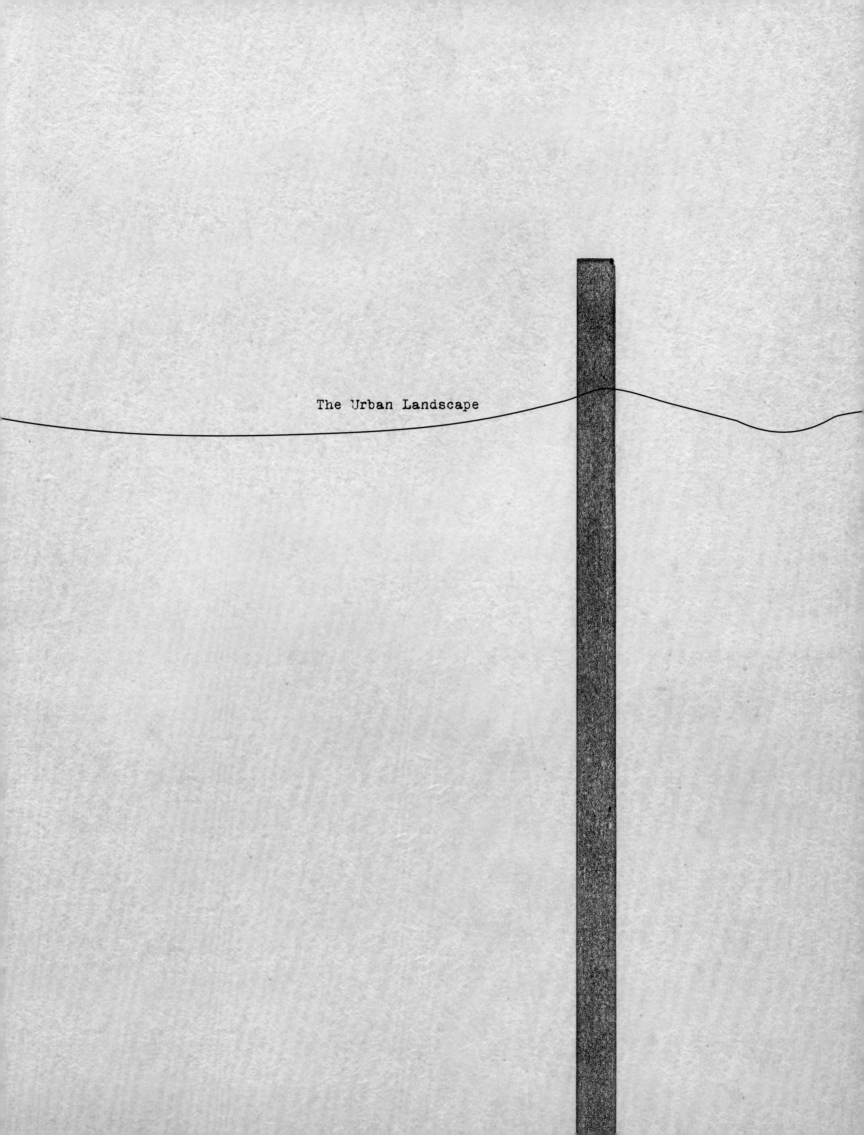

The Urban Landscape

...Give me your tired, your poor,
Your huddled masses yearning to breathe free,
The wretched refuse of your teeming shore.
Send these, the homeless, tempest-tost to me,
I lift my lamp beside the golden door!

Emma Lazarus,
American poet

Words inscribed on a tablet within
the pedestal beneath the Statue of Liberty,
New York harbor

"To Pavements and Homesteads Here"

- Landscape, Photography, and the Transcendence of Time and Space

Philip Brookman

Photography appears on this scene
as though someone had found a way
to freeze the water of passing
time; appearances that were once
as fluid as water running through
one's fingers became solid objects.

Rebecca Solnit,
River of Shadows:
Eadweard Muybridge and the
Technological Wild West

During the second half of the nineteenth century, photography, more than any other art, helped change our understanding of the world. Hand in hand with the process of mechanization, which shifted how we identify with time and space, the camera changed our way of seeing and proposed a new form of expression. Photographs exhibited many traits of printed text, including a narrative structure and, eventually, a reproducibility that made them pervasive. Moreover, this more democratic art opened people's eyes to a new way of seeing. Along with sweeping changes in science, transportation and manufacturing, photography helped create the world we know today.

For years the scale and beauty of the North American landscape had coloured the development of a national consciousness in the United States. During much of the nineteenth century, images of the American landscape were akin to self-definition, helping a growing confederation of immigrants to characterize and distinguish themselves from their foreign roots. Frequently inspired by European Romanticism, Hudson River School painters created an essentialist view of the land. The lush forests, coursing rivers and dappled meadows in the paintings of Thomas Cole (1801–1848), Asher B. Durand (1796–1886), Frederic Edwin Church, John Frederick Kensett and Albert Bierstadt were often expressions of spiritual connections between settlers and the Divine. The human spirit was embodied in the natural world, as painters created images that placed the civic individual at its service. Durand's *Kindred Spirits* (fig. 1) depicts a fusion of actual albeit idealized

sites that invite and inspire those who are but visitors within its eternal, invented universe. The wilderness appears painted by nature, unspoiled by those who trod its paths.

By the early 1850s, nature still stood between people and progress, between stasis and the frontier. With its limitless skies, plentiful rivers and vast mountains, it was seen as a powerful force, a representation of Eden, a transcendent spiritual influence. It was also often portrayed by artists to connote the psyche of the young country. Nature was the sublime embodiment of collective dreams. The enormity and remoteness of wonders like Niagara Falls pointed to the insignificance of people in relation to the scale and power of the natural world. Niagara Falls came to symbolize the limitless westward movement and economic potential of the population. In some ways the falls were enigmatic, as their real strength and beauty could rarely be depicted in a work of art.[1]

Photographers fashioned Niagara Falls as an icon of nature. Devoid of the grand scale and luminous colours of paintings but uncannily realistic in their topographic portrayals, photographs—even when taken at a remote distance from the subject—were more factual and accessible in the minds of new audiences. American photographers Albert Sands Southworth (1811–1894) and Josiah Johnson Hawes (1808–1901) depicted Niagara Falls around 1850. Technical challenges made such outdoor photography a rarity.[2] Shot in the dead of winter, their full-plate daguerreotype, *Niagara Falls from the Canadian Side*

(fig. 2), shows the cascade from an outlook close to the cliff. The foreground and distant shore are frozen over, the usual roar is hushed and a veil of ice and mist obscures the drama. Here, however, we are close to the scene, peering down over the brink. Our sense of gravity and location is disturbed. The detail in the frozen branches and the aerial mist that subsumes the horizon project an unearthliness akin to the fleeting drama sought by Hudson River School painters.

After numerous visits to the region, Frederic Church completed his monumental painting, *Niagara* (fig. 3), in 1857. It appears like a wide-screen movie that places the viewer right on the rim of the gorge. The panoramic composition proved to be a theatrical tour de force, which even today feels like a photographic view, cutting off the surrounding landscape and focusing on the plunge of the falls. Illuminated by the rekindled light of a clearing storm, the rushing water engulfs the solid rock below. Church's prismatic rainbow, spawned by the sun on spray, connects the dematerialized, secular ground to the metaphorically sacred sky in a manner that spoke to the American ambition of the time. *Niagara* quickly became one of the most popular paintings of its day. When the work was first exhibited, a *New York Times* critic stated, "Mr. Church has shown himself the great artist in the selection of his point of view."[3] Niagara Falls had come to stand for the passions of Manifest Destiny and the boundless future of the country. As a result it became one of the most significant emblems of

fig. 1 Asher B. Durand, *Kindred Spirits*, 1849

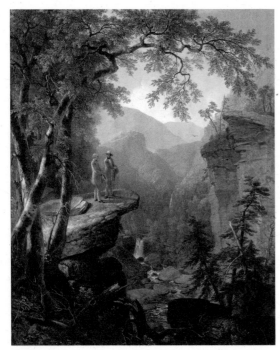

fig. 1

the American and Canadian landscape. In 1867, Church reprised the theme in *Niagara Falls, from the American Side* (cat. 1)—a composition that closely mirrors the Southworth and Hawes daguerreotype. Even more forceful than his 1857 rendition, *Niagara Falls, from the American Side* depicts the ferocious cascading water transcended by the depiction of light and, again, the prismatic connection between earth and spirit.

William Notman's 1869 photograph, *Niagara Falls* (cat. 4), shot from the same point of view, is less theatrical and more taut than Church's painting. It speaks matter-of-factly of the Niagara River's ease of access, its connection to real life and its potential as a tourist attraction. Notman, the Montreal-based photographer who built one of the largest photographic studios in North America, was known for his portraits, city views, railroad surveys, landscape scenes and photomontages of festivals and special events. His iridescent photograph of Niagara depicts the river in motion against its static surroundings; the gauzy surface and a vaporous mist hover at a safe distance from the rocky shore in the foreground. A prolonged exposure time blurred the moving water.[4] The pictorial arrangement of ground, water, trees, horizon and sky in a succession of planes flattens the perspective and distorts the relative scale of various elements.

In stark contrast, the realistic style, vast space and dizzying viewpoint of Church's *Niagara Falls, from the American Side* immobilizes the flow of water as if time itself was momentarily stopped through divine

intervention. The viewer peers down into the chasm of the falls as if thrust over the gorge, suspended like the water, without any sense of real time. It depicts a spiritual moment rather than an earthly one grounded in corporeal materiality. While Notman proposes a modern, more prosaic approach to the landscape, Church connects us to a more lyrical, rhythmic representation of the falls.

As a cultural icon, Niagara Falls symbolizes our ultimate lack of control over nature—over the inevitable cycle of death and rebirth.[5] Powerful and beautiful, the falls are always in motion, like a narrative thread, from the calm eddy of the river above to the formidable currents, precipitous cascade and deluge; they climax, like the biblical story of Noah, in a drenching mist and peaceful rainbow, connecting earth and sky. In 1855, Walt Whitman mentions Niagara in *Leaves of Grass*, likening the mightiness of nature to the "torrents" of settlers "pouring" into the cities.

Now we go forth to receive what the
earth and the sea never gave us,

Not through the mighty woods we go,
but through the mightier cities,
Something for us is pouring now
more than Niagara pouring,

Torrents of men, (sources and rills
of the Northwest are you indeed
inexhaustible?)

What, to pavements and homesteads
here, what were those storms of the
mountains and sea?

What, to passions I witness around
me to-day? was the sea risen?[6]

Against the layered complexity of Whitman's metaphoric queries and the westward movement of settlers in the wake of the Civil War, the principal subject of photography came to encompass the topography of the landscape and the passage of time.

In the 1860s, the camera, like the railroads, could transcend both time and space. And like the emerging disciplines of geology and evolution theory, photography enabled some uniformity in our comprehension of the universal nature of humankind. As photographers struggled with the technical limitations of the medium, governments and businesses increasingly turned to them to market their visions of the western frontier. The discovery of gold in the Sierra foothills precipitated a huge increase in California's population during the 1850s and 1860s, and the young state expanded to bookend the nation's colonization. San Francisco became the principal port of supply for the Gold Rush, and between 1847 and 1860, the city's population grew from about 460 to 56,000 people.[7]

In 1851, lured by the Gold Rush, Carleton E. Watkins travelled from Oneonta, New York, to California, with Collis P. Huntington, a shopkeeper and hardware supplier who later helped finance the construction of

fig. 2 Albert Sands Southworth and Josiah Johnson Hawes, *Niagara Falls from the Canadian Side*, about 1850

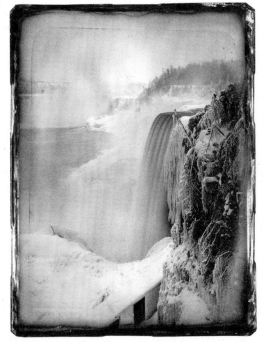

fig. 2

the Central Pacific Railroad. Watkins first worked for Huntington as a store clerk in Sacramento, and then moved to San Francisco, probably to assist the city's best-known photographer, Robert Vance, in his studio and outdoor work. By 1856, Watkins had established his own practice, and in 1861, he travelled to Yosemite, just two years after Charles Leander Weed (1824–1903), the first photographer to enter and document the valley. Watkins's early views of Yosemite, made between 1861 and 1872, such as *River View of the Royal Arches, Yosemite* (fig. 4), are among the most innovative landscape photographs of the time. His ability to create mammoth plate images that could be reproduced and hung on a wall like a painting helped transform the way photographs were viewed. Watkins's large-scale photographs were composed to draw attention to the overall complexity and scale of the topography.[8] In Yosemite, his use of reflections to mirror trees and cliffs, and of luminescent skies to divide the geologic rigidity of valley cliffs from the fluidity of the water below, project a decidedly modern character.[9] There is a torque between the sharp, detailed representation of objects and the rendering of flattened pictorial space through careful selection of viewpoint and geometric composition.

Watkins's later images of rivers, railroads, architecture and mines refined this vision. *Cofferdam at End of Main Diversion (Golden Feather Mining Claim)* (cat. 96) looks down on a group of miners removing dirt from a giant pit. Wooden ramps, boardwalks and scaffolds jut diagonally into the frame, crisscrossing

the photograph. However, considered in relation to his earlier photographs that depict a geologic sense of timelessness, Watkins's mining images are documents of a specific moment, cut from the continuum. The landscape is transformed as dirt is removed, shovelful by shovelful, exposing by force the layers of rock beneath the surface. One senses the urgency of the operation, its destructive power, pressed by an appetite for resources to feed the growing cities.

Eadweard Muybridge, who settled in San Francisco via New York in 1855, also travelled to Yosemite Valley on several occasions.[10] When he first entered the remote wilderness area in 1867, making photographs still involved carting cumbersome equipment—including heavy cameras, glass plates, chemicals, dark tents and camping supplies—across long distances and arduous terrain. Muybridge's 1867 views supplemented the drama and mystery of the valley that was known to the public through writings and paintings as well as photographs, such as Weed's and Watkins's, and engravings made from them. Muybridge's first photographs consisted of 6 x 8 inch half-plate landscapes and a number of smaller stereographic views. When seen through a stereo viewer, these gave the illusion of great depth and helped feed a growing Victorian market for travel photographs that brought distant lands within reach of home. In 1868, twenty of Muybridge's images were used to illustrate John S. Hittell's *Yosemite: Its Wonders and Its Beauties*, one of the first guidebooks of the region. The *Philadelphia Photographer*, a leading journal of the time, praised these pictures and within

a few years, Muybridge had become one of the best-known photographers in San Francisco.

The same year, Bret Harte published his acclaimed story "The Luck of Roaring Camp" in *Overland Monthly*. Harte's classic parable balanced the concepts of luck and destiny in men's lives with the irreconcilable forces of the natural world. "Nature was his nurse and playfellow," wrote Harte, referring to an orphan baby boy nicknamed The Luck taken in by a group of hardscrabble Forty-niners who had vowed to raise him. "For him she [nature] would let slip between the leaves golden shafts of sunlight that fell just within his grasp."[11] Despite their belief that the boy would bring them luck, he perished in a flood that swept through the miner's camp. Harte's story suggests the growing tension between the settlers and nature, as their fortune-bound pursuit of a better life ultimately became tied to domestication of the wilderness.

Despite this tension, the economy and population of California grew rapidly in the late 1860s and early 1870s. Spurred by the completion of the transcontinental railroad in 1869, the availability of fertile land, minerals and timber, and the importation of a labour force from Asia, Latin America and Europe, California was often thought a promised land, an economic and cultural Eden. As historian Kevin Starr observed, "California was now joining the national economy, including the industrial culture that had been expanded and intensified by the Civil War."[12] But the economic reality in the rest of the country and abroad was dismal, as political strife, labour issues

fig. 3 Frederic Edwin Church, *Niagara*, 1857

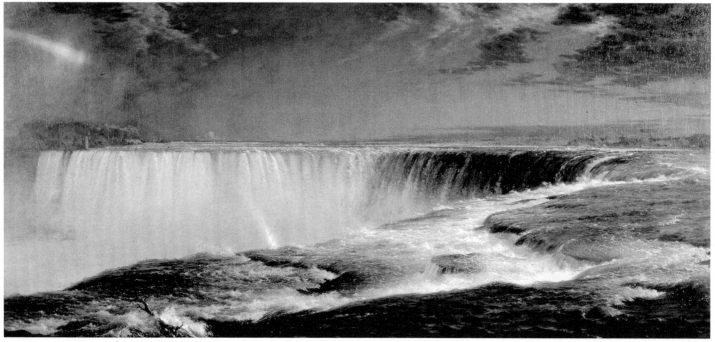

fig. 3

and fiscal problems brought about a destabilizing depression that called into question the human cost of such rapid industrialization. Americans were redefining their role in the industrial world. Nationally, the 1870s was a decade of poverty and self-absorption, of political violence and self-scrutiny. The West was less affected and, consequently, Californians were at the forefront of redefining America's cultural relationship to time and space.

Even in his earliest landscapes, Muybridge displayed a keen interest in the temporal effects of nature. He depicted sunlight playing on the surface of water and rocks, clouds advancing in dramatic formations across the sky, a stencilled moon playing peek-a-boo above dark cliffs and water, glassy smooth or broken into a sparkling spray that resembled stars spilling from an atmospheric mist. In 1872 Muybridge returned to Yosemite and produced an award-winning series of mammoth plate landscape photographs, along with numerous stereos. These images were a technical tour de force. Consisting of fifty-one albumen prints, each measuring about 41 x 52 cm and detailing features of Yosemite Valley, the High Sierra and Mariposa Grove, they were significantly different from Watkins's or those of any other landscape photographer to date. Muybridge shot from dizzying heights and precipitous angles, looking over cliffs and waterfalls, and focused on the effects of light and moving water rather than the solidity of things. *Pi-Wi-Ack. Valley of the Yosemite* (cat. 19) depicts Vernal Falls emerging from a sheer cliff face. There is no visible horizon and, like Timothy

O'Sullivan's survey photograph *Ancient Ruins in the Canyon de Chelle, New Mexico* (cat. 64), the pictorial space is quite flat and the image compositionally advanced. Due to the long exposure time, the water appears as a light-filled volume, a representation of dimensional space occupied through time. In contrast to the rock-solid cliffs, water exists here within a different aesthetic framework—different from Church's or Notman's—as though a virtual, conceptual construct rather than a documentary one describes its flow.

In other photographs of Yosemite, diagonal swaths of textured rocks and trees break the image into zones of light and dark, and vales of deep space punctuate the flat surface, yielding a new visual structure that is more dramatic and emotionally driven than Watkins's. In *Tenaya Canyon, Valley of the Yosemite, from Union Point* (cat. 45), the scene is broken into a grid of inverted triangles, organized in receding planes from dark to light, accentuating the remarkable depth of the valley and the granite textures that map its geological formation. The subject of geologic time, signified by eons of glacial formation visible in the cliffs, is balanced by the transient grandeur of ever changing light and foliage. The intricate relationship between the vastly different scales of human and geologic time, and their delicate equilibrium, is inherent in the structure of this photograph; it establishes an environmental assertion that was distinctly modern. This was a land worth visiting and preserving since history was discernible.

San Francisco's population had nearly tripled in a decade—to almost 150,000 people by 1870—and one

could sense mounting public interest in the subjects of transformation, time and space.[13] The pace of life accelerated, as railroads connected East and West—first in the United States in 1869 and then Canada in 1885. It was possible to travel from New York to San Francisco in a matter of days rather than weeks and also to communicate by telegraph across huge distances in mere moments. Technical advances in photography brought new ways to observe the passage of time, document it, stop it, analyze it and put it back in motion. Muybridge was one of the first to describe it so succinctly and time became his real subject. Less than a year after his second journey to Yosemite, no later than April 1873, he devised a way to stop time altogether.[14] Working for railroad baron and politician Leland Stanford in a series of experiments at the Agricultural Park Racetrack in Sacramento, Muybridge successfully photographed the silhouette of a running horse. In the first of many trials, he produced images, now lost, that froze the speeding silhouette of a horse and sulky on a glass negative and showed the horse suspended momentarily in air with its four hooves off the ground—something that could not otherwise be seen.[15]

Muybridge's interest in sequential photography—that is, a series of pictures arranged in sequence that shows the progression of an occurrence over time—was already considered in 1869 when he began to document the construction of the San Francisco Mint, a process that took more than two years. His project chronicled the transformation of the urban environment. Later,

fig. 4 Carleton E. Watkins, *River View of the Royal Arches, Yosemite*, 1861

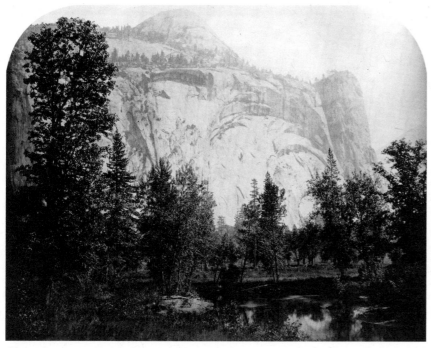

fig. 4

in an album made for Leland Stanford around 1878, Muybridge described the interior of Stanford's San Francisco home in the manner of a sequential tour, bringing visitors in from the street, through various rooms and then upstairs for a panoramic view of the city. The narrative, picture-story quality reveals his interest in documenting the city's growth.

The culmination of Muybridge's interest in urban landscape photography came in his astonishing 360-degree panoramic views of San Francisco made in 1877 and 1878. The first, *Panorama of San Francisco from California Street Hill* (fig. 5), was shot from the home of Central Pacific Railroad financier Mark Hopkins at California and Mason Streets. Eleven images were made in about five hours from the house's tower, revealing a complete and detailed view of the city, its bustling harbour, and surrounding islands and hills. Prints were mounted to paper, joined together in sequence to a single sheet of linen and then folded accordion style into a folio binding. Published by Morse's Gallery, the panorama was sold with an accompanying photographic "key" that labelled and listed a number of important buildings and sites. The following year Muybridge created a second, larger panorama from the same location, made up of thirteen mammoth plate prints. Bound similarly on linen as an elephant folio, the panorama unfolds to a length of about 5.5 metres. Even though the panoramas are static and highly detailed, one senses stories unfolding. Looking across the vast scenes, scanning them as if turning pages or slowly moving to take in the entire horizon, one can

easily get lost in the pictures while scrutinizing the smallest details. In this way Muybridge alluded to the passage of time, allowing the viewer to stroll from frame to frame or street to street, across the entire urban scene. He connected his fluid understanding of the links between the place—and situation—of this ocular view and the highly influential experiments with sequences, motion photography and animation on which he was then embarking. His transcendence of space led him to a parallel understanding that time itself could be halted, taken apart, analyzed and reassembled to codify our place in the world.

fig. 5 Eadweard James Muybridge, *Panorama of San Francisco from California Street Hill*, about 1877

fig. 5

** * * *

1 Franklin Kelly, "Niagara," in Eleanor Heartney et al., *A Capital Collection: Masterworks from the Corcoran Gallery of Art* (Washington D.C.: Corcoran Gallery of Art; London: Third Millennium Publishing, 2002), 130.

2 Weston J. Naef, *Era of Exploration: The Rise of Landscape Photography in the American West, 1860–1885* (Buffalo: Albright-Knox Art Gallery, 1975), 21.

3 John K. Howat, *Frederic Church* (New Haven: Yale University Press, 2005), 72. Cited in Jeremy E. Adamson, "Frederic Edwin Church's 'Niagara': The Sublime as Transcendence," 2 vols. (PhD diss., University of Michigan, 1981), 2:352.

4 Beginning in the early 1860s the predominant photographic process was wet-plate collodion emulsion on glass. This process required a very long exposure time.

5 For a geopolitical discussion of Niagara Falls as symbol of death in American culture, see Patrick V. McGreevy, *Imagining Niagara: The Meaning and Making of Niagara Falls* (Amherst: University of Massachusetts Press, 1994).

6 Walt Whitman, "Rise O Days from Your Fathomless Deeps," in *Leaves of Grass* (Boston: Small, Maynard and Company, 1897), 229.

7 Peter E. Palmquist, *Carleton E. Watkins: Photographer of the American West* (Albuquerque: University of New Mexico Press, 1983), 5.

8 A mammoth plate photograph was made using a very large camera and collodion glass plate negative. Used principally by several landscape photographers of the American West, including Watkins, Eadweard Muybridge and William Henry Jackson, this technically difficult process created a negative of up to 46 x 56 cm that was contact printed on albumen paper. Mammoth prints were extremely sharp and detailed and were made primarily for display.

9 Douglas Nickel argues rightly that the modern look of Watkins's photographs stems more from their historical and technical context and subject than from any prescient understanding of the avant-garde. See Douglas R. Nickel, *Carleton Watkins: The Art of Perception* (New York: Harry N. Abrams, 1999), 20–21.

10 Muybridge, born Edward J. Muggeridge, emigrated from Kingston-upon-Thames, a British market town upriver from London, to New York City in 1852. The exact date and route is not known.

11 Bret Harte, *The Luck of Roaring Camp and other Tales* (Boston: Houghton, Mifflin and Company, 1897), 11.

12 Kevin Starr, *California: A History* (New York: Modern Library, 2007), 119.

13 Ibid., 121.

14 Rebecca Solnit, *River of Shadows: Eadweard Muybridge and the Technological Wild West* (New York: Viking, 2003), 79.

15 Eadweard Muybridge, *Animals in Motion* (New York: Dover Publications, 1957), 13.

Although born in Halifax, Lawson made his career in the United States. Trained in Kansas City, he developed his style in New York in 1891 under John Henry Twachtman and Julian Alden Weir, from whom he took classes at the Art Students League, adopting Impressionist techniques and exploring the effects of light and colour on landscapes. In 1893, he travelled to Paris and lived with William Somerset Maugham, later inspiring the writer's character Frederick Lawson in *Of Human Bondage*. In Paris, Lawson was drawn to the art of Paul Cézanne and Alfred Sisley, whose influence is particularly evident in this work. In 1898 he returned to New York, settling in Upper Manhattan and Washington Heights, and associating with a group of artists with whom he would form The Eight in 1908, creating the so-called Ashcan School movement. Hoboken Heights is opposite Manhattan, close to Newark. In the years after his return Lawson sought semi-industrial landscapes, the juxtaposition of the outskirts of cities and open hills and farms with the urban reality of new high-rises, as embodied in this painting. His Impressionist brushwork of this period is often mingled with denser impasto he applied with palette knives and his fingers.

142 Ernest Lawson, Hoboken Heights, 1900-10

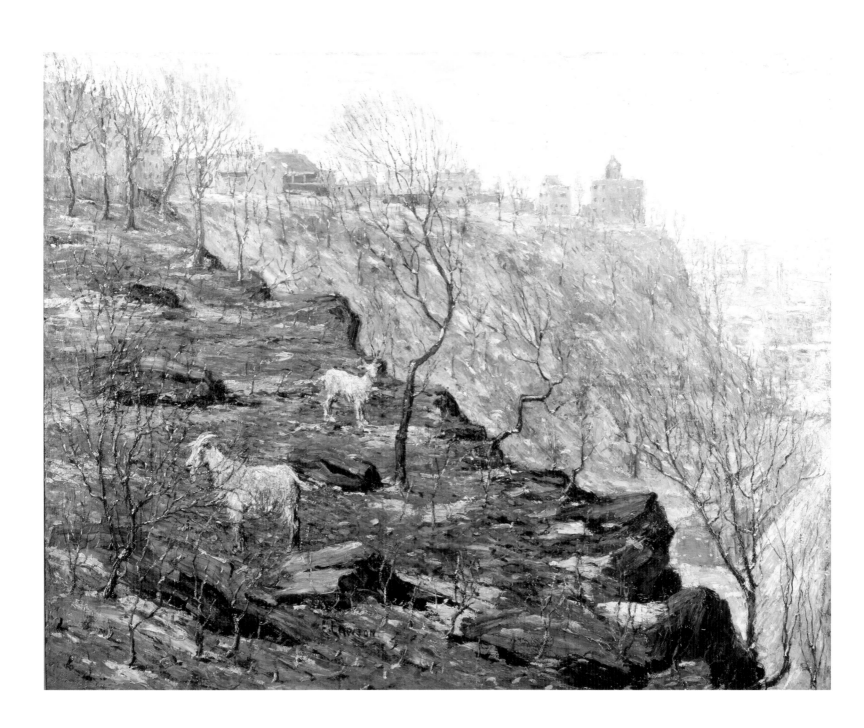

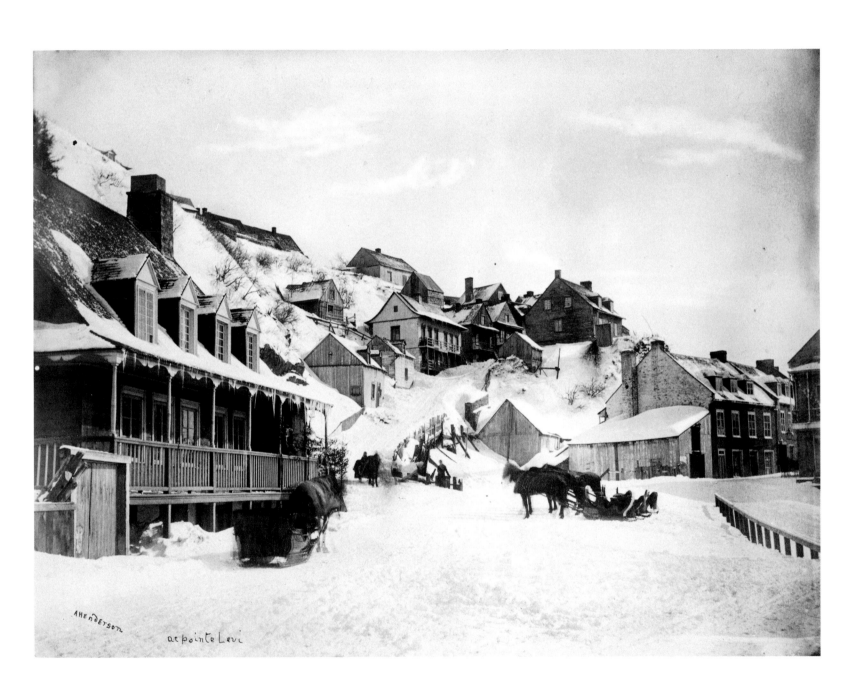

Point Levis, located on the south shore of the St. Lawrence River opposite Quebec City, became an important railway centre in 1854, with its potential for connections south and east, including to Maine and the Maritimes. The city was incorporated in 1861 and soon developed into an active, moderate-scaled commercial centre with ferries to Quebec City.

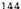
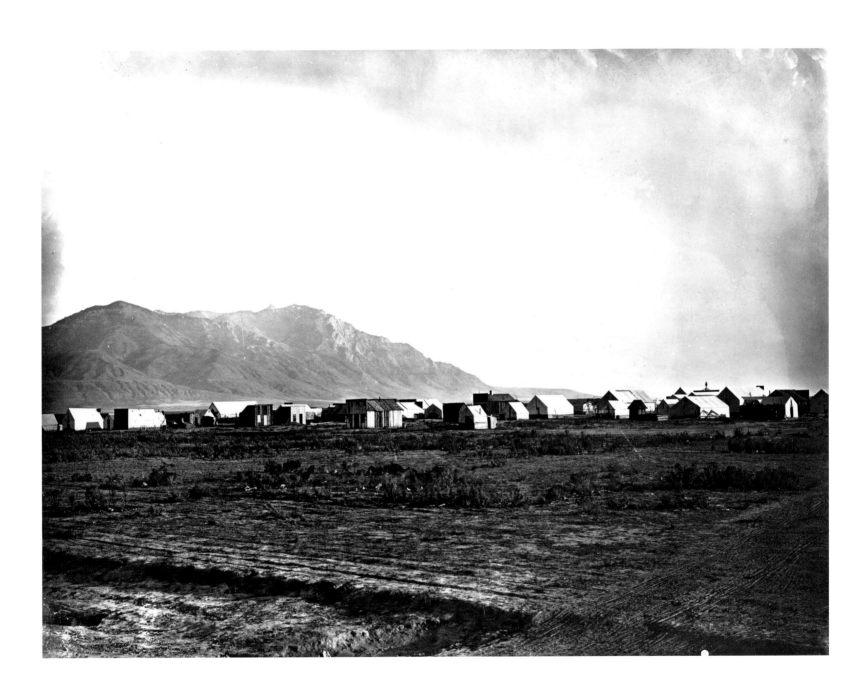

A small railroad town, as recorded in Russell's photograph, constituted a group of tents and temporary houses and shacks set up about the tracks being constructed. As the railroad moved onward, the dwellings were readily taken down or disassembled and carried to the next temporary centre. Sometimes these centres took root and grew into incorporated towns; more often they ended with the line's movement westward.

145 Carleton E. Watkins, Depot and RR Works from Los Angeles, S.P.R.R., 1880

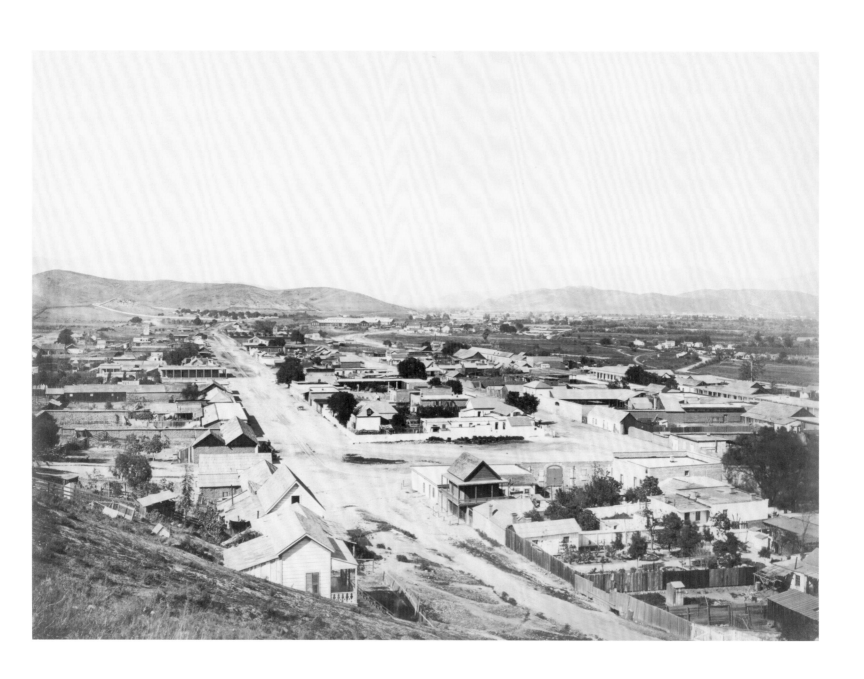

In 1880 Watkins travelled along the Southern Pacific Railroad, including an extended stretch northward along the coast from San Diego, promoting the area of Southern California by photographing its agricultural development as well as such new industries as the oil wells, and capturing, among other towns, the quiet streets of the burgeoning community of Los Angeles.

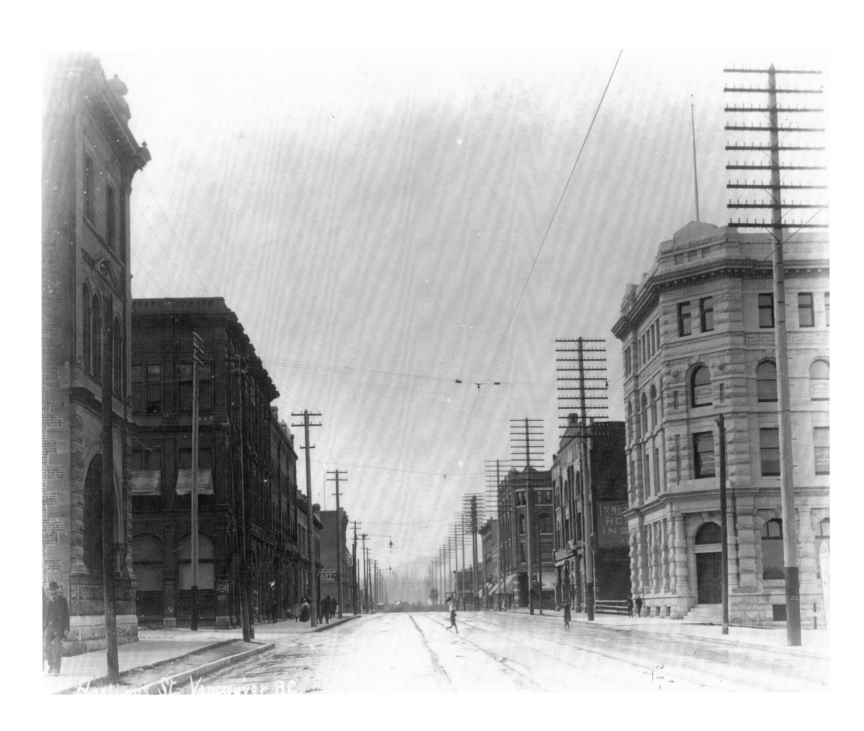

Although earlier explored by Easterners (notably by Simon Fraser in 1808), the Vancouver area was only settled by Europeans in 1862 due to its longstanding and assertive occupation by the Squamish Nation. Like Seattle, lumbering was its earliest industry and exportation of timber began in 1865. Surveyed in 1870, the land for the development of the modern town began to take shape under the name of Granville in the Gastown area where this view of Hastings Street was taken. A fire in June 1886 offered the opportunity to develop the town along modern urban planning principles. Canadian Pacific Railway officials had seen the possibilities of the harbour from the outset and extended the transcontinental line from Port Moody to Vancouver in 1887, the town having been reincorporated under that name the preceding year. The impact of development is reflected in the city's rapid population growth from 5,000 in 1887 to 15,000 in 1892 and then to 100,000 in 1900.

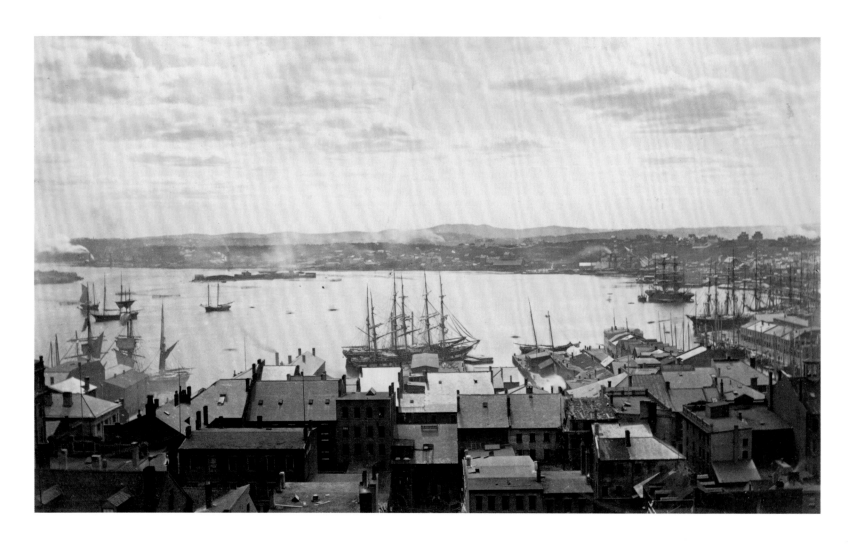

The commercial and military possibilities of Saint John were recognized early by European settlers and a fort was established there in the 1630s. Situated where the Saint John River empties into the Bay of Fundy, it became a major centre of commerce and immigration in the nineteenth century. This photograph was taken before the devastating 1877 fire that destroyed most of the city, dominated by wooden structures. Rebuilding was done with stone and brick.

Founded in 1642, Montreal made a superb port of entry for the interior of Quebec and Lower Canada. During the eighteenth and nineteenth centuries the city became the commercial and cultural centre of the colony and nation, Toronto only gaining commercial ascendancy during the second half of the twentieth century.

149 Asahel Curtis, Denny Hill Regrade, about 1910

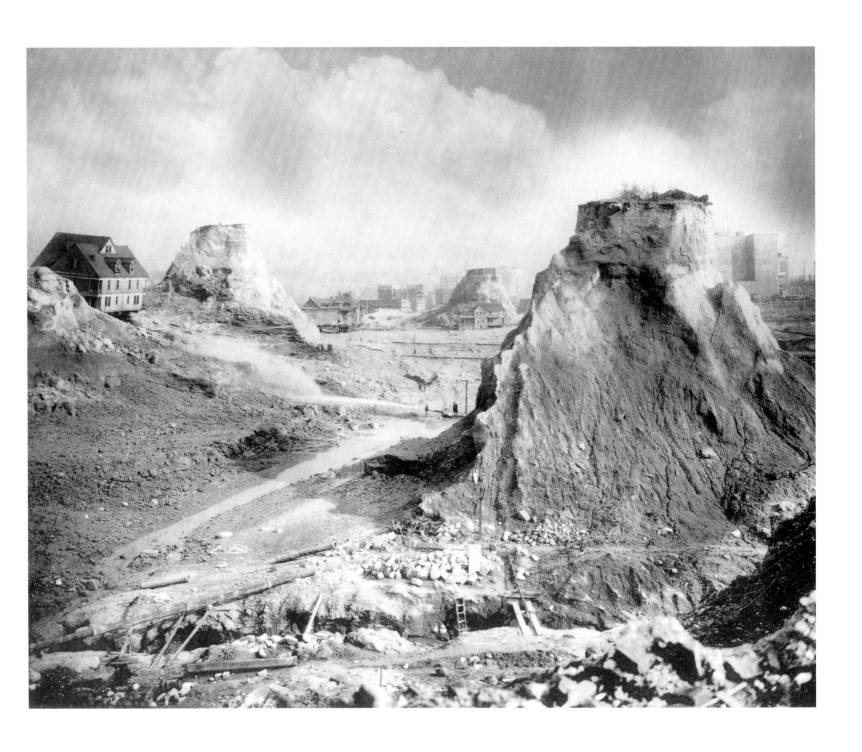

Seattle was founded in 1851 and in its early years served as a centre in the lumber industry. The town was circumvented by the railroad in the 1870s, after railroad officials chose Tacoma as the terminus for a transcontinental line. The beginning of Seattle's tremendous expansion can be dated to 1897, when it served as a port of return from the Klondike Gold Rush. Rapid development Denny immigration resulted. In 1910, following proposals by the engineer R. H. Thompson, the city undertook a major redevelopment campaign, levelling the steep hills in the Denny Hill area with new hydraulic technology adapted from mining. Asahel was the brother of Edward Curtis (cat. 62–67). After having gone to the Klondike as both miner and photographer, he returned to the family photographic business in Seattle, ultimately setting up his own studio.

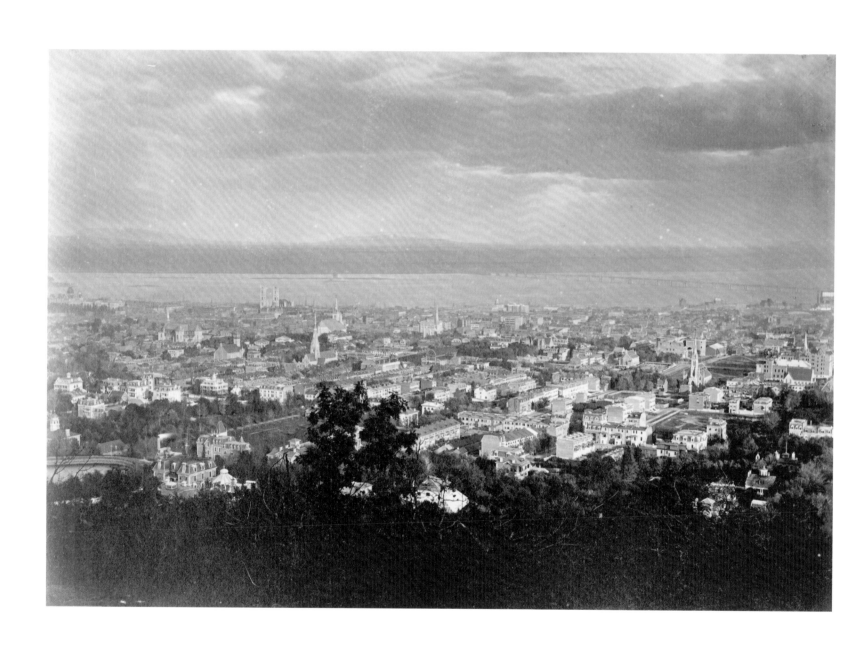

The 1850s witnessed the beginning of a rapid expansion of Montreal's population. In 1852 the city numbered 58,700, and by 1871 it numbered over 107,000. By 1901 greater Montreal's population would surpass 325,000. This picture was taken from the summit of Mount Royal (an area which opened to the public in 1876 as a park designed by Olmsted). In the distance toward the left near the St. Lawrence can be seen the twin towers of the Notre-Dame Basilica, while among the trees in the foreground are visible some of the houses of the wealthy in the newly developing residential quarter of St. Antoine.

151 Maurice Galbraith Cullen, Wolfe's Cove, 1904

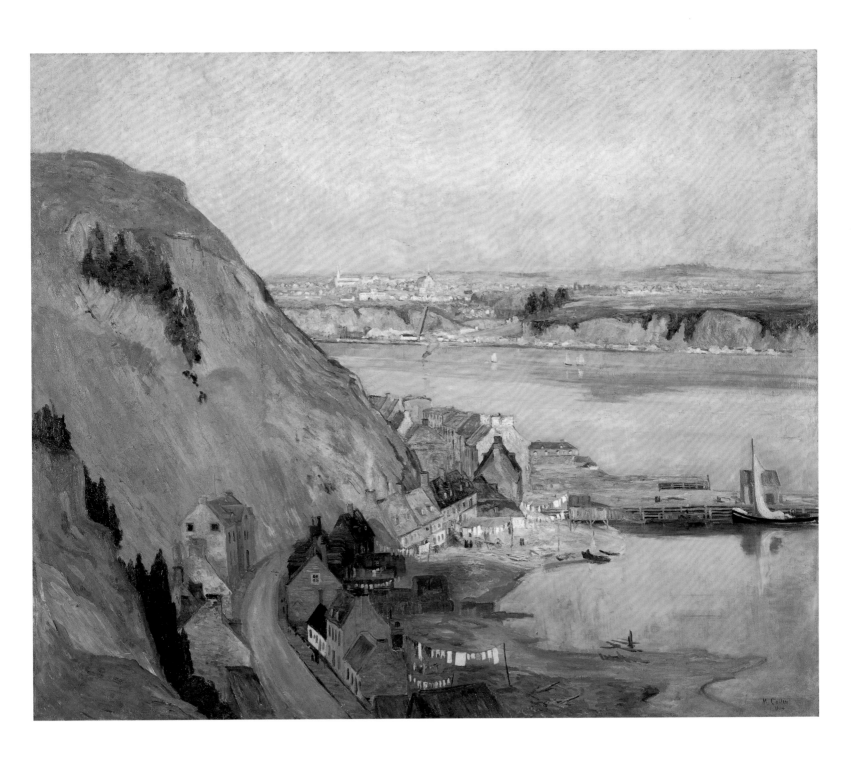

After initial studies in drawing and sculpture in Montreal, Cullen travelled to Paris in 1888, where he remained until 1895, studying painting and discovering the art of Alfred Sisley and Claude Monet. During this time, he also visited Pont-Aven, familiarizing himself with the art of Paul Gauguin and the Nabis. In Paris, Cullen came to know James Wilson Morrice, with whom he painted in Brittany and Venice, and, not surprisingly, it was through Morrice that he came to appreciate the work of James McNeill Whistler. After his return to Montreal (interrupted by another European sojourn between 1900 and 1902), Cullen continued to paint in a style influenced by Monet, especially evident in his more atmospheric works (cat. 156), but was criticized, as had been the Impressionists, for his "unnatural" use of vermilions (cat. 152, 156). In this work, however, his palette is lighter and his contours crisper. Executed in 1903 and dated the following year, it was painted on a trip from Beaupré to beyond Quebec City with Morrice and others and is taken from the high ground over-looking the city with the massive, looming Cap Diamant on the left and Lévis on the far shore of the St. Lawrence. The afternoon view is animated by white paint strokes that define the building facades and create the effect of reflected light.

152 Maurice Galbraith Cullen, Twilight, Dufferin Terrace, Quebec City, 1905

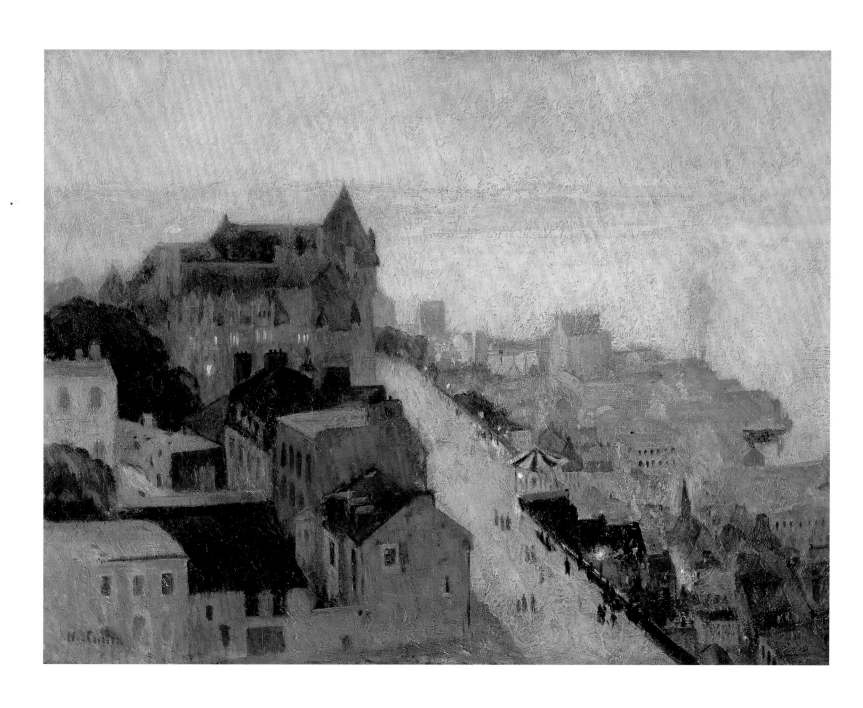

Cullen's painting is a study in tones, with particularly effective ranges of colour to convey twilight amidst the massed architectural forms. He adopts an elevated perspective. The painting is notable for its atmospheric effects, recalling the work of both Whistler and the Impressionists (see cat. 151).

153 Robert Henri, Street Scene with Snow (57th Street, NYC), 1902

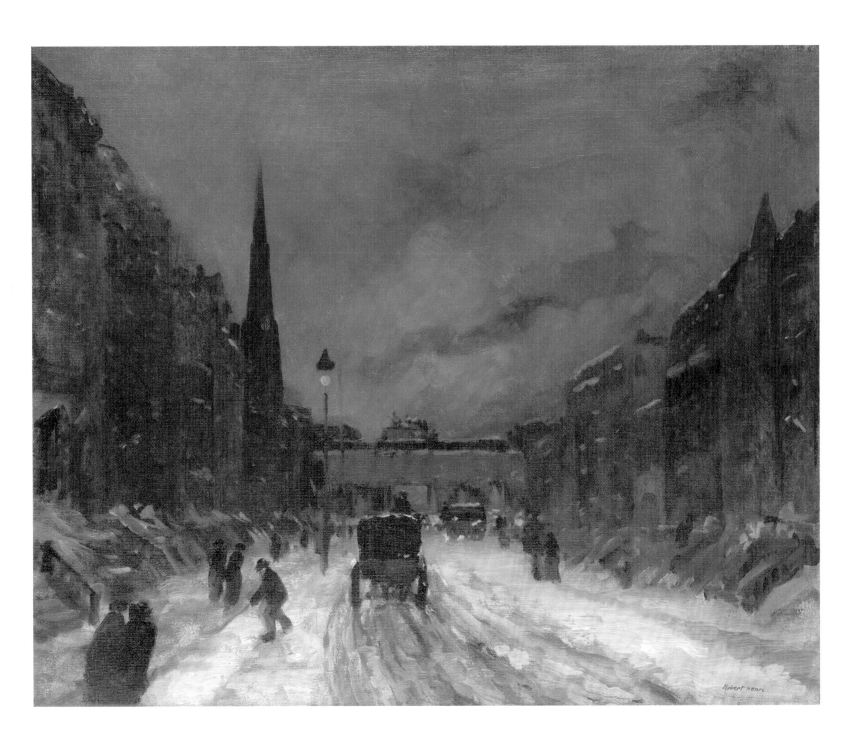

Having been trained at the Philadelphia Academy and then the Académie Julian, Henri returned to Philadelphia before settling permanently in New York in 1900, first teaching at the New York School of Art and then at the Art Students League, where his students included George Bellows, Stewart Davis and Edward Hopper. An anti-traditionalist, Henri founded the group known as The Eight (the core of the so-called Ashcan School) in 1908. From the beginning of that decade he focused increasingly on the sort of dark yet dynamic cityscapes featured here. Henri rented a studio at 57th Street at Sixth Avenue.

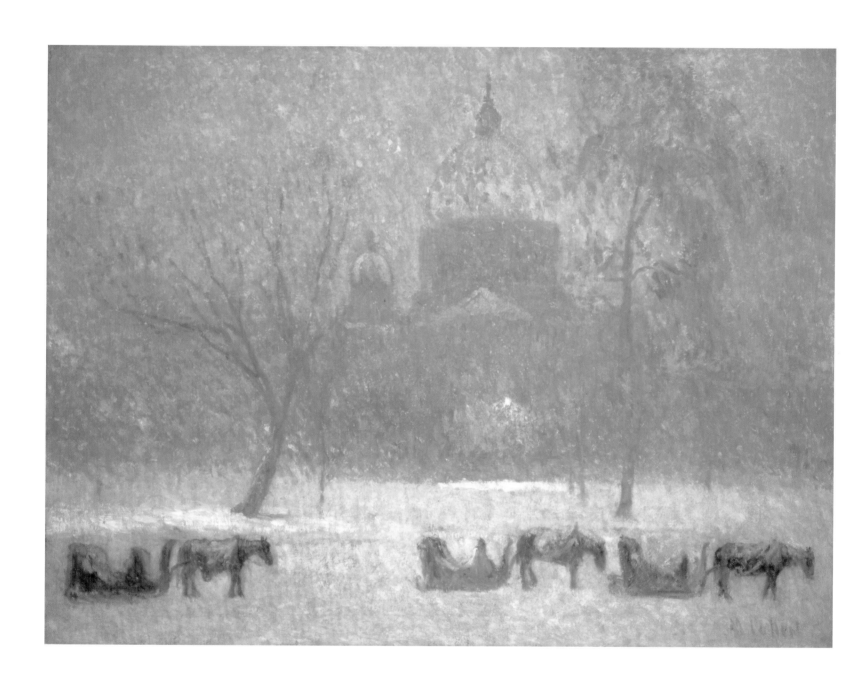

Cullen's palette features violets, pinks and blues, simulating the effects of reflected and refracted light through atmosphere, here characterized by falling snow and twilight, the forms on the verge of dissolving into colour fields. Yet the decorative line of the horse-drawn carriages in the foreground asserts the two-dimensionality of the picture plane and anchors this modernist work.

Marc-Aurèle de Foy Suzor-Coté, Smog, Port of Montreal, 1914

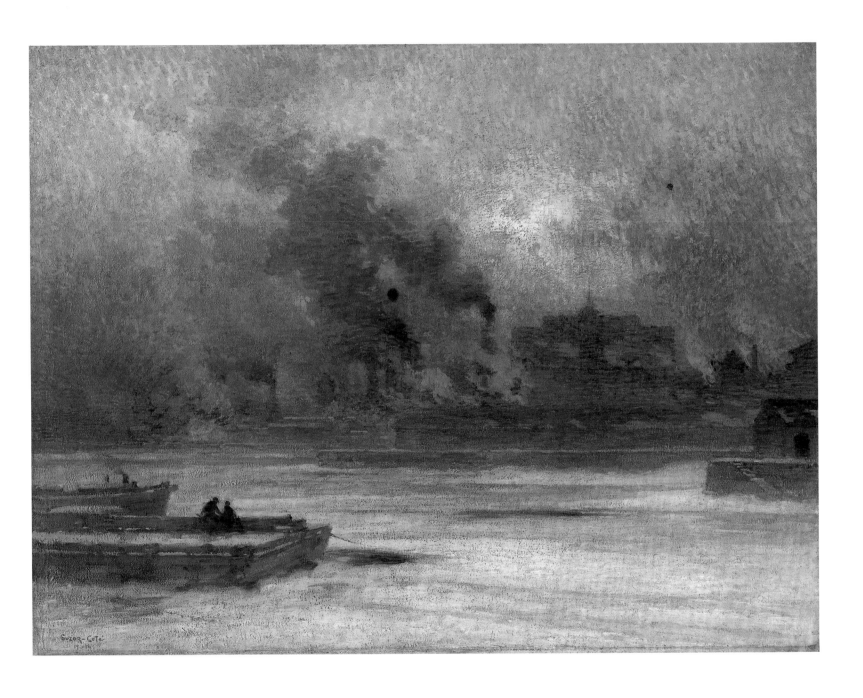

This contemporary city landscape by Suzor-Coté, an unusual subject for the artist, is his most urban scene. The view of Old Montreal is taken from the icy St. Lawrence, with the City Hall visible beyond the rising smoke. The painting is a study of lighting and atmospheric effects, but not in the conventional manner of Impressionism, whose technique sought to capture everyday elements under fleeting light effects. Rather, Suzor-Coté adapted the technique to convey, on a monumental scale, the effects of light themselves.

156 Maurice Galbraith Cullen, Montreal Harbour, 1915

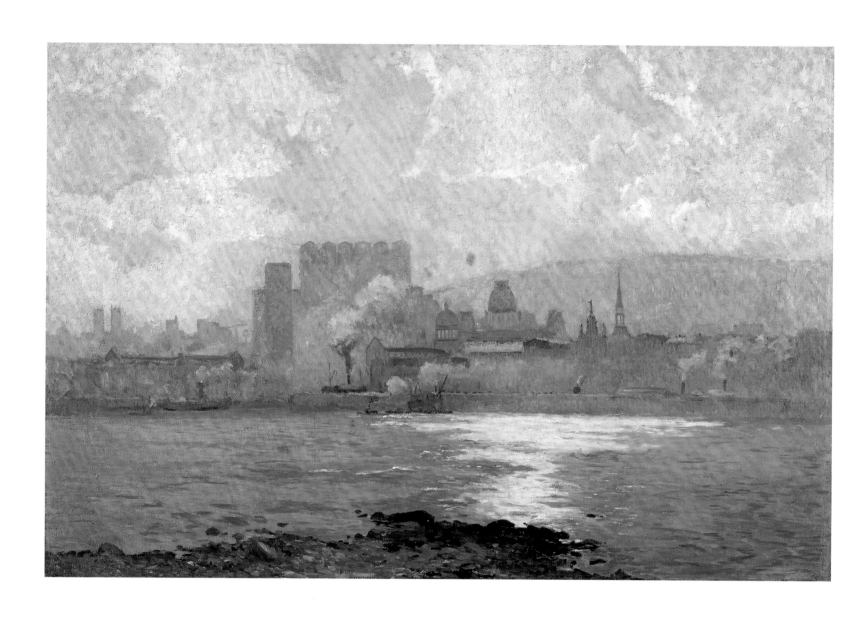

Between 1896 and 1914 Montreal experienced extraordinary economic growth, the commercial possibilities of the port with access from the Ottawa River to the Atlantic being exploited. The atmospheric effects offered by the cityscape attracted Cullen's Impressionist-influenced colourism. This panoramic and monumental view encompasses in its grand scale Mount Royal, smokestacks and storage silos, steeples and new urban towers.

157 James Edward Hervey MacDonald, Tracks and Traffic, 1912

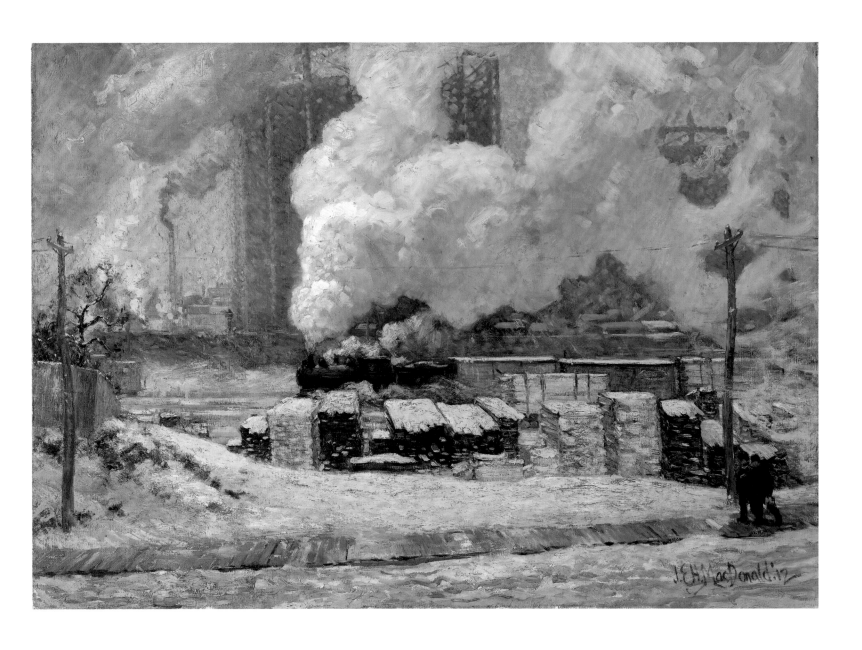

A founding member of the Group of Seven, MacDonald gained early inspiration from the work of the Impressionists, both in subjects and colour ranges, and like Cullen he explored the effects of light offered by snow and, in this case, urban train smoke. Between 1903 and 1907 he worked for a leading designer and illustrator in London, England, followed by successful employment as a commercial artist in Toronto immediately upon his return. A surer linearism and even hints of Art Nouveau would emerge in his later works. Less concerned than the Impressionists with the dissolving of forms in light, he created solid industrial shapes even within a palpable atmosphere, carefully juxtaposing horizontals and verticals. This painting captures a crisp winter morning at the Grand Trunk Railway yard near the train station in Toronto, just west of Bathurst Street. Toronto was rapidly developing into an important commercial hub for Ontario and the Plains. The picture was created at a moment of stylistic transition for the artist. In 1913 he would visit the *Exhibition of Contemporary Scandinavian Art* in Buffalo with Harris and would travel to Georgian Bay.

158 Alfred Stieglitz, The Hand of Man, 1902

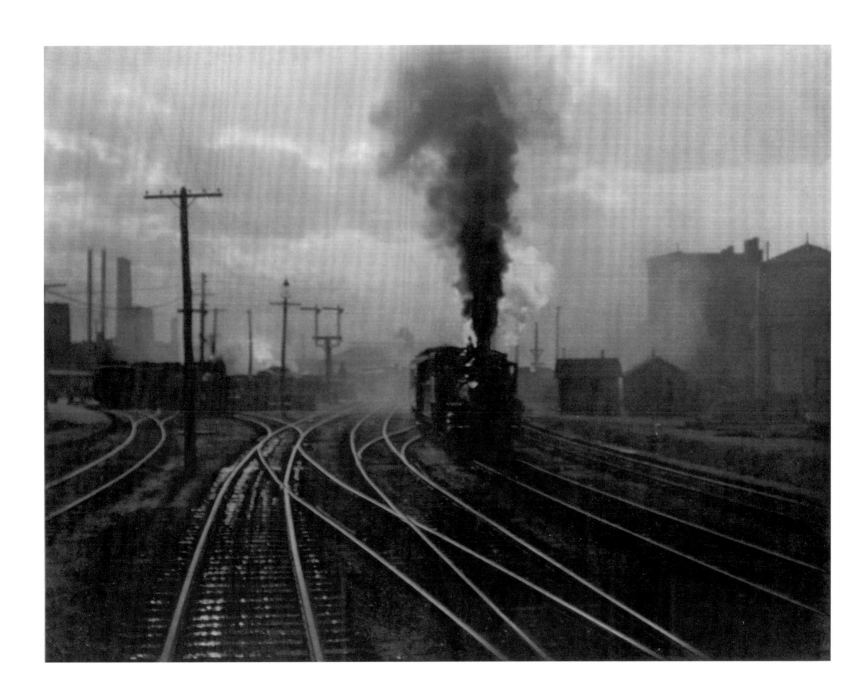

Stieglitz's emblematic paean to human progress and modern technology, underlined by the title, is also paradigmatically a Photo-Secessionist print: with its smoky atmospheric light, it is at once realistic and highly symbolist. Formally, it is dominated by the train movement, energized by the joining and crossing rails and contrasts of lights and darks, and especially the dark smoke rising from the train against the lighter sky. The exposure was taken from the back of a train as it approached the Long Island Rail Road train yard in Queens. Produced in 1903, it was published as a photogravure in the first issue of *Camera Work*. The artist preferred the controlled effects obtainable through photogravures to photographs and the image was only produced as a gelatin silver print years later.

159 Colin Campbell Cooper, Main Street Bridge, Rochester, 1908

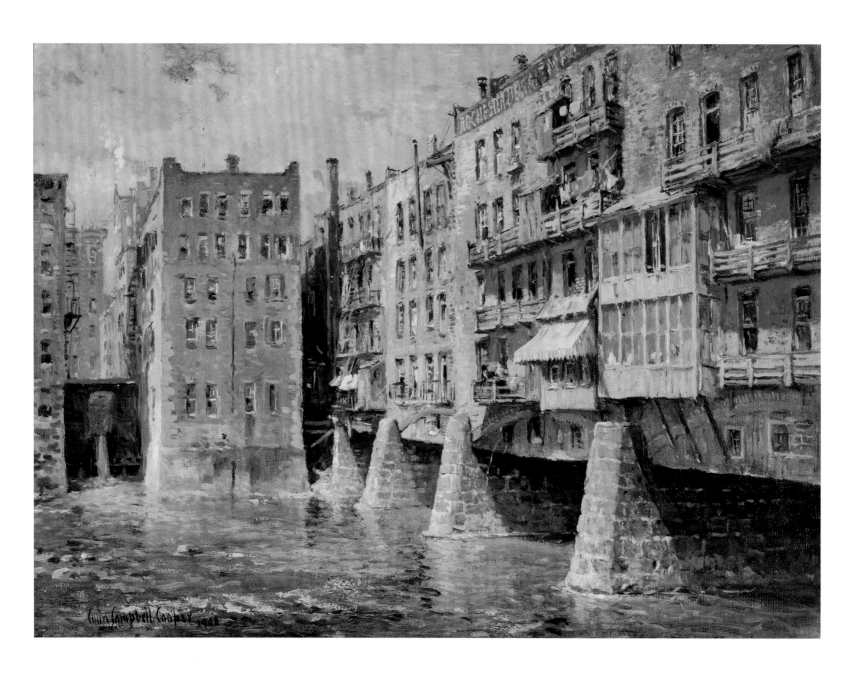

Born in Philadelphia and initially trained at the Philadelphia Academy, Cooper travelled to Paris, profoundly affected by the art of Impressionism, especially of Claude Monet, although his American variant reflects the influence of Childe Hassam (cat. 169). The artist also travelled in Italy, notably Venice, and along the Mediterranean. Specializing in American landscapes, both rural and urban, he gained a reputation for his images of the rising New York skyline. Cooper's depiction of the Main Street Bridge in Rochester, New York, which crosses the Genesee River, captures a principal monument in a city that had become affluent under the industry of the Eastman Kodak Company. Constructed between 1855 and 1857 (although work on it continued for several years), the Main Street Bridge was the fourth bridge at the site. The wide crossing rapidly developed as an extended commercial street, a sort of American Ponte Vecchio, with businesses building remarkably high edifices along its piers. Thus for all of its seemingly domestic appearance to the modern viewer, the painting actually glorified industry and commerce, however picturesquely. After various renovations, the bridge was dramatically altered during the 1950s and 1960s with the removal of buildings and the insertion of railings.

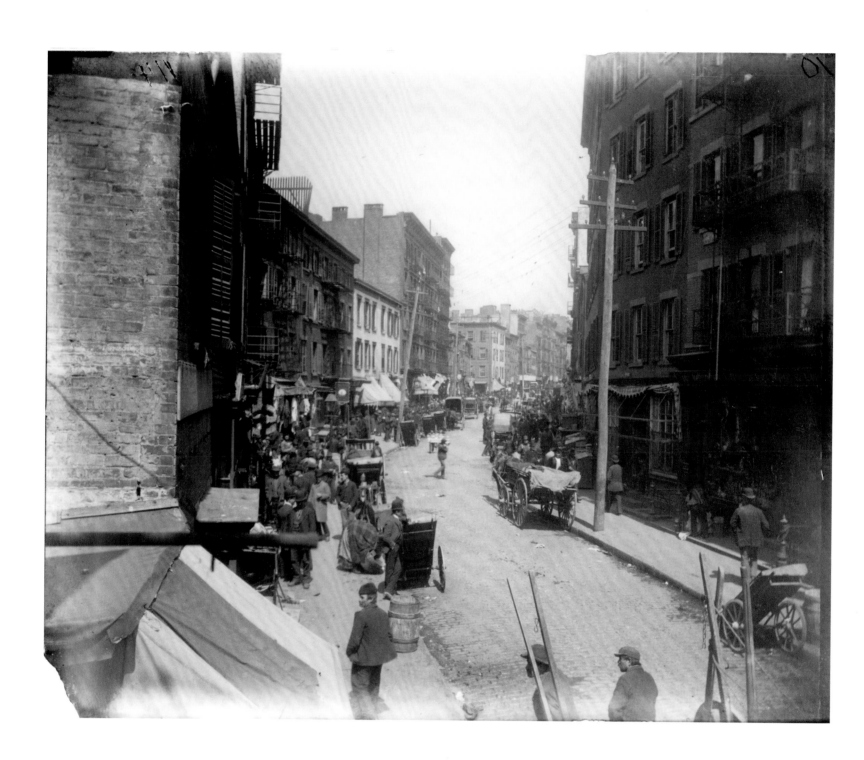

160–162

Riis was an immigrant to New York from Denmark and his photographs and line drawings, published in 1890 in *How the Other Half Lives* (edited and revised in multiple editions), explored the underside of New York's immigrant neighbourhoods and the horrors cast by extreme poverty, unspeakable living conditions and high crime. The images accompanied texts that documented the conditions both statistically and by case studies. By 1880 over one million immigrants in the city lived in about thirty-five thousand tenements. An ardent social reformer, Riis took photographs that were intended mainly to effect political change through public outrage. Using these images for slide lectures and public exhibitions, as well as through publications, he profoundly influenced reform. Some of the images, such as *Bandit's Roost, 59 1/2 Mulberry St.* or *Mullin's Alley, Cherry Hill*, were posed portrayals of youth gangs, families or criminals and muggers. Others were candid accounts of appalling slums and working conditions. *The Mulberry Bend* records daily life on a commercial street in the Lower East Side.

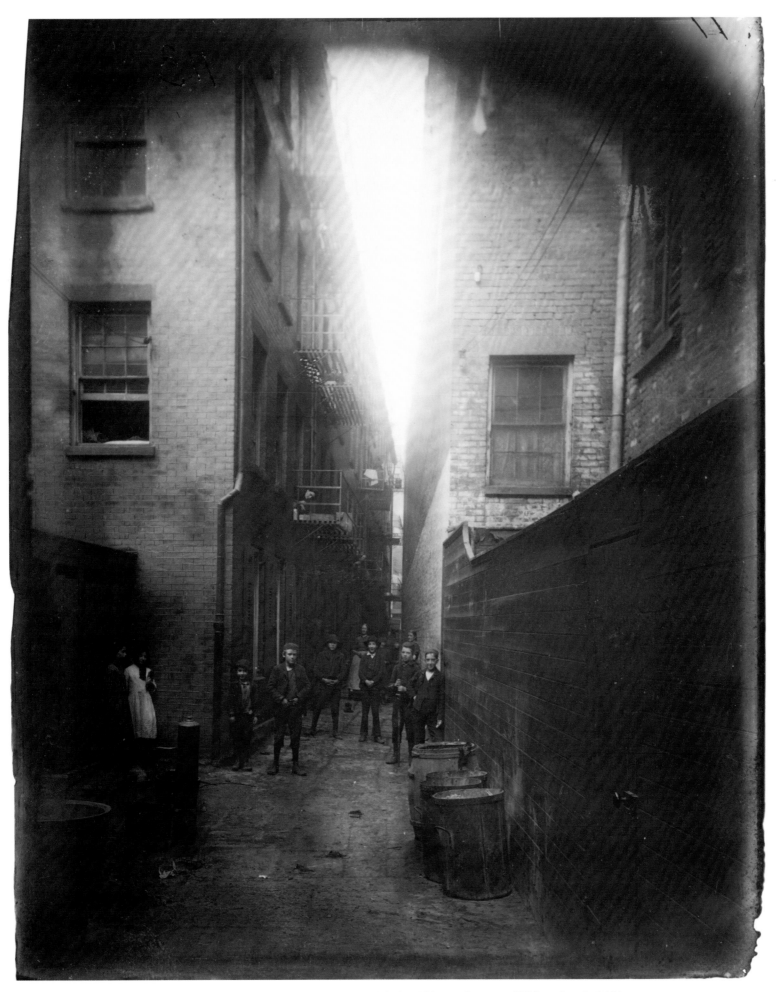

161 Richard Hoe Lawrence and Jacob August Riis, Mullin's Alley, Cherry Hill, about 1890

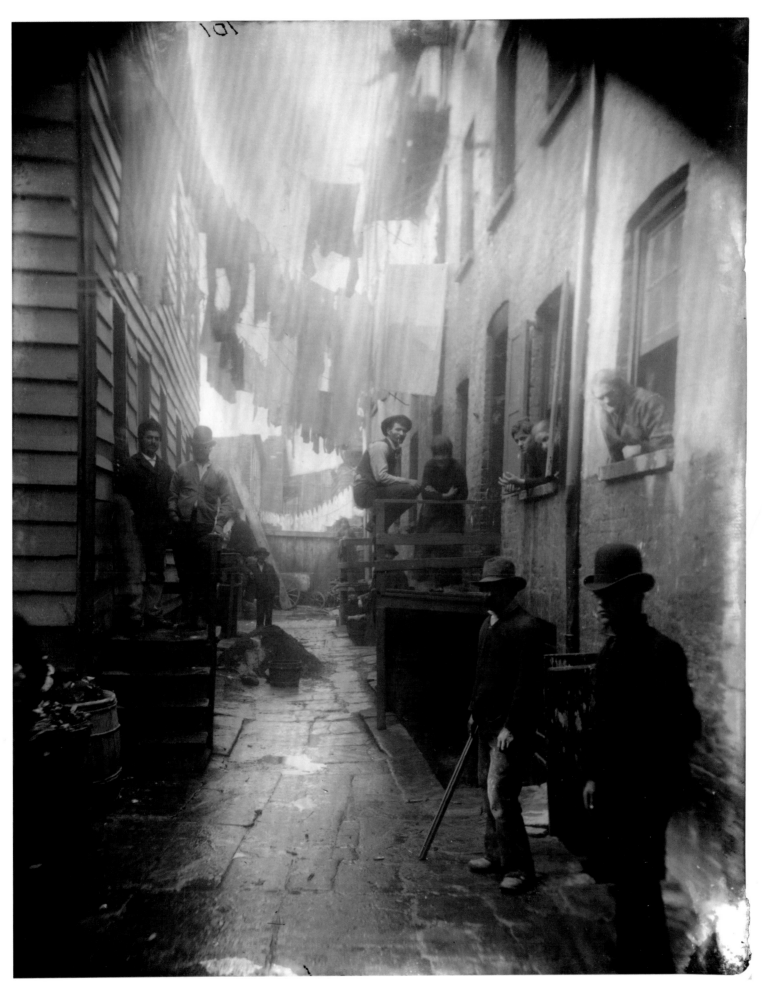

162 Richard Hoe Lawrence and Jacob August Riis, Bandit's Roost, 59 1/2 Mulberry St., about 1890

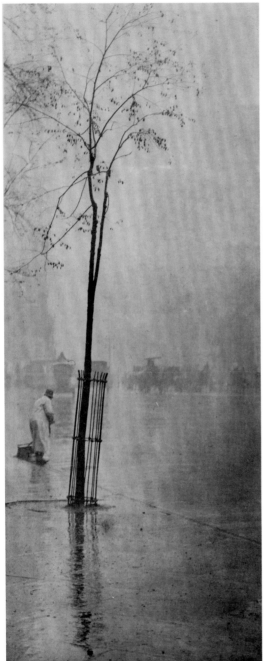

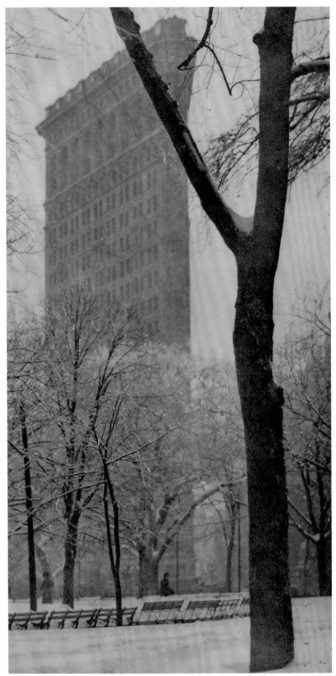

163 164

163 **Alfred Stieglitz, Spring Showers, 1900-01**
Stieglitz took this photograph from Madison Avenue and 23rd Street, juxtaposing verticals and horizontals in a contemporary urban context. The delicacy of the tree and the hunched figure of the street cleaner, however, recall the Japanese woodblock prints of Hiroshige. This photographic image is a particularly elegant study of atmospheric effects and tonal subtleties. Taken by the artist in 1900 or 1901, the image appeared in *Camera Work* in 1911.

164 **Alfred Stieglitz, The Flatiron (Winter), 1903**
Considered an architectural marvel in its time, the Flatiron Building (so nicknamed for its shape) was constructed in 1902 by Daniel Burnham at the junction of 23rd Street, Fifth Avenue and Broadway. While the iron-constructed building seems relatively modest to the modern viewer, it was admired for its refinement and technology, and Stieglitz himself described photographing it as "unnerving." In the accompanying text to a photogravure by Sydney Allan in a 1903 issue of *Camera Work* (as usual, Stieglitz oversaw the conversion of the negative into a photogravure), the edifice is described as most resembling "the prow of a giant man-of-war. And we would not be astonished in the least, if the whole triangular block would suddenly begin to move northward through the crowd of pedestrians and traffic of our two leading thoroughfares, which would break like the waves of the ocean on the huge prow-like angle...." The snowy setting of the park and the lacy, snow-laden tree boughs contrast with the building's solid and daunting mass, which complements the verticality of Nature embodied in the foreground tree.

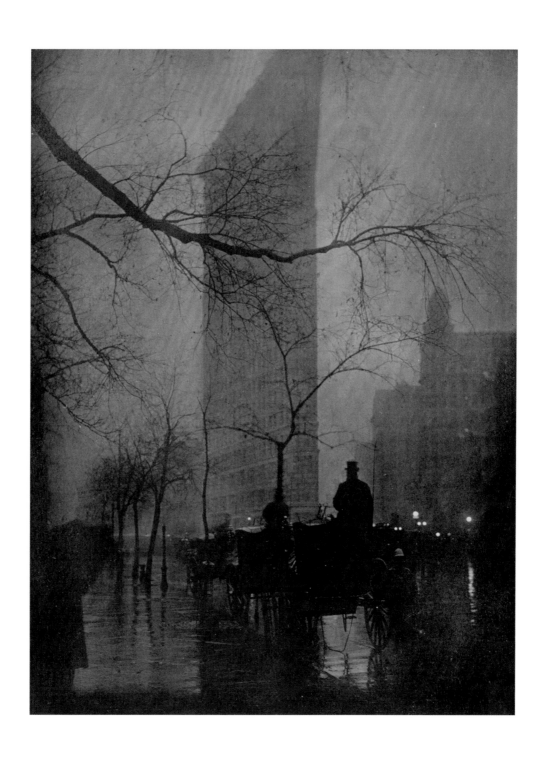

165 Edward Steichen, The Flatiron (Evening), 1905
Steichen's image is far more overtly aesthetic than Stieglitz's, with the pictorial delicacy and tonal ranges reminiscent of a Whistler etching or Japanese woodblock print. Photographed the previous year, the work was printed in *Camera Work* in 1906. The three-colour halftone was achieved through the use of gum bichromate over platinum.

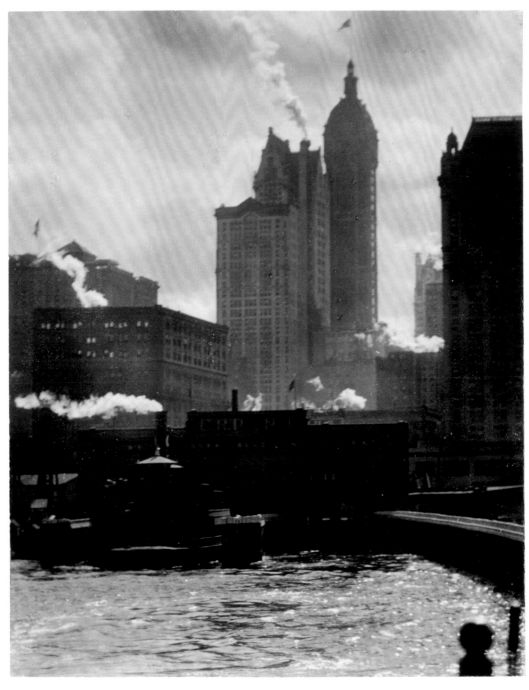

166

166 Alfred Stieglitz, The City of Ambition, 1910
Inspired by Alvin Langdon Coburn's recent photography of the New York docks, Stieglitz executed this image in 1910, publishing it in *Camera Work* the following year as part of a series dedicated to New York. An emotive title (he changed "ambitions" to "ambition") captures the spirit of this study of skyscrapers and industrial smoke, streaming outward in white like so many jubilant ribbons, against the cloud-swept sky, asserting the promising new world of modern life. The tallest skyscraper in the background is the Singer Building.

167 Paul Strand, Wall Street, New York, 1915
It was Stieglitz who first advanced the career of Paul Strand. Profoundly impressed by Strand's images when he saw them in 1915, he gave the artist a one-man show at Gallery 291 the following year and featured his work in the last two issues of *Camera Work* in 1917. Strand's photograph of Wall Street stands out from Steichen's works of the period by its rejection of the decorative aestheticism of Pictorialism which had characterized his own early work. Strand's early exposure to Cubism also contributed to his assertion of the two-dimensionality and abstract structure of the photographic image. To this end Strand's urban images are often taken from an elevated perspective. *Wall Street, New York* perfectly expresses this balance between figuration and abstraction, the human figures serving to create animated light and dark patterns against the angled base line. Indeed, humanity is effectively reduced to irregularly spaced units and the harsh, crisp reality of the image is somehow enhanced by the brilliant light, the absence of atmospheric effects and the massing of architecture.

168 Karl Struss, The Avenue (Dusk), 1914-15
Struss learned photography in New York under Clarence H. White and became a member of the Photo-Secession group in 1912. Stieglitz published eight of his photographs in *Camera Work*. A Pictorialist, he was a leading practitioner of the aestheticized, poetic manipulation of images, creating a lens and employing soft focuses long after the peak of the movement in New York around 1915. His early images of New York are among his finest. He moved to California in 1919, becoming a leading cinematographer and one of the most influential advocates of Pictorialism on the West Coast.

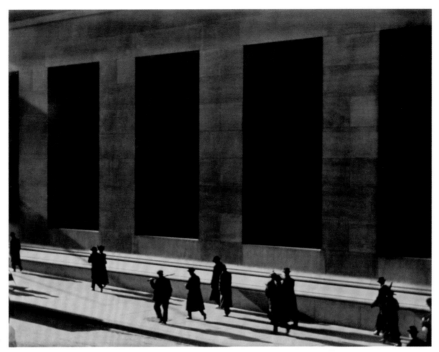

167

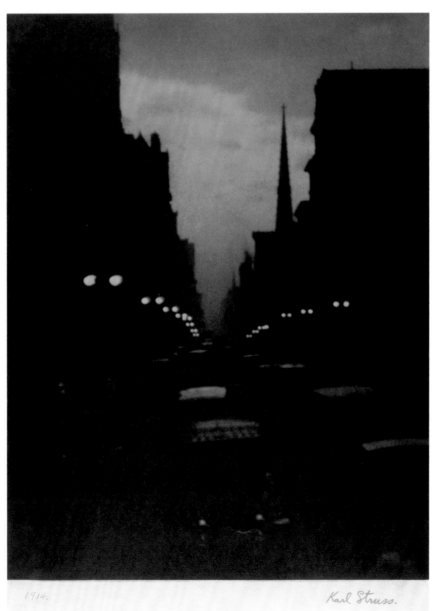

1914. Karl Struss.

168

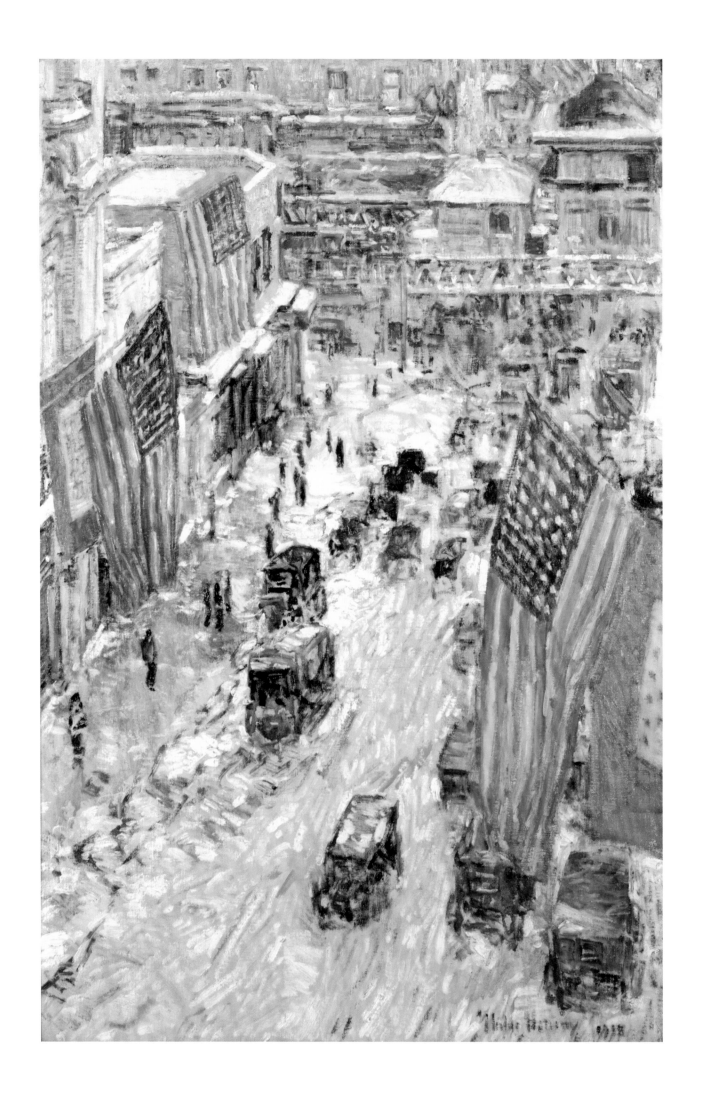

169 Frederick Childe Hassam, Flags on 57th Street, Winter of 1918

This painting is one of a group of so-called "Flag" paintings Hassam executed in the American patriotic fervour of the First World War and its immediate aftermath. Most of the works celebrate parades, often down Fifth Avenue and in this case along 57th Street. The artist had a studio on West 57th Street near Sixth Avenue. The subject, which coincided with his own sentiments, also provided a marvellous visual potential for his American Impressionist sensibilities (the precedent of Claude Monet's *The Rue Montorgueil in Paris. Celebration of June 30, 1878* is obvious): the waving multi-coloured flags; the snow, unique in this series; the traffic and even the modern urban element of the elevated train line at the end of the block. The composition is further animated by the open zigzag of brushstrokes along the street with its steeply ascending perspective. That viewpoint recalls both bird's-eye photographic urban views and French Impressionist paintings with their own antecedents in Japanese woodblock prints. The series, including this picture, was exhibited in New York in 1919 and garnered much praise.

Return to Nature

"It is the unexplainable thing in nature that makes me feel the world is big far beyond my understanding—to understand maybe by trying to put it into form.

To find the feeling of infinity
on the horizon line or just over
the next hill."

Georgia O'Keeffe,
American artist

Georgia O'Keeffe (New York: Viking Press, 1976)

At the outset of the twentieth century, a new generation of landscape artists turned to Nature seeking to express its evocative power on a personal level yet in terms distinct from the compositional and tonal sophistication of Luminism or the optical theories underlining Impressionism. Their sources were diverse. Alfred Stieglitz's Gallery 291 in New York was an essential gathering point for young, innovative artists. The influential gallery operator, photographer and publisher of Camera Work encouraged and inspired a broad range of painters and photographers, including Marsden Hartley, Georgia O'Keeffe, Edward Steichen and Alvin Langdon Coburn, through discussions, collaborations and exhibitions. Even before the Armory Show of 1913, these artists had become acquainted with contemporary French art, including early Cubism, and Wassily Kandinsky's colour theories. Other sources of inspiration, especially for Canadian artists, included international publications, such as Jugend, a German cultural magazine that featured works by modern European artists; the Albright-Knox Art Gallery's 1913 Exhibition of Contemporary Scandinavian Art in Buffalo, which brought to the fore Scandinavian artists' sense of surface design and use of liberated, radiant and unmodified colour; and the direct experience of vast expanses of raw nature in an undeveloped North. Their intention was to convey with awe and visionary fervour the profoundly moving and highly spiritual character of their experiences of Nature. This recalls the religious zeal of artists of the Hudson River School, whose works figured in the opening thematic section, "Nature Transcendent." With their reference to a vast repertoire of European artistic traditions, their understanding of contemporary scientific and philosophic works by thinkers as diverse as Alexander von Humboldt, Ralph Waldo Emerson and Charles Darwin, and subjects that offered unprecedented dramatic panoramic views, those earlier artists sought to place modern science in the service of faith, of Nature's Designer. For the artists of the new century, the spiritual dimension of Nature was ineffable but equally reasserted itself as undeniable and fundamental. Albeit separated by time, all of these painters and photographers spoke to essential feelings before the visual sensation of Nature. In "Return to Nature," the exhibition thus comes full circle in artists' exaltation before the North American continent's awesome splendour.

In autumn 1895 Twachtman visited Yellowstone, America's first national park, established in 1872. Among the paintings he produced were three of the Emerald Pool, a basin near the Old Faithful geyser. Evidently the basin's rich colourism of blue, turquoise and green against the stark surroundings attracted him. The cropping of the composition, resulting in a partial angled view of the pool and vapour virtually filling the entire canvas, emphasizes the painter's abstract formal concerns far more than his other, more topographic depictions. The powerful confrontation with the pool, the striking yet emotionally soothing colourism, and the remarkable abstractness of the scene make it among the most modernist paintings produced in the United States in its time.

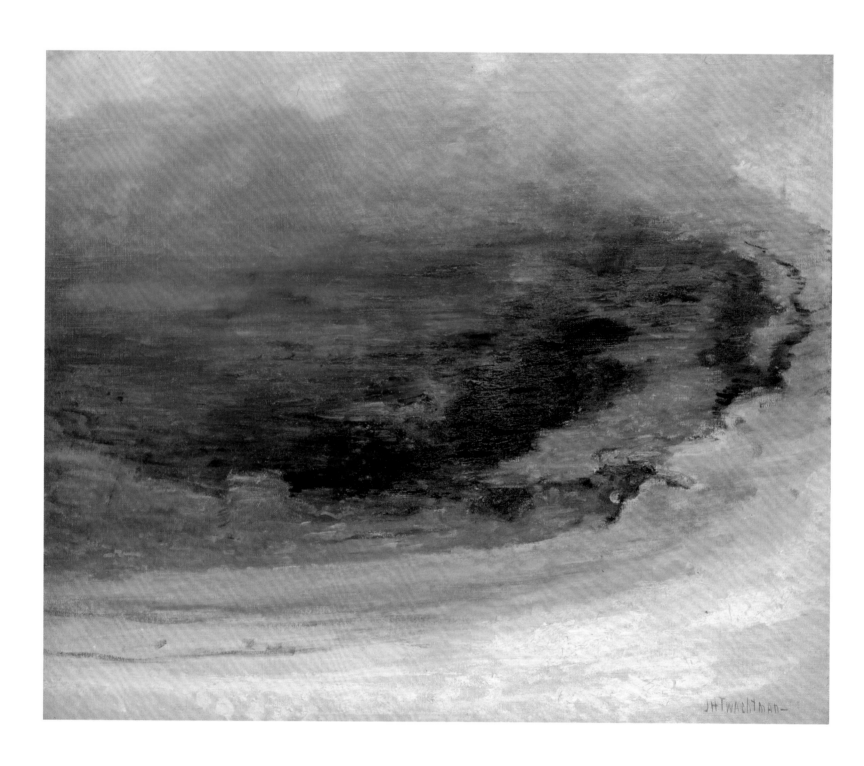

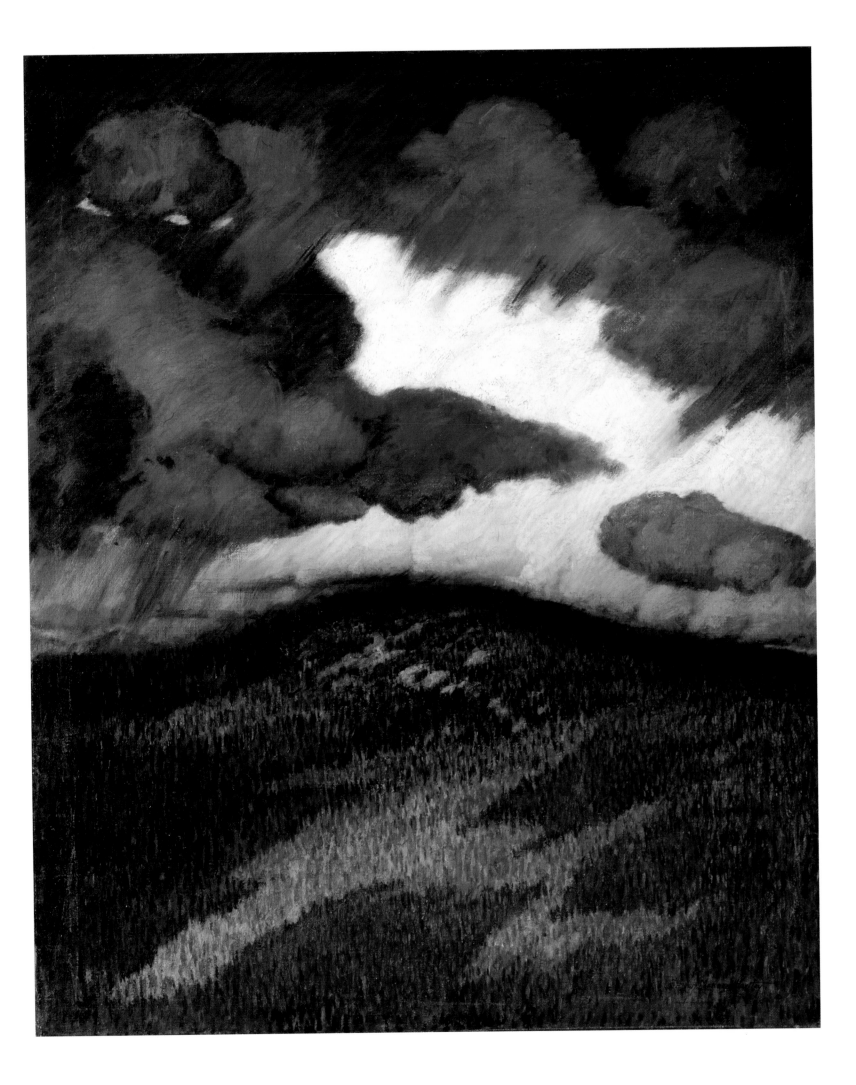

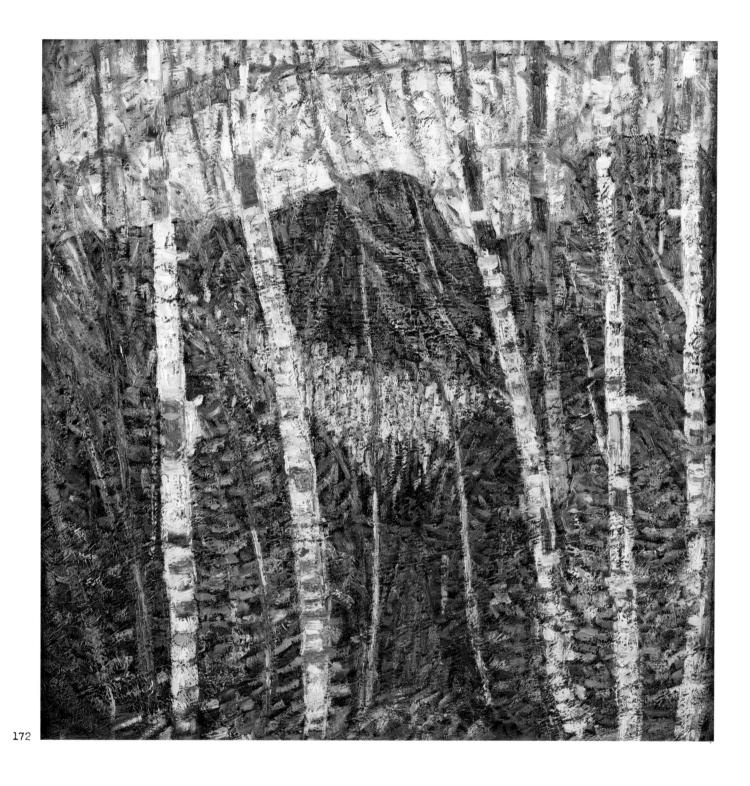

172

171 Marsden Hartley, Storm Clouds, Maine, 1906–07
During the fall of 1906 the young Hartley opened an art studio in Lewiston, Maine, where he offered art classes. While the venture was not a success, it solidified his resolve to devote himself to a painting career and resulted in this picture, characterized by Bruce Robertson as his "first really successful painting." Using a limited palette, Hartley created an extra-ordinarily dramatic composition with intensely romantic overtones, presenting the mountain, with its zigzag of autumnal-orange foliage echoing the thunderclouds overhead, and the ominous sky surging over its peak, creating a dynamic confrontation between the rising storm and the earth below. Colour and formalist devices articulate a profound, subjective response to Nature.

172 Marsden Hartley, White Birches, 1908
Another picture executed in the mountains of Maine, this work reflects the increased influence of modernist painting on the artist, who had become aware of the work of the Swiss artist Giovanni Segantini in the German cultural magazine *Jugend*. Hartley had been especially struck with the artist's breaking up of intense colours in defining forms and his use of short, open brushstrokes. Hartley thickly applied brilliant colours, setting them off against each other in intense, close juxtapositions. Furthermore, traditional perspective begins to dissolve against the arch confrontation of colour fields. The previously unknown artist leapt into the avant-garde mainstream the following year with the exhibition of his Maine landscapes at Stieglitz's Gallery 291.

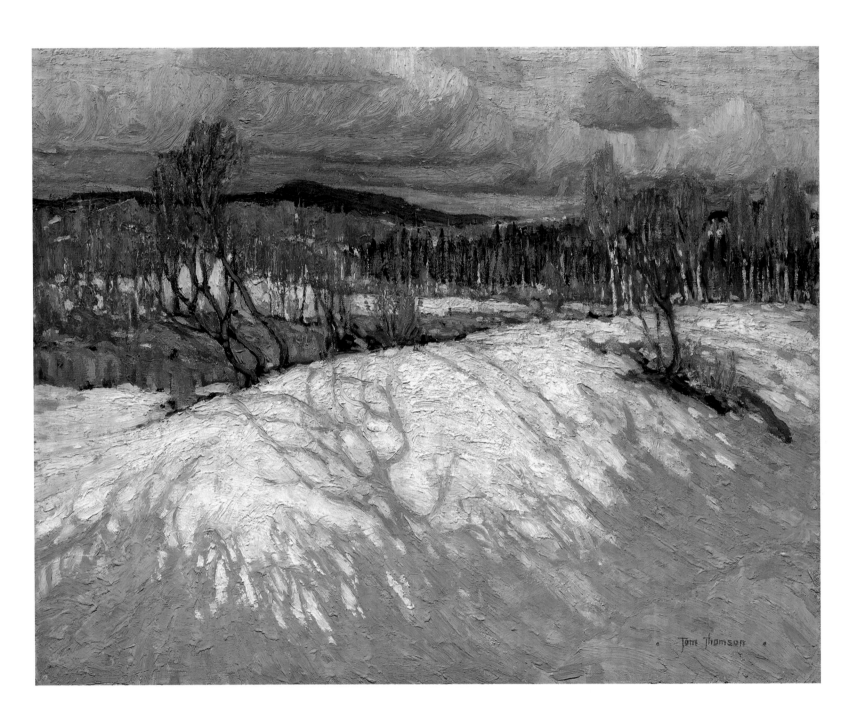

The subject of this painting derives from a sketch Thomson executed in Algonquin Provincial Park, where he would go on canoe trips with fellow artists who would later constitute the Group of Seven, notably A. Y. Jackson, with whom he shared a studio. Thomson was also close to Franklin Carmichael, Arthur Lismer, Lawren Harris, Frederick Varley and especially J.E.H. MacDonald, who influenced his compositions and palette through the exchange of ideas and experiences. An early appreciation of the Arts and Crafts movement (with its integration of the arts and aesthetics based on an honest, direct communion with Nature) and an intense pleasure in the time spent in Northern Ontario wilderness expressed themselves through an increasingly accomplished orchestration of assertive colour, composition and lighting effects. Through his artistic circle, Thomson absorbed the influence of Impressionism, Post-Impressionism and Scandinavian painting.

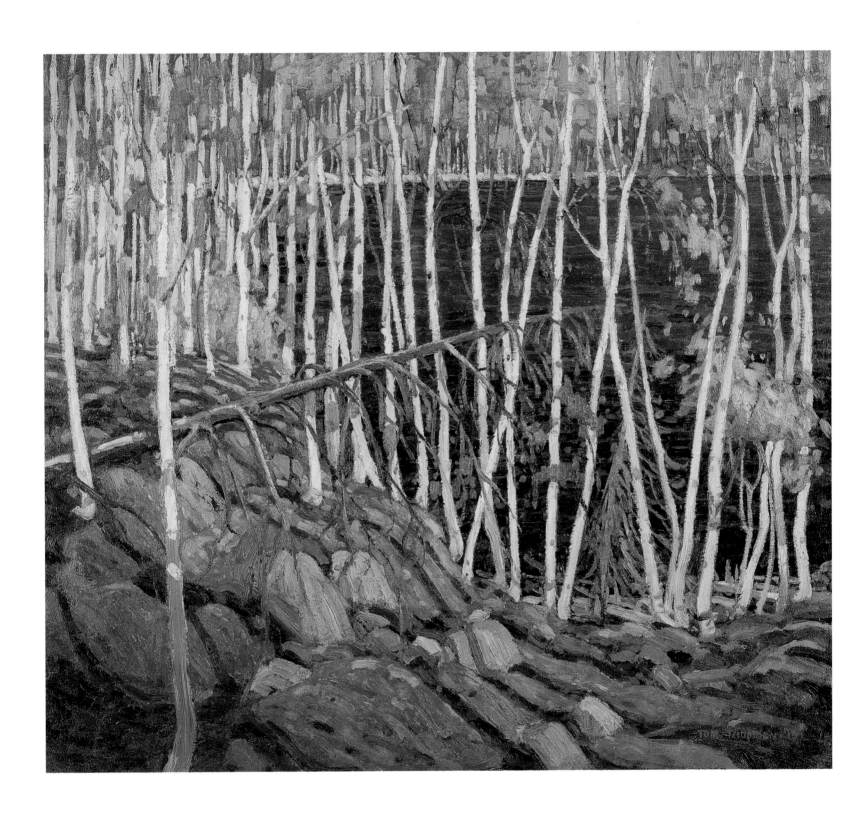

This celebrated work, also derived from a sketch made in Algonquin Park and datable to the fall of 1914, represents Thomson at the mastery of his style: the painting is at once strongly decorative in its pattern of colours and its arrangement of shadows and trees, and intensely evocative in its presentation of the Northern Ontario countryside in autumn. For all its apparent directness, the work is carefully composed, with the diagonal of the fallen tree drawing the eye into the space it asserts, and the strong yet limited colour ranges, the powerful juxtapositions of richly applied strokes of oranges and cream-whites against resonant deep blues, judiciously orchestrated.

175 Lawren Stewart Harris, Snow Fantasy, about 1917

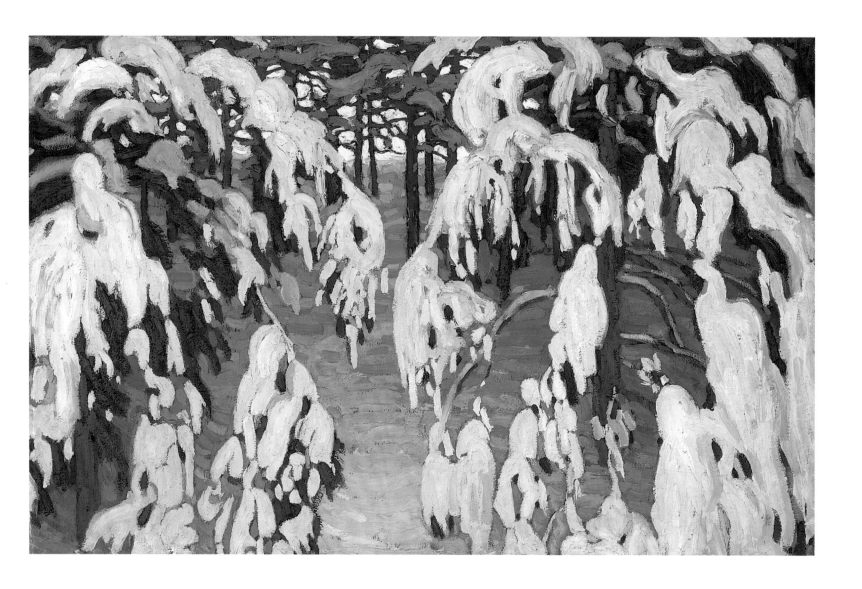

This painting, one of a series of snow scenes of the Ontario north executed between 1915 and 1918, embodies Harris's talent for combining assertive decorative surface design with the direct experience of Nature, influenced by contemporary Scandinavian painters. Harris had seen the 1913 *Exhibition of Contemporary Scandinavian Art* at the Albright-Knox Gallery in Buffalo with J.E.H. MacDonald, and Gustav Fjaestad's paintings of snow-covered fir trees had particularly appealed to him. The controlled palette, consisting of mauves, greens and whites against isolated touches of complementary colours and a creamy yellow horizon, enhances the decorative effect.

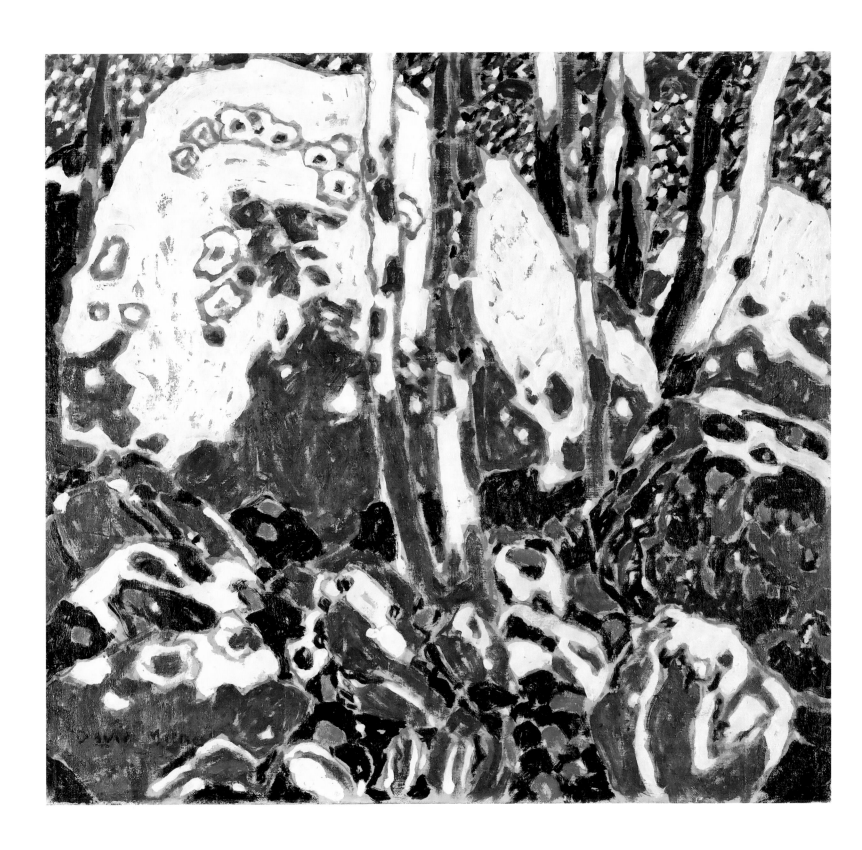

Born in Ontario, Milne received his early training at the Art Students League in New York. He remained in that city, working as an illustrator, and became known for his experimental painting style influenced by Post-Impressionism, Fauvism and the art of Maurice Prendergast (cat. 133–135). Although invited to participate in the 1913 Armory Show, he became frustrated by his lack of career advancement in New York and moved to Boston Corners in the lower Berkshires of New York State in 1916. *The Boulder* is typical of his work of this period, in which white and a limited range of colours are used to define the shapes and surfaces of rocks and vegetation. Dennis Reid has compared Milne's use of colour blocks to Edouard Vuillard's.

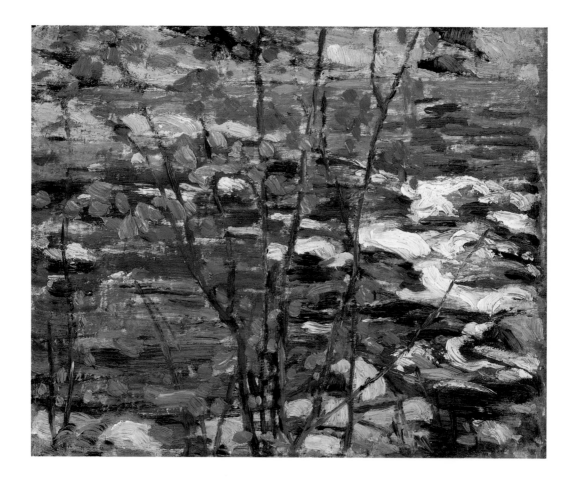

In the fall of 1914 Tom Thomson and A. Y. Jackson, who shared a studio in Toronto in a building that Lawren Harris had partially financed, travelled to Algonquin Provincial Park. The two artists painted with Arthur Lismer and Frederick Varley in this inspiring natural setting. It was during October that Jackson created the sketches used for the painting

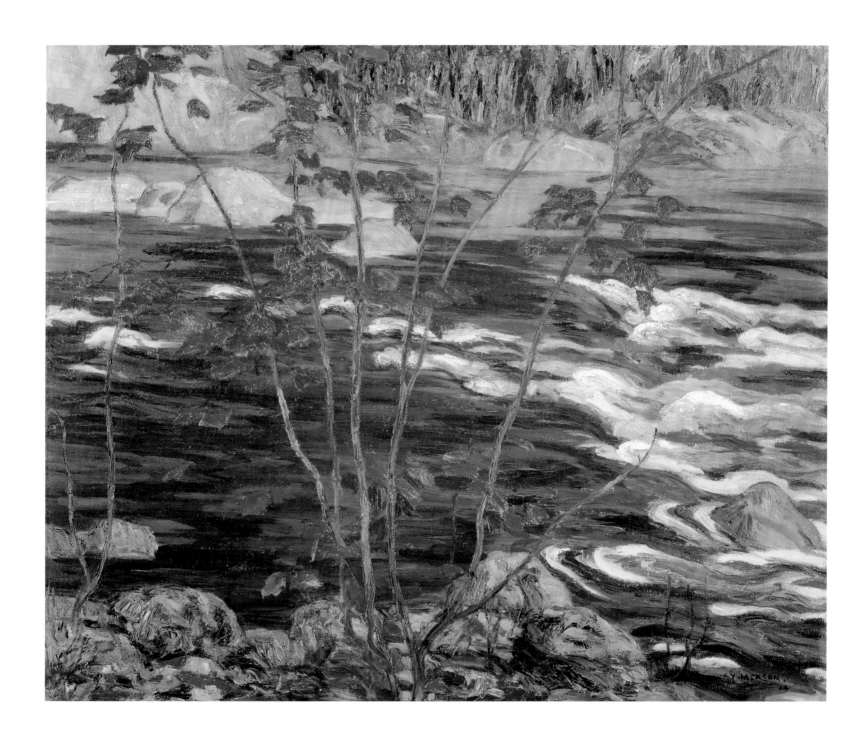

The Red Maple, a work completed immediately upon his return to the studio in November. That work is among his most radical in terms of its extremely decorative composition, its monumental directness and the artist's use of single brushstrokes of unmodified colours. The painting's faithfulness to his visual experience is underlined by the remarkable correlation between the small, rapidly executed oil sketch and the final painting.

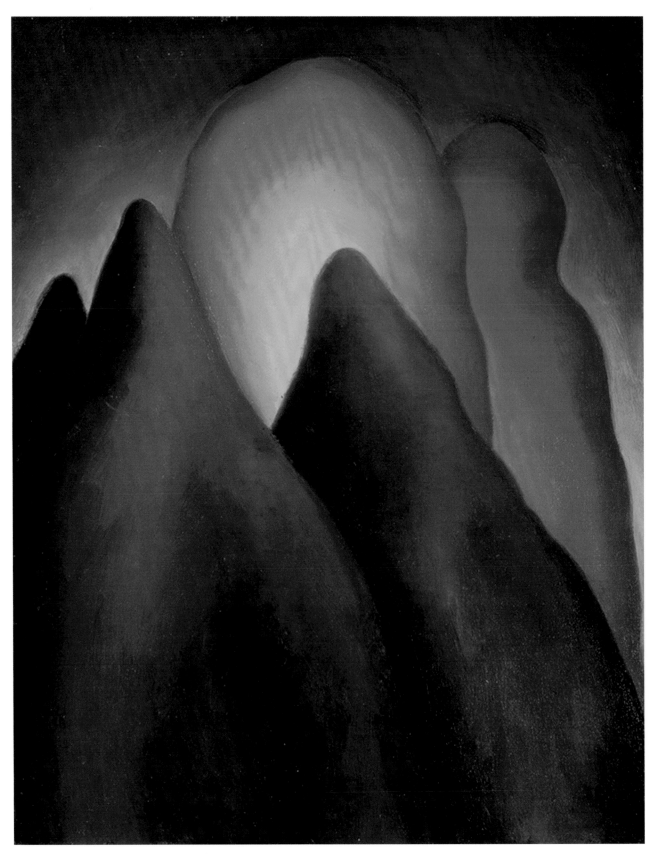

179 Georgia O'Keeffe, Anything (Red and Green Trees), 1916

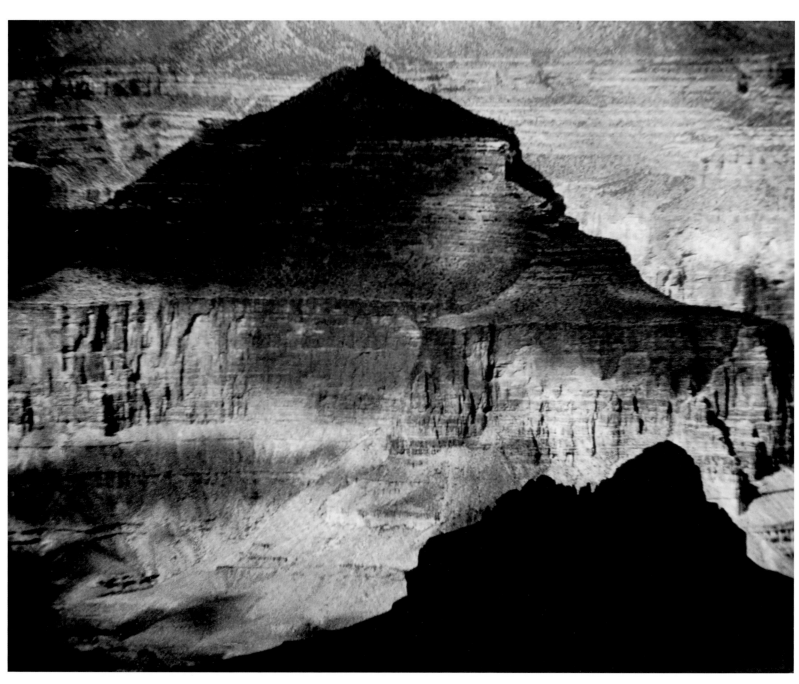

180 Alvin Langdon Coburn, The Great Temple, Grand Canyon, 1911

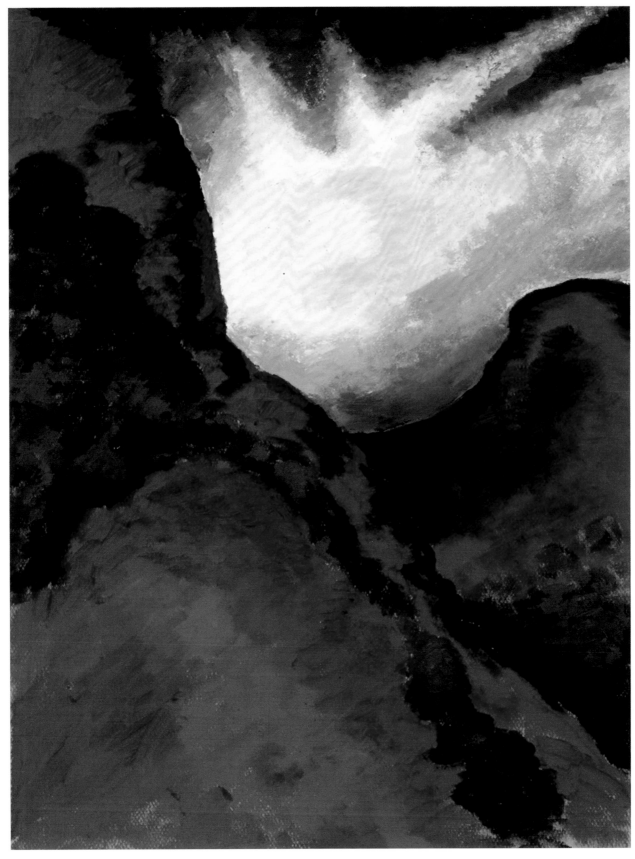

181 Georgia O'Keeffe, Red Landscape, 1916-17

179-182
The period of 1914 to 1916 was crucial to the future of O'Keeffe's stylistic development (cat. 140). It was during this time in New York that she became familiar with and internalized the tenets of leading currents in French contemporary art, including Cubism and Kandinsky's theories of colour. Alfred Stieglitz and his Gallery 291 were crucial to this transformation. Her return to Texas in 1916-1917 provided her with the possibility to consolidate these lessons in her landscapes, minimizing forms and asserting strident, vivid and emotive

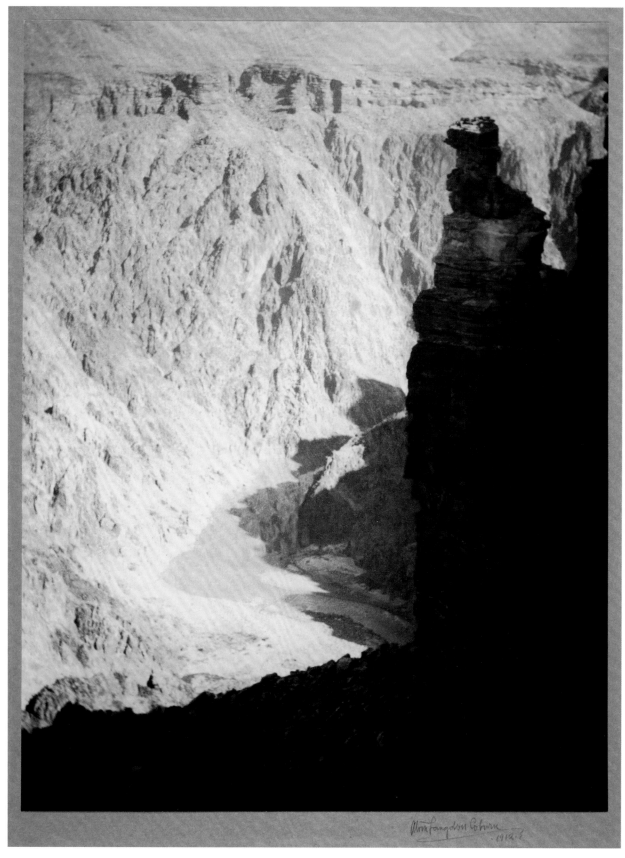

182 Alvin Langdon Coburn, Grand Canyon, about 1912

colours. It is particularly interesting to compare these extraordinary paintings with Coburn's nearly contemporary photographs (cat. 50, 180, 182). Coburn, who had been closely associated with Stieglitz since the previous decade and was a member of the Photo-Secessionist movement, also exploited the potentiality of the vast, crisply profiled and inspiring Southwestern landscape in his toned platinum prints. He converted the panoramas into abstract studies of monumental blocks created through sharp juxtapositions of light and dark, much as O'Keeffe did in her colour fields. Both artists convey the grandeur of their subjects and a spiritual affinity with Nature.

183 Alexander Young Jackson, Terre Sauvage, 1913

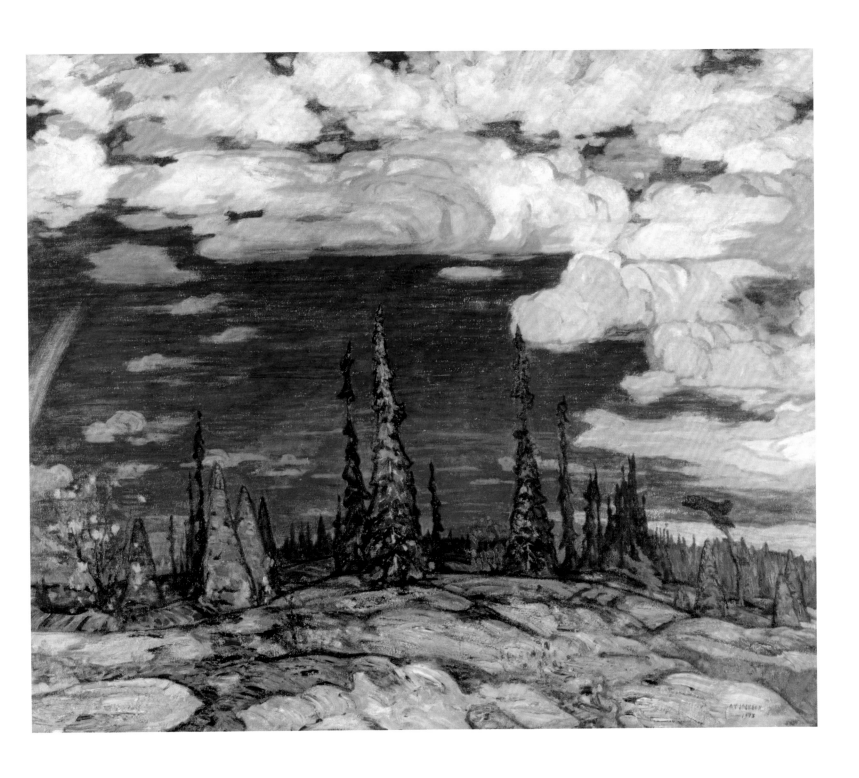

In 1913 Jackson shared a studio with Lawren Harris and painted what would be his largest work, *Terre Sauvage*, originally titled *The Northland*. The intensity suggested by the title is reflected in the rhythmic, gestural and intense application of forms and colours. The painting reflects the influence of recent Northern European painting, so championed by Harris and MacDonald after their trip in January of that year to the exhibition of contemporary Scandinavian artists in Buffalo. The direct source of the subject was a trip the artist had made north to Georgian Bay that spring. The work fascinated Tom Thomson, who witnessed its gestation in Jackson's shared studio.

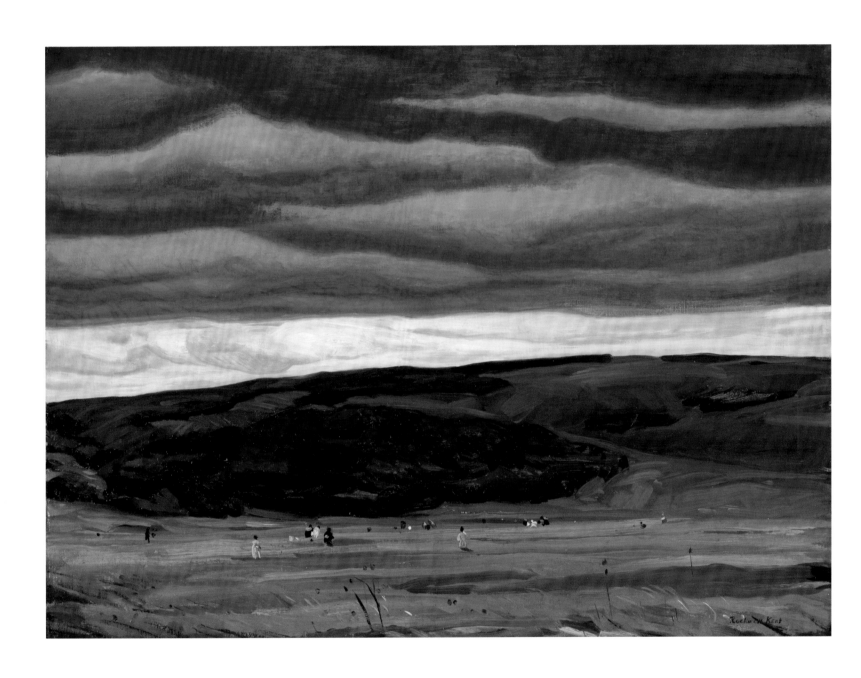

Kent received his early artistic training in New York. He had entered Columbia University with the intention to become an architect but began studying art with William Merritt Chase (cat. 125), Abbott Thayer and especially Robert Henri (cat. 153), a progressive teacher profoundly influenced by the art of Edouard Manet and Diego Veláquez. Although his own work was of a less progressive personal style, Henri nonetheless encouraged innovation among his students. In 1908 he helped plan an exhibition of anti-academic artists who focused on direct, realist images of working-class New York. These artists became known as the Ashcan School. In 1903 Henri had visited Maine, urging his students to go there for motifs. In 1905, Kent moved to Monhegan Island, Maine, sixteen kilometres off the coast, working in isolation on the island intermittently until 1911 to develop a personal style. The resulting paintings, which he first exhibited in 1907 in New York, where they were well received, compared favourably to the simplicity, power and directness of Winslow Homer's late landscapes (cat. 21).

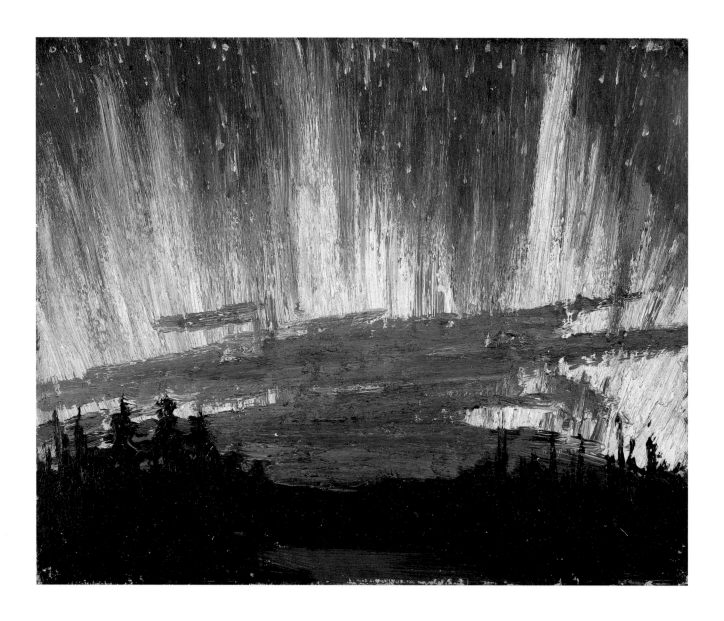

This small gem of a painting, generally dated to the spring of 1916, is one of five sketches the artist painted of this subject roughly between 1915 and 1917. The vibrant and nearly abstract composition of this Nocturnal study, the passionate, bold brushstrokes and brilliant colours against the severe blackness of the tree line below, and the starry sky above make it among the most dramatic of his works. According to a ranger who knew the artist, Thomson would observe the borealis for an extended period from his camp at Algonquin Park. He would then paint his impressions in his lamp-lit cabin either immediately or shortly thereafter, while the memory was still vivid.

186 James Edward Hervey MacDonald, The Elements, 1916

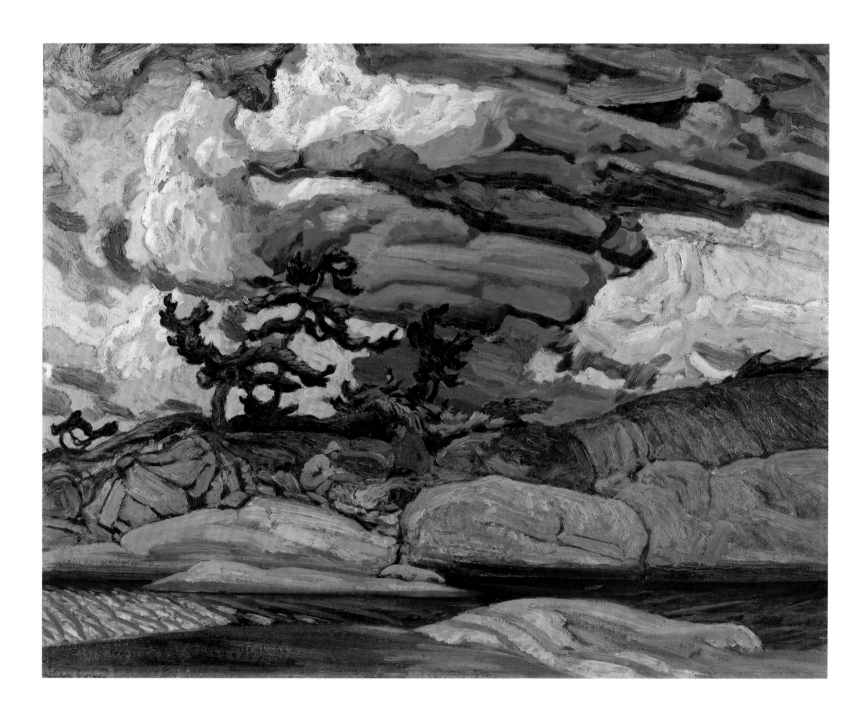

The Elements is an image inspired by the rugged Jack-Knife Island in Georgian Bay. The rocks, boulders and scrub pines against the complementarily imagined sky pattern, the colours acidic and arbitrary, overwhelm the figures about the campfire on the beach and convey the interrelation between earth and the heavens as well as the power of Nature in a hostile mood. After the painting was exhibited in Toronto in 1916, where it baffled critics and received negative comments for its "grotesque" and "chaotic ... convulsive" shapes, the artist reworked the sky without compromising the picture's intensity. MacDonald replied at the time that the painting embodied "a big idea, the spirit of our native land" (*Toronto Globe*, March 27, 1916).

187 Arthur Garfield Dove, Sun on the Lake, 1938

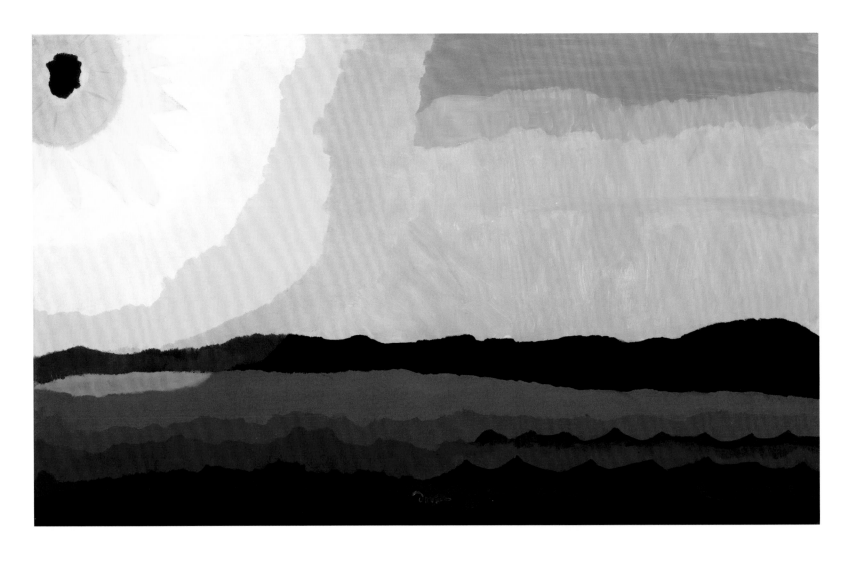

The final two paintings in this exhibition are selected as an epilogue to *Expanding Horizons*, demonstrating the continuity of American and Canadian landscape painting traditions in the evocation of Man's relation to Nature well into the twentieth century. Dove's explorations into the abstract always remained grounded in the experience of Nature, and his fascination with the cosmic rhythm of life was expressed through expanding, concentric rings of colour. The sun, symbolically, colouristically and formally, presented a transcendent opportunity for the artist to express this greater harmony. Working outward, "extracting," as he called it, from Nature, he presented spiritual verities through his visionary style.

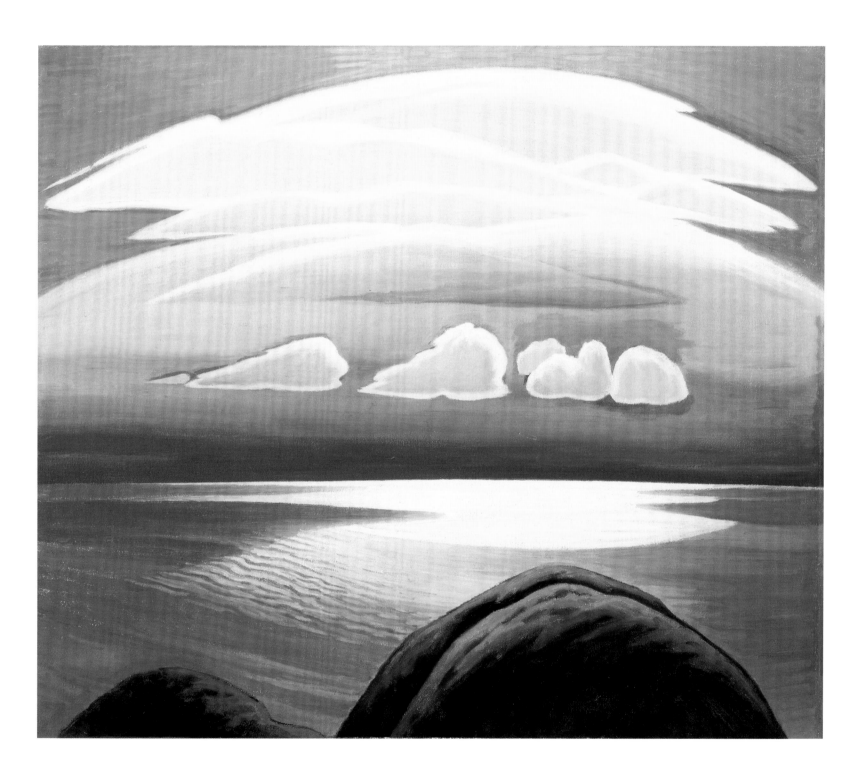

This painting has an interesting history. While its precise date is disputed between the 1920s and the 1940s, we know that it is based on studies the artist executed in 1925. However it does not feature in an inventory of works left behind in Toronto in 1934, when Harris went to Dartmouth College in Hanover, New Hampshire, for four years, returning definitively to Canada in 1944. Harris himself referred to the painting in a letter of 1951 to Dartmouth, stating, "I want to do a little work on it" before presenting it to the college. Although the painting has recently been dated to about 1948, the fact that the artist reworked it in 1951, changing its appearance, could affect this dating. A similar composition in the collection of the Montreal Museum of Fine Arts dates to the 1920s. The artist first ventured to the austere northern shores of Lake Superior in 1921, returning there the next several years. The site's larren splendour and sharp contrasts as well as its purity and sublimity offered him an ideal format to express his theosophically influenced beliefs in the greater cosmic harmonies of Nature and Man's fulfillment through it. As in Dove's painting, the sunlight, here reflecting over the water and irradiating the complementary cloud formations above, conveys a spiritual grace.

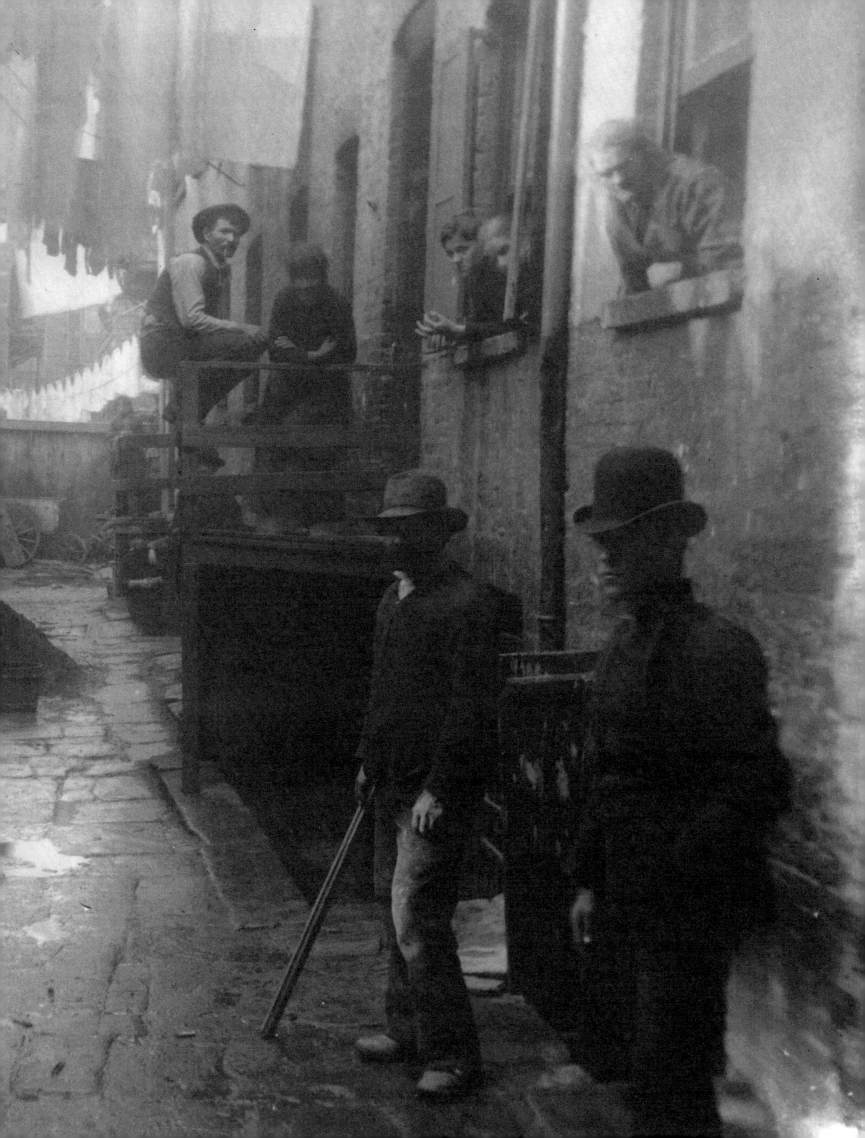

Chronology

1860

Canada
Founding of the Art Association of Montreal. The Association's goal was to foster appreciation of the fine arts, in keeping with a widespread philanthropic tradition in North America. It organized exhibitions and drawing classes.

—

The United States
Abraham Lincoln, an anti-slavery Republican, elected president.

—

Europe
Advances in the science of meteorology. Synoptic maps were being drawn up, and forecasts became a daily occurrence. Many artists began working out of doors, since the weather could now be predicted.

1861

The United States
April 12, outbreak of the American Civil War due to the opposition between the North and South over slavery. The South hoped to win the support of future western states, while the North wanted to stop the expansion of slavery into the western territories. ▶ For the first time, photography was used systematically as a journalistic tool.

1863

The United States
July 1 to 3, the decisive Battle of Gettysburg, at Gettysburg, Pennsylvania, turned back the Confederate Army's invasion of the North.

1865

The United States
April 9, Robert E. Lee, commander in chief of the Confederate Army, was surrounded after the siege of Petersburg, Virginia. He surrendered to Ulysses Grant, bringing the Civil War to an end. ▶ April 14, Abraham Lincoln assassinated by a Southern sympathizer at a Washington theatre.

1867

Canada
In March, British Parliament passed the *British North America Act*. This law established the Dominion of Canada and defined how the government was to function. Charles S. Monck was named the first Governor General of Canada and John A. Macdonald, the first Prime Minister. ▶ July 1, the creation of the Canadian Confederation (Ontario, Québec, New Brunswick and Nova Scotia).

The United States
Russia sold Alaska to the United States for seven million dollars.

1869

Canada
Canada's first crisis since Confederation occurred when the politician Louis Riel, chief of the Metis, defended his territory in the Canadian prairies, a centre of the fur trade that had just been sold to Canada by the Hudson's Bay Company.

—

The United States
May 10, the Union Pacific and Central Pacific railroads came together at Promontory Point, Utah, to create the first transcontinental railroad in the United States.

—

Elsewhere in the World
Opening of the Suez Canal.

1870

Canada
With the passing of the Manitoba Act, Manitoba became a province in the Canadian Confederation.

—

The United States
The American geologist Ferdinand V. Hayden explored Colorado and Wyoming on behalf of the US Geological and Geographical Survey, with a view that a transcontinental railway was soon to be built. He was accompanied by the photographer William Henry Jackson. The two men catalogued and photographed natural sites. These images helped promote legislation supporting the creation of protected areas—the future national parks, like Yellowstone. ▶ In the following years, other large-scale explorations, for example those headed by John W. Powell, Lieutenant Wheeler and Clarence King, led to the discovery of natural resources in Utah, Nevada, Arizona, the Grand Canyon and the Rockies. Enthusiasm for the West grew more intense as the region developed.

—

Europe
Beginning of the Franco-Prussian War, between Second Empire France and the Kingdom of Prussia. ▶ Proclamation of the Third Republic after the defeat of Napoleon III at Sedan.

1871

Canada
Fearing the annexation of British Columbia by the United States, the Dominion of Canada promised to link the Pacific Coast to the eastern provinces by rail. On July 20, British Columbia joined the Confederation and became a Canadian province.

—

Europe
Founding of the German Empire by Wilhelm I.

1872

Canada
Founding of the Ontario Society of Artists.

—

The United States
Creation of Yellowstone, the world's first natural park. ▶ Opening of the Metropolitan Museum of Art in New York, with John Taylor Johnston as its president. His father, James Boorman Johnston, had founded the Tenth Street Studio, where Albert Bierstadt, Frederic Church and Winslow Homer worked.

1873

The United States
Inauguration of Central Park, New York, after thirteen years' work by four thousand men.

1874

Europe
First Impressionist exhibition. Monet, Pissarro, Renoir, Sisley, Cézanne, Berthe Morisot and Degas were the main organizers.

1876

Canada
Inauguration of Montreal's Mount Royal Park, laid out by Frederick Law Olmsted, the landscape architect who had designed Central Park (1858–1861), Prospect Park (1865–1873) in Brooklyn and later the landscaping of the Niagara Falls State Reserve on the American side of the falls. The Reserve was reclassified as Niagara Falls State Park in 1885.

—

The United States
June 25 and 26, the Battle of the Little Bighorn ("Custer's Last Stand") in southeast Montana. Sitting Bull, the Lakotas and Cheyennes defeated the troops of General George Armstrong Custer, who was killed in the fighting.

1879

Canada
Inauguration on Phillips Square of the Art Association of Montreal's Art Gallery, the first building in Canada designed to house artworks.

1880

Canada
Inauguration of the first exhibition of the Royal Canadian Academy of Arts (RCA), at the Clarendon Hotel in Ottawa, by the Governor General, the Marquis de Lorne, and his wife, Princess Louise, the daughter of Queen Victoria. Lucius O'Brien was named president of the RCA, which became the National Gallery of Canada in 1913.

1881

Canada
Beginning of construction of Canada's first transcontinental railroad by the Canadian Pacific Railway Company. The rail link between Vancouver and Montreal fostered the development of the Canadian West.

1882

Canada
Oscar Wilde visited Toronto and formed a friendship with Homer Watson. The writer compared him to the great English landscape painters, calling him the "Canadian Constable." At about the same time, Queen Victoria commissioned works from Watson.

1883

Europe
The Orient-Express made its first run, from Paris to Giurgiu, Romania.

1885

Canada
Banff National Park became Canada's first national park. ▶ The North-West Rebellion broke out after Louis Riel, who had returned from exile in the United States, presented the Canadian government with the Metis people's demands for an independent state. The new railway allowed rapid deployment of the army. Riel was arrested, tried, found guilty of treason and hanged.

—

The United States
The American portion of Niagara Falls became the first state park in the United States.

1886

Canada
Creation of Yoho National Park.

—

The United States
In April, the art dealer Paul Durand-Ruel organized an exhibition of thirty-six paintings and pastels by Renoir in New York, giving Americans their first look at Impressionism. ▶ Inauguration in New York of the Statue of Liberty, a gift from France commemorating the centennial of American independence and a symbol of the two countries' friendship.

1888

The United States
George Eastman introduced the Kodak, an easy-to-operate camera that used the gelatin-paper roll film he had invented four years earlier. By replacing glass plates, he revolutionized the world of photography.

1889

Europe
World's Fair in Paris. One of the designers of the Statue of Liberty, Gustave Eiffel, erected a three-hundred-metre-tall iron tower that is now named for him.

1890

The United States
December 29, the massacre at Wounded Knee. This confrontation between the Seventh Regiment of the US Cavalry and the Lakotas was the last armed conflict with the Aboriginal people, putting an end to long years of warfare. ▶ In California, Yosemite classified a national park.

1893

Canada
Algonquin Park, in Ontario, became Canada's first provincial park.

1894

Europe
Alfred Dreyfus, a French army officer of Alsatian-Jewish origin, accused of handing information over to the German military attaché in Paris, setting off what came to be known as the Dreyfus Affair, a scandal tinged with espionage and anti-Semitism arising from a judicial error. Four years later, Émile Zola published an open letter, "J'accuse," denouncing the flaws in the Third Republic. It caused a stir on the political and social scene in France.

1896

Canada
Wilfrid Laurier became the first French Canadian to serve as Canada's Prime Minister. He held office from July 1896 to October 1911. ▶ Discovery of gold in the Yukon, in several tributaries of the Klondike River. The Gold Rush drew more than a hundred thousand people to the region.
—

The United States
Henry Ford road-tested his first motor car.

1898

The United States
Formation of an Impressionist group, the Ten American Painters, also known as The Ten. Childe Hassam, John Henry Twachtman and Julian Alden Weir were among its members (William Merritt Chase joined in 1902, after Twachtman died). An exhibition of their work opened on March 31 at the Durand-Ruel gallery, where they would exhibit frequently until 1919. ▶ In April, onset of the Spanish-American War, which led to Cuban independence and the taking over of control of various Pacific and Caribbean colonies by the United States.

1901

The United States
In September, William McKinley, twenty-fifth president of the United States, assassinated. Theodore Roosevelt succeeded him. From an eminent New York family, Roosevelt was a nature lover known for his prowess as a hunter. A strict naturalist, he preached the conservation of fauna and the dissemination of knowledge about animals. Roosevelt was very popular with the American people because of his key role in the preservation of forests and nature reserves, now overseen by the National Parks Service, as well as for his remarkable stand on foreign policy.
—

Europe
Death of Queen Victoria. Her son acceded to the throne as Edward VII.

1902

The United States
Construction of the Flatiron Building in New York. ▶ The National Arts Club of New York presented *Photo-Secession*, an exhibition of the new group formed by Alfred Stieglitz to gain recognition for photography as an art in its own right. With other members, including Alvin Langdon Coburn, Edward Steichen, Clarence H. White and Fred Holland Day, Stieglitz founded the magazine *Camera Work*.

1905

Europe
A group of young European painters using strong, "wild" colours in an exuberant style exhibited at the Salon d'automne in Paris and adopted the term "Fauvism." Emily Carr was strongly influenced by them.

1907

Canada
Creation of the Canadian Art Club, made up of members of the RCA. Homer Watson was its first president.
—

Europe
Pablo Picasso painted *Les Demoiselles d'Avignon*, considered to be the starting point of Cubism.

1908

Canada
Founding of the Arts & Letters Club of Toronto, a private club for the city's architects, painters, musicians, graphic designers and stage actors. Artists of the future Group of Seven were members.
—

The United States
The Macbeth Gallery in New York presented The Eight (Ashcan School), a new movement of realist painters that counterbalanced American Impressionism. Among its members were Maurice Prendergast, Robert Henri and Ernest Lawson. Some of The Eight were responsible for the landmark Armory Show held in 1913.

1909

Canada
The British Columbia Society of Artists was founded to promote artists there.

1911

Canada
The future members of the Group of Seven met for the first time.

Europe
In June, Coronation of George V, grandson of Queen Victoria, at Westminster Abbey, London. In May, a Festival of the Empire at the Crystal Palace in Hyde Park had celebrated the coming event. ▶ At the Salon des Indépendants, the first exhibition by the Cubists, artists who flattened forms and depicted multiple viewpoints simultaneously of a single object.

1912

Canada
The most talented cowboys met in Alberta to take part in the Calgary Stampede, an international rodeo.

1913

Canada
After the previous year's success of her more traditional works produced in Europe, Emily Carr exhibited paintings whose subject matter featured Native communities. The exhibition, held in Vancouver, was a failure. ▶ A. Y. Jackson joined the Group of Seven.
—

The United States
February 17 to March 15, the legendary Armory Show in New York presented the European avant-garde to a scarcely receptive American public for the first time.

1914

Canada
In January, opening in Toronto of the Studio Building financed by Dr. James MacCallum and Lawren Harris, a painter and heir of the Massey-Harris Co., which manufactured farm machinery. Many artists, including Tom Thomson, Franklin Carmichael and A. Y. Jackson, had studios there. ▶ August 4, Great Britain declared war on Germany. The nations of the British Empire were thus at war as well. The regular Canadian army numbered only three thousand one hundred, but Canada recruited more than thirty-two thousand soldiers in just a few weeks. The majority were briefly trained at Valcartier, near Quebec City, before crossing the Atlantic to Salisbury, England. Canadian losses would total more than sixty-seven thousand soldiers.
—

Europe
In late July, the beginning of World War I with Austria-Hungary's declaration of war against Serbia. The assassination in Sarajevo on June 28 of Archduke Francis Ferdinand, successor to the Austro-Hungarian Empire, is considered the incident that unleashed the conflict. One after another in the first days of August, the nations of the Triple Entente (France, Great Britain and Russia) and the Triple Alliance (Germany, Austria-Hungary and Italy) declared war on one another.
—

Elsewhere in the World
Inauguration of the Panama Canal.

1916

Canada
John Singer Sargent visited Yoho National Park and the Rockies, where he painted many oils and watercolours, producing two series of North American landscapes during a two-year stay.

1917

Canada
April 9, the thirty-five thousand combatants of the Canadian army stationed at Vimy took possession of the last two pockets of resistance, in Canada's first military victory as an independent nation. ▶ July 13, the painter Tom Thomson's body was found in Canoe Lake, in Algonquin Park. The cause of his death has remained a mystery to this day. ▶ December 6, a French boat loaded with ammunition collided with a Norwegian boat in Halifax harbour, causing the largest accidental non-nuclear explosion. The flames reached nearly 2 km into the sky, and the conflagration caused a tidal wave. Two thousand were killed and nine thousand wounded.
—

The United States
April 6, President Woodrow Wilson brought the United States into the War. A poster design for the recruiting campaign featured Uncle Sam saying, "I Want YOU for U. S. Army." More than one million two hundred thousand American soldiers went to the front.

Europe
In February, demonstrations and clashes in Russia forced Czar Nicholas II to abdicate. The last rulers of the Romanov Dynasty, on the throne since 1613, were imprisoned in western Siberia and executed there the following year. In October, Lenin's Bolshevik Party came to power.

1918

Europe
November 11, end of World War I. Human loss amounted to nine million dead and six million maimed. At the same time, the Spanish influenza spread around the world. According to the Institut Pasteur, it caused thirty million deaths. Approximately forty-five thousand Canadians died in the epidemic.

Prepared by
Thierry-Maxime Loriot

Biographical Notes

Benjamin Baltzly
Tuscarawas, Ohio, 1835 – Cambridge, Massachusetts, 1883
Benjamin Baltzly settled in Montreal in 1866 with the intention of opening a photography studio. Employed by William Notman in 1870, he set off to explore the Canadian Rockies on behalf of the Canadian Pacific Railway the following year. He took 120 photographs on this trip. In 1879, Baltzly moved to Cambridge, where he continued to exercise his profession.

George Barnard
Coventry, Connecticut, 1819 – Cedarville, New York, 1902
George Barnard began using the daguerreotype in 1842 and with this process became a pioneer in photo-reportage. After a trip to Cuba in 1860, he was employed by Mathew B. Brady in New York and Washington. Barnard was an official Civil War photographer from 1863 to 1865, and in the 1880s, he helped George Eastman perfect the dry plate.

Albert Bierstadt
Solingen, Germany, 1830 – New York, 1902
Albert Bierstadt was three years old when his family arrived from Germany to settle in New Bedford, Massachusetts. The budding painter studied at the Düsseldorf Academy from 1853 to 1857 and then returned to the United States. An influential figure in the Hudson River School, he produced huge Romantic panoramas of the virgin wilderness prior to colonization and industrialization. His sublimely luminous paintings are outstanding for their contrasts of atmosphere. Bierstadt mainly explored the American West, interpreting the mystery and beauty of its remote regions.

William Bradford
Fairhaven, Massachusetts, 1823 – New York 1892
A Romantic painter, photographer and explorer, William Bradford developed his own style by painting pictures of boats in New Bedford harbour. In 1854, he made the acquaintance of the Dutch painter Albert van Beest, who taught him his techniques. Bradford travelled with Van Beest and shared a studio with him at the Tenth Street Studio Building, where he met Albert Bierstadt. A member of the Hudson River School, Bradford earned recognition with his Arctic seascapes and effects of light on the water. In 1873, after a series of expeditions to the Far North, he published *The Arctic Regions*, illustrated with 141 photographs.

William Merritt Chase
Williamsburg, Indiana, 1849 – New York, 1916
A painter and teacher, William Merritt Chase received his training at the Royal Academy of Fine Arts in Munich and the National Academy of Design in New York. An admirer of the Impressionist movement, he worked in oils, ink and pastel, creating a varied oeuvre that included landscapes, still lifes and portraits that made his reputation. A founding member of the American Society of Painters in Water Colors, he opened the Shinnecock Summer School of Art on Long Island and the Chase School of Art in New York. In 1909, the Chase School became the New York School of Fine and Applied Arts and, eventually, Parsons The New School for Design. Chase taught in many institutions in the United States, and among his most notable students were Marsden Hartley and Georgia O'Keeffe.

Frederic Edwin Church
Hartford, Connecticut, 1826 – New York, 1900
Frederic Edwin Church studied painting with Thomas Cole, who passed on to him his heroic and spiritual vision of the American landscape. A dominant member of the Hudson River School, he became the most famous American painter of his time when he painted *Niagara* (1857) after visiting that region. In 1853 and again in 1857, he travelled to South America, where the fauna and luxuriant vegetation fascinated him. He made many sketches of the volcanoes Cotopaxi, Sangay, Pichincha and Cayambe. In 1859, *The Heart of the Andes* was sold for 10,000 dollars, the highest price paid up to that time for a painting by a living American artist. In the late 1860s, Church's reputation waned, and he was criticized for his brilliant tonalities. He nevertheless remains an important figure in American painting. Suffering from rheumatism in his hands, he stopped painting in 1877 and retired to Olana, a farm overlooking the Hudson River that later housed a museum of his work.

Alvin Langdon Coburn
Boston, 1882 – Rhos-on-Sea, Wales, 1966
At first an amateur photographer, Alvin Langdon Coburn undertook a professional career in 1899 after meeting Edward Steichen at the Camera Club. With Steichen, Alfred Stieglitz and others, he founded the Photo-Secession in 1902. The members of this group, which sought to win recognition for photography as an art in its own right, published their pictures in the magazine *Camera Work*. Coburn moved to London in 1912, where he turned his attention to portraits of celebrities. He was subsequently associated with Vorticism, a movement that distinguished itself from Cubism and Futurism. His "vortographs" evoke a gyrating movement through radiating curved and broken lines.

Colin Campbell Cooper
Philadelphia, 1856 – Santa Barbara, California, 1937
An Impressionist painter, Colin Campbell Cooper learned his art at the Julian, Vitti and Delécluse academies in Paris. In 1895, he began teaching watercolour technique at the Drexel Institute in Philadelphia. He lived in New York, where he made a series of architectural paintings. His wide travels in Europe and Asia inspired portrait, landscape, garden and architectural photographs.

Jasper Francis Cropsey
Rossville, New York, 1823 – Hastings-on-Hudson, New York, 1900
A landscape painter and architect associated with the first generation of the Hudson River School, Jasper Francis Cropsey was a cofounder of the American Society of Painters in Water Colors. After his marriage in 1847, he toured Europe for two years. He then spent seven years in London, where he came in contact with artists and accepted commissions for American subjects, which were highly prized abroad. Upon his return to the United States, Cropsey turned to autumn panoramas of New York State. He favoured intoxicating colours, convinced

that the landscape is the ultimate representation of the manifestation of God in nature. His structured compositions also show his interest in architecture. As a painter, he celebrated the prosperity of a nation recently at peace.

Asahel Curtis
Minnesota, 1874 – Seattle, 1941
Asahel Curtis began his career as a photographer alongside his older brother, Edward Sheriff Curtis. At age twenty-three, he set out for the Yukon to take pictures of the Gold Rush. After a dispute over reproduction rights for these pictures, Asahel severed all ties with his brother. In 1911, he launched his own studio, where he made many portraits and advertisements for magazines like *National Geographic*. Although Asahel was not as famous as Edward, he became the official photographer of the Seattle Chamber of Commerce. He made over 60,000 photographs of this region, which he was fond of.

Edward Sheriff Curtis
Whitewater, Wisconsin, 1868 – Los Angeles, 1952
Self-taught, Edward Sheriff Curtis created portraits and was particularly interested in Native American tribes. In 1906, the industrialist J. P. Morgan asked him to survey the customs of the American Indian. This investigation resulted in a twenty-volume encyclopedia entitled *The North American Indian*, with more than 2,500 photographs. The publication caused its share of controversy over the method used to collect the images and the truthfulness of the settings.

Arthur Garfield Dove
Canandaigua, New York, 1880 – Long Island, New York, 1946
A graduate of Cornell University, Arthur Garfield Dove first encountered the work of Cézanne, Matisse and the Fauvists on a trip to Europe early in the twentieth century. He took part in the Salon d'Automne of 1908 and 1909. Back in America, he worked as an illustrator for various newspapers to make a living. His fortunes changed the day he met Alfred Stieglitz, who recognized his potential as a modern artist. Stieglitz exhibited Dove's work at Gallery 291 in New York every year from 1912 to 1946. An early exponent of the incorporation of collage into painting, Dove is known for his abstractions showing a sensitivity to nature.

Robert S. Duncanson
Fayette, New York, 1821 – Detroit, 1872
Robert S. Duncanson's father was Canadian and his mother Afro-American. A painter and photographer, Duncanson lived in Canada until he was a teenager and then went to the United States. He began studying painting in Scotland in 1839 and specialized in portraits of the Abolitionist senators. Back in the United States in 1842, he was influenced by the Hudson River School. He made his reputation with lush Romantic landscapes. Considering himself a free artist of colour, he fled to Montreal during the American Civil War.

Thomas Eakins
Philadelphia, 1844 – Philadelphia, 1916
A painter, photographer and sculptor, Thomas Eakins studied anatomy at Jefferson Medical College and attended the École des beaux-arts in Paris and the Pennsylvania Academy of Fine Arts in Philadelphia. A proponent of realism, he combined scientific and artistic interests, turning to photographs to compose his paintings. In 1886, this provocateur used a nude male model in a drawing class, which cost him his teaching job at the Pennsylvania Academy of Fine Arts.

Alexander Gardner
Paisley, Scotland, 1821 – Washington, 1882
The Scottish-born American photographer Alexander Gardner worked for Mathew B. Brady's studio in New York starting in 1856, the year he arrived in the United States. In 1867 the Union Pacific Railroad sent him to Kansas to document

the construction of the railroad. He took pictures with dry collodion plates and albumen glazes and developed them on the spot in a portable darkroom. Over his career, he produced more than 10,000 negatives—2,000 of the Civil War—and distinguished himself with his photographs of the American West, not to mention his celebrated portraits of Abraham Lincoln.

Sanford Robinson Gifford
Greenfield, New York, 1823 – New York, 1880
A member of the Hudson River School and the Luminist movement, Sanford Robinson Gifford crisscrossed the state of New York and several European countries from 1855 to 1857. During this time, he met Albert Bierstadt and Worthington Whittredge. He also became acquainted with the work of Joseph Mallord William Turner and the Barbizon School before returning to America.

Marsden Hartley
Lewiston, Maine, 1877 – Ellsworth, Maine, 1943
Painter, poet and writer Marsden Hartley was a student of William Merritt Chase. After his studies and throughout his life, he made many trips to California, New Mexico and Eastern Europe. In 1909, Alfred Stieglitz, who became his patron, gave him his first solo exhibition, at Gallery 291 in New York. Hartley's work drew inspiration from current modernist ideas, Kandinsky and Picasso. It is punctuated with Cubist and Expressionist influences, and incorporates abstract forms evoking the forces of nature in an individual way. Often considered the official painter of Maine, Hartley endeavoured to create a distinct regional art.

Frederick Childe Hassam
Dorchester, Massachusetts, 1859 – New York, 1935
A student at the Boston Art School, Frederick Childe Hassam enrolled at the Académie Julian in Paris in 1883. There, he met John Henry Twachtman. Strongly influenced by the Impressionist movement that was at its height in Europe, from 1898 he presented his vision of American culture. Hassam took part in the formation of the Ten American Painters (The Ten), who held their Impressionistic painting up in opposition to the values of the Society of American Artists, which they deemed overly commercial.

Frank Jay Haynes
Saline, Michigan, 1853 – Saline, 1921
Frank Jay Haynes set up his first studio in Moorhead, Michigan, in 1876. The same year, the Northern Pacific Railroad hired him to take promotional photographs of Yellowstone. He became the park's official photographer and held the post for thirty-two years, publishing *Haynes Guidebook*. Very popular with tourists, his photographs were also often used by painters for making sketches. In 1916, his son, Jack Ellis Haynes, took over both the studio and his post as official photographer of Yellowstone, of which he became director.

Martin Johnson Heade
Lumberville, Pennsylvania, 1819 – St. Augustine, Florida, 1904
Perceived as a pioneer of Impressionism, Martin Johnson Heade led a nomadic life in the United States and South America. His frequent moves marked his painting, which is often associated with the Luminist tradition. The subject matter of the highly diversified, unconventional compositions he is best known for is luxuriant tropical vegetation, rare birds and haystacks. Heade also painted many landscapes with his close friends and New York studio mates Frederic Edwin Church and John Frederick Kensett.

Robert Henri
Cincinnati, Ohio, 1865 – New York, 1929
After studying at the Académie Julian in 1888, Robert Henri, a distant cousin of Mary Cassatt, often returned to Paris to acquaint himself with Impressionism. He taught in Philadelphia and at the New York School of Art. George Bellows, Edward Hopper and Rockwell Kent are among his students. His methods, alien to the academic tradition, earned him a reputation as an anarchist. He joined The Eight in 1908, organized the Artistes Indépendants' New York exhibition in 1910 and exhibited five paintings at the Armory Show in 1913.

John K. Hillers
Hannover, Germany, 1843 – Washington, 1925
As a young man, John K. Hillers, a German immigrant, fought in the American Civil War on the Union side. At that time, he met John Wesley Powell, an explorer whom he accompanied on a series of expeditions to the American West beginning in 1869. He then joined Ferdinand Hayden's surveying missions as an assistant photographer, along with the photographer William Henry Jackson. Hillers took many pictures of Yosemite, the Grand Canyon and New Mexico. Toward the end of his career, he made portraits of Native Americans who passed through Washington.

Winslow Homer
Boston, 1836 – Prouts Neck, Maine, 1910
Winslow Homer was a lithographer's assistant when he began training at the National Academy of Design in New York in 1859. His mastery of the woodcut gave his works a coarse look and a modern feel. As a painter, he did much technical and pictorial experimentation. From his early Civil War scenes, he evolved toward calm coastal and rural landscapes of Maine and England, often working out of doors like the Impressionists. Though specializing in oil, Homer nonetheless devoted himself to watercolour during his vacations and distinguished himself with, among other things, seascapes suffused with strength and beauty. He is considered one of the best painters of his day.

Layton Alton Huffman
Castalia, Iowa, 1854 – Billings, Montana, 1931
Layton Alton Huffman learned photography in the studio of his father, P. C. Huffman. He became a photographer for the Northern Pacific Railroad and then an assistant to Frank Jay Haynes in Minnesota. From 1878 to 1882, he worked for the US Army at Fort Keogh, in Montana, where he photographed the buffalo slaughter and made portraits of Native Americans and celebrities like Calamity Jane.

William Morris Hunt
Brattleboro, Vermont, 1824 – Appledore Island, Maine, 1879
Thrown out of Harvard, the young William Morris Hunt studied painting and sculpture in Paris with Thomas Couture. There, he discovered the basic principles of the Barbizon School and was drawn to Millet. The years following his return to Boston in 1855 were productive. However, most of the many portraits and landscapes he painted were lost in the Boston fire of 1872. In the summer of 1878, a year before his death, he created the finest works of his career, a series of bucolic landscapes of Niagara Falls.

George Inness
Newburgh, New York, 1825 – Bridge of Allan, Scotland, 1894
George Inness trained in the United States and Europe during the 1850s. He rented a studio in Rome for a year and there developed an interest in the dark, atmospheric palettes of the Barbizon School. Inness's landscapes interpret the age of industrialization, with its railroads for example, and dramatically juxtapose sky and earth, thus giving rise to Luminism.

William Henry Jackson
Keeseville, New York, 1843 – New York, 1942
After a tour of duty in the Civil War, William Henry Jackson explored Yellowstone, Mount Holy Cross and the Rockies with the geologist Ferdinand Hayden. The photographs he took played a decisive role in the creation of Yellowstone National Park in 1872. Subsequently, he explored the West on many occasions for the US Geological and Geographical Survey, during which he met a new collaborator, Thomas Moran. Jackson showed photographs of the Mesa Verde Anasazi site at the World's Fair of 1876. Taking up painting at the age of eighty-one, he made many canvases and murals of the American West, besides serving as a technical assistant for the movie *Gone with the Wind*.

Eastman Johnson
Lovell, Maine, 1824 – New York, 1906
Eastman Johnson was a painter, photographer and printmaker. At the age of sixteen, he worked as a lithographer for the publisher J. H. Bufford's Lith. He furthered his training in The Hague from 1849 to 1855 and became the official painter of the Dutch royal family. Influenced by the seventeenth-century Dutch Masters, he was considered the American Rembrandt. When he returned to the United States in 1855, he painted genre scenes as well as portraits of famous people like Abraham Lincoln.

John Frederick Kensett
Cheshire, Connecticut, 1816 – New York, 1872
John Frederick Kensett, whose father was a printmaker, studied painting in Europe from 1840 to 1847. There, he first encountered the great European masters and the seventeenth-century Dutch landscape painters, whom he especially admired. When he returned to the United States, he visited the Catskills and the White Mountains, and painted ambitious landscapes influenced by Thomas Cole that embody the harmony of Man and Nature. Associated with the second generation of the Hudson River School and the Luminist movement, from 1855 he painted realistic New England coastal landscapes, abandoning the panoramas of his early career. In 1870, he was among the founding members of the Metropolitan Museum of Art, New York, to which he donated all his canvases.

Rockwell Kent
Tarrytown, New York, 1882 –
Au Sable Forks, New York, 1971
Rockwell Kent, an author, painter and illustrator, studied architecture at Columbia University and painting under William Merritt Chase. In 1905, he presented some works at the National Academy of Design in New York. But it was a solo exhibition two years later in the same city that brought him to public attention. The 1913 Armory Show was decisive for this pioneer of American modernism: thereafter, he countered abstraction, which held no meaning for him, and with Cubism. In the 1930s, he increasingly asserted his leftist political views. He is remembered as one of the twentieth century's great illustrators. Throughout his life, he lived in remote areas like Greenland, Newfoundland, Tierra del Fuego and Alaska, which he chose for their austere and wild beauty.

Darius and Tabitha Kinsey
D. Kinsey: Maryville, Missouri, 1869 –
Sedro-Woolley, Washington, 1945
T. Kinsey: United States, 1875 – United States, 1963
The marriage of Darius and Tabitha Kinsey lasted nearly fifty years. He was a photographer, and she worked at development and printing. In 1906, the couple moved to the rapidly expanding city of Seattle. Fascinated by the atmosphere of the forest and the variety of wood grains, they took pictures of logging camps. Their photographs found buyers in the forestry industry and among lumberjacks. The venturesome couple traversed glaciers, rivers and mountains, exploring natural parks such as the Garden of the Gods, Colorado Springs, and Yosemite Valley. They retired in 1940, after Darius fell out of a tree.

Joseph Rusling Meeker
Newark, New Jersey, 1827 – Saint Louis, Missouri, 1887
Joseph Rusling Meeker learned to paint at the National Academy of Design in 1845 and 1846 along with Asher Brown Durand, who inspired him throughout his career. He was fond of the Louisiana bayous, which he first saw from the Mississippi River when he was an accountant in the Union Navy. The calm, misty atmosphere of this swampy region is a recurrent subject in his work, as are Acadia, the Cajuns and Native Americans.

Willard Leroy Metcalf
Lowell, Massachusetts, 1858 – New York, 1925
Willard Leroy Metcalf began his career illustrating popular magazines. His success earned him a scholarship to the School of the Museum of Fine Arts, Boston. In 1883, he studied at the Académie Julian in Paris. Paintings he made on his travels in Tunisia and Morocco were shown in the Paris Salon. Metcalf moved to New York in 1891 and there exhibited with The Ten. He subsequently taught at the Cooper Union Institute and the Rhode Island School of Design.

Thomas Moran
Bolton, England, 1837 – Santa Barbara, California, 1926
On a visit to London in 1861, Thomas Moran encountered the work of Joseph Mallord William Turner. He was touched by that painter's particular effects of atmosphere, which would be his lifelong inspiration. In 1871, Moran took part in a US Geological and Geographical Survey expedition along with Ferdinand Hayden and created a series of pencil drawings from photographs of Yellowstone taken by William Henry Jackson. This mission was a turning point in his career. He subsequently made many trips to the future Grand Teton and Grand Canyon National Parks, where he found subject matter for the watercolours he is best known for. He contributed to the Etching Revival along with his wife, etcher Mary Nimmo Moran, and joined the New York Etching Club.

Stanley J. Morrow
Richland County, Ohio, 1843 – Dallas, 1921
Stanley J. Morrow got his start as a volunteer for Mathew B. Brady during the Civil War. He took many pictures of the Lakota and striking images of the Great Sioux War (1876–1877), in particular the Battle of the Little Bighorn. He established a studio in North Dakota, where he made portraits of Indian chiefs, including Red Cloud.

Eadweard James Muybridge
Kingston-upon-Thames, England, 1830 – Kingston-upon-Thames, 1904
Eadweard James Muybridge immigrated to the United States at the beginning of the 1850s but returned to England in 1852 to study photography. He travelled to Yosemite Valley in 1867–1868 and again in 1872. That year, he made elaborate landscape photographs composed of fifty-one plates that caused a sensation. A few months later, he turned his attention to the theories of the physiologist Étienne-Jules Marey and perfected the zoopraxiscope, a projector-like device that dissected motion to enable its consecutive stages to be viewed in rapid succession. In 1877 and 1878, he produced a series of 360-degree panoramas of San Francisco. For Muybridge, photography was both a science and an art. His techniques of analyzing locomotion heralded the advent of the cinema.

Georgia O'Keeffe
Sun Prairie, Wisconsin, 1887 – Santa Fe, New Mexico, 1986
Georgia O'Keeffe is the most famous American woman painter of the twentieth century. She acquired her training at the Art Institute of Chicago, then at the Art Students League in New York, where she was a friend of William Merritt Chase. In 1917, the photographer Alfred Stieglitz presented ten of her drawings in his New York gallery, which marked the inception of their professional relationship. Stieglitz encouraged her to move to New York to practise her art. She married him in 1924, sharing his life until he died in 1946. In New Mexico and at Lake George, O'Keeffe painted abstract landscapes, architectural compositions and outsized flowers that were very successful. In 1972, she lost her sight to a degenerative illness and stopped painting. However, she published a book about her work in 1976.

Timothy O'Sullivan
New York, 1840 – New York, 1882
The renowned photographer Timothy O'Sullivan started out as an apprentice in the daguerreotype studio of Mathew B. Brady. He demonstrated his talent in a series of reportages: during the Civil War from 1862 to 1865; with the US Geological and Geographical Survey under the direction of Clarence King from 1867 to 1870; on the Selfridge Expedition to Panama in 1871; and on a number of other arduous missions. Considered the best expeditionary photographer of his time, in 1880 he became the official photographer of the US Treasury because of the quality of his work. Two years later, he died of tuberculosis. Thanks to Ansel Adams, his work, which had fallen into oblivion, was rediscovered and appreciated by the general public more than sixty years after his death.

Maurice Prendergast
St. John's, Newfoundland, 1858 – New York, 1924
While Maurice Prendergast was studying in Paris at the Académie Colarossi and the Académie Julian, he met the Canadian painter James Wilson Morrice, who introduced him to avant-garde artists. The emerging group The Eight took him in, and he exhibited with them at the Macbeth Gallery in New York in 1908. He presented seven paintings at the illustrious 1913 Armory Show, which he also helped organize. Prendergast first worked in watercolour, then switched to oil painting. His style is characterized by a reliance on intense colours and depthless, mosaic-like superimposed vertical planes. His Post-Impressionist painting is regarded as a sociological testimony.

Henry Lathrop Rand
1862 – 1945
An amateur photographer from the Boston area, Henry Lathrop Rand spent his summers in Southwest Harbor, Maine. He made portraits of Victorian women in formal dress, photographed steamships and sailing vessels and images of New England, in particular on Mount Desert Island, a place he was particularly fond of. In 1974 his widow Dorothy bequeathed about fourteen hundred of his photographs to the Southwest Harbor Library.

Jacob August Riis
Ribe, Denmark, 1849 – Barre, Massachusetts, 1914
Jacob Riis arrived in New York in 1870, at the height of a political and social crisis. He was unemployed and experienced some difficult months living in the poorhouse. He became a police photographer and a photographer for the New York Tribune, producing reportages on the life of the underprivileged. His admiration for Charles Dickens and the influence of his journalist father prompted him to publish a book entitled How the Other Half Lives in 1890. Its intention was to reveal to the middle and upper classes the existence of poverty in the United States. After it was published, Theodore Roosevelt, then the chief of police of New York, closed the poorhouses. A pioneer of photography, Riis was among the first to use the flash.

Andrew Joseph Russell
Walpole, New Hampshire, 1830 – Brooklyn, 1902
The versatile Andrew Joseph Russell was an engineer photographer for the Military Railroad Construction Corps, which oversaw the layout of the American railroads and battlefields. He was hired by the Union Army during the Civil War, then by the Union Pacific Railroad, for which he took pictures of the construction of the transcontinental railway. In 1869, he published an album of fifty photographs compiled from series of portraits of Native Americans and scenes of California. His photograph showing locomotives face to face before the crowd at the meeting of the rails at Promontory Point, Utah, on May 10, 1869, ensured his fame.

John Singer Sargent
Florence, 1856 – London, 1925
Born in Italy of American parents, John Singer Sargent was a pupil of Carolus-Duran and Léon Bonnat at the École des beaux-arts in Paris. During his many trips to Spain, he discovered the rich complexity of the work of Diego Velázquez. Sargent painted alla prima and exhibited regularly at the Paris Salon, where he presented his famous Madame X in 1884. Reaction to it was so negative that he decided to go to London, where he received plentiful portrait commissions. He travelled throughout Europe, the Middle East and America and made more than 900 oil paintings and 2,000 watercolours in all. His entire oeuvre follows the chronology of his travels.

Edward Steichen
Bivange, Luxembourg, 1879 – West Redding, Connecticut, 1973
Arriving in Michigan at the age of two, Edward Steichen began his artistic career as a painter, then branched out into photography in 1902, when he settled in Paris. He came in contact with Henri Matisse and Auguste Rodin and, with them, took part in exhibitions at Gallery 291 in New York, run by his friend Alfred Stieglitz. At the time, he was thought of as a cultural intermediary between Europe and the United States. At first a Pictorialist, he joined the Photo-Secession movement and was involved with the founding of the magazine Camera Work. During World War I, he made documentary photographs for the United States government. Eventually, he began to doing fashion photography for Vogue and Vanity Fair. From 1947 to 1962, he was the curator of photography at the Museum of Modern Art in New York.

Alfred Stieglitz
Hoboken, New Jersey, 1864 – New York, 1946
Of German descent, Alfred Stieglitz took up photography while studying engineering and chemistry in Berlin. Fascinated by the possibilities of the medium, he experimented in and out of the darkroom, day and night, thus contributing to the development of Pictorialism. In 1902, he founded the Photo-Secession group with friends and mounted an exhibition that asserted photography's place among the arts. He ran Gallery 291 in New York, a springboard for many artists, including his future wife, Georgia O'Keeffe, and the European avant-garde. In fact, it was Stieglitz who introduced Picasso, Braque, Matisse and Cézanne to the American public in 1908.

Paul Strand
New York, 1890 – Orgeval, France, 1976
From a family of Jewish Czechoslovakian immigrants, Paul Strand first became interested in photography in the early 1910s, after a visit to Gallery 291 (headed by Alfred Stieglitz). Ahead of his time, he used the camera as a tool for social reform, largely motivated in this by the Cubist movement. Stieglitz devoted an exhibition and the two last issues of Camera Work to him. Strand produced a series of abstract still lifes in the late 1910s, then made documentary films in Russia and Mexico and introduced Henri Cartier-Bresson to filmmaking.

Karl Struss
New York, 1886 – New York, 1981
Karl Struss learned photography under Clarence H. White at Columbia University and shared a studio with him. His

pictures were published in newspapers and in magazines like *Vogue* and *Harper's Bazaar*. He defended his work as a fashion photographer, saying that it was a form of Pictorialism, and joined the Photo-Secession group. He pursued a career in Hollywood and was hired as a cameraman by Cecil B. DeMille. He took part in shooting many films, including *Dr. Jekyll and Mr. Hyde* and *The Great Dictator*. He was also a pioneer of 3-D cinema. Struss was nominated for four Academy Awards and won an Oscar for best director of photography for *Sunrise*, a full-length feature from 1927.

Trager and Kuhn

George Trager and Fred Kuhn bought the Bon Ton Art Gallery, where Kuhn devoted himself to photography. He often went to the Pine Ridge reservation and made many portraits of Sioux chiefs. Kuhn produced two well-known series: "Ghost Dance," in 1890, and one on the Battle of Wounded Knee.

John Henry Twachtman
Cincinnati, Ohio, 1853 – Gloucester, Massachusetts, 1902

A painter and printmaker, John Henry Twachtman was trained in painting in Paris and Munich and visited Italy with Frank Duveneck and William Merritt Chase. When he returned to the United States in 1886, he went to Chicago and worked on the cyclorama of the Battle of Gettysburg. With Julian Alden Weir, he painted and exhibited Impressionist landscapes using bright colours applied and mixed directly on the canvas. One of the most innovative artists of his time, Twachtman belonged to The Ten and exhibited with the group in 1898.

Carleton E. Watkins
Oneonta, New York, 1829 – Imola, California, 1916

Carleton E. Watkins began making photographs in 1858, when he discovered the mines of the Sierra Nevada and the landscapes of Yosemite Valley. He took part in many geological and topographical expeditions in the West on behalf of the United States government, including those of Clarence King. He illustrated *Yosemite Book*, published by Josiah Dwight Whitney. Watkins was the first to use large-format "mammoth plates" to capture the sublime panoramas and rocky formations of the region. Commercially successful in his lifetime, he received important commissions from industry. However, he spent lavishly and was obliged to sell his photographs and renounce his rights to them. The majority of his negatives were destroyed in the San Francisco earthquake of 1906.

John Ferguson Weir
West Point, New York, 1841 – Providence, Rhode Island, 1926

The American painter, sculptor and writer John Ferguson Weir took his early art training at the National Academy in New York under his father, Robert Walter Weir. In 1861, he opened his own studio in New York. He became a member of the National Academy and later directed the Yale University School of Fine Arts. Often in the shadow of his brother and father, John distinguished himself with notable sculptures, like that of Yale president Theodore D. Woolsey, and by writing a biography of John Trumbull.

Julian Alden Weir
West Point, New York, 1852 – New York, 1919

Julian Alden Weir, a landscape painter associated with the Hudson River School, studied in Paris with his father, the painter Robert Walter Weir, and Jean-Léon Gérôme. He was unsurpassed in his use of gradual shading of light and received an honourable mention at the Paris Salon of 1880. When he returned to the United States, his encounter with Japanese art led him to explore pastel, printmaking and engraving. He became a friend of the collector Duncan Phillips and then founded the Society of American Artists and

the Ten American Painters (The Ten). From 1905 to 1917, he was president of the National Academy in New York.

Clarence H. White
West Carlisle, Ohio, 1871 – Mexico City, 1925

An amateur photographer, Clarence H. White came to the attention of Alfred Stieglitz in 1898, and with him inaugurated the Photo-Secession. White, an accomplished portraitist, is known for his skilful effects of light. In 1906, he moved to New York and taught Columbia University's first photography course the following year. Cofounder and first president of Pictorial Photographers of America, he established his own school, the Clarence H. White School of Modern Photography.

Thomas Worthington Whittredge
Springfield, Ohio, 1820 – Summit, New Jersey, 1910

Thomas Worthington Whittredge learned to paint at the prestigious Düsseldorf Academy in 1849. He spent the next ten years in Europe, where he met Albert Bierstadt and Sanford Gifford, two fellow members of the Hudson River School. In 1865, he travelled to the Rocky Mountains and the Great Plains with Gifford and John Frederick Kensett, which was crucial to his approach and his career. He admired the linear beauty of the plains and the immensity of the mountains, visited Native American encampments and lingered over the flora and fauna—all of which contributed to his most influential works.

Canadian Artists

Frederick Marlett Bell-Smith
London, 1846 – Toronto, 1923

Frederick Marlett Bell-Smith studied painting at the South Kensington Art School in London and the Académie Colarossi in Paris. In 1866, he immigrated to Montreal. He worked in a photography studio and illustrated Canadian publications. At the same time, he painted landscapes, portraits and historical subjects in oil and watercolour. A founding member of the Art Association of Montreal, he exhibited there for the first time in 1868. Queen Victoria commissioned a portrait from him in 1897, on the occasion of her diamond jubilee. This commission marked a turning point in the artist's career.

William Brymner
Greenock, Scotland, 1855 – Wallasey, England, 1925

William Brymner, a painter and draftsman, arrived in Canada at the age of two. In 1878, he studied at the Académie Julian and the Académie Carolus-Duran in Paris to learn the latest techniques. From 1886 to 1921, this outstanding pedagogue made use of the aesthetic ideas he had acquired in Europe and taught at the Art Association of Montreal's Art School. Clarence Gagnon, Alexander Young Jackson and several members of the Beaver Hall Group were among his students. In the summer of 1886, he received a free pass from the Canadian Pacific Railway and began painting Native subjects as well as large-format landscapes. From 1909 to 1917, he was the president of the Royal Canadian Academy of Arts. Highly regarded by his peers, Brymner fostered freedom of expression and was involved in a number of Canadian artistic and teaching institutions.

Emily Carr
Victoria, 1871 – Victoria, 1945

A painter, potter and writer, Emily Carr was from a middle-class family and attended the California School of Art in San Francisco and the Académie Colarossi in Paris. In 1911, she returned to Canada and successfully exhibited the Fauvist-influenced works she had painted in Europe. She then became interested in the ways of the Aboriginal people, a subject that

proved unpopular. Her fortunes changed in 1927, when the ethnologist Marius Barbeau discovered her work. Carr showed twenty-six paintings at the National Gallery of Canada, where she met Lawren Stewart Harris, who encouraged her to continue in this direction. The last years of her life were very prolific. She used new mediums and explored abstraction. She suffered a first heart attack in 1937, and declining health gradually forced her to discontinue painting, and she wrote autobiographical short stories that were published and read on the radio.

Maurice Galbraith Cullen
St. John's, Newfoundland, 1866 – Chambly, Quebec, 1934

Maurice Galbraith Cullen took sculpture lessons in Montreal from Louis-Philippe Hébert, on whose advice he went to Paris in 1895 to perfect his art. There, he became enamoured of painting. In the company of James Wilson Morrice, he interpreted the French countryside and created winter scenes in an Impressionist style. In 1918, he became a captain and an official War Artist for the Canadian Forces. Fascinated by the beauty of nature and the effects of light on snow, Cullen was a pioneer of Canadian landscape painting. Through his work and teaching, he paved the way for the Group of Seven and many other artists.

Aaron Allan Edson
Stanbridge, Quebec, 1846 – Glen Sutton, Quebec, 1888

Of American descent, Aaron Allan Edson trained in the fine arts in London, Paris and Philadelphia. His distinctive style shows influences from the Hudson River School and contemporary British and French art. In Canada, he regularly exhibited wilderness landscapes of the Quebec Eastern Townships. The Marquis of Lorne and his wife, Princess Louise, purchased some of his paintings and even gave two to Queen Victoria. Edson was a founding member of the Ontario Society of Artists and the Royal Canadian Academy of Arts.

John Arthur Fraser
London, 1838 – New York, 1898

John Arthur Fraser immigrated to Canada in 1858. Soon after he arrived, he worked at the William Notman photography studio in Montreal. He became Notman's partner, and Notman-Fraser opened branches in Ottawa and Toronto. Fraser visited the Rockies. He produced many watercolours and some oils of western Canada for the Canadian Pacific Railway. In addition, he took part in the founding of the Society of Canadian Artists and taught at the Ontario School of Art. Some of his students, Horatio Walker and Henry Sandham for example, became well known.

Clarence Gagnon
Montreal, 1881 – Montreal, 1942

Clarence Gagnon acquired his art training under William Brymner at the Art Association of Montreal and from Jean-Paul Laurens at the Académie Julian in Paris. He travelled widely in Europe and spent time with James Wilson Morrice, Alexander Young Jackson and Edwin Holgate. The style of the Barbizon School and Fauvism is noticeable in his paintings. He had an affinity for nature and the simplicity of rural life and was especially fond of the Charlevoix region. His highly coloured style was not always appreciated, which prompted him to take up illustration. He illustrated Louis Hémon's novel *Maria Chapdelaine*, using various mediums to do so such as etching.

Lawren Stewart Harris
Brantford, Ontario, 1885 – Vancouver, 1970

Between 1904 and 1908, Lawren Stewart Harris studied drawing and painting in Berlin. He took advantage of this transatlantic sojourn to visit various European and Middle Eastern countries. When he returned to Toronto, he met J. E. H. MacDonald, with whom he later founded the Group

of Seven. In January 1913, the two saw many northern landscapes at the *Exhibition of Contemporary Scandinavian Art* in Buffalo, New York. The experience had a profound effect on their painting, which thereafter focused on Canadian reality. A series of more abstract winter landscapes grew out of this approach, attesting in particular to Harris's spiritual and anthrophilosophical quest. From a well-to-do family, he contributed financially to the creation of the Studio Building in Toronto and assisted many needy artists. In 1930, he travelled in the Arctic with A. Y. Jackson. Something of a rarity, two retrospectives of his work were held during his lifetime.

Alexander Henderson
Edinburgh, Scotland, 1831 – Montreal, 1913
Alexander Henderson settled in Canada in 1855. Soon after he arrived, he published his first photographs, and ten years later he opened a studio. The railway companies commissioned pictures of their facilities, from Montreal to Ottawa to Rogers Pass in British Columbia. In his early career, Henderson developed a somewhat Romantic style in the British landscape tradition during visits to Niagara Falls with William Notman. Later, his urban compositions became quite architectural. He won a silver medal at the 1878 Paris World's Fair.

Frances Anne Hopkins, née Beechey
London, 1838 – London, 1918
Married to the secretary of the governor of the Hudson's Bay Company, Frances Anne Hopkins lived in Montreal from 1858 to 1870. With her husband and his colleagues, she went on canoe outings all over the country, and so the fur trade, voyageurs and Native people figure in her work. She took part in the exhibition held by the Art Association of Montreal in 1870, then left for Great Britain, where her paintings were shown frequently.

Charles George Horetzky
Edinburgh, Scotland, 1838 – Toronto, 1900
An engineer and photographer, Charles George Horetzky left Scotland at the age of sixteen to explore the gold mining regions of Australia and then went to Canada to work for the Hudson's Bay Company. In 1871, he was hired by the Canadian Pacific Railway to make surveying photographs and record the topography of unexplored regions in northern British Columbia and the Northwest Territories.

Alexander Young Jackson
Montreal, 1882 – Kleinburg, Ontario, 1974
A. Y. Jackson studied at the Art Institute of Chicago and the Académie Julian in Paris. When he returned to Canada in 1913, he met the members of the future Group of Seven. The following year, in the Fauvist manner, he painted one of his first landscapes, *Terre Sauvage*, at the Studio Building in Toronto. He enlisted in 1915, was wounded in 1916 and became a War Artist, a function he performed until 1918. When he returned from the War, he painted in the Algoma region, Georgian Bay, the Rockies and even the Arctic, where he went twice. In 1933, after the dissolution of the Group of Seven, he took part in the founding of the Canadian Group of Painters, which included more than forty artists.

Otto Reinhold Jacobi
**Königsberg, East Prussia, 1812 –
Ardoch, North Dakota, 1901**
Trained at the Düsseldorf Academy from 1833 to 1837, Otto Reinhold Jacobi was the official painter to the Prussian royal family. Passing through Canada in 1860, the Prince of Wales invited him to paint Shawinigan Falls. Jacobi then decided to settle in Montreal. The renowned artist joined Notman's studio and sometimes based his works on Notman's photos. Jacobi had a predilection for waterfalls and autumn landscapes. President of the Royal Canadian Academy of Arts from 1890 to 1893, he became one of the first watercolour teachers at the Ontario School of Art.

Charles William Jefferys
Rochester, England, 1869 – Toronto, 1951
A renowned illustrator for the *Toronto Star*, the *Globe* and the *New York Herald*, Charles William Jefferys was unsurpassed as a watercolourist. He is recognized for his images of the prairies and his recreations of pivotal moments in Canadian history. For the fiftieth anniversary of Confederation, he painted two masterful 3-by-4.3-metre murals, one for the Chateau Laurier, in Ottawa, and the other at Manoir Richelieu, in La Malbaie. He declined to join the Group of Seven and taught architecture at the University of Toronto.

Cornelius Krieghoff
Amsterdam, 1815 – Chicago, 1872
After studying painting at the Düsseldorf Academy, Krieghoff arrived in New York as a soldier in 1837. There, he met his future wife, Émilie Gauthier, with whom he settled in Quebec in 1840. An accomplished colourist who worked without making sketches or preparatory drawings, he painted outdoor scenes of popular life peopled with rural folk and Native people and tinged with humour. He was successful during his lifetime, and in Quebec City he briefly taught others how to imitate his works.

Ernest Lawson
Halifax, 1873 – Miami, 1939
Ernest Lawson studied at the Art Students League in New York. He was also taught by John Henry Twachtman and Julian Alden Weir before pursuing his training in Paris at the Académie Julian. His fascination with effects of light comes through in his compositions—urban pictures in an Impressionist idiom. Lawson took part in the Armory Show in 1913. He was associated with The Eight and the Ashcan School, with whom he exhibited.

Ozias Leduc
Saint-Hilaire, Quebec, 1864 – Saint-Hyacinthe, Quebec, 1955
Ozias Leduc was one of Quebec's most prolific church decorators and painted at least thirty-one murals. His early training as a painter came as an assistant to the muralists Luigi Capello and Adolphe Rho. In 1897, he went to Paris to study, along with Marc-Aurèle de Foy Suzor-Coté. Thereafter, he showed a mitigated realism and a gentler, more polished manner. After a decisive meeting with Maurice Denis, he created church and easel paintings infused with a kind of symbolism. His *trompe l'oeil* still lifes and landscapes, considered important works, are mystical interpretations of reality. Leduc did not adhere to any trend. Among the projects he worked on are the decoration of the baptistery of the Notre-Dame Basilica in Montreal and the Church of Notre-Dame in Shawinigan-Sud, which he supervised until the age of ninety. From 1920 to 1932, he taught Paul-Émile Borduas.

James Edward Hervey MacDonald
Durham, England, 1873 – Toronto, 1932
James Edward Hervey MacDonald's training as a graphic artist enabled him to develop a calligraphic style. Exploiting a rich raw and dark palette, his paintings sometimes evoke Japanese art, which he especially appreciated. With Lawren Stewart Harris, he made many stays north of Lake Superior and in Algonquin Park. A founding member of the Group of Seven and the Canadian Group of Painters, at the end of his life he taught at the Ontario College of Arts.

David Milne
Burgoyne, Ontario, 1882 – Bancroft, Ontario, 1953
Inspired by Matisse and Fauvism, David Milne worked in watercolours and developed his own technique of drypoint colour engraving. He exhibited five paintings at the Armory Show in 1913. In 1918, he became a War Artist in the region of Vimy-Arras and recorded the horrors of battle in 107 watercolours. Throughout his career, he was supported by his patrons Alice and Vincent Massey.

James Wilson Morrice
Montreal, 1865 – Tunis, 1924
From an upper-middle-class family, in 1895 James Wilson Morrice undertook a series of long expeditions in Africa, Europe and the West Indies, punctuated with visits to Montreal. After a brief stint at the Académie Julian in Paris, he became friends with Maurice Prendergast and Robert Henri. He turned to modernism and was influenced by, among others, his friend Henri Matisse, with whom he went to Tangier. The Nabi sensitivity apparent in his works made Morrice the first Canadian to be exhibited at the Venice Biennale.

William Notman
Paisley, Scotland, 1826 – Montreal, 1891
In 1856, when William Notman arrived in Montreal to open his studio, he was already skilled with the daguerreotype and had taken courses in painting and drawing as an amateur in Scotland. With his gift for portraiture and unique talent for capturing the beauty of the Canadian landscape, he developed the market for painted and composite photographs. Three of his children became his partners, as did the photographer John Arthur Fraser. Many renowned artists worked for him, which enabled him to open twenty-six studios in North America. The Notman collection of 400,000 photographs is now kept at the McCord Museum of Canadian History in Montreal.

Lucius O'Brien
Shanty Bay, Ontario, 1832 – Toronto, 1899
After a career as an engineer, Lucius O'Brien began painting in 1872 and joined the Ontario Society of Artists. He was among the first to explore the Rockies and the Canadian West and transcribe their beauty onto canvas. One of the greatest landscape painters of his time, he was influenced by the Hudson River School and Luminism. Moreover, he is often compared to Albert Bierstadt. O'Brien was a founding member and the first president of the Royal Canadian Academy of Arts.

William Raphael
Nakel, Prussia, 1833 – Montreal, 1914
William Raphael studied at the prestigious School of Art in Berlin. He settled in Montreal in 1857 and was hired by the Notman Studio all the while devoting himself to painting. He depicted the everyday life of the people in genre scenes similar to those of Cornelius Krieghoff and executed the greater part of his production in Quebec. He was involved in various artists' associations and also taught in Montreal area schools.

Henry John Sandham
Montreal, 1842 – London, 1910
As an adolescent, Henry John Sandham assisted John Arthur Fraser and Otto Reinhold Jacobi in Notman's Montreal studio, becoming a partner after Fraser left for Toronto. He perfected his painting technique and his method of making large-format composite photographic montages. In the wake of the landscape movement typical of the Confederation era, he took part in the Paris and Chicago World's Fairs and won several prizes. A founding member of the Royal Canadian Academy of Arts, Sandham made various trips in America and Europe, where he illustrated many publications.

Marc-Aurèle de Foy Suzor-Coté
Arthabaska, Quebec, 1869 – Daytona Beach, Florida, 1937
A painter, sculptor and illustrator who trained at the École des beaux-arts, Marc-Aurèle de Foy Suzor-Coté went to Paris to study at the Académie Julian and Académie Colarossi, returning to Quebec in 1907. He set aside the realist academic style for a Divisionist technique, and rejected history painting in favour of nature, which he depicted in an Impressionist style. A virtuoso

with colour, oil and pastel, he was afflicted with paralysis in 1927, which brought his career to an abrupt end.

Tom Thomson
Claremont, Ontario, 1877 – Canoe Lake, Ontario, 1917
A self-taught painter and draftsman, Tom Thomson met the members of the future Group of Seven while working as a printmaker at Grip Ltd. in Toronto. With the encouragement of J.E.H. MacDonald and the support of a patron, Dr. MacCallum, in 1912 he began painting seriously. Thomson later shared a studio with A. Y. Jackson at the Studio Building in Toronto. His fascination with the Algonquin Park region and the diversity of its landscapes gave rise to the properly Canadian pictorial representation that he ardently wished to foster. Though never a member of the Group of Seven, he is closely associated with it. When he drowned in 1917, he left behind highly colourful paintings typical of northern Ontario, of an enormous heritage value.

Ernest Percyval Tudor-Hart
Montreal, 1873 – Montreal, 1954
As a student at the École des beaux-arts in Paris, the painter and sculptor Ernest Percyval Tudor-Hart exhibited at the Paris Salon, the Royal Academy of Arts in London and the Art Association of Montreal. He lived in London for nearly twenty years, restoring Old Master paintings.

Frederick Arthur Verner
Sheridan, Ontario, 1836 – London, 1928
After studying at the South Kensington Art School in London, Frederick Arthur Verner returned to Canada in 1862 and became a photograph colourist in the Notman Studio. He later visited the plains of the Canadian Northwest, painting portraits of the First Nations chiefs and Romantic representations of the fauna that were well received. Meeting his idol, the painter Paul Kane, deeply influenced his work. Kept for the most part in London, the majority of his paintings were destroyed in the bombing of World War II.

Horatio Walker
Listowel, Ontario, 1858 – Sainte-Pétronille, Quebec, 1938
Horatio Walker, a painter and photographer, worked at the Notman-Fraser Studio in Toronto from 1873 to 1876. His bucolic approach, influenced particularly by the Barbizon School, earned him the nickname "the American Millet." The most highly rated living painter of his time, he spent winters in New York and summers on Île d'Orléans, near Quebec City. He succeeded Homer Watson as president of the Canadian Art Club and won many prestigious prizes during his career.

Homer Ransford Watson
Doon, Ontario, 1855 – Doon, 1936
Homer Ransford Watson started painting by copying famous works. Encouraged by his meeting with George Inness in New York in 1876, he began to paint professionally in the style of the Hudson River School, Barbizon School and European masters he had seen at the Philadelphia World's Fair. His depictions of life in the Ontario countryside transpose the art of Constable to Canadian reality. At the end of the century, he counted Queen Victoria among his clients, broke sales records, gained international recognition and lived well from his work—a rare occurrence for the period.

Charles Jones Way
Dartmouth, England, 1835 – Lausanne, Switzerland, 1919
A student at the South Kensington Art School in London, Charles Jones Way married a Canadian and settled in Montreal in 1858. The creator of many watercolours in a Romantic style, in 1898 he made a trip to the Rockies during which he painted several paintings commissioned by the Canadian Pacific Railway. Despite his infrequent stays in Canada, he actively participated in the arts milieu. He was elected president of the Canadian Society of Artists and was a founding member of the Royal Canadian Academy of Arts.

Prepared by Thierry-Maxime Loriot

List of Works

List in alphabetical order of artists' names and catalogue numbers.
Ⓜ Montreal only
Ⓥ Vancouver only

Benjamin Baltzly

16 [ill. p. 54]
Cascade on the Hammond (Garnet) River
1871
Albumen print
19.3 x 23.8 cm
Library and Archives Canada, Ottawa
Inv. 1936-272

30 [ill. p. 69]
Forest Trees on the North Thompson River, 165 Miles above Kamloops
1871
Albumen print
23.6 x 18.3 cm
Library and Archives Canada, Ottawa
Inv. PA-201666

35 [ill. p. 73]
Selkirk Mountains as Seen from the Top of the Mountains near the Confluence of the Blue and North Thompson Rivers
1871
Albumen print
17.2 x 23.2 cm
Library and Archives Canada, Ottawa
Inv. 1936-272

George Barnard

53 [ill. p. 109]
Rebel Works in Front of Atlanta, Georgia, No. 1
1864
Albumen print
25.6 x 35.6 cm
George Eastman House, Rochester, New York
Museum purchase; ex-collection Philip Medicus
Inv. 1981:0001:0039

84 [ill. p. 155]
Trestle Bridge at Whiteside
About 1864
Albumen print
25.5 x 35.7 cm
George Eastman House, Rochester, New York
Museum purchase; ex-collection Philip Medicus
Inv. 1981:0001:0004

Frederick Marlett Bell-Smith

39 [ill. p. 76]
Coming Storm in the Rockies
1914
Oil on canvas
77 x 51 cm
Collection Power Corporation of Canada

Albert Bierstadt

18 [ill. p. 56]
Cho-looke, the Yosemite Fall
1864
Oil on canvas
87 x 68.9 cm
Timken Museum of Art, San Diego
The Putnam Foundation
Inv. 1966:001

23 [ill. p. 62]
Moat Mountain, Intervale, New Hampshire
About 1862
Oil on paper mounted on canvas
48.6 x 66.4 cm
Currier Museum of Art, Manchester, New Hampshire
Museum purchase, Currier Funds
Inv. 1947.3

43 [ill. p. 81]
Passing Storm over the Sierra Nevadas
1870
Oil on canvas
92.7 x 139.7 cm
San Antonio Museum of Art
Purchased with funds from the Robert J. and Helen C. Kleberg Foundation
Inv. 85.94

47 [ill. p. 85]
Yosemite Valley
1868
Oil on canvas
137.8 x 184.2 cm
Oakland Museum of California
Gift of Miss Marguerite Laird in memory of Mr. and Mrs. P. W. Laird
Inv. A64.46

William Bradford

79 [ill. p. 148–149]
An Incident of Whaling
Undated
Oil on canvas
55.9 x 91.4 cm
The Metropolitan Museum of Art, New York
Bequest of DeLancy Thorn Grant, in memory of her mother, Louise Floyd-Jones Thorn, 1990
Inv. 1990.197.1

William Brymner

122 [ill. p. 212]
Champ-de-Mars, Winter
1892

Oil on canvas
74.9 x 101.6 cm
The Montreal Museum of Fine Arts
Mrs. R. MacD. Paterson Bequest (R. B. Angus Collection)
Inv. 1949.1008

130 [ill. p. 220]
Summer Landscape
1910
Oil on canvas
74.3 x 102.6 cm
The Montreal Museum of Fine Arts
Gift of the Reverend and Mrs. Sydenham B. Lindsay
Inv. 1968.1591

Emily Carr

68 [ill. p. 124]
Totem by the Ghost Rock
1912
Oil on canvas
90.2 x 114.7 cm
Vancouver Art Gallery
Emily Carr Trust
Inv. VAG 42.3.10

69 [ill. p. 125, not exhibited]
Tanoo, Queen Charlotte Islands
1913
Oil on canvas
109.2 x 167.7 cm
British Columbia Archives Collection, Royal BC Museum Corporation, Victoria
Inv. PDP02145

70 [ill. p. 126]
Indian War Canoe (Alert Bay)
1912
Oil on panel
65 x 95.5 cm
The Montreal Museum of Fine Arts
Purchase, gift of A. Sidney Dawes
Inv. 1948.995

141 [ill. p. 231]
Vancouver Street
1912–1913
Oil on cardboard
18.4 x 22.9 cm
Private collection

William Merritt Chase

125 [ill. p. 215]
Morning at Breakwater, Shinnecock
About 1897
Oil on canvas
101.6 x 127 cm
Terra Foundation for American Art, Daniel J. Terra Collection, Chicago
Inv. 1999.30

Frederic Edwin Church

1 [ill. p. 39]
Niagara Falls, from the American Side
1892

1867
Oil on canvas
257.5 x 227.3 cm
The National Gallery of Scotland, Edinburgh
Inv. NG 799

Alvin Langdon Coburn

9 [ill. p. 47]
Niagara Falls
About 1910
Platinum print
40.8 x 30.1 cm
George Eastman House, Rochester, New York
Gift of Alvin Langdon Coburn
Inv. 1967:0158:0004

50 [ill. p. 88]
The Amphitheatre, Grand Canyon
1912
Platinum print
32.8 x 41 cm
George Eastman House, Rochester, New York
Gift of Alvin Langdon Coburn
Inv. 1967:0157:0073

130 [ill. p. 291]
The Great Temple, Grand Canyon
1911
Gum platinum print
32.8 x 41 cm
George Eastman House, Rochester, New York
Gift of Alvin Langdon Coburn
Inv. 1977:0114:0028

132 [ill. p. 293]
Grand Canyon
About 1912
Gum platinum print
40.9 x 31.4 cm
George Eastman House, Rochester, New York
Gift of Alvin Langdon Coburn
Inv. 1967:0157:0030

Colin Campbell Cooper

159 [ill. p. 264]
Main Street Bridge, Rochester
1908
Oil on canvas
66.7 x 91.4 cm
Memorial Art Gallery of the University of Rochester, New York
Gift of Mr. Hiram W. Sibley
Inv. 26.20

Jasper Francis Cropsey

85 [ill. p. 156]
Study for Starrucca Viaduct—Autumn
Mid-1850s–early 1860s
Oil on canvas
45.7 x 30.5 cm
The Newington-Cropsey Foundation, Hastings-on-Hudson, New York
Inv. 455

Maurice Galbraith Cullen

151 [ill. p. 256]
Wolfe's Cove
1904
Oil on canvas
144.6 x 176.2 cm
Musée national des beaux-arts du Québec, Quebec City
Inv. 49.75

152 [ill. p. 257]
Twilight, Dufferin Terrace, Quebec City
1905
Oil on canvas
68.6 x 91.2 cm
Art Gallery of Windsor
Purchased by subscription by members of the Windsor medical profession, 1961
Inv. 1961.025

154 [ill. p. 259]
St. James Cathedral, Dominion Square, Montreal
About 1909–1912
Oil on canvas
76.8 x 102.2 cm
The Beaverbrook Art Gallery, Fredericton, New Brunswick
Gift of Miss Olive Hosmer
Inv. 1959.350

156 [ill. p. 261]
Montreal Harbour
1915
Oil on canvas
115 x 171 cm
Musée national des beaux-arts du Québec, Quebec City
Inv. 34.114

Asahel Curtis

149 [ill. p. 254]
Denny Hill Regrade
About 1910
Collotype
18.7 x 23.7 cm
University of Washington Libraries, Special Collections Division, Seattle
Inv. UW 4812

Edward Sheriff Curtis

62 [ill. p. 118]
Flathead Camp on Jocko River, Reservation in Western Montana by the Rockie Mountains
1911
Photogravure no. 232, *The North American Indians*, supplementary portfolio to vol. 7
30 x 40 cm
Library and Archives Canada, Ottawa
Inv. 1966-122, PA-039371

63 [ill. p. 119]
[Sioux Warriors] at Sheep Mountain in the Badlands of Pine Ridge Reservations, South Dakota
1908
Photogravure no. 119,

The North American Indians, supplementary portfolio to vol. 3
29 x 40 cm
Library and Archives Canada, Ottawa
Inv. 1966-122, PA-039296

65 [ill. p. 121]
Mishongnovi Village Showing a Comprehensive View of This Middle Mesa Pueblo
1900
Photogravure no. 425, *The North American Indians*, supplementary portfolio to vol. 12
29 x 39 cm
Library and Archives Canada, Ottawa
Inv. 1966-122, PA-039512

66 [ill. p. 122]
A Mamalelekala Chief's Mortuary House
1914
Photogravure, *The North American Indians*, vol. 10, facing p. 52
14 x 19.2 cm
Library and Archives Canada, Ottawa
Inv. 1966-122

67 [ill. p. 123]
A Wishham Spearing Salmon with a Double Pointed Spear
1911
Photogravure no. 276, *The North American Indians*, supplementary portfolio to vol. 8
30 x 39.5 cm
Library and Archives Canada, Ottawa
Inv. 1966-122, PA-039410

Arthur Garfield Dove

137 Ⓜ [ill. p. 298]
Sun on the Lake
1938
Oil, wax and resin on canvas
56.2 x 91.4 cm
Museum of Fine Arts, Boston
Gift of William H. and Saundra B. Lane and Juliana Cheney Edwards Collection, Bequest of Robert J. Edwards and Gift of the Misses Hannah Marcy and Grace Edwards, by exchange
Inv. 1990.372

Robert S. Duncanson

102 [ill. p. 192–193]
View of the St. Anne's River
1870
Oil on canvas
54 x 101.9 cm
Saint Louis Art Museum
Museum purchase
Inv. 163:1966

John L. Dunmore and George Critcherson

under the supervision of William Bradford

76.2 x 104.8 cm
Corcoran Gallery of Art,
Washington
Gift of Mr. Cecil D.
Kaufmann
Inv. 66.34

George Inness

3 [ill. p. 46]
Niagara
1893
Oil on canvas
114.9 x 177.9 cm
Hirshhorn Museum and
Sculpture Garden,
Smithsonian Institution,
Washington
Gift of The Joseph H.
Hirshhorn Foundation,
1966
Inv. 66.2542

Alexander Young Jackson

137 [ill. p. 227]
*Early Spring, Emileville,
Quebec*
1913
Oil on canvas
63.5 x 82.5 cm
McMichael Canadian Art
Collection, Kleinburg,
Ontario
Gift of Dr. and Mrs. Max
Stern, Dominion Gallery,
Montreal
Inv. 1978.23

177 [ill. p. 288]
The Red Maple
1914
Oil on wood panel
21.6 x 26.9 cm
McMichael Canadian Art
Collection, Kleinburg,
Ontario
Gift of Mr. S. Walter Stewart
Inv. 1968.8.18

178 [ill. p. 289]
The Red Maple
1914
Oil on canvas
82 x 99.5 cm
National Gallery of Canada,
Ottawa
Inv. 1038

183 [ill. p. 294]
Terre Sauvage
1913
Oil on canvas
128.8 x 154.4 cm
National Gallery of Canada,
Ottawa
Inv. 4351

William Henry Jackson

34 [ill. p. 72]
*The Upper Twin Lake,
Sawatch Range*
1873
Albumen print
20.6 x 33.2 cm
George Eastman House,
Rochester, New York
Museum purchase,

ex-collection Charles Carruth
Inv. 1981:2242:0067

40 [ill. p. 77]
*Pike's Peak from the Garden
of the Gods*
About 1880
Albumen print
53.3 x 43 cm
George Eastman House,
Rochester, New York
Gift of Harvard University
Inv. 1981:2248:0003

41 [ill. p. 78–79]
*Pike's Peak from the Garden
of the Gods*
1888
Albumen print
52.1 x 178.9 cm
San Francisco Museum
of Modern Art
Purchased through a gift of
the Judy Kay Memorial Fund
Inv. 96.182

90 [ill. p. 161]
*Canyon of the Rio Las Animas,
W. H. J. and Co., Denver*
1882
W. H. Jackson sample album,
Colorado Book, vol. 8, no. 2
Albumen print mounted
on album page
41 x 53 cm
Denver Public Library,
Western History Collection
Inv. WHJ-1630

Otto Reinhold Jacobi

11 [ill. p. 49,
not exhibited]
Falls of St. Anne, Quebec
1865
Oil on canvas
76.2 x 58.8 cm
Art Gallery of Ontario,
Toronto
Gift of Thomas Jenkins,
Toronto, 1927
Inv. 884

13 [ill. p. 51]
The Montmorency River
1860
Oil on canvas
41 x 49 cm
Musée national des beaux-
arts du Québec, Quebec City
Inv. 36.39

Charles William Jefferys

111 [ill. p. 199]
Wheat Stacks on the Prairies
1907
Oil on canvas
62 x 91 cm
The Government of Ontario
Art Collection, Archives of
Ontario, Toronto
Inv. 619864

Eastman Johnson

54 [ill. p. 110,
not exhibited]
*Union Soldiers Accepting
a Drink*

About 1865
Oil on canvas
44.5 x 54.6 cm
Carnegie Museum of Art,
Pittsburgh
Heinz Family Fund
Inv. 1996.45

121 [ill. p. 211]
Hollyhocks
1876
Oil on canvas
63.5 x 78.7 cm
New Britain Museum of
American Art, Connecticut
Harriet Russell Stanley Fund
Inv. 1946.7

John Frederick Kensett

[hors catalogue] Ⓥ
On the Hudson
1855
Oil on canvas
154.3 x 119.7 cm
The Montreal Museum
of Fine Arts
Gift of the family of
Dr. F. Wolferstan Thomas
Inv. 1918.91

32 Ⓜ [ill. p. 71]
Lake George
1869
Oil on canvas
112.1 x 168.6 cm
The Metropolitan Museum
of Art, New York
Bequest of Maria DeWitt
Jesup, from the collection
of her husband, Morris K.
Jesup, 1914
Inv. 15.30.61

124 [ill. p. 214,
not exhibited]
*View of the Beach at Beverly,
Massachusetts*
1860
Oil on canvas
36.2 x 61.6 cm
Santa Barbara Museum of Art
Gift of Mrs. Sterling Morton
to the Preston Morton
Collection
Inv. 1960.68

Rockwell Kent

134 [ill. p. 295]
Cranberrying, Monhegan
About 1907
Oil on canvas
71.3 x 97.2 cm
Terra Foundation for
American Art, Chicago
Gift of Mr. Dan Burne Jones
Inv. C1983.4

Darius Kinsey

91 [ill. p. 162–163]
*Four Logs from One Fir Tree
Scaled 27,000 Feet. Cherry
Valley Timber Co., Stillwater,
Washington*
About 1918
Gelatin silver print
34.5 x 34.5 cm

National Gallery of Canada,
Ottawa
Gift of Albert A. Shipton,
Penticton, British Columbia,
1983
Inv. 19775

93 [ill. p. 165]
*Three Loggers Felling
a Fir Tree, Washington*
1906
Gelatin silver print
26 x 33.8 cm
University of Washington
Libraries, Special Collections
Division, Seattle
Inv. PH Coll 126

94 [ill. p. 166]
*Cherry Valley Timber
Company, Stillwater*
1919
Gelatin silver print
33.6 x 26 cm
San Francisco Museum
of Modern Art
Accessions Committee Fund
Inv. 2007.162

Cornelius Krieghoff

56 [ill. p. 112]
*Chippewa Indians
at Lake Huron*
1864
Oil on canvas
64 x 90 cm
Collection Power
Corporation of Canada

78 [ill. p. 147]
*Royal Mail Crossing
the St. Lawrence*
About 1860
Oil on canvas
43.2 x 61 cm
Private collection

81 [ill. p. 152]
Indian Hunter and His Family
1856
Oil on canvas
45 x 66.6 cm
The Montreal Museum
of Fine Arts
Mary Fry Dawson Bequest
Inv. 1954.1104

Richard Hoe Lawrence and Jacob August Riis

161 [ill. p. 266]
Mullin's Alley, Cherry Hill
About 1890
Gelatin silver print
12.8 x 10.3 cm
Museum of the City
of New York
Inv. 2008.1.7

162 [ill. p. 267]
*Bandit's Roost,
59 1/2 Mulberry St.*
About 1890
Gelatin silver print
12.7 x 10.3 cm
Museum of the City
of New York
Inv. 2008.1.5

Ernest Lawson

142 [ill. p. 247,
not exhibited]
Hoboken Heights
1900–1910
Oil on canvas mounted
on masonite
95.3 x 120 cm
Norton Museum of Art,
West Palm Beach, Florida
Bequest of R. H. Norton
Inv. 53.105

Ozias Leduc

98 [ill. p. 170]
Day's End
1913
Oil on canvas
50.8 x 34.3 cm
The Montreal Museum
of Fine Arts
Purchase, Horsley and
Annie Townsend Bequest
Inv. 1960.1271

112 [ill. p. 200]
The Hayfield
1901
Oil on canvas
61 x 91.5 cm
Private collection

113 [ill. p. 201]
Fall Plowing
1901
Oil on canvas
62.2 x 92.2 cm
Musée national des beaux-
arts du Québec, Quebec City
Inv. 42.57

James Edward Hervey MacDonald

157 [ill. p. 262]
Tracks and Traffic
1912
Oil on canvas
71.1 x 101.6 cm
Art Gallery of Ontario,
Toronto
Gift of Walter C. Laidlaw,
Toronto, 1937
Inv. 2435

186 [ill. p. 297]
The Elements
1916
Oil on board
71.1 x 91.8 cm
Art Gallery of Ontario,
Toronto
Gift of Dr. Lorne Pierce,
Toronto, 1958, in memory
of Edith Chown Pierce
(1890–1954)
Inv. 57/45

Joseph Rusling Meeker

55 [ill. p. 111]
The Land of Evangeline
1874
Oil on canvas
84.1 x 114.6 cm
Saint Louis Art Museum
Gift of Mrs. Wright Prescott
Edgerton in memory of

Dr. and Mrs. W. T. Helmuth
by exchange
Inv. 163:1946

Willard Leroy Metcalf

129 [ill. p. 219]
Midsummer Shadows
1911
Oil on canvas
66.4 x 74 cm
Yale University Art Gallery,
New Haven, Connecticut
Robert W. Carle, B.A. 1897,
Fund
Inv. 1976.55

David Milne

176 [ill. p. 287]
The Boulder
1916
Oil on canvas
61.7 x 66.7 cm
The Winnipeg Art Gallery
Acquired with the assistance
of the Women's Committee
and The Winnipeg
Foundation
Inv. G-62-12

Thomas Moran

48 [ill. p. 86]
Mountain of the Holy Cross
1875
Oil on canvas
219.1 x 195.8 cm
Courtesy of the Autry
National Center of the
American West, Museum
of the American West
Collection, Los Angeles
Donated by Mr. and Mrs.
Gene Autry. Gilded frame,
1995, by Gold Leaf Studios,
Washington; frame
acquisition made possible
by Clyde E. Tritt with
generous underwriting from
Ambassador and Mrs. Glen
Holden
Inv. 91.221.49

49 [ill. p. 87]
Grand Canyon with Rainbow
1912
Oil on canvas
63.5 x 76.2 cm
Fine Arts Museums
of San Francisco
Gift of Mr. and Mrs. Robert F.
Gill through the Patrons
of Art and Music
Inv. 1981.89

James Wilson Morrice

123 [ill. p. 213]
*Ice Bridge over the
Saint-Charles River*
1908
Oil on canvas
60 x 80.6 cm
The Montreal Museum
of Fine Arts
Gift of James Wilson
Morrice Estate
Inv. 1925.333

132 [ill. p. 222]
The Terrace, Quebec
1910–1911
Oil on canvas
60.9 x 76.2 cm
Private collection

138 [ill. p. 228]
*The Old Holton House,
Montreal*
About 1908–1909
Oil on canvas
60.5 x 73.2 cm
The Montreal Museum
of Fine Arts
Purchase, John W.
Tempest Fund
Inv. 1915.129

Stanley J. Morrow

74 Ⓥ [ill. p. 130]
*Gen'l Custer's Last Stand,
Looking in Direction
of Ford and Indian Village*
About 1876
Stereoscopic photograph
10 x 17.8 cm
Library of Congress,
Prints and Photographs
Division, Washington
Inv. Lot 3038 (S) no. 34

75 Ⓥ [ill. p. 130]
*The Monument on Custer's
Hill, Containing the Bones
on the Field*
About 1876
Stereoscopic photograph
10 x 17.8 cm
Library of Congress,
Prints and Photographs
Division, Washington
Inv. Lot 3038 (S) no. 42

Eadweard James Muybridge

19 [ill. p. 57]
*Pi-Wi-Ack. Valley
of the Yosemite*
About 1870
Albumen print
54.6 x 43 cm
George Eastman House,
Rochester, New York
Gift of Harvard University
Inv. 1981:2377:0002

45 [ill. p. 83]
*Tenaya Canyon, Valley of the
Yosemite, from Union Point*
About 1868
Albumen print
42.7 x 54.3 cm
George Eastman House,
Rochester, New York
Gift of Virginia Adams
Inv. 1981:2375:0006

Herman F. Nielson

7 [ill. p. 45]
*Winter Landscape (View of
Niagara Falls in Winter)*
About 1885
Gelatin silver print
19.1 x 24.3 cm
The J. Paul Getty Museum,
Los Angeles
Inv. 84.XP.707.1

William Notman

3 [ill. p. 41]
*The Horseshoe Falls and
Terrapin Tower, Niagara,
Ontario*
1869
Silver salts on glass,
wet collodion process
(modern contact print from
original negative)
20 x 25 cm
McCord Museum, Montreal
Inv. I-36352

4 [ill. p. 42]
Niagara Falls
1869
Albumen print
33.2 x 41.9 cm
National Gallery of Canada,
Ottawa
Inv. 40109

10 [ill. p. 48]
St. Anne Falls, near Quebec
About 1860
Albumen print
23 x 28 cm
National Gallery of Canada,
Ottawa
Inv. 32408

12 [ill. p. 50]
*Natural Steps on the
Montmorency near Quebec*
About 1860
Albumen print
18.4 x 23 cm
National Gallery of Canada,
Ottawa
Inv. 32407

61 [ill. p. 117]
*Indian Camp, Blackfoot
Reserve, near Calgary, Alberta*
1889
Silver salts on glass, gelatin
dry plate process (modern
contact print from original
glass plate negative)
20 x 25 cm
McCord Museum, Montreal
Inv. View.2157

87 [ill. p. 158]
Glacier Range, from Summit
About 1887
Albumen print
43 x 54 cm
George Eastman House,
Rochester, New York
Gift of Alden Scott Boyer
Inv. 1981:1857:0003

89 [ill. p. 160]
*The Glacier, Mt. Sir Donald
and C.P.R. Hotel*
About 1887
Albumen print
37.5 x 50 cm
George Eastman House,
Rochester, New York
Gift of Alden Scott Boyer
Inv. 1981:1857:0005

William Notman and Son

37 [ill. p. 74]
*Victoria Glacier and Lake
Louise, near Laggan, Alberta*
1889
Albumen print
18.5 x 23.8 cm
Library and Archives
Canada, Ottawa
Inv. 1954-150

88 [ill. p. 159]
*Loop Showing the Four
Tracks on the Canadian
Pacific Railway*
About 1886
Collodion print
18.4 x 23.2 cm
Library and Archives
Canada, Ottawa
Inv. 1982-248

146 [ill. p. 251]
*Hastings Street, Vancouver,
British Columbia*
About 1890
Albumen print
18.9 x 23.6 cm
Library and Archives
Canada, Ottawa
Inv. 1954-150

147 Ⓥ [ill. p. 252]
*View of Saint John,
New Brunswick, from Trinity
Church, Looking West*
Before 1877
Collodion print
13.7 x 23.1 cm
Library and Archives
Canada, Ottawa
Inv. 1980-149

150 Ⓜ [ill. p. 255]
Montreal from Mount Royal
Before 1878
Collodion print
16.5 x 23.3 cm
Library and Archives
Canada, Ottawa
Inv. 1980-149

Lucius O'Brien

15 [ill. p. 53]
*Kakabeka Falls,
Kamanistiquia River*
1882
Oil on canvas
83.9 x 121.7 cm
National Gallery of Canada,
Ottawa
Inv. 4255

22 [ill. p. 61]
*Sunrise on the Saguenay,
Cape Trinity*
1880
Oil on canvas
90 x 127 cm
National Gallery of Canada,
Ottawa
Royal Canadian Academy of
Arts diploma work, deposited
by the artist, Toronto, 1880
Inv. 113

Georgia O'Keeffe

140 [ill. p. 230]
Church Bell, Ward, Colorado
1917
Oil on board
43.2 x 35.6 cm
Georgia O'Keeffe Museum,

Santa Fe, New Mexico
Gift of The Georgia O'Keeffe
Foundation
Inv. CR 213

179 [ill. p. 290]
Anything (Red and Green Trees)
1916
Oil on board
50.8 x 40 cm
Georgia O'Keeffe Museum,
Santa Fe, New Mexico
Gift of The Georgia O'Keeffe
Foundation
Inv. CR 90

181 [ill. p. 292]
Red Landscape
1916–1917
Oil on board
62.2 x 47 cm
Panhandle Plains Historical
Museum, Canyon, Texas
Gift of The Georgia O'Keeffe
Foundation
Inv. 1994.109.1

Timothy O'Sullivan

51 [ill. p. 107]
*A Harvest of Death,
Gettysburg, Pennsylvania*
1863
Albumen print
17.4 x 22.5 cm
National Gallery of Canada,
Ottawa
Gift of Phyllis Lambert,
Montreal, 1975
Inv. 20749.36

64 Ⓜ [ill. p. 120]
*Ancient Ruins in the Canyon
de Chelle, New Mexico*
1873
Albumen print
50.8 x 40.6 cm
Library of Congress,
Prints and Photographs
Division, Washington
Inv. Lot 4677 - C, no. 12

95 [ill. p. 167]
*Gould Curry Mine.
Comstock Lode Mine Works,
Virginia City, Nevada*
1868
Albumen print
17.7 x 21.9 cm
George Eastman House,
Rochester, New York
Gift of Harvard University
Inv. 1981:1887:0017

Maurice Prendergast

133 [ill. p. 223]
Summer Day, Salem
About 1915–1918
Oil on canvas
45.7 x 71.8 cm
Williams College Museum
of Art, Williamstown,
Massachusetts
Gift of Mrs. Charles
Prendergast
Inv. 86.18.80

134 [ill. p. 224]
Summer Hotel, Maine

About 1914–1915
Oil on panel
35.6 x 47 cm
Williams College Museum
of Art, Williamstown,
Massachusetts
Gift of Mrs. Charles
Prendergast
Inv. 86.18.65

135 [ill. p. 225]
Central Park
About 1914–1915
Oil on canvas
52.7 x 68.6 cm
The Metropolitan Museum
of Art, New York
George A. Hearn Fund, 1950
Inv. 50.25

Henry L. Rand

126 [ill. p. 216]
Somes Sound, Looking South
1893
Platinum print
11.7 x 17 cm
Southwest Harbor Public
Library, Maine
Inv. 5200

William Raphael

58 [ill. p. 114]
*Indian Encampment
on the Lower St. Lawrence*
1879
Oil on canvas
61.3 x 107 cm
National Gallery of Canada,
Ottawa
Royal Canadian Academy of
Arts diploma work, deposited
by the artist, Montreal, 1880
Inv. 59

120 [ill. p. 210]
With the Current
1892
Oil on canvas
40.8 x 63.5 cm
The Montreal Museum
of Fine Arts
Purchase, Horsley and
Annie Townsend Bequest
Inv. 1963.1433

Jacob August Riis

160 [ill. p. 265]
The Mulberry Bend
About 1890
Gelatin silver print
10.3 x 12.7 cm
Museum of the City
of New York
Inv. 2008.1.8

Andrew Joseph Russell

144 [ill. p. 249]
*Corinne Panoramic View
No. 2, Utah*
1869
Albumen print
40.6 x 33 cm
Collection of the Union
Pacific Railroad,
Council Bluffs, Iowa
Inv. 8145

Henry John Sandham

59 [ill. p. 115]
On an Eastern Salmon Stream
About 1874
Oil on canvas
76.2 x 101.9 cm
National Gallery of Canada,
Ottawa
Inv. 18882

John Singer Sargent

115 [ill. p. 204]
Tents at Lake O'Hara
1916
Oil on canvas
55.9 x 71.4 cm
Wadsworth Atheneum
Museum of Art, Hartford,
Connecticut
The Ella Gallup Sumner
and Mary Catlin Sumner
Collection Fund
Inv. 1944.57

116 [ill. p. 205]
*Inside a Tent in
the Canadian Rockies*
1916
Oil on canvas
56.5 x 71.8 cm
Collection of Meredith and
Cornelia Long, Houston

117 [ill. p. 206–207]
Yoho Falls
1916
Oil on canvas
94 x 113 cm
Isabella Stewart Gardner
Museum, Boston
Inv. P3e7

Edward Steichen

165 [ill. p. 269]
The Flatiron (Evening)
1905
Three-colour half-tone
photogravure
20.6 x 16 cm
McGill University Libraries,
Rare Books and Special
Collections, Montreal

Alfred Stieglitz

158 [ill. p. 263]
The Hand of Man
1902
Photogravure
47.1 x 57.2 cm
Library of Congress,
Prints and Photographs
Division, Washington
The Alfred Stieglitz
Collection, gift of Georgia
O'Keeffe
Inv. PH - Stieglitz (A.) no.10
(B-size)

163 [ill. p. 268]
Spring Showers
1900–1901
Photogravure
47.6 x 33 cm
Library of Congress,

Prints and Photographs
Division, Washington
The Alfredw Stieglitz
Collection, gift of
Georgia O'Keeffe
Inv. PH - Stieglitz (A.) no. 9
(B-size)

164 [ill. p. 268]
The Flatiron (Winter)
1903
Photogravure
46.6 x 31.7 cm
Library of Congress,
Prints and Photographs
Division, Washington
The Alfred Stieglitz
Collection, gift of
Georgia O'Keeffe
Inv. PH - Stieglitz (A.) no. 11
(B-size)

166 [ill. p. 270]
The City of Ambition
1910
Photogravure
34 x 26 cm
Philadelphia Museum
of Art, The Alfred Stieglitz
Collection, 1949
Inv. 1949-18-52

Paul Strand

167 [ill. p. 271]
Wall Street, New York
1915
Mercury-toned platinum
print
24.8 x 32.3 cm
Canadian Centre for
Architecture, Montreal
Aperture Foundation, Inc.,
Paul Strand Archive, 1971
Inv. PH1985:0224

Karl Struss

168 [ill. p. 271]
The Avenue (Dusk)
1914–1915
Platinum print
30.8 x 23.7 cm
Amon Carter Museum,
Fort Worth, Texas
Inv. P1983.23.92

Marc-Aurèle de Foy Suzor-Coté

26 [ill. p. 65]
*Bend in the River Gosselin
at Arthabaska*
About 1906
Oil on canvas
77 x 62 cm
The Montreal Museum
of Fine Arts
Robert A. Snowball Bequest
Inv. 1982.4

155 [ill. p. 260]
Smog, Port of Montreal
1914
Oil on canvas
99 x 131.4 cm
Musée national des beaux-
arts du Québec, Quebec City
Inv. 38.18

Tom Thomson

100 [ill. p. 172]
*The Pointers (Pageant
of the North)*
1915
Oil on canvas
102 x 116 cm
The Justina M. Barnicke
Gallery, Hart House
Permanent Collection,
Toronto
Purchased by the Art
Committee with the Print
Fund
Inv. 1928129

173 [ill. p. 284]
In Algonquin Park
1914
Oil on canvas
63.2 x 81.1 cm
McMichael Canadian
Art Collection, Kleinburg,
Ontario
Gift of the Founders,
Robert and Signe
McMichael, in memory
of Norman and Evelyn
McMichael
Inv. 1966.16.76

174 [ill. p. 285]
In the Northland
1915
Oil on canvas
101.7 x 114.5 cm
The Montreal Museum
of Fine Arts
Purchase, subscription
Inv. 1922.179

135 [ill. p. 296]
Northern Lights
About 1916–1917
Oil on panel
21.6 x 26.7 cm
The Montreal Museum
of Fine Arts
Purchase, A. Sidney Dawes
Fund
Inv. 1947.984

Trager and Kuhn

76 [ill. p. 131]
*Big Foot's Camp after the
Battle of Wounded Knee,
South Dakota*
1891
Albumen print
14.8 x 21.1 cm
Library of Congress,
Prints and Photographs
Division, Washington
Inv. Lot 11347 (H)

Ernest Percyval Tudor-Hart

131 [ill. p. 221]
Springtime in Canada
1903
Oil on canvas
97.9 x 135.4 cm
Art Gallery of Hamilton
Gift from the estate of the
artist, 1973
Inv. 75.11

John Henry Twachtman

25 [ill. p. 64]
Winter Harmony
About 1890–1900
Oil on canvas
65.4 x 81.3 cm
National Gallery of Art,
Washington
Gift of the Avalon Foundation
Inv. 1964.22.1

170 [ill. p. 281]
*Edge of the Emerald Pool,
Yellowstone*
About 1895
Oil on canvas
63.5 x 76.2 cm
Stark Museum of Art,
Orange, Texas
Inv. 31.266.1

Frederick Arthur Verner

73 [ill. p. 129]
*Buffaloes on the
Canadian Prairies*
1885
Oil on canvas
75.4 x 125.5 cm
McCord Museum, Montreal
Gift of Mr. A. Sidney Dawes
Inv. M21660

118 [ill. p. 208]
*Salmon Pool on the
Godbout River*
1877
Oil on canvas
68 x 122 cm
Musée national des beaux-
arts du Québec, Quebec City
Inv. 48.115

Horatio Walker

99 [ill. p. 171]
The Ice Cutters
1904
Oil on canvas
60.9 x 91.5 cm
The Montreal Museum
of Fine Arts
Gift of Mrs. F. S. Smithers in
memory of Charles Francis
Smithers
Inv. 1941.736

Carleton E. Watkins

33 [ill. p. 72]
*Fallen Leaf Lake,
Looking South*
1860s
Albumen print
38.5 x 54.5 cm
Library of Congress,
Prints and Photographs
Division, Washington
Inv. PR 06 CN 14C

44 [ill. p. 82]
*Mt. Lola, Looking towards
Lake Tahoe*
About 1880
Albumen print
39.2 x 53.9 cm
Library of Congress,
Prints and Photographs

Division, Washington
Inv. DLC/PP-1914.44730

96 [ill. p. 168]
*Cofferdam at End of
Main Diversion (Golden
Feather Mining Claim)*
1871–1876
Albumen print
39.4 x 53.3 cm
The Bancroft Library,
University of California,
Hearst Collection of Mining
Views by Carleton E.
Watkins, Berkeley
Inv. BANC PIC
1905.17172:122–ffALB

97 [ill. p. 169]
*Chinese Laborers
Excavating River Gravel
(Golden Gate Mining Claim)*
1871–1876
Albumen print
39.4 x 53.3 cm
The Bancroft Library,
University of California,
Hearst Collection of Mining
Views by Carleton E.
Watkins, Berkeley
Inv. BANC PIC
1905.17172:132–ffALB

145 Ⓥ [ill. p. 250]
*Depot and RR Works
from Los Angeles, S.P.R.R.*
1880
Albumen print
39 x 53.8 cm
Library of Congress,
Prints and Photographs
Division, Washington
Inv. Lot 13476, no. 4

Homer Ransford Watson

31 [ill. p. 70]
*A Coming Storm
in the Adirondacks*
1879
Oil on canvas
85.7 x 118.3 cm
The Montreal Museum
of Fine Arts
Gift of George Hague
Inv. 1887.203

92 [ill. p. 164]
The Loggers
About 1902
Oil on canvas
85 x 120.4 cm
Collection Power
Corporation of Canada

103 [ill. p. 194]
After the Rain
1883
Oil on canvas
81.3 x 125.1 cm
The Beaverbrook Art Gallery,
Fredericton, New Brunswick
Gift of Lord Beaverbrook
Inv. 1959.275

104 [ill. p. 195]
Country Road, Stormy Day
About 1895
Oil on board
61 x 76.2 cm
Private collection

Charles Jones Way

72 [ill. p. 128]
Landscape with Indians
1871–1872
Oil on canvas
49 x 56.3 cm
Vancouver Art Gallery
Annie M. Mack Bequest
Fund
Inv. VAG 64.30

John Ferguson Weir

2 [ill. p. 40]
Niagara Falls
1871
Oil on canvas
107.3 x 89.2 cm
Yale University Art Gallery,
New Haven, Connecticut
Gift of Dr. Henry P. Moseley,
B.A. 1894
Inv. 1928.384

Julian Alden Weir

128 Ⓜ [ill. p. 218]
The Red Bridge
1895
Oil on canvas
61.6 x 85.7 cm
The Metropolitan Museum
of Art, New York
Gift of Mrs. John A.
Rutherfurd, 1914
Inv. 14.141

Clarence H. White

127 [ill. p. 217]
*Jane White with Crystal Globe,
Newark, Ohio*
1906
Platinum print
24.1 x 19.2 cm
Library of Congress,
Prints and Photographs
Division, Washington
Inv. PH-White (C.), no. 30
(A-size) (P&P)

Thomas Worthington Whittredge

27 [ill. p. 66]
Woods of Ashokan
1868
Oil on canvas
144.8 x 102.9 cm
Chrysler Museum of Art,
Norfolk, Virginia
Gift of Mr. Edward J.
Brickhouse
Inv. 81.109

60 [ill. p. 116]
Indian Encampment
Between 1870 and 1876
Oil on canvas
36.8 x 55.6 cm
Terra Foundation for
American Art, Daniel J.
Terra Collection, Chicago
Inv. 1999.151

Cambridge, Massachusetts
Gift of Edward W. Forbes
Inv. 1969.185

fig. 4
John Singer Sargent
A Tent in the Rockies
1916
Watercolour, graphite
on wove paper
38 x 52 cm
Isabella Stewart Gardner
Museum, Boston
Inv. P3w17

fig. 5
John Singer Sargent
Camp at Lake O'Hara
1916
Watercolour, graphite
on wove paper
40 x 53.3 cm
The Metropolitan Museum
of Art, New York
Gift of Mrs. David Hecht
in memory of her son,
Victor D. Hecht, 1932
Inv. 32.116

fig. 6
John Singer Sargent
Camping near Lake O'Hara
1916
Watercolour on paper
40 x 53 cm
The Newark Museum,
New Jersey
Inv. 57.86

fig. 7
John Singer Sargent
Camp and Waterfall
1916
Watercolour, graphite
on wove paper
50.5 x 35.6 cm
The Metropolitan Museum
of Art, New York
Gift of Mrs. Francis Ormond,
1950
Inv. 50.130.80I

"To Pavements and Homesteads Here"-Landscape, Photography, and the Transcendence of Time and Space
Philip Brookman
[p. 237-243]

fig. 1
Asher B. Durand
Maplewood, New Jersey,
1796 – Maplewood, 1886
Kindred Spirits
1849
Oil on canvas
111.8 x 91.4 cm
Crystal Bridges Museum of
American Art, Bentonville,
Arkansas

fig. 2
Albert Sands Southworth
and Josiah Johnson Hawes
A. S. Southworth:
West Fairlee, Vermont,
1811 – Boston, 1894
J. J. Hawes: East Sudbury,
Massachusetts, 1808 –
Crawford Notch, New
Hampshire, 1901
*Niagara Falls from the
Canadian Side*
About 1850
Daguerreotype
21.6 x 16.5 cm
The Metropolitan Museum
of Art, New York
Gift of I. N. Phelps Stokes,
Edward S. Hawes, Alice Mary
Hawes and Marion Augusta
Hawes, 1937
Inv. 37.14.7

fig. 3
Frederic Edwin Church
Niagara
1857
Oil on canvas
108 x 229.9 cm
Corcoran Gallery of Art,
Washington
Museum purchase,
Gallery Fund
Inv. 76.15

fig. 4
Carleton E. Watkins
*River View of the Royal
Arches, Yosemite*
1861
Albumen print
41.3 x 52.4 cm
Corcoran Gallery of Art,
Washington
Museum purchase, with
funds from the bequest
of Marva Patterson to the
Women's Committee of the
Corcoran Gallery of Art, and
gift of Jeffrey Fraenkel and
Frish Brand
Inv. 2005.018

fig. 5
Eadweard James Muybridge
*Panorama of San Francisco
from California Street Hill*
About 1877
12 albumen prints:
11 mounted in album,
1 loose
19.1 x 219.7 cm
Library of Congress,
Prints and Photographs
Division, Washington

Selected Bibliography

General

Adamson, Jeremy Elwell. *Niagara: Two Centuries of Changing Attitudes, 1697–1901.* Exhib. cat. Washington: Corcoran Gallery of Art, 1985.

Auer, Michèle and Michel Auer. *Encyclopédie internationale des photographes de 1839 à nos jours/ Photographers Encyclopaedia International 1839 to the Present.* 2 vols. Hermance, Switzerland: Camera Obscura, 1985.

Browne, Turner and Elaine Partnow. *Macmillan Biographical Encyclopedia of Photographic Artists and Innovators.* New York: Macmillan, 1983.

Jessup, Lynda, ed. *Antimodernism and Artistic Experience: Policing the Boundaries of Modernity.* Toronto: University of Toronto Press, 2001.

Johns, Elizabeth, Andrew Sayers, and Elizabeth Mankin Kornhauser. *New Worlds from Old: 19th Century Australian and American Landscapes.* Exhib. cat. Canberra: National Gallery of Australia; Hartford, Connecticut: Wadsworth Atheneum, 1998.

Lears, T. J. Jackson. *No Place of Grace: Antimodernism and the Transformation of American Culture, 1880–1920.* Chicago: University of Chicago Press, 1994.

McDarrah, Gloria S., Fred W. McDarrah, and Timothy S. McDarrah. *The Photography Encyclopaedia.* New York: Schirmer Books, 1999.

Newhall, Beaumont. *The History of Photography: From 1839 to the Present Day.* New York: Museum of Modern Art, 1999.

Truettner, William H. and Roger B. Stein. *Picturing Old New England: Image and Memory.* Exhib. cat.

Washington: National Museum of American Art, Smithsonian Institution; New Haven: Yale University Press, 1999.

American General

American Paintings from the Manoogian Collection. Exhib. cat. Washington: National Gallery of Art; Detroit: Detroit Institute of Art, 1989.

American Paradise: The World of the Hudson River School. Introduction by John K. Howat. Exhib. cat. New York: Metropolitan Museum of Art, 1987.

Avery, Kevin J. and Franklin Kelly, eds. *Hudson River School Visions: The Landscapes of Sanford R. Gifford.* Assisted by Claire A. Conway. Exhib. cat. New York: Metropolitan Museum of Art, 2003.

Baigell, Matthew. *Dictionary of American Art.* New York: Harper and Row, 1979.

Encyclopedia of American Art. New York: E. P. Dutton; Toronto: Clarke, Irwin and Co., 1981.

Falk, Peter H., ed. *Who Was Who in American Art: Compiled from the Original Thirty-four Volumes of American Art Annual—Who's Who in Art, Biographies of American Artists Active from 1898–1947.* Madison, Connecticut: Sound View Press, 1985.

Fielding, Mantle and Glenn B. Opitz. *Mantle Fielding's Dictionary of American Painters, Sculptors and Engravers.* Poughkeepsie, New York: Apollo, 1986.

Flexner, James Thomas. *Nineteenth Century American Painting.* New York: Putnam, 1970.

Fort, Ilene Susan and Michael Quick. *American Art: A Catalogue of the Los Angeles County Museum of Art Collection.* Los Angeles: Los Angeles County Museum of Art, 1991.

Gerdts, William H. *The Golden Age of American Impressionism.* Exhib. cat. New York: Watson-Guptill, 2003.

Hagood, Martha N. and Jefferson C. Harrison. *American Art at the Chrysler Museum: Selected Paintings, Sculpture and Drawings.* Norfolk, Virginia: Chrysler Museum of Art, 2005.

Hayden, Ferdinand Vandeveer. *The Yellowstone National Park and the Mountain Regions of Portions of Idaho, Nevada, Colorado and Utah; Described by Professor F. V. Hayden; Illustrated by Chromolithographic Reproductions of Water-color Sketches by Thomas Moran, Artist of the Expedition.* Boston: L. Prang and Company, 1876.

Hiesinger, Ulrich W. *Impressionism in America: The Ten American Painters.* Exhib. cat. Munich: Prestel, 1991.

Junker, Patricia A. et al. *An American Collection: Works from the Amon Carter Museum.* New York: Hudson Hills Press in association with the Amon Carter Museum, 2001.

Kornhauser, Elizabeth Mankin and Amy Ellis. *Hudson River School: Masterworks from the Wadsworth Atheneum Museum of Art.* New Haven: Yale University Press in association with the Wadsworth Atheneum Museum of Art, 2003.

Lewis, Michael J. *American Art and Architecture.* London: Thames and Hudson, 2006.

Marchetti, Francesca Castria, ed. *American Painting.* New York: Watson-Guptill, 2002.

McNeil, Barbara. *Artist Biographies Master Index.* Detroit: Gale Research, 1986.

Morgan, Ann Lee. *The Oxford Dictionary of American Art and Artists.* New York: Oxford University Press, 2007.

Novak, Barbara. *American Painting of the Nineteenth Century: Realism, Idealism, and the American Experience.* New York: Praeger, 1969.

Novak, Barbara. *Nature and Culture: American Landscape and Painting, 1825–1875.* New York: Oxford University Press, 1980.

Searl, Marjorie B. *Seeing America: Painting and Sculpture from the Permanent Collection of the Memorial Art Gallery of the University of Rochester.* Rochester, New York: University of Rochester Press, 2006.

Session, Ralph. *The Poetic Vision: American Tonalism.* Exhib. cat. New York: Spanierman Gallery, 2005.

Stewart, Rick. *A Century of Western Art: Selections from*

the Amon Carter Museum. Fort Worth, Texas: Amon Carter Museum, 1998.

Turner, Jane, ed. *Encyclopedia of American Art before 1914.* Basingstoke, England: Macmillan References; New York: Grove's Dictionaries, 2000.

Wilmerding, John, ed. *American Light: The Luminist Movement, 1850–1875: Paintings, Drawings, Photographs.* Exhib. cat. Washington: National Portrait Gallery, 1980.

Wilton, Andrew and Tom Barringer. *American Sublime: Landscape Painting in the United States, 1820–1880.* Princeton: Princeton University Press, 2002.

Young, Mahonri Sharp. *The Eight: The Realist Revolt in American Painting.* New York: Watson-Guptill, 1973.

Canadian General

Baker, Victoria A. *L'Art des Cantons de l'est, 1800-1950.* Exhib. cat. Sherbrooke: Université de Sherbrooke, Galerie d'art du Centre culturel, Centre de documentation, 1980.

Barreto-Rivera, Rafael et al. *Contemporary Canadian Artists.* Scarborough: Gale Canada, 1997.

Blodgett, Jean et al. *The McMichael Canadian Art Collection.* Kleinburg, Ontario: McMichael Canadian Art Collection; Toronto: McGraw-Hill Ryerson, 1989.

Brown, George W. et al. *Dictionary of Canadian Biography.* 15 vols. Toronto: University of Toronto Press, 1966.

Burnett, David. *Masterpieces of Canadian Art from the National Gallery of Canada.* Edmonton: Hurtig, 1990.

Canadian Treasures: 25 Paintings, 25 Artists, 25 Years. Kitchener-Waterloo Art Gallery, 8 October–1 November 1981. Exhib. cat. Kitchener, Ontario: Kitchener-Waterloo Art Gallery, 1981.

Cavell, Edward and Dennis Reid. *When Winter Was King: The Image of Winter in 19th Century Canada.* Banff: Altitude Publishing in association with the Whyte Museum of the Canadian Rockies, 1988.

Christensen, Lisa. *A Hiker's Guide to Art of the Canadian Rockies.* Calgary: Glenbow Museum, 1996.

Duval, Paul, *Canadian Impressionism.* Toronto: McClelland and Stewart, 1990.

Farr, Dorothy. *Urban Images, Canadian Painting.* Kingston: Agnes Etherington Art Center, 1990.

Harper, J. Russell. *Early Painters and Engravers in Canada.* Toronto: University of Toronto Press, 1970.

Harper, J. Russell. *Painting in Canada: A History.* Toronto: University of Toronto Press, 1966.

Hill, Charles C. *The Group of Seven: Art for a Nation.* Exhib. cat. Ottawa: National Gallery of Canada; Toronto: McClelland and Stewart, 1995.

Lacasse, Yves and John R. Porter, eds. *A History of Art in Quebec: The Collection of the Musée national des beaux-arts du Québec.* Translated by Donald Pistolesi. Quebec City: Musée national des beaux-arts du Québec, 2004.

Lord, Barry. *The History of Painting in Canada: Toward a People's Art.* Toronto: NC Press, 1974.

Lowrey, Carol. *Visions of Light and Air: Canadian Impressionism, 1885–1920.* Exhib. cat. New York: Americas Society Art Gallery, 1995.

MacDonald, Colin S. *A Dictionary of Canadian Artists.* 7 vols. Ottawa: Canadian Paperbacks, 1967.

MacDonald, Colin S. *A Dictionary of Canadian Artists.* Vol. 1. 5th ed. revised and expanded. Ottawa: Canadian Paperbacks, 1997.

McKendry, Blake. *A to Z of Canadian Art, Artists and Art Terms.* Kingston: B. McKendry, 1997.

Murray, Joan. *Impressionism in Canada: 1835–1935.* Exhib. cat. Toronto: Art Gallery of Ontario, 1973.

Ostiguy, Jean-René. *Un siècle de peinture canadienne 1870–1970.* Quebec City: Presses de l'Université Laval, 1971.

Reid, Dennis. *Collector's Canada: Selections from a Toronto Private Collection.*

Exhib. cat. Toronto: Art Gallery of Ontario, 1988.

Reid, Dennis. *A Concise History of Canadian Painting.* 2nd ed. Toronto: Oxford University Press, 1988.

Reid, Dennis. *"Our Own Country Canada": Being an Account of the National Aspirations of the Principal Landscape Artists in Montreal and Toronto, 1860–1890.* Ottawa: National Gallery of Canada, 1979.

Thomas, Ann. *Fact and Fiction: Canadian Painting and Photography, 1860–1900.* Exhib. cat. Montreal: McCord Museum, 1979.

American Artists

Adelson, Warren et al. *Sargent Abroad: Figures and Landscapes.* New York: Abbeville Press, 1997.

Anderson, Nancy K. *Albert Bierstadt: Cho-looke, the Yosemite Fall.* Exhib. cat. San Diego: Timken Art Gallery, 1986.

Anderson, Nancy K. *Thomas Moran.* Exhib. cat. Washington: National Gallery of Art; New Haven: Yale University Press, 1997.

Anderson, Nancy K. and Linda S. Ferber. *Albert Bierstadt: Art and Enterprise.* Exhib. cat. New York: Brooklyn Museum in association with Hudson Hills, 1990.

Atkinson, D. Scott and Nicolai Cikovsky, Jr. *William Merritt Chase: Summers at Shinnecock 1891–1902.* Exhib. cat. Washington: National Gallery of Art, 1987.

Boyle, Richard J. *John Twachtman.* New York: Watson-Guptill, 1979.

Buhler Lynes, Barbara. *Georgia O'Keeffe: Catalogue Raisonné.* New Haven: Yale University Press; Washington: National Gallery of Art; Abiquiu, New Mexico: The Georgia O'Keeffe Foundation, 1999.

Carbone, Teresa A. and Patricia Hills. *Eastman Johnson: Painting America.* Exhib. cat. New York: Brooklyn Museum of Art in association with Rizzoli International Publications, 1999.

Cash, Sarah. *"Ominous Hush": The Thunderstorm Paintings of Martin Johnson Heade.*

Exhib. cat. Fort Worth, Texas: Amon Carter Museum, 1994.

Cikovsky, Jr., Nicolai and Michael Quick. *George Inness*. Exhib. cat. Los Angeles: Los Angeles County Museum of Art; New York: Harper and Row, 1985.

Clark, Carol, Nancy Mowll Mathews, and Gwendolyn Owens. *Maurice Brazil Prendergast, Charles Prendergast: A Catalogue Raisonné*. Exhib. cat. Williamstown, Massachusetts: Williams College Museum of Art; Munich: Prestel, 1990.

Dee, Elaine Evans. *Frederic E. Church: Under Changing Skies. Oil Sketches and Drawings from the Collection of the Cooper-Hewitt, National Museum of Design, Smithsonian Institution*. Exhib. cat. Philadelphia: Arthur Ross Gallery of the University of Pennsylvania, 1992.

Driscoll, John Paul and John K. Howat. *John Frederick Kensett: An American Master*. Susan E. Strickler, ed. Exhib. cat. New York: Worcester Art Museum in association with W. W. Norton and Company, 1985.

Fairbrother, Trevor. *John Singer Sargent: The Sensualist*. Exhib. cat. Seattle: Seattle Art Museum; New Haven: Yale University Press, 2000.

Fort, Ilene Susan. *The Flag Paintings of Childe Hassam*. Exhib. cat. Los Angeles: Los Angeles County Museum of Art; New York: Harry N. Abrams, 1988.

Gardner, Albert Ten Eyck. *Winslow Homer, American Artist: His World and His Work*. New York: Clarkson N. Potter, 1961.

Goldfarb, Hilliard T., Erica E. Hirshler, and T. J. Jackson Lears. *Sargent: The Late Landscapes*. Exhib. cat. Boston: Isabella Stewart Gardner Museum, 1999.

Haskell, Barbara. *Arthur Dove: San Francisco Museum of Art*. Exhib. cat. Boston: New York Graphic Society, 1974.

Hendricks, Gordon. *Albert Bierstadt: Painter of the American West*. New York: Harrison House, 1988.

Hendricks, Gordon. *The Life and Work of Winslow Homer*. New York: Harry N. Abrams, 1979.

Homer, William Innes. *Thomas Eakins: His Life and Art*. New York: Abbeville Press, 1992.

Howat, John K. *John Frederick Kensett 1816–1872*. Exhib. cat. New York: American Federation of Arts, 1968.

Ireland, LeRoy. *The Works of George Inness: An Illustrated Catalogue Raisonné*. Austin: University of Texas Press, 1965.

Kelly, Franklin. *Frederic Edwin Church*. Exhib. cat. Washington: National Gallery of Art, Smithsonian Institution Press, 1989.

Kinsey, Joni Louise. *Thomas Moran and the Surveying of the American West*. Washington: Smithsonian Institution Press, 1992.

Kugler, Richard C. *William Bradford: Sailing Ships and Arctic Seas*. Exhib. cat. New Bedford, Massachusetts: New Bedford Whaling Museum; Seattle: University of Washington Press, 2003.

Large Boston Public Garden Sketchbook. Introduction by George Szabo. New York: G. Braziller in association with the Metropolitan Museum of Art, 1987.

Martin, Constance. *Distant Shores: The Odyssey of Rockwell Kent*. Exhib. cat. Chesterfield, Massachusetts: Chameleon Books; Berkeley: University of California Press; Stockbridge, Massachusetts: Norman Rockwell Museum, 2000.

McDonnell, Patricia. *Marsden Hartley: American Modern. Selections from the Ione and Hudson D. Walker Collection*. Exhib. cat. Minneapolis: Frederick R. Weisman Art Museum, University of Minnesota, 2006.

Perlman, Bennard B. *Robert Henri, Painter: Delaware Art Museum*. Exhib. cat. Wilmington: The Museum, 1984.

Peters, Linda N. *John Twachtman (1853–1902): A "Painter's Painter."* Exhib. cat. New York: Spanierman Gallery, 2006.

Robert S. Duncanson: A Centennial Exhibition. Exhib. cat. Cincinnati: Cincinnati Art Museum, 1972.

Robertson, Bruce. *Marsden Hartley*. New York: Harry N.

Abrams in association with the National Museum of American Art, Smithsonian Institution, 1995.

Sewell, Darrel. *Thomas Eakins*. Exhib. cat. Philadelphia: Philadelphia Museum of Art, 2001.

Sewell, Darrel. *Thomas Eakins: Artist of Philadelphia*. Exhib. cat. Philadelphia: Philadelphia Museum of Art, 1982.

Wattenmaker, Richard J. *Maurice Prendergast*. New York: Harry N. Abrams in association with the National Museum of American Art, Smithsonian Institution, 1994.

Wilmerding, John. *Winslow Homer*. New York: Praeger, 1972.

Witkin, Lee D. and Barbara London. *The Photograph Collector's Guide*. Boston: New York Graphic Society, 1979.

Canadian Artists

Adamson, Jeremy Elwell. *Lawren S. Harris: Urban Scenes and Wilderness Landscapes 1906–1930*. Exhib. cat. Toronto: Art Gallery of Ontario, 1978.

Antoniou, Sylvia. *Maurice Cullen 1886–1934*. Exhib. cat. Kingston: Agnes Etherington Art Centre, 1982.

Barbeau, Marius. *Cornelius Krieghoff: Pioneer Painter of North America*. Toronto: The MacMillan Company of Canada, 1934.

Beaudry, Louise. *Contemplative Scenes: The Landscapes of Ozias Leduc*. Exhib. cat. Montreal: Montreal Museum of Fine Arts, 1986.

Boissay, René. *Clarence Gagnon*. La Prairie, Quebec: Éditions Marcel Broquet, 1988.

Boulet, Roger. *Frederick Marlett Bell-Smith*. Exhib. cat. Victoria: Art Gallery of Greater Victoria, 1977.

Clark, Janet E. and Robert Stacey. *Frances Anne Hopkins, 1838–1919: Canadian Scenery*. Exhib. cat. Thunder Bay: Thunder Bay Art Gallery, 1990.

Dupont-Tanguay, Louise et al. *Leduc et Borduas: le sage et le rebelle. L'empreinte de deux grands artistes*. Exhib. cat.

Montreal: Éditions Histoire Québec; Beloeil: Société d'histoire de Beloeil–Mont-Saint-Hilaire; Mont-Saint-Hilaire: Musée d'art de Mont-Saint-Hilaire, 2005.

Goelman, Sharon. *William Raphael (1833–1914): Retrospective Exhibition*. Exhib. cat. Montreal: Walter Klinkhoff Gallery, 1978.

Harper, J. Russell. *Krieghoff*. Toronto: University of Toronto Press, 1979.

Hill, Charles C., Johanne Lamoureux, and Ian Thom. *Emily Carr: New Perspectives on a Canadian Icon*. Exhib. cat. Vancouver: Douglas and McIntyre in association with the National Gallery of Canada and Vancouver Art Gallery, 2007.

Hunter, E. Robert. *J. E. H. MacDonald: A Biography and Catalogue of His Work*. Toronto: Ryerson Press, 1940.

Jouvancourt, Hugues de. *Clarence Gagnon*. Montreal: Éditions La Frégate, 1970.

Jouvancourt, Hugues de. *Cornelius Krieghoff*. Montreal: Éditions Stanké, 1979.

Karel, David. *Horatio Walker*. Exhib. cat. Quebec City: Musée du Québec, 1987.

Lacroix, Laurier, ed. *Ozias Leduc: An Art of Love and Reverie*. Exhib. cat. Quebec City: Musée du Québec; Montreal: Montreal Museum of Fine Arts, 1996.

Lacroix, Laurier. *Suzor-Coté, Light and Matter*. Exhib. cat. Montreal: Éditions de l'Homme, 2002.

MacGregor, Alasdair Alpin. *Percyval Tudor-Hart, 1873–1954: Portrait of An Artist*. London: P. R. Macmillan, 1961.

Moray, Gerta. *Unsettling Encounters: First Nations Imagery in the Art of Emily Carr*. Vancouver: UBC Press, 2006.

Murray, Joan. *The Best of Tom Thomson*. Edmonton: Hurtig, 1986.

Murray, Joan. *Lawren Harris: An Introduction to His Life and Art*. Toronto: Firefly Books, 2003.

Murray, Joan. *Northern Lights: Masterpieces of Tom Thomson and the Group of Seven*. Toronto: Key Porter Books, 1994.

Newlands, Anne. *Clarence Gagnon: An Introduction to His Life and Art*. Richmond Hill, Ontario: Firefly Books, 2005.

Ostiguy, Jean-René. *Marc-Aurèle de Foy Suzor-Coté: Winter Landscape*. Exhib. cat. Ottawa: National Gallery of Canada, National Museums of Canada, 1978.

Ostiguy, Jean-René. *Ozias Leduc, 1864–1955*. Exhib. cat. Ottawa: The National Gallery of Canada; Quebec City: Le Musée de la Province de Québec, 1955.

Reid, Dennis. *Krieghoff: Images of Canada*. Exhib. cat. Vancouver: Douglas and McIntyre; Toronto: Art Gallery of Ontario, 1999.

Reid, Dennis. *Lucius R. O'Brien: Visions of Victorian Canada*. Exhib. cat. Toronto: Art Gallery of Ontario, 1990.

Reid, Dennis, ed. *Tom Thomson*. Exhib. cat. Toronto: Art Gallery of Ontario in association with Douglas and McIntyre, 2002.

Robertson, Nancy E., ed. *J.E.H. MacDonald, R.C.A., 1873–1932*. Exhib. cat. Toronto: Art Gallery of Ontario, 1965.

Silcox, David P. *Painting Place: The Life and Work of David B. Milne*. Toronto: University of Toronto Press, 1996.

Silcox, David P. *The Group of Seven and Tom Thomson*. Toronto: Firefly Books, 2003.

Stacey, Robert. *Western Sunlight: C. W. Jefferys on the Canadian Prairies*. Exhib. cat. Saskatoon: Mendel Art Gallery, 1986.

Triggs, Stanley G. *William Notman: The Stamp of a Studio*. Exhib. cat. Toronto: Art Gallery of Ontario; Coach House Press, 1985.

Whiteman, Bruce. *J. E. H. MacDonald*. Kingston: Quarry Press, 1995.

Copyrights

© The Estate of
Arthur G. Dove

A. Y. Jackson: Courtesy of
the Estate of the late
Dr. Naomi Jackson Groves

© Estate of Ozias Leduc /
SODRAC (2009)

© Georgia O'Keeffe Museum /
SODRAC (2009)

© Yinka Shonibare, MBE.
Courtesy the artist and
Stephen Friedman Gallery,
London

© Aperture Foundation, Inc.,
Paul Strand Archive

Photo credits

Exhibited works

Cat. 21
Addison Gallery of American
Art, Phillips Academy

Cat. 13, 155, 156
Patrick Altman

Cat. 119, 168
Amon Carter Museum,
Fort Worth, Texas

Cat. 131
Art Gallery of Hamilton

Cat. 11, 157, 186
© 2008 Art Gallery of Ontario

Cat. 152
Art Gallery of Windsor, Ontario

Cat. 48
Courtesy of the Autry
National Center, Museum
of the American West
collection, Los Angeles

Cat. 96, 97
The Bancroft Library,
University of California,
Berkeley

Cat. 100
The Justina M. Barnicke
Gallery, Hart House
Permanent Collection

Cat. 103, 154
The Beaverbrook Art Gallery

Cat. 121
E. Irving Blomstrann

Cat. 69
British Columbia Archives
Collection, Royal BC
Museum Corporation,
Victoria

Cat. 167
Canadian Centre for
Architecture, Montreal

Cat. 54
Carnegie Museum of Art,
Pittsburgh

Cat. 27
Chrysler Museum of Art

Cat. 114
© 2001 Clark Art Institute

Cat. 5
Corcoran Gallery of Art,
Washington, D.C.

Cat. 23
Currier Museum of Art

Cat. 90
Denver Public Library

Cat. 116
Tom Dubrock

**Cat. 9, 19, 34, 40, 45, 50, 53,
84, 87, 89, 95, 180, 182**
Courtesy of George Eastman
House, International
Museum of Photography
and Film

Cat. 49
Fine Arts Museums of
San Francisco

Cat. 117
Isabella Stewart
Gardner Museum

Cat. 7
The J. Paul Getty Museum

Cat. 42
Glenbow Museum

Cat. 188
Hood Museum of Ar

Cat. 113, 118, 151
Jean-Guy Kérouac

Cat. 93
D. Kinsey A14

**Cat. 6, 14, 16, 17, 30, 35,
36, 37, 57, 62, 63, 65, 66, 67,
71, 83, 86, 88, 143, 146, 147,
148, 150**
Library and Archives Canada

**Cat. 33, 44, 64, 74, 75, 76,
127, 145, 158, 163, 164**
Library of Congress,
Washington, D.C.

Cat. 3, 61, 73
McCord Museum, Montreal

Cat. 165
McGill University Libraries
Rare Books and
Special Collections

Cat. 137, 173, 175, 177
McMichael Canadian
Art Collection

Cat. 110, 159
Memorial Art Gallery of
the University of Rochester,
New York

Cat. 132
Brian Merrett

Cat. 32, 79, 128, 135
Image © The Metropolitan
Museum of Art

Cat. 78, 112
Mois

**Cat. 24, 26, 29, 31, 46, 70,
81, 98, 99, 101, 120, 122,
123, 130, 138, 174, 185**
The Montreal Museum
of Fine Arts

Cat. 111
Thomas Moore Photography

Cat. 28
© 2009 Museum Associates /
LACMA

Cat. 160, 161, 162
Museum of the City of
New York

Cat. 20, 187
Museum of Fine Arts,
Boston

**Cat. 4, 10, 12, 15, 22, 38, 51,
52, 58, 58, 91, 136, 178, 183**
© National Gallery of
Canada, Ottawa

Cat. 169
The New York
Historical Society

Cat. 142
Norton Museum of Art

Cat. 47
Oakland Museum of
California

Cat. 40, 179, 181
© Georgia O'Keeffe Museum

Cat. 105, 106, 107, 108
Pennsylvania Academy of
the Fine Arts

Cat. 39, 56, 92
Collection Power
Corporation of Canada

Cat. 104
Private collection

Cat. 141
Private collection

Cat. 1
A. Reeve

Cat. 41
Ian Reeves

Cat. 166
Lynn Rosenthal

Cat. 55, 102, 172
Saint Louis Art Museum

Cat. 77, 94
San Francisco Museum
of Modern Art

Cat. 124
Santa Barbara Museum
of Art

Cat. 149
Seattle Collection, University
of Washington Librairies,
Special Collections / UW 4812

Cat. 126
Southwest Harbor
Public Library

Cat. 8
Lee Stalsworth

Cat. 25, 170
Stark Museum of Art

Cat. 43
Peggy Tenison

Cat. 60, 125, 184
Terra Foundation for
American Art, Chicago

Cat. 85
Terry Thompson

Cat. 18
Timken Museum of Art

Cat. 80
University of Calgary Arctic
Institute of North America
and Special Collections

Cat. 68, 72, 139
Vancouver Art Gallery

Cat. 115
Wadsworth Atheneum
Museum of Art

Cat. 171
Walker Art Center

Cat. 133, 134
Williams College Museum
of Art

Cat. 176
The Winnipeg Art Gallery,
Ernest Mayer

Cat. 82, 109
Graydon Wood

Cat. 144
Union Pacific Railroad

Cat. 2, 129, 153
Yale University Art Gallery

Figures

T. J. Jackson Lears
fig. 1, 2
Collection of The New York
Historical Society
fig. 3
Library of Congress,
Washington, D.C
fig. 4
The Architect of the Capitol
fig. 5
Museum of American
History, Smithsonian
Institution

Rosalind Pepall
fig. 1
Library and Archives Canada
fig. 2
Bildarchiv Preussischer
Kulturbesitz / Art Resource,
NY / Photo Elke Walford
fig. 3
Dallas Museum of Fine Arts
fig. 4
University of Calgary
Arctic Institute of
North America and
Special Collections

Lynda Jessup
fig. 1
Courtesy of Lynda Jessup
fig. 2
© National Gallery of
Canada, Ottawa
fig. 3
© The National Gallery,
London

Richard Hill
fig. 1
National Museum of Ireland
fig. 2, 3
© 1981, Detroit Institute
of Arts
fig. 4
The Montreal Museum
of Fine Arts
fig. 5
Courtesy of the artist

Ian Thom
fig. 1, 2, 6
McCord Museum, Montreal
fig. 3, 4, 5
Courtesy of BC Archives
collections

Brian Foss
fig. 1
© National Gallery
of Canada, Ottawa
fig. 2
Toronto Public Library
fig. 3, 5
The Montreal Museum
of Fine Arts
fig. 4, 6, 7
McGill University Libraries
Rare Books and
Special Collections

Hilliard T. Goldfarb
fig. 1
Marc Pinel,
Grand Nature Club
fig. 2, 3
© President and Fellows
of Harvard College
fig. 4
Isabella Stewart
Gardner Museum
fig. 5, 7
Image © The Metropolitan
Museum of Art
fig. 6
The Newark Museum /
Art Resource, NY

Philip Brookman
fig. 1
Courtesy Crystal Bridges
Museum of American Art,
Bentonville, Arkansas
fig. 2
Image © The Metropolitan
Museum of Art
fig. 3, 4
Corcoran Gallery of Art,
Washington, D.C.
fig. 5
Library of Congress,
Washington, D.C.